IT HAPPENED IN OUR

LIFETIME

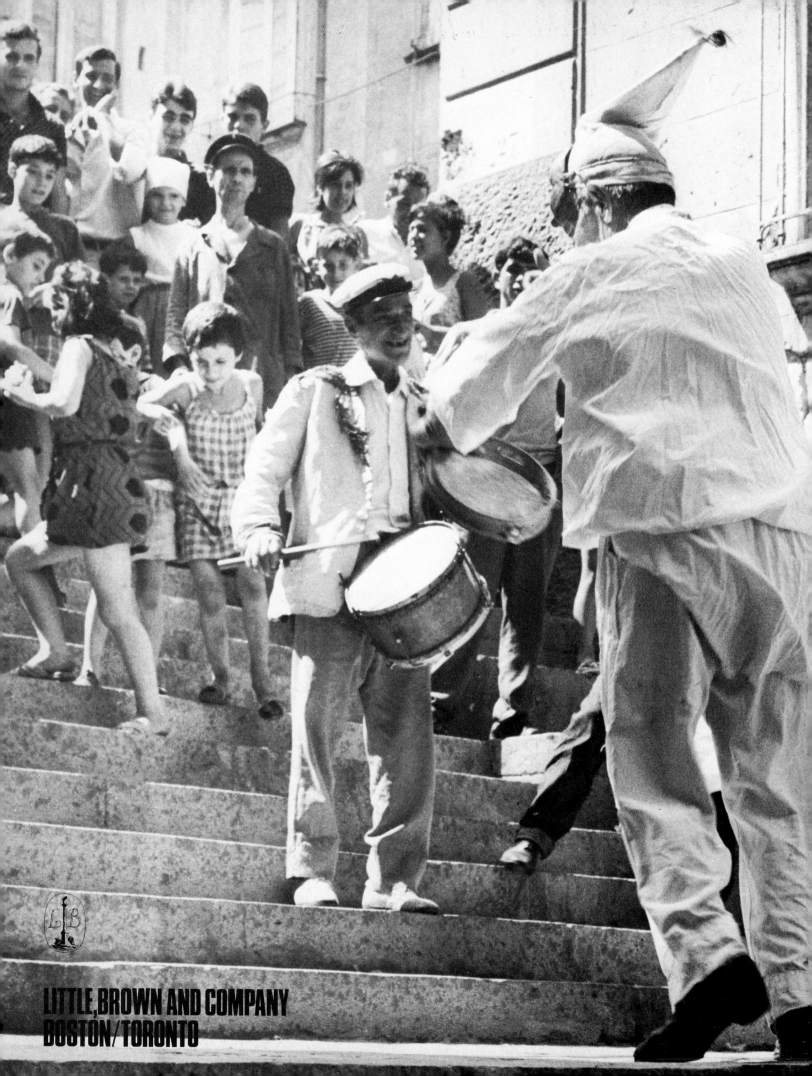

LITTLE, BROWN AND COMPANY
BOSTON / TORONTO

IT HAPPENED
IN OUR
LIFETIME

**A MEMOIR
IN WORDS AND PICTURES
JOHN PHILLIPS**

The author gratefully acknowledges the generosity of Time Inc., and in particular *Life* magazine publisher Charles A. Whittingham, for permission to reprint one hundred and five photographs originally taken on staff assignment for *Life* magazine during the years 1936 through 1949. Copyright © 1936–1949 by Time Inc. Copyright on all other photographs is owned by John Phillips.

Library of Congress Cataloging-in-Publication Data

Phillips, John, 1914–
 It happened in our lifetime.

 1. Phillips, John, 1914– . 2. Photographers--United States--Biography. 3. Photography, Journalistic. I. Title.
TR140.P47A33 1985 770′.92′4 [B] 85-13116
ISBN 0-316-70609-4

**COVER AND BOOK DESIGN:
ARMANDO MILANI**

PICTURE COORDINATOR:
ANNA MARIA PHILLIPS

First Edition

Published simultaneously in Canada by Little, Brown & Company (Canada) Limited

Acknowledgments

A quick glance at this book will convince anyone that I owe so many thanks to so many people in so many languages, alphabets, and scripts that I must reluctantly forgo the pleasure of reeling off enough names to fill a small-town telephone book.

I will never forget René Pansier and Henry R. Luce, the former teaching me enough about photography that the latter could take a chance on hiring an untried young foreigner. I would be remiss if I did not recall David K. Ritchie, of the London bureau, who did so much to help me get my start, and Edward K. Thompson, *Life*'s managing editor and my boss for so many years. I would also like to express my gratitude to Reginald K. Brack, Jr., for recommending me to Little, Brown, and to Roger Donald and Mike Mattil, who proved to be the editors one always hopes to meet.

I am beholden to several generations of Time-Life photo lab technicians who always took great care with my work, going back to the time of George Karas and Herbert Orth and on to the present-day chief, Peter Christopoulos, and his deputy Hanns Kohl.

I certainly cannot overlook Donald Seaman, who gave up a year of his life to come work with me on this project, Thomas M. Stone for many lost weekends in my darkroom, and Margaret Weiss for good advice and a perfect index.

I am very much obliged to Alan Pryce-Jones for giving me the particulars on Eton and Valentine Lawford for keeping me up on the British upper classes.

I am indebted to Bill Mauldin for his cartoon recalling a jaunt we made to a company rest camp on the Italian front when we had occasion to play good Samaritans.

Contents

To A. M.

The Making of a *Life* Photographer

I believe in Fate, possibly because I was born beneath the sky of Islam. There people are guided by *mektoub,* a conviction that whatever happens is inevitable. In retrospect I can see a pattern emerge from a series of unrelated circumstances: my parents moving from my native Algeria to France, which led to my meeting Monsieur René Pansier. He was the one who taught me photography before my family and I moved on to England. With no formal English education, I wound up doing odd jobs in London at the age of twenty-one. On one of these I salvaged a bundle of old *Time* magazines. I had no idea this would alter my life within three months. Everything changed on November 2, 1936.

"Mail from America," the postman called out, handing me a letter from *Time* magazine. The editor thanked me for the unsolicited picture I had sent. Although it had not been used, *Time* was keeping it. I was paid $14 — more than I earned being published in Europe — and was advised to get in touch with their London bureau. Time Inc. was about to launch *Life* magazine and there might be work for me in England.

Years later Sonia Orwell tried to convince me that without *Life* I would have made my way in England, but I do not think so. Without the rancor I once felt, I now realize I was a misfit in a rigidly stratified society. There was nothing I could do about it. My father was no help.

Edgar Phillips Bosomworth Phillips came from North Wales. His parents divorced before he was old enough to remember. He was never told why, and never met his father. A fellow suffragette with my grandmother offered me a clue: "Your grandfather was much too handsome for his own good." A five-foot-two disciplinarian, my grandmother decided that at twelve her son was ripe for boarding school. Sent to a public school, my father was soon in trouble for refusing to obey the senior boys. In an effort to instill respect for his betters, he was hazed before an open hearth. He was in the infirmary recovering from burns when he learned he had been kicked out of school for lack of public spirit. This left his mother with no alternative but to send him to Switzerland — the Siberia of the well-to-do. There my father lived in Lausanne with the family of a German professor until he graduated. By the time he enrolled at Edinburgh's medical school, his mother had died and there were no relatives left in England.

It was in Munich, where he was spending his summer holidays, that my father met my American mother. She was making the Grand Tour with her mother and sisters. He created an everlasting impression by fighting a duel over her. A quiet woman, Mother once remarked with a smile, "That sort of thing never happened in Troy, New York."

In 1904, six months before his finals, my father gave up medicine, sailed for New York, and married Mother in Albany. With a private income, no responsibilities, and no definite aims, they returned to Europe and visited my father's Swiss tutor in Lausanne. He was the one who suggested they visit Algeria.

The two-week tour lasted twenty-one years. My father bought a farm in Greater Kabylia, where I was born ten years later on Friday, November 13, 1914. As it was not the British Raj, I did not have a nanny to teach me the King's English. A Kabyle girl whose parents worked on the farm watched over me. She crooned in her native Kabyle, which is why the first words I spoke were in that Arab dialect. I no longer speak Kabyle, but its sharp guttural still scars my English.

After my father sold the farm we moved to Algiers, where he became fascinated by color photography. The bathroom was made into a darkroom, while the dining room was turned into a finishing room as photography spread throughout the apartment. Although he was a very good photographer, my father never had the patience to teach me anything. He

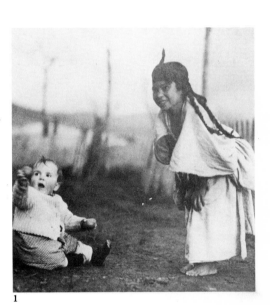

1

(1) At eighteen months on my father's farm in the mountains of Algeria with my twelve-year-old Kabyle nanny.

would travel to France to attend photographic congresses, leaving Mother and me behind in Algiers.

I attended Le Petit Lycée, where you had to fend for yourself. In addition to the French from France and the French born in Algeria, there were Jews and Arabs, Spaniards, Italians, Greeks, Portuguese, and Maltese. The only English boy in school, I was a minority among the other minorities and became streetwise very young. Mother decided we should move to France, which coincided with my father's plans to open a photographic studio in Paris. We wound up at the Studio Hotel in Montparnasse, a few steps from the Café du Dôme. Paris in 1925 was all that Hemingway was to write about. My father was carried away by the expatriate life on the Left Bank, made even more agreeable by a favorable rate of exchange.

At twelve I fidgeted at the Dôme while my father and Man Ray delved into Surrealism. At one of these sessions Man Ray told my father about a remarkable new Russian movie called *Battleship Potemkin*. The very next day our teacher asked us to write about a film we had liked. I chose *Battleship Potemkin* although I had never seen it and simply repeated, in Man Ray's own words, the relentless march of the soldiers with fixed bayonets, cutting to the perambulator careening down the wide stairway after the shooting started, et cetera. Even for a school like L'École Alsacienne, where brilliance was the norm (I had made it through patronage), my teacher was impressed and felt that a new genius had been added to the school roster. Unfortunately, late one Saturday night he dropped by the Café du Dôme and found me leaning against the bar munching a chocolate wafer while my father and Leo Stein debated the question: Is good art better than bad and, if so, can it be proved? Sizing up the situation, my teacher realized that he had been taken in by a fraud. "You charlatan!" he said in disgust.

Too young to enjoy the free liquor that flowed at the opening of La Coupole, I am probably the only one besides M. Laffont, the owner, with any clear recollection of that memorable event. I regret that I did not have a camera then because the Dôme, La Coupole, and Le Select were crowded with an array of colorful drunks—today's venerable artistic geniuses. My picaresque existence lasted eighteen months, when my father's funds dwindled and we had to move from the elegant Studio Hotel to much less chic abodes.

We moved from Paris to Nice in 1927. At Christie's bar my father got to know the wealthy Anglo-American expatriates who flourished on the Riviera. He believed these people would commission him to do their portraits, but he was so slow, so temperamental, and so unbusinesslike he never made any money.

As Fate would have it, my father struck up a friendship with a cheerful middle-aged Frenchman, M. René Pansier. M. Pansier owned a photographic shop where I spent my summer holidays. As his apprentice, I followed film processing through tank developing, fixing and washing, contact printing, drying, and trimming, learning as much about human nature as about photography. I soon found that photography has a way of bringing out the bawdy and recording the lewd. (For all my experience it never occurred to me to buy stock when the Polaroid camera came on the market and home pornography became possible.)

As the official photographer for the city of Nice, Pansier covered every kind of event. I tagged along, picking up tricks of the trade. The Leica camera had just burst on the scene. M. Pansier dove into miniature photography, with me right behind him. We practiced getting pictures under minimum light conditions and became proficient in candid photography using available light.

In 1934 I completed my studies. My father, who had always complained about the English climate, now decided we should move "back home." The country my father was returning to after thirty years—and I was visiting for the first time—was new to both of us. The old estate agent, hat in hand, who had always greeted my father was no longer around. His son would still end his letters to my father "Your obedient servant," but with some property sold and others mortgaged to pay for my father's

2

3

(2) At age sixteen with René Pansier, who owned a photographic store in Nice on the French Riviera. As M. Pansier's apprentice, I learned enough about photography to become a Life *photographer at twenty-one.*

(3) The Leica camera burst upon the world in the late twenties and allowed for picture-taking under minimum light conditions, impossible up to then. The circus was a perfect testing ground. I took this picture of clowns in 1930.

photographic excesses, there was precious little to be obedient about.

My father, who had always been considered an eccentric—that is, a person who can afford his nonconformity—was regarded as a misfit the moment he could not. This did not bother him at all. It never dawned on him that, by giving me a French education, then bringing me to England, he had created a second-generation misfit. With a background like mine there were few openings. One was offered in an oblique way. The friend of an acquaintance arranged for me to meet a third party in a quiet pub. A tweedy type, he suggested that someone like me would be welcomed back to Algeria, and my family's friends would find it perfectly natural for me to settle down there. Who would ever suspect I worked for British Intelligence? Would I be interested? I was not.

We moved to a London neighborhood that displayed a streamer proclaiming we were "LOUSY BUT LOYAL" during George V's 1935 Silver Jubilee. Thanks to the jubilee I got a break. Fleet Street was frantic for any news related to the festivities. Boo-Boo, a chimp at the Regent Park zoo, had an offspring named Jubilee. Photographers in droves showed up at the monkey pavilion. A surprise awaited them. Dr. Vivus, in medical attendance to the chimps, had sealed mother and child behind a glass partition to protect them from the adoring mob. No one—and Dr. Vivus meant no one except the keeper—was allowed behind the partition. The bars of the cage marred all pictures.

Undaunted, the *Sunday Express* assigned a reporter to write a mother-and-child story if he could produce a picture without bars. He offered me a fiver if I could succeed. After inspecting the pavilion, I borrowed a camera and a pound note, had a chat with the keeper, and waited for the pavilion to be evacuated in anticipation of Dr. Vivus's visit. I asked the doctor if he objected to the keeper's taking a few pictures for the *Sunday Express*. Dr. Vivus agreed. After the doctor left I slipped a roll of film in my camera, which the keeper had returned, gave him a pound, followed him into the chimps' cage, and got my picture. It had a good play, but did not further my career.

My only chance to sell pictures was to cover stories that staff photographers passed up. I managed to ingratiate myself with Walter Allward, the Canadian sculptor who had never allowed himself to be photographed, but the war memorial he had worked on for sixteen years was no longer news. The Ethiopian war was making peace passé.

I did all sorts of odd jobs. One was to help auction the contents of a country house. Among the odds and ends to be thrown out was a bundle of old *Time* magazines that I took home. I had never heard of this publication but, after going through several copies, on an impulse I sent *Time* my picture of Walter Allward.

Receiving a reply on November 2, 1936, I promptly called *Time*'s London bureau and got an appointment that afternoon. David Ritchie, *Life*'s assistant editor for Europe, showed me a dummy of the forthcoming magazine and took my telephone number.

The call came next day. My assignment was to get atmosphere shots of the opening of Parliament. I was not to photograph Edward VIII, whom the agencies would cover. My job was to get crowd scenes in an original way. "Original" was the key word. I realized my future with *Life* depended on the pictures I would turn in, but I was so shy it prevented me from photographing people head on. I shot everybody from behind, getting every kind of back, from the cheerful slouch of youth to the painful stoop of old age.

"I asked for something original and I sure got it," the editor said, shaking his head in disbelief when I turned in my pictures.

My backs appeared in the first issue. As Fate would have it, I had hit upon the *Life* style. Within a month I was put on staff.

(4) By not playing the game, I got the first picture of the London zoo's pet chimp Boo-Boo and her offspring Jubilee in 1934, which led to my being published in a major newspaper.

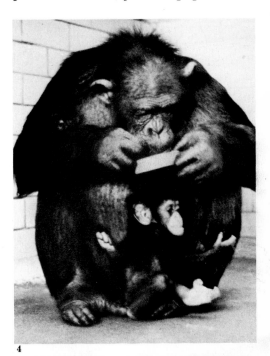
4

5

(5) The Canadian sculptor Walter Allward allowed me to be the first to take his picture in sixteen years. This precipitated a chain of events that would lead up to my becoming a Life photographer.

Kings Come, Kings Go

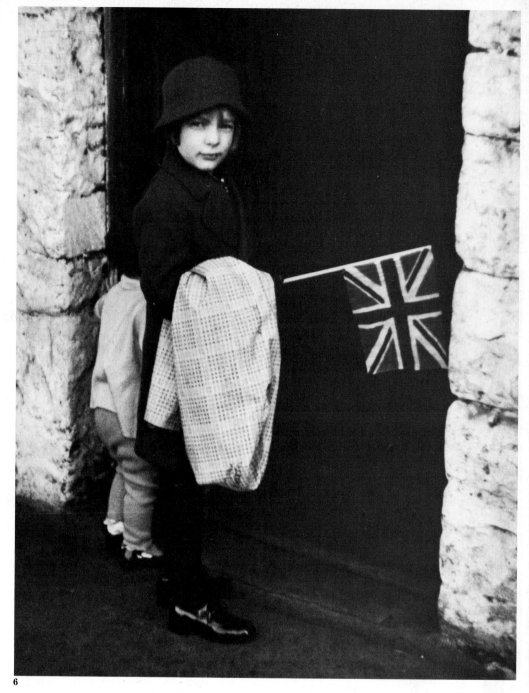

6

(6) This little Welsh girl and her younger brother returned home after waving a Japanese-made Union Jack while King Edward VIII drove past during his tour of distressed mining areas, where unemployment fluctuated between 40 and 70 percent. Said the monarch, "Something must be done." Twenty-three days later he abdicated his throne and left England.

(7) Edward VIII's wistful look during his South Wales tour was due to a corn on the little toe of his right foot, which was "killing him." I gleaned this tidbit from the Time *correspondent, whose paid informant was a member of the king's entourage.*

The first and last time I photographed Edward VIII was during his tour of South Wales on November 18, twenty-three days before he abdicated his throne "for the woman I love." I had never heard of Mrs. Simpson until I went to work for *Life*. In those days the British press displayed great restraint over the private lives of the royals. Any reference in the American press to "Eddie's romance with Wally" was systematically eliminated on reaching England by the self-censoring British magazine distributors — stifling news in the pre-TV era was that easy.

The people of South Wales had no idea of the impending "constitutional crisis" when they greeted "Teddy." Recalling those times many years later, Edward — by then the Duke of Windsor — observed, "One thing I did well was make inspection tours." His talent had moved the Welsh to tears even though unemployment fluctuated between 40 and 70 percent. Perhaps on account of my Welsh blood, I could not help but admire these people. Many had never found, and never would find, work — and yet they had faith in Edward when he said, "Something must be done." I got a more realistic view from a Pontypridd barmaid. "They're so damn miserable," she told me. "They have no idea how awful their plight is. In the good old prewar days the fines in this neighborhood for being drunk and disorderly were over a thousand pounds a year. Now it's not even ten bob."

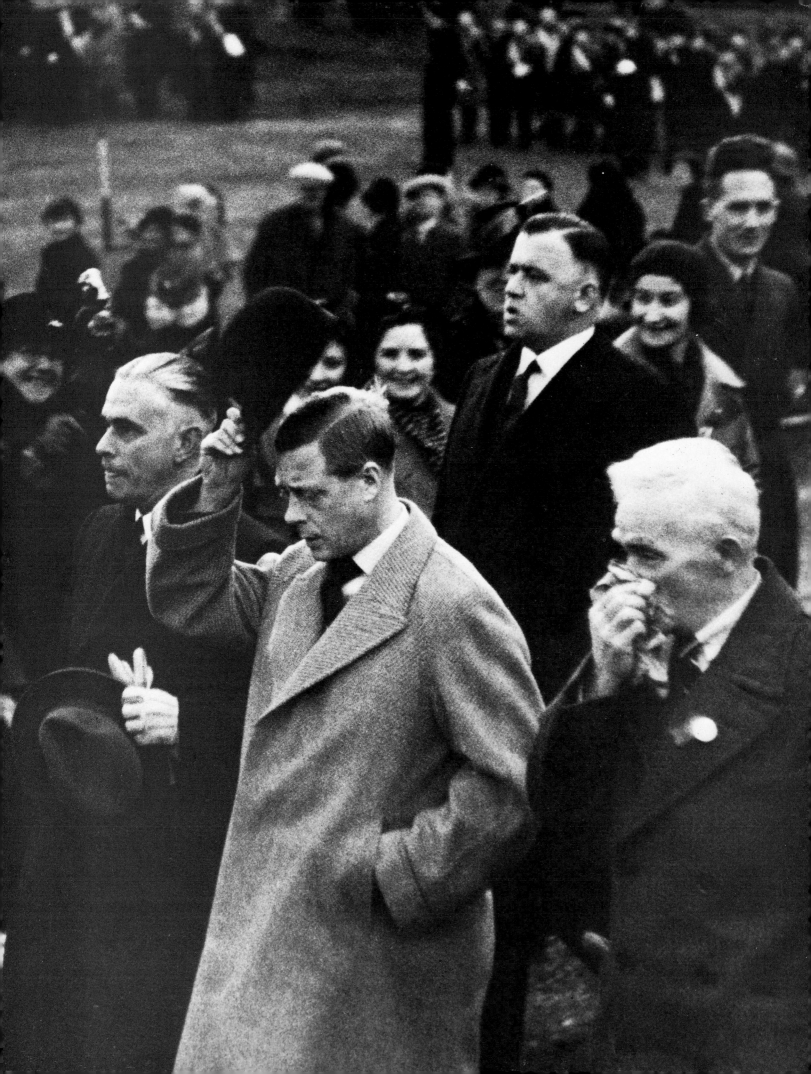

I never got another chance to photograph Edward. While I was waiting for his cortège to pass through Merthyr Tydfil, I got a shove from a hefty constable that sent me sprawling across the street. "If you bloody Yanks try and follow the royal procession," he said, "I'll bloody well run you in." It was then I learned from the *Time* correspondent traveling with me that the British authorities were irritated with Time Inc. for publishing stories on the royal romance. With the memory of that experience fresh in my mind, I got depressed when handed a cable from New York that requested "a fast act on Eddie's servants at Buck House." This was out of the question, especially since the royal family's traditional sense of privacy was never greater. Disconsolately I circled Buckingham Palace and studied the wide driveway separating the towering gates from the main building. There lay the psychological moat beyond which the king's affairs became his private business—genuinely the case of a man's castle being his home. I was trying to figure out a way to get into the servants' quarters when another facet of the British character dawned on me. The English press would never even consider the existence of a tradesmen's entrance at the palace. But there had to be one because, like everyone else, the royals ate—even boiled potatoes, as I was to discover. The only way I could get into Buckingham Palace would be through the tradesmen's entrance, but who would let me in? Certainly no Britisher. The palace staff would be horrified by such a proposal. Possibly because I was thinking in French— as I always do when working out a problem—it struck me that only a foreigner might be willing to help me. A friendly Frenchman was what I needed, and that meant the lord and master of the royal kitchens—the king's chef. As Fate would have it, M. Avignon, the chef at the Ritz, lived three floors above me. I asked him if he could introduce me to the king's chef, whose name I did not even know.

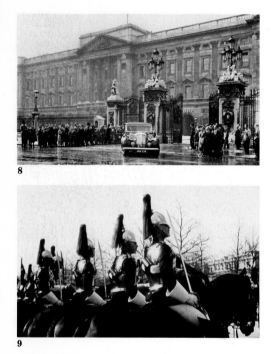

(8) *Buckingham Palace.*

(9) *The Household Cavalry.*

"I don't know him myself," M. Avignon said, adding after some thought, "but as he belongs to our association of French chefs in London, I can invite him for tea."

I met M. Legros a week later. He was resolutely Gallic in appearance despite a brand-new bowler, which looked as alien on his head as he himself did against the British landscape. Small, even by French standards, he wore a black jacket that gave him gentle billowing lines. A disciple of the formidable Montagne, M. Legros was a most unusual chef: he lacked the terrible temper that generally goes with gastronomic excellence. He sounded like the most contented man I had ever met and accepted "*le climat anglais*" with equanimity. Suddenly noticing it was black and wet outside, he hurried off, but not before inviting me to visit him at Buckingham Palace. He pronounced Buckingham, a very difficult word for a Frenchman, slowly and with relish. "You cannot miss me if you go through the gate in the right wing. It leads straight to my office. We are also in the phone book. Just call the palace and ask for me."

A few days later, on Thursday, December 3, 1936, Edward's romance with Mrs. Simpson broke in the British press. By Friday, December 11, Edward abdicated, which caused his mother, Queen Mary, to remark caustically, "Imagine giving up all this for that." In those nine days that shook the Empire, a monarch was undone. The job was performed by a figure straight out of Dickens—the British prime minister Stanley Baldwin. So ended a reign that had started with such promise. In his hurried departure for exile, Edward left much behind, including a small French chef. George VI, not wanting to be his brother's chef's keeper, dismissed M. Legros and rehired his father's cook.

On the last day before M. Legros departed for France, I paid him a visit at the palace and got an insight into the differences in personality between Edward VIII and his brother George VI. The chef's office was a bleak oblong room with a high ceiling, which had not been renovated since Queen Victoria restored the palace. Victoria's Superintendent of Works having neglected to install a heating system in the servants' quarters, M. Legros's office was chilly on that winter morning. I found him seated on a swivel chair looking as cheerless as the room itself, and expressed my regrets at his leaving.

"I'm sailing for France tomorrow morning and will retire to my little house outside Paris," he said with a shrug.

Turning to a small table on which rested a bottle of port and two burgundy glasses, he carefully poured out drinks.

"It's very good port," I remarked to break the silence.

"His Majesty drank only the very best," M. Legros replied. Whenever he said "His Majesty," the Frenchman meant the Duke of Windsor.

Reclining in his chair, his feet off the floor, M. Legros prefaced his next words with a heavy sigh. "There was a man who appreciated good food." His face lit up. "It was a pleasure to cook for His Majesty. How often we discussed the menus together. We used to make them up from day to day. Now . . ." His voice trailed off. "Now . . . menus are sent up to Queen Elizabeth for approval two weeks in advance." He sighed again.

We had another glass of port. The Frenchman smiled at a recollection. "I well remember preparing *moules marinières* for His Majesty. We were at Balmoral Castle in Scotland. His Majesty had a second helping."

Somehow this sounded like a happy memory of the deceased in the next room. On our third glass of port he confided, "I was very much displeased with the quality of the food being purchased. I pointed this out to His Majesty, although it was not my department. 'Don't worry, M. Legros. We will work together,' His Majesty told me. 'You will straighten out the kitchen problems and I will do the same for the country.' He said it *comme ça*," the Frenchman added, nodding to give emphasis to his words.

For a while he fell silent. "I did my utmost to satisfy the king and queen," he mused. "Let me give you an example." He picked up an agenda on which the daily menus were transcribed and thumbed through the pages of delicately balanced meals, pointing to terse marginal notes. "The queen's handwriting," he said. "She made all the changes on my menus herself — in French." He paused and looked up. "But there was no personal contact."

Finding the page he had been looking for, the chef studied an order written in sharp angular letters with a pointed pencil. "I have here," he said very deliberately, "instructions from Queen Elizabeth to serve boiled potatoes with every meal."

M. Legros closed the book. "Potatoes with every meal," he repeated. "Who would have expected that from a queen who speaks perfect French?" Outside, French could be heard. The chefs from London's great restaurants had come to say goodbye and stay to lunch.

"Of course you'll join us," M. Legros said to me.

We trooped after him into the dining room and sat on benches placed on either side of a large table presided over by M. Legros, who faced the windows looking out on the driveway that led to the main gate of the palace. Unconcerned by their surroundings, the chefs made themselves comfortable. Some shed their jackets, others unbuttoned their waistcoats or loosened their belts. One removed his collar. They tucked napkins under their chins.

There followed an expectant silence. In France a calamity does not spoil the appetite. The soup was spooned with noisy satisfaction, and animation appeared over the Dover sole. The roast beef *à l'anglaise* was eaten French style, with chunks of bread to soak up the gravy. Conversation between courses dealt with the merits of what we had just eaten. As bottles of wine were emptied, the tone of our voices rose. Outside, the sentries stood guard, figures from another world. When we rose from the table covered with empty coffee cups and liqueur glasses, our faces glowed. I got a good meal but no pictures.

The time had come to bid our host goodbye. We filed past him, looking suitably afflicted, and straggled out of the palace. It was like a scene outside a cemetery before the mourners scatter.

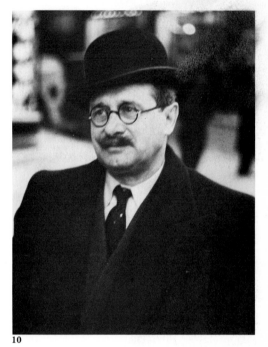
10

(10) M. René Legros was Edward VIII's chef. Not wishing to be his brother's chef's keeper, George VI, who succeeded Edward, fired M. Legros. I was among the twenty guests M. Legros entertained at lunch in the kitchens of Buckingham Palace the day before he returned to France.

(11) Londoners line the street waiting for the royal family to ride past.

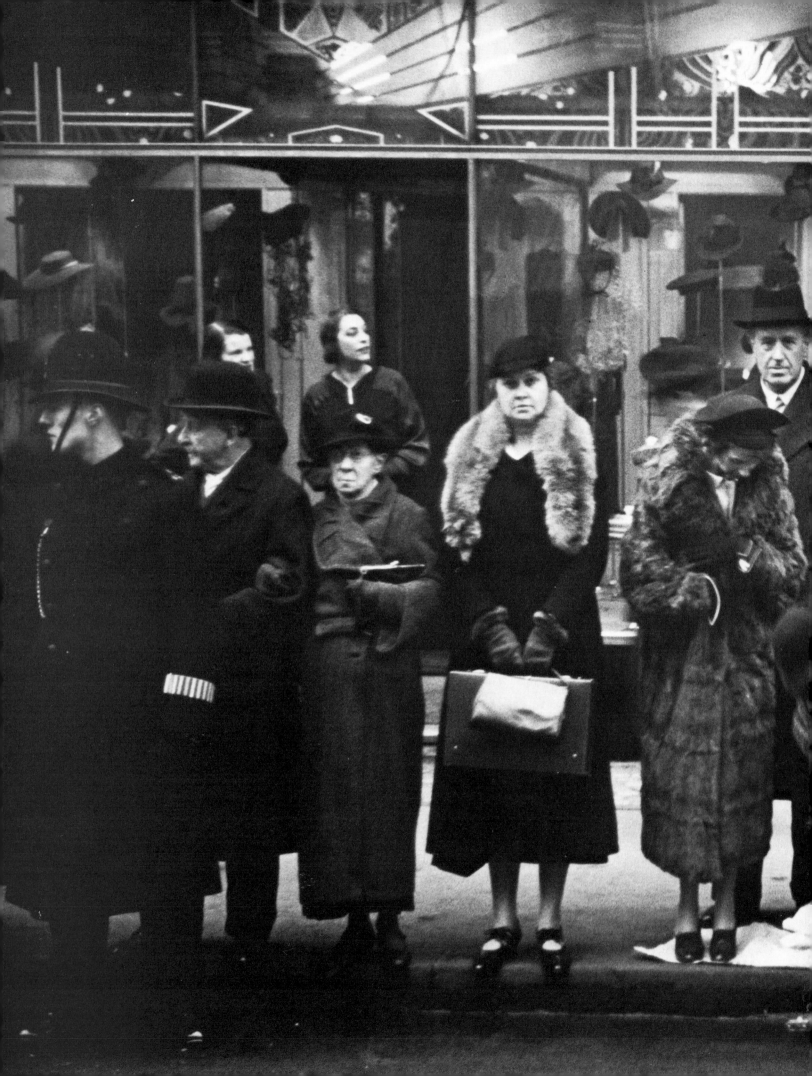

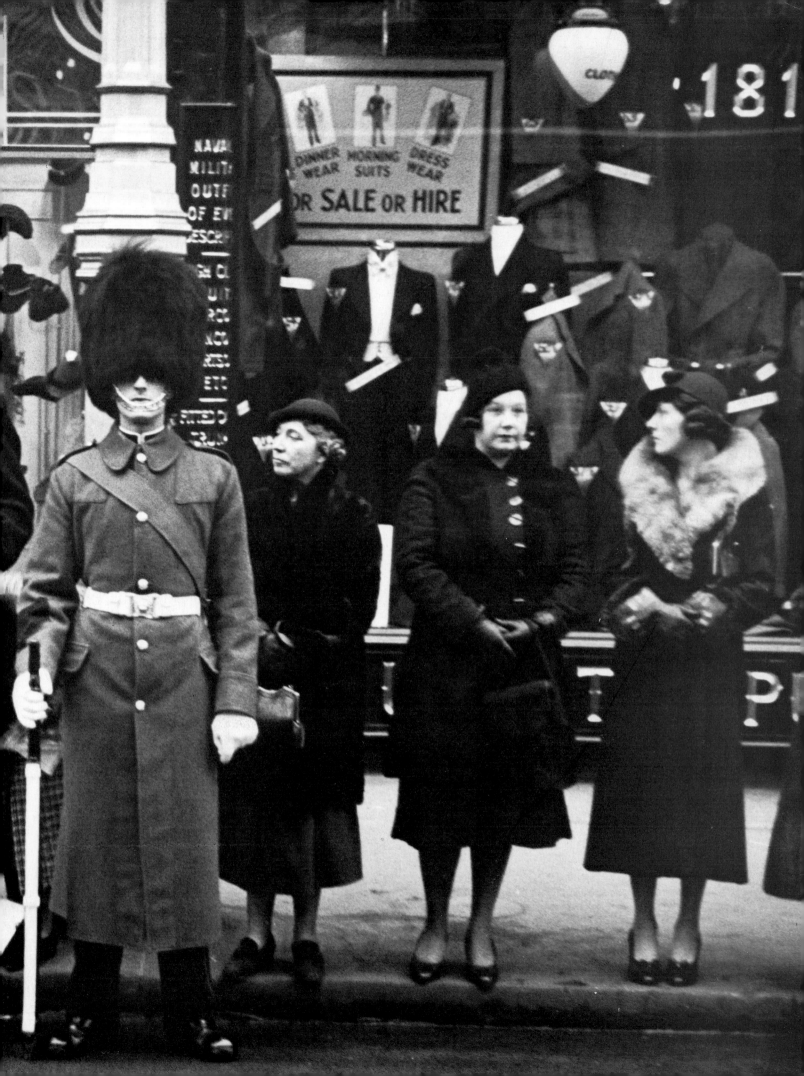

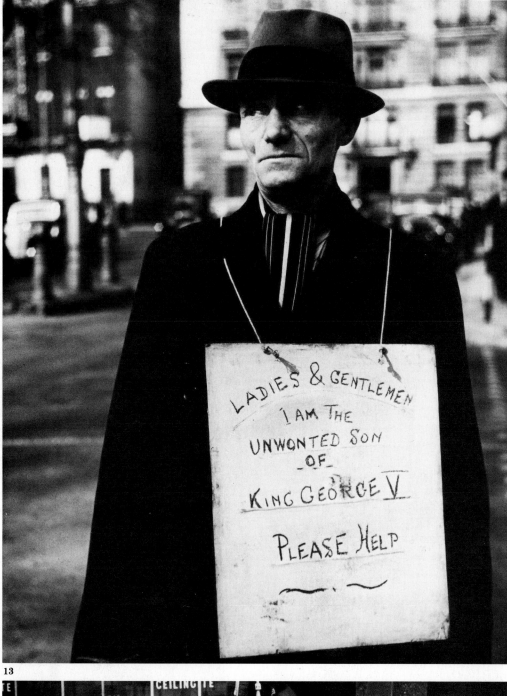

(12) *Life in London during the Depression could be difficult and often demanded ingenuity. Two handicapped World War I veterans sold matches on Piccadilly Circus.*

(13) *Another approach was seeking help, as this man did by claiming to be King George V's unwanted son.*

(14) *Street musicians such as this quartet of decorated war veterans were a common sight in London.*

13

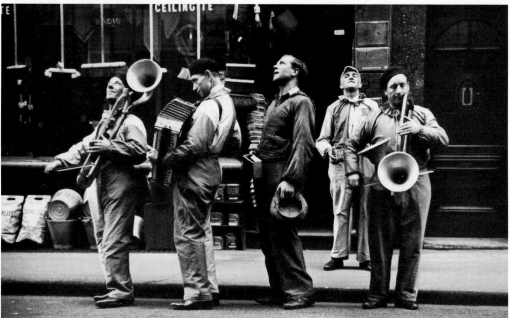

14

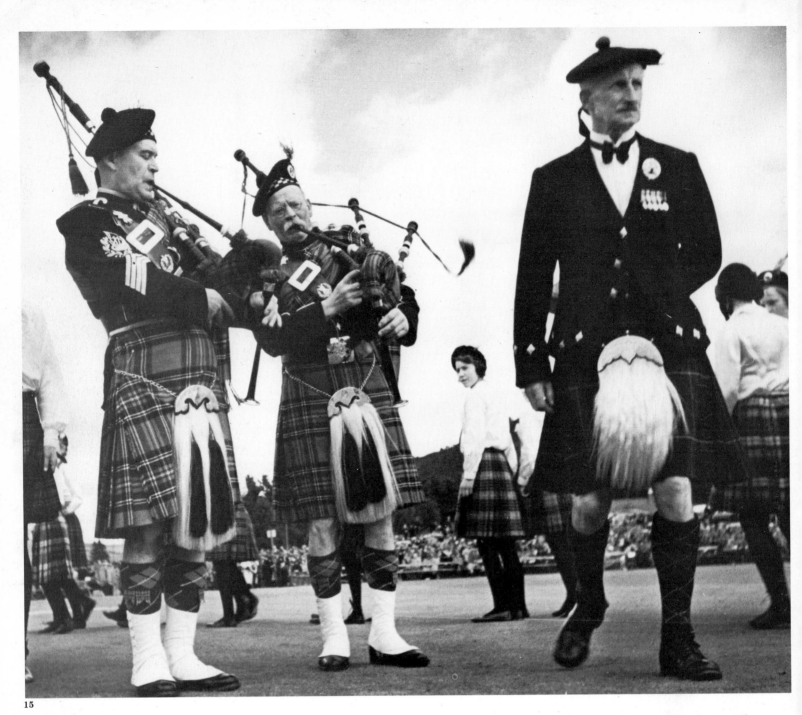

15

(15) *The Scottish games in Braemar attracted bagpipers by the hundreds as well as kilted participants in such contests as tossing the caber — heaving a tree trunk.*

(16) *George VI, Queen Elizabeth, Princess Elizabeth (now Elizabeth II), and Princess Margaret Rose attended the Braemar games during the summer of 1937.*

On May 12, 1937, George VI was crowned at Westminster Abbey. I was stationed at the Eros statue on Piccadilly Circus. Although the procession would not reach Piccadilly until four in the afternoon, I had to be in place twelve hours before. Dutifully I showed up at four A.M. and to my great relief saw that the Eros statue had been boarded up, with a platform on top of the scaffolding. I asked the two plainclothesmen occupying the platform if I could join them there. They told me to bugger off. By five A.M. there was such a crush of people that the bobby assigned to keep a clear space for the photographers had been swept away. By six-thirty I found myself jammed against the hoarding. At times my feet did not even reach the ground. At nine it started to drizzle. Every room with a window overlooking Piccadilly had been rented out. Each room was crammed with people and each had been well stocked with food and beverages. "My God, they're as tight as ticks," a colleague complained at eleven as bananas, oranges, and buns rained down on us. By one-thirty people in the crowd were fainting. At long last the procession came into sight. Cheers went up, and I braced myself to shoot pictures over the heads of the crowd. At that very moment all the men raised their hats while women and children waved Union Jacks. When the cheering stopped, the royal cortège was out of sight. I did not get one picture.

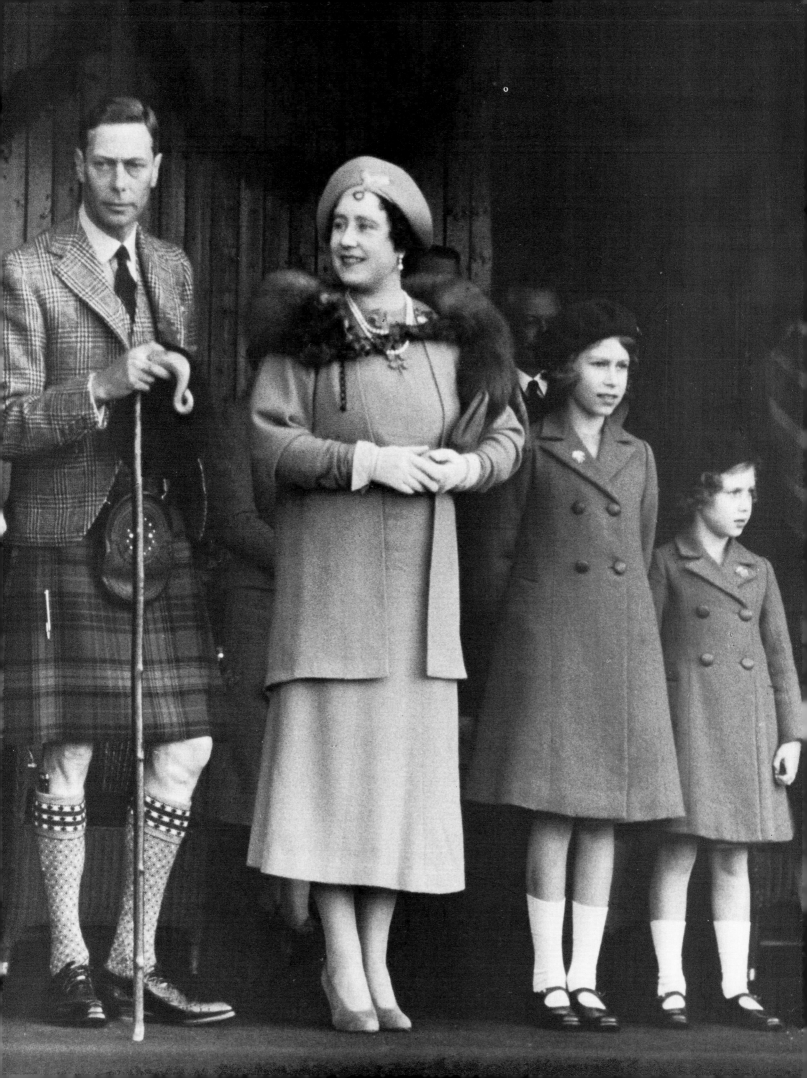

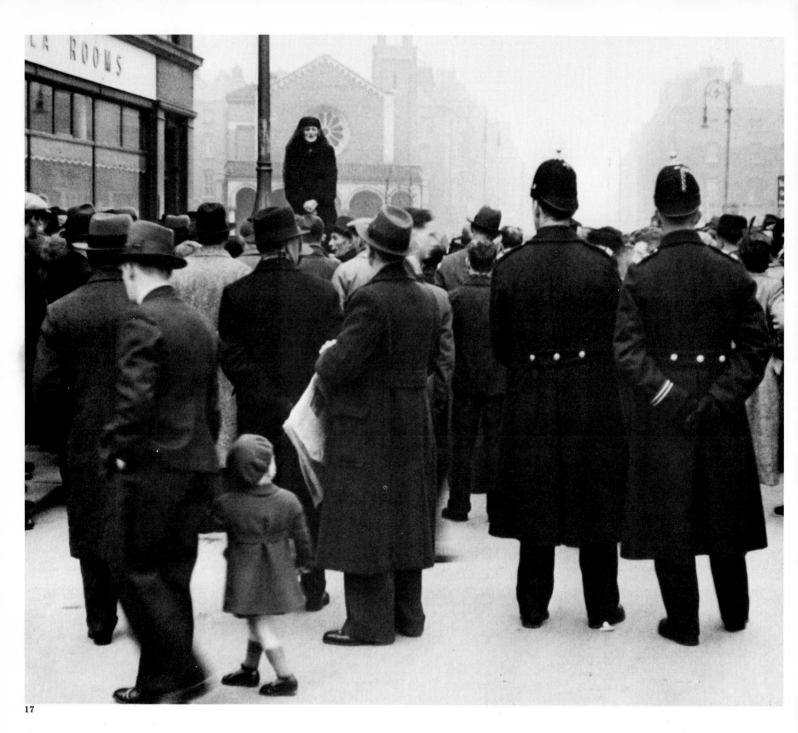

17

(17) Although she was seventy-one, Maud Gonne MacBride addressed Dubliners every Sunday morning under the watchful eye of policemen. She denounced the Coercion Act and started every speech with, "Sixty prisoners . . . ," a reference to the IRA men languishing in Mountjoy prison.

"Letters of introduction are useless in Dublin," our Irish correspondent informed me. "If the Irish like you, letters aren't necessary. If they don't, letters won't help. Anyway, you'll have our stringer, Geoffrey Coulter, to help you."

My assignment was to photograph the passionately idealistic Maud Gonne MacBride, whom James Joyce had called "the Irish Joan of Arc." On my landing at Dun Laoghaire, a beggar came up and asked me, "Can y'spare a copper, your honor?" with such panache that I gave him one. By the fifth beggar, "his honor" was out of coins. When I tried to explain, he eyed me coldly. "May ye roast in hell, y'Protestant bastard!" he spat.

Coulter, a quiet and well-informed Irish journalist, took me to a pub in the basement of a Dublin police station where reporters could drink after hours since most of them were busy filing their stories when the pubs were officially open. In this smoky atmosphere where plainclothesmen in dirty macintoshes were drinking porter, Coulter filled me in on Maud Gonne.

She was born in England in 1866 and was two months old when her father, an Irish officer, was assigned to the Curragh—England's largest military base in Ireland. By the time she was sixteen, George Bernard Shaw had already described her as "outrageously beautiful." In her quest for Irish independence, her political views were also considered

outrageous. Smitten by her, the great Irish poet William Butler Yeats wrote the patriotic Gaelic play *Cathleen ni Houlihan* for her. The press criticized Maud's performance as simply "acting herself," but *Cathleen ni Houlihan* was never forgotten and became a symbol of Irish nationalism. While Maud was a revolutionary in Ireland, in France — where she spent much time — she became involved in right-wing politics through her lover, Lucien Millevoye. He was rabidly anti-Semitic and attempted to smear Clemenceau, who defended Dreyfus, by publicizing forged documents alleging that the future French prime minister was in the pay of the British. By the time Millevoye was discredited, he and Maud had had two children — a son who died in infancy, and a daughter. She then married a swashbuckling Irishman, Major John MacBride, with whom she had a son, Sean. Maud and MacBride had little in common except the desire for Irish independence. They were not living together by the time MacBride participated in the 1916 Easter Week uprising and was executed by the British.

"The Troubles," as Easter Week came to be known, had taken place twenty-one years before I landed in Dublin but were still as turbulent in the public mind as the thunderclouds overhead that gave the city a fierce beauty. By the time Coulter had updated me, I had consumed more Guinness beer than I would ever drink again. Seeing me back to my hotel, he warned me not to go out alone that evening. Sean MacBride, Maud Gonne's son, was on the run and reported to be in town. Since I was supposed to resemble him, Coulter did not want me to become the victim of mistaken identity. (Sean MacBride was then a member of the outlawed IRA. Soon after I photographed his mother he took up law practice, representing defendants who might well have once been himself. From 1948 to 1951 he served as minister of external affairs in a coalition government and in 1974 was awarded the Nobel Prize as the chairman of Amnesty International.)

During a performance at the Gate Theater I saw Yeats in the audience. He was in a wheelchair with a plaid blanket across his lap. He looked the way a poet should look. Later, when I met Maud Gonne, she talked about Yeats. "Willie wanted the theater to be art for art's sake. I wanted the theater to be art for propaganda's sake," she told me, adding with a smile, ". . . Willie was a sissy." Maud Gonne was towering and gaunt in her widow's weeds, still a striking figure at seventy. Her living-room chairs were overturned and several windowpanes were broken. I wondered if her son Sean had been captured in his mother's home.

"What happened?" I asked.

"O'Duffy's men," Maud Gonne said, scornful of Ireland's blue-shirt fascists.

"This morning?"

"No. Seven years ago," she replied, dismissing the subject.

Irrepressible, she was opposing the Irish government with the same fervor she had fought the British years before.

For the next few days I photographed her addressing groups on street corners, demanding the release of political prisoners. I got a glimpse of how very different nineteenth-century rebels were from twentieth-century revolutionaries as she reminisced at one point about the French phase of her life when she was making numerous trips between Dublin and Paris to visit exiled Irishmen. "I used to smuggle in their favorite brand of tea, which you couldn't get in Paris."

Because she was an international figure, a customs inspector said to her, "Mademoiselle Gonne, I don't like searching through your luggage. Just tell me you have nothing to declare. I'll take your word for it."

"That was very naughty of him," Maud Gonne complained. "How could I smuggle anything else in after I gave my word?"

Back in Ireland some months later, I ran into her at the Dublin Horse Show. She had seen my story in *Life.* "You were very naughty," she scolded. "You made me look old."

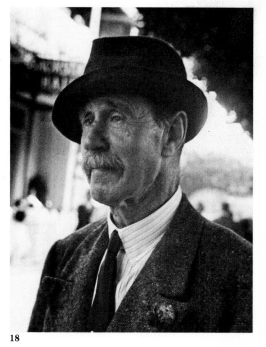

18

(18) Tom Casement, brother of Sir Roger Casement who had been hanged by the British during World War I for his attempts to keep Ireland out of the war.

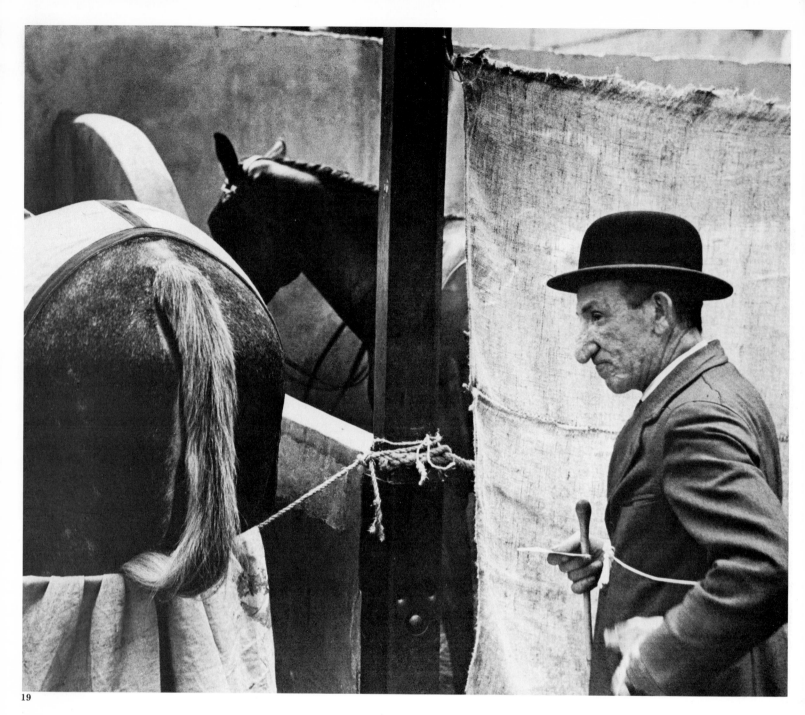

19

The Dublin Horse
Show

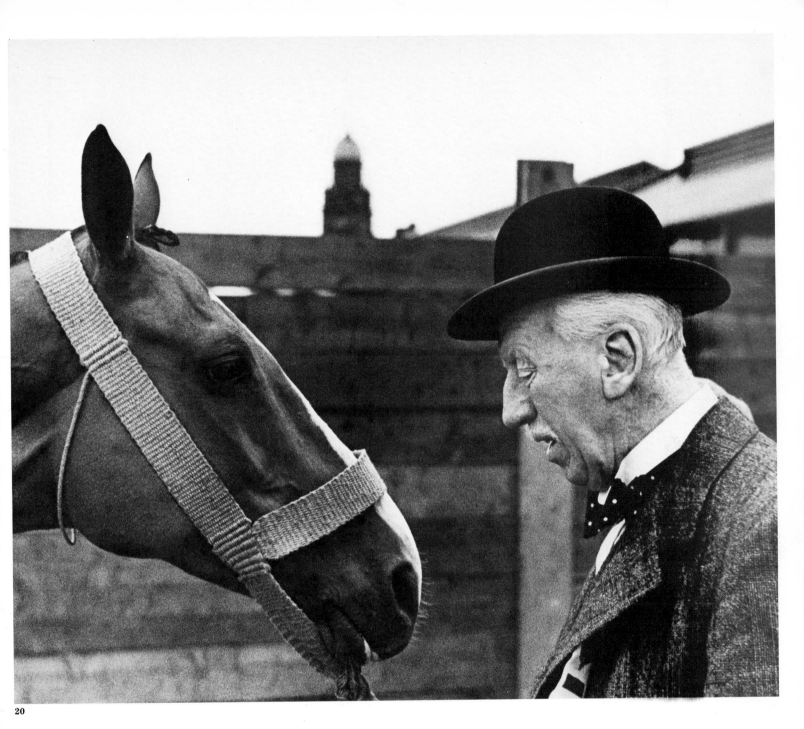

20

I got an idea of how important the horse was in Ireland when a Catholic priest tried to sell me "a lovely hunter" while I was photographing the Dublin Horse Show in 1937. When I expressed surprise that a man of the cloth could also be a horse trader, the priest beamed. "Aye, but I'm an Irishman." He was not the only colorful personality I came across at this equine world's fair. After I was introduced to the film censor he said, "If you want to take in a good picture while you're here, better come see me before I tinker with it." Then he obligingly offered to guide me around. We came to an eccentrically dressed lady draped to her heels in Irish lace. Pointing her out, the censor said, "That chip off an old Victorian mantelpiece is Parnell's sister." She was not the only person I photographed that afternoon who had been touched by more-than-passing fame. When we came to a bleary-eyed tweedy type, the censor remarked, "That's Tom Casement—Sir Roger's ne'er-do-well brother. You know who I mean, the Irish patriot hanged by the British for trying to keep Ireland out of the war." Later we ran into a stout figure in his twenties. "That's Viscount Elveden," said my guide. "His fortune comes from Guinness beer." (Years afterward I got to know a member of the Guinness family, who, in a moment of confidence, said, "Guinness is a tart's drink in Belgium. I only wish it were in Paris.")

(19) A civilian contestant in one of the equestrian competitions held during the 1937 Dublin Horse Show.

(20) Owner with his Irish hunter at the horse show.

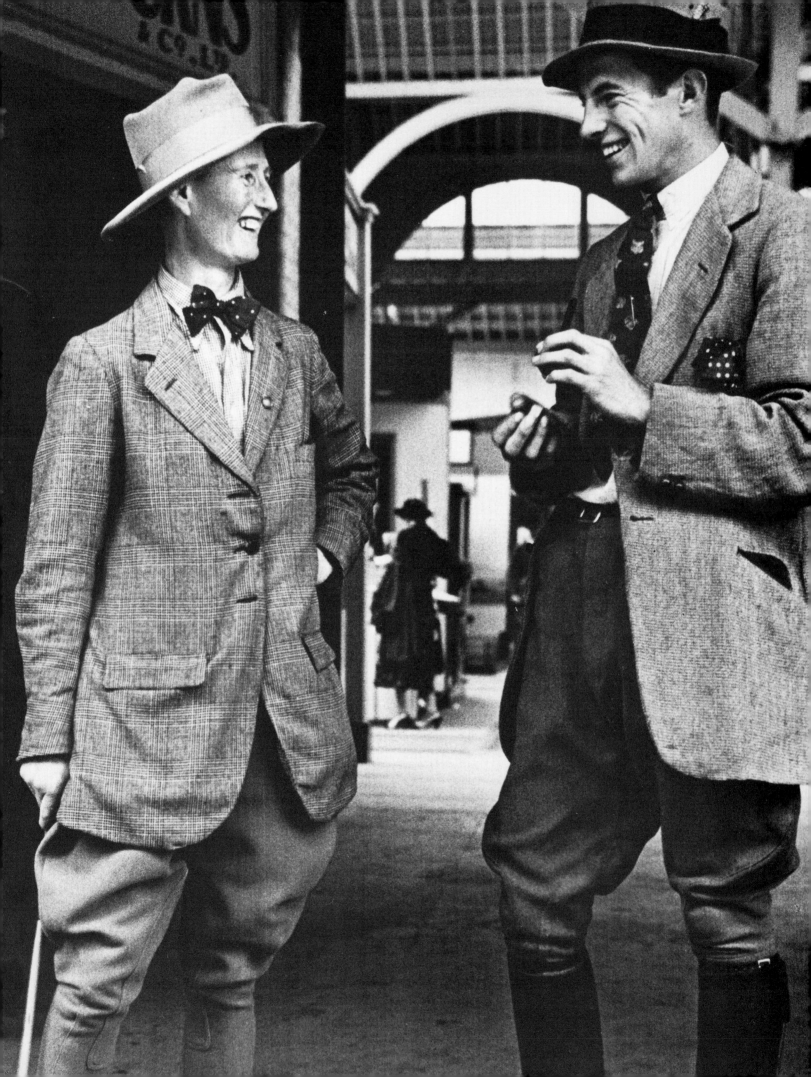

(21) Mrs. Trent and E. C. Alley, horse trainers from Tipperary, attended the Dublin Horse Show.

(22) My informant at the Dublin Horse Show told me, "This chip off an old Victorian mantelpiece is a sister of the Irish statesman Parnell," adding, "but which sister I can't tell you."

There'll Always Be an Eton

24

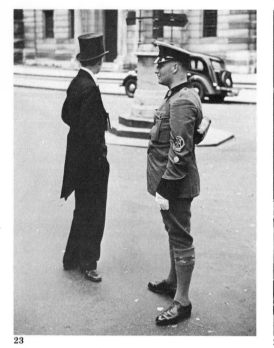

23

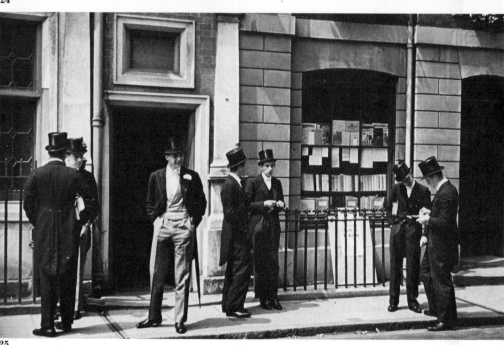

25

(23) *Etonian in tailcoat and top hat looking across Eton High Street. Uniformed man in the foreground was a member of the Automobile Club.*

(24) *Three "beaks" (as professors are known at Eton) in their caps and gowns.*

(25) *An Etonian group in front of Spottiswode Bookshop on Eton High Street.*

In 1937 *Life* sent me to photograph Eton College. Even before learning that Wellington—an old Etonian—declared that the battle of Waterloo had been won on the playing fields of Eton, I was made conscious of the school's Olympian atmosphere. The young men I encountered strolling along Eton High Street in their top hats, tailcoats, and striped pants were in manner and spirit budding versions of Great Britain's ruling class, hardly surprising as Eton had long been the cornerstone of the Empire. Shown around one of the houses where each student had his own room, I immediately sensed the pictorial possibilities. But I was soon made to understand that I would not be allowed to trespass with my camera upon the intimacy of a 497-year-old school where some students were tenth-generation Etonians, with a vocabulary all their own (an "oppidan" was a student who paid full tuition, while a "tug" was on scholarship). Although oppidans and tugs had little contact at Eton, each group frequently had an impact on its generation. While the tug Eric Blair later became George Orwell, his contemporary Lord Dunglass was to be the fourteenth Earl of Home before he disclaimed his title to become the British prime minister Sir Alexander Douglas-Home, finally winding up as Lord Home of the Hirsel, a metamorphosis as complex as Eton's Wall Game, which explains why, had Eton allowed me to take pictures, Eton would not have been Eton.

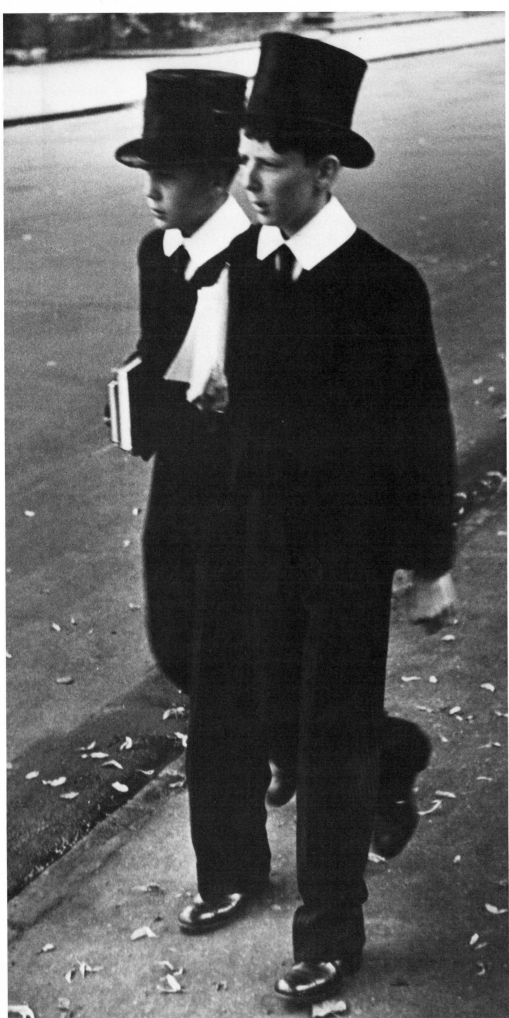

26

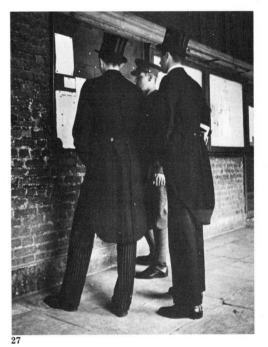

27

(26) Two young students in Eton collars and jackets. The pair would graduate to tailcoats after they reached five feet or fourteen years, whichever came first.

(27) Etonians studying a school bulletin board.

Old World France

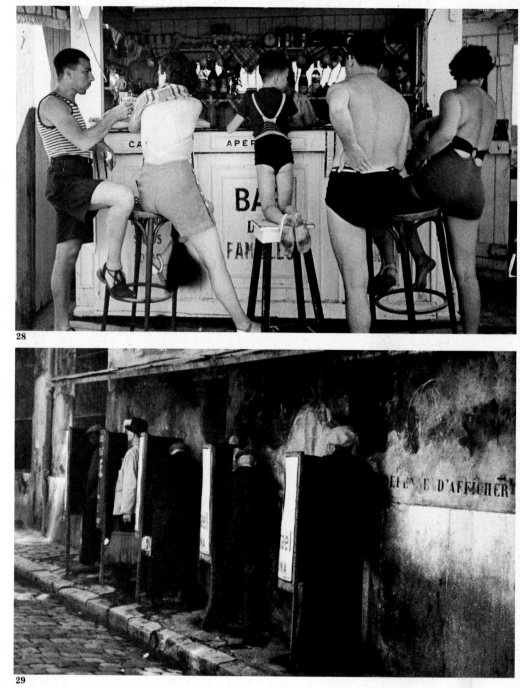

28

29

(28) *Chez Tétou,* the bar de famille *at Golf Juan, during the summer of 1937.*

(29) *Once a French institution, the* pissotière *is now denounced as a bastion of French male chauvinism.*

(30) *Holding hands French style on the banks of the Seine in Paris.*

(31) *Chez Pascal in Marseilles was famous for its bouillabaisse.*

My first assignment in France for *Life* was the Rotary International convention in Nice. When not taking pictures I went to see M. Pansier, who had taught me photography, and, for old time's sake, I took him to Chez Tétou, the *bar de famille* at Golf Juan, where he used to invite me for bouillabaisse. Nothing had changed, including the aroma of garlic and the same coat of paint on the walls. When I was a boy my height had been measured every birthday by standing in the neighborhood *pissoir* to see how much more of me appeared annually above the metal screen, so I shot one of these edifices as a souvenir. Who could have imagined that this institution would one day be denounced as a bastion of male chauvinism? When I stopped off in Paris I came upon a couple gazing at the Seine. It was a Sunday, otherwise they would not have been indulging in that weekly afternoon stroll dear to the French middle class. The pair evoked my father's generation. The woman was in deep mourning, down to the black crepe veil draped around her throat. Age and constant wear gave the man's hat brim a weary tilt. His clothes had shrunk on his middle-aged girth. The couple radiated prewar frugality. To my twenty-three-year-old eyes they looked very old and represented the end of an era which I had no idea I was about to photograph.

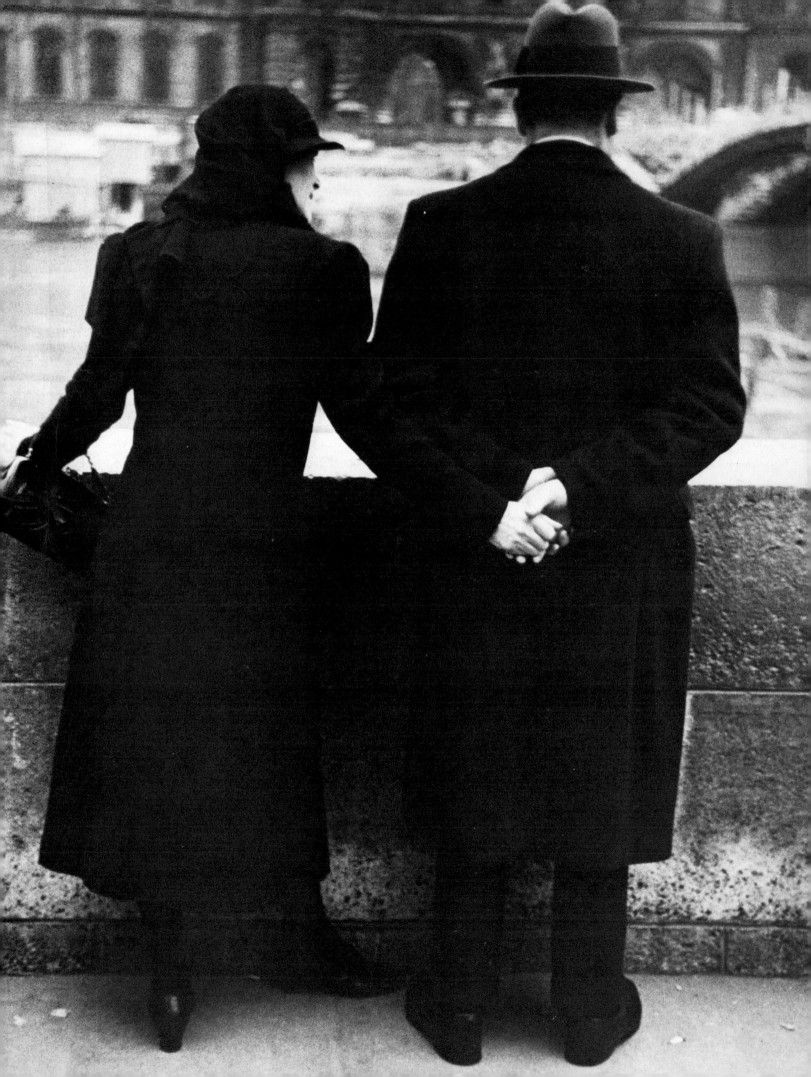

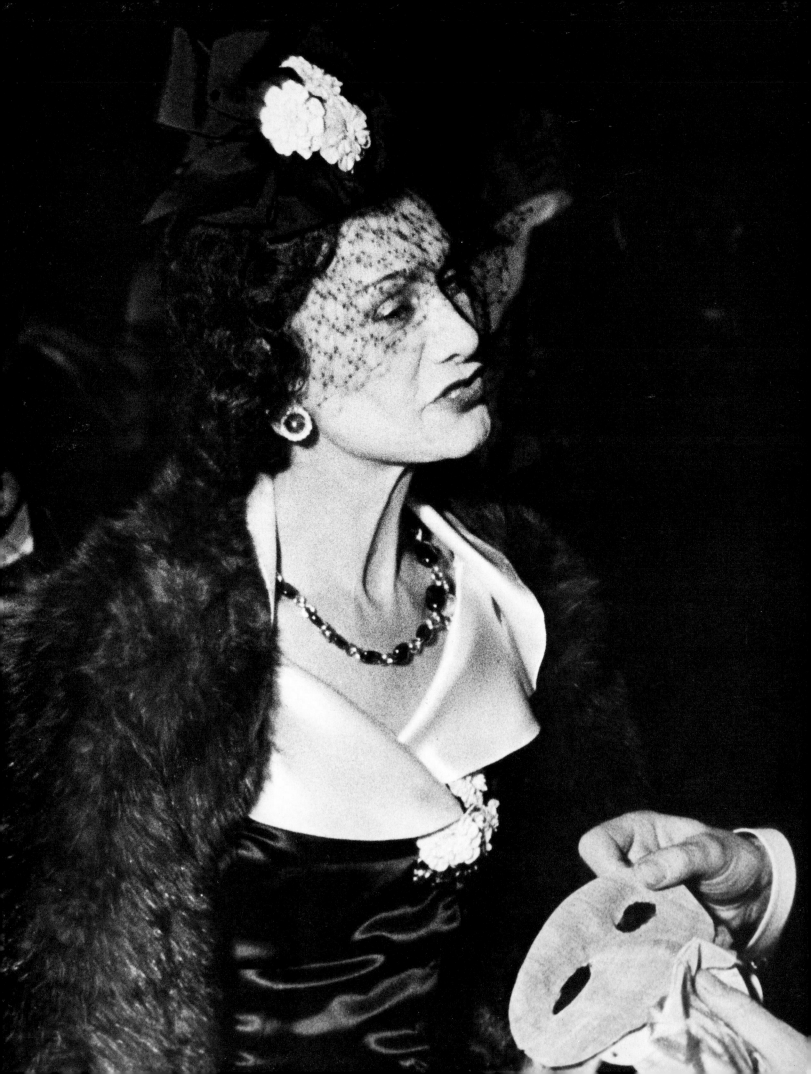

Parties Meant Work

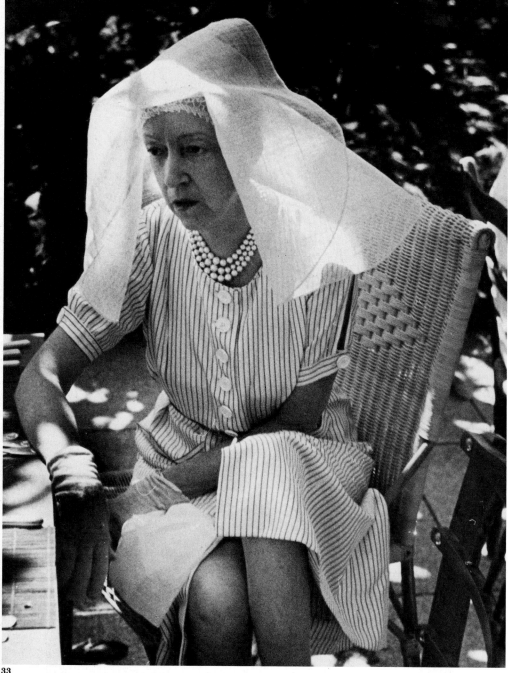

(32) Madame Gabrielle Chanel, a French institution known as "Coco" Chanel, revitalized fashion in the twenties and also created the perfume Chanel No. 5. She is seen here at a 1937 ball in Paris.

(33) Elsie de Wolfe, famed American interior decorator better known to the smart set as Lady Mendl, wife of the British press attaché in Paris. Past seventy, she frequently startled dinner guests by standing on her head.

Parties always meant work for me. This was especially true in 1937, when there were festivities of every kind to celebrate George VI's coronation. These parties spread from London to Paris, on to the Riviera, and all the way to Salzburg as the Mayfair Set, Café Society, and *le tout Paris* joined together in what would turn out to be a last fling before the jarring reality of the times caught up with them.

The first party I was assigned by *Life* to photograph was the Servants' Ball at London's Albert Hall. My American editor, influenced by P. G. Wodehouse, whose fictional butler Jeeves enlivens English literature, saw this ball in literary terms. "It will make a swell '*Life* Goes to a Party,'" he said.

I should have realized there was something amiss about this ball — which was already sold out — after I telephoned a number of London's great homes, hoping the footman or butler who answered would be willing to part with his ticket for five pounds. To my surprise — and their chagrin on hearing my offer — none of them knew anything about the ball. At last my editor, who had been invited by friends to sit in a box, managed to get me a ticket. "But you'll be admitted only if you're in costume," he warned. "And I want that story."

The London costumiers had rented out everything in stock, except one store, which still had a regulation navy uniform. Although I had some

misgivings about showing up in a sailor suit, I was so new on staff and so willing to please my editor that I went to the ball looking like a seaman in His Majesty's Royal Navy. Even before I reached the box where my editor was sitting and overheard his hostess remark, "Darling, do you really want your photographer to get raped?," I knew I had made a mistake with the outfit I was wearing. I never got a story, but I did get chased around by a hairy-legged character in a mini-toga.

Another story I missed out on was photographing the American ambassador to the Court of St. James's, Joseph P. Kennedy. *Vogue* was eager to do a picture story on the newly arrived American ambassador and his large family. *Vogue*'s editor asked my boss if I could be loaned for the job. He was agreeable and told me to make my own deal. Still smarting from the cold shoulder I had once got from the British press, I demanded the outrageous fee of one hundred guineas — a sum amounting to several months' salary. I was politely turned down and missed the opportunity of photographing John F. Kennedy at age twenty, pictures a photographer much smarter than I later cashed in on handsomely.

Notwithstanding, I had so much work by then that I no longer had the time to process my negatives or make the necessary blowups. The office agreed to my getting a darkroom technician. I had the unfortunate idea of asking my father if he would care for the job. He was an excellent photographer and could do the work easily while picking up five pounds a week, which would come in very handy. While I might consider my father a darkroom man during working hours, he never forgot he was my dad. He refused to keep regular hours, and when I complained that he had not completed the work on time, he let out an Olympian "Arseholes!" which sent me into the darkroom to do his work. Once, when asked what my greatest luxury in life was, I sighed, "My old man."

Cecil Beaton, whose "Fête Champêtre" was *the* ball of the London season, was not only a photographer, but also sketched, designed costumes and settings for the theater, and influenced the fashion of his day. He was soon to provide an epitaph for his era by writing in Mona Williams's Capri guest book forty-eight hours before the outbreak of World War II: "It was simply divine, darling." The success of the story I did for *Life* on Beaton's "Fête" got me to Paris to photograph the Bal du Directoire. Since I knew none of the personalities there, our Paris office got Braddish Johnson, a young Philadelphia Main Liner, to point them out to me. He knew *le tout Paris* well enough to be on first-name terms with most. Nonchalantly he introduced me around. That was how I met the Baron Maurice de Rothschild. The baron was friendly, even pointing out Coco Chanel, but made it clear he did not want his picture taken.

"Don't pay any attention to him," Braddish whispered. "He loves to be photographed."

"Are you sure?" I asked, dubious about defying a Rothschild.

"Trust me," Braddish insisted and, when I still hesitated, he nudged me.

The flash of my camera was nothing compared to the baron's wrath. He called me "a shit" with such conviction I felt he must be right.

"Momo was a bit touchy tonight," Braddish sighed as we left the ball.

I took readily to Braddish's world and for the rest of that year came as close as ever I would to becoming a society photographer. Like any other toff, I rented gray toppers, tails, and morning suits from Moss Bros., except that, in my case, they were work clothes. The elegance of that era — which had broken away from stiff wing-collars and starched shirt fronts — was comfortably costly. In those days you sent a suit to your tailor whenever a button dropped off — it would be returned by messenger with the button sewed on, the suit dry-cleaned and neatly wrapped in tissue paper at no expense. Soon after my arrival in New York I did the same thing as a matter of course and was taken aback to find the suit was not cleaned and I had been billed for sewing on one button. The superficial advantages of wealth in those days were more obvious than they are today, in part because wealthy people dressed well. In the thirties, if you dressed like a bum, you were one. At a dinner party recently I sat next to a stranger who recalled those times. "It was so much more fun being rich then," she

34

(34) In my morning coat and gray topper before going off to attend the lord chief justice's garden party in London.

sighed. "We were so few." By the time I got to the Riviera I had already become addicted to a way of life I could afford only on expenses. I swam with the celebrities I had photographed at Eden Roc and at dusk had an aperitif on the veranda of the Carlton with them. There I ran into the pretty switchboard operator I had photographed at Schiaparelli's.

"Where are you staying?" she asked.

"Here at le Carlton," I said, feeling *très nouveau riche.*

She made a face. "*Moi,* I'm staying with my lover at a château."

As I kept seeing the same faces, I realized how small this exclusive world really was, so much so that I got to be known as a friend. But on occasion I was reminded that I was merely a photographer.

I was no longer the shy young man who shot everybody from the back. Sneaking pictures of total strangers without their knowledge had always made me feel like a con artist, but since it had to be done I developed the technique of looking past the person I was photographing so that if he noticed me he would turn his head to see what it was I appeared to be looking at, while I then walked away. It worked most of the time. Then there were certain cases where it had been agreed I could take pictures but was considered an inferior creature. At such times I found that, instead of feeling uncomfortable myself, I made others feel that way, as when I photographed Lady Mendl's luncheon in Antibes. On arriving I was told by her snobbish adopted son there was no place for me at any of the tables but that food awaited me in the kitchen.

"I never eat when I work," I said.

Sir Charles Mendl, who was mixing himself a drink, stopped me. "I'd rather you not take my picture with all these . . . you know what I mean." Lunch was served on a veranda where the tables had been placed around a tall fig tree. Perching in it, I snapped pictures throughout the meal. I even refused to come down when Lady Mendl's adopted son pleaded that he had discovered a place for me at one of the tables.

"You were gruesome up in that tree photographing every mouthful we ate," one of the guests remarked.

"Why, you reminded me of that play where Death is trapped in a tree," someone else said.

"You mean *On Borrowed Time,*" another volunteered.

When I got to Salzburg it looked as though we were all living on borrowed time. The glitter of the city's 1937 music festival prevented foreign visitors from noticing that ten miles away Adolf Hitler's "Eagle's Nest" peered down on them from across a shaky border and threatened our fragile world. One of the first people I recognized at the Mirabell bar was the Baron Maurice de Rothschild. He was seated with a group of friends and made such imperious gestures for me to come over to his table that I complied.

"Your face is familiar," the baron said. "Please remind me where we met."

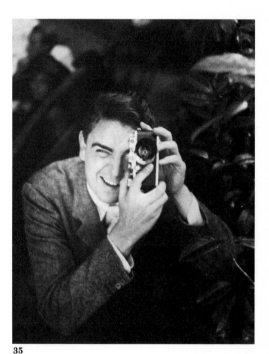

(35) Portrait of me taken by Cecil Beaton at the 1937 Salzburg Music Festival.

"Are you sure you want to know?" I asked.

"Certainly," he said.

"It was at le Bal du Directoire. You . . . called me a shit."

The baron laughed and offered me a glass of champagne.

In 1940 I went to register as an alien in New York and sat next to a broken old man. I would not have recognized him if he had not said, "Your face is familiar. Please remind me where we met."

"Salzburg, 1937," I said.

"*Le beau temps,*" he sighed, and we reminisced until his name was called.

On my return to London from the festival I found an invitation that was symbolic of my ambivalent status in the class-conscious world I was moving in. I had met so many society people that links had been forged to a world with which I had little in common. The dinner invitation, to be followed by a performance of the ballet at the Old Vic, came from a Mayfair hostess whose name meant nothing to me. I accepted the invitation, put on my dinner jacket, attended the dinner for twenty, went to the ballet, and wrote a thank-you note without ever having the foggiest notion of who my hostess was.

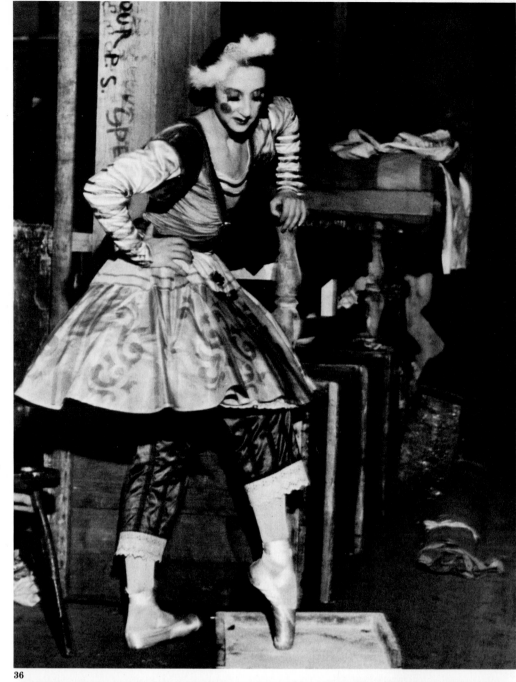

36

(36) *Alexandra Danilova as the doll in* Stravinsky's Petrouchka, *performed at London's Covent Garden. A prima ballerina from St. Petersburg's famed Mariinsky theater, Danilova came out of Russia in 1924 with George Balanchine to dance in Diaghilev's Ballets Russes de Monte Carlo, which had become Colonel de Basil's company by 1937.*

(37) *Last-minute stitching of a torn tutu before the curtain went up at Covent Garden.*

(38) *Chatting backstage were choreographer Michel Fokine, his wife, Vera, and ballerina Tatiana Riabouchinska.*

(39) *Men's dressing room at Covent Garden.*

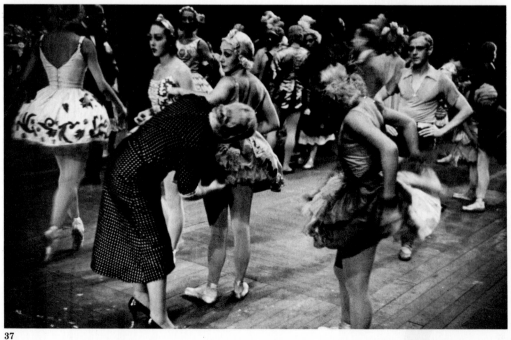

37

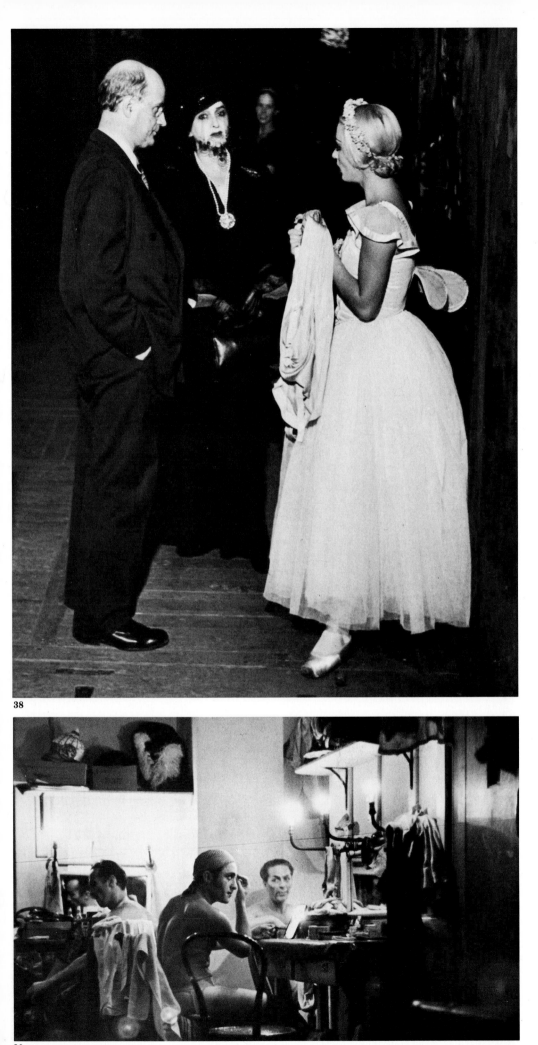

38

39

31

Cecil Beaton's "Fête Champêtre"

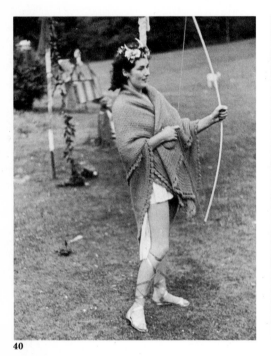

40

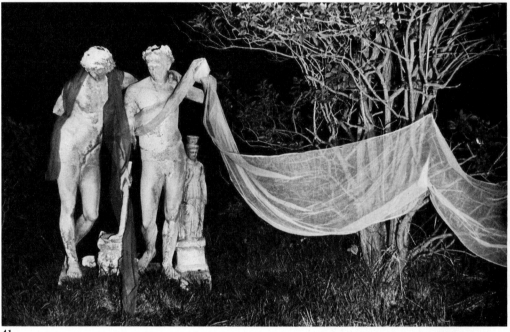

41

(40) Costumes ranged from Greek mythology to romantic Victorianism. Here the goddess Diana is greeting the dawn.

(41) Papier-mâché figures draped in tulle directed guests to the party.

(42) Beaton as a scarecrow, his second costume change of the evening.

(43) The central figure is Lady Juliet Duff; other guests were William Paley, lower right, with Mona Williams directly behind him.

In 1978 I paid a visit to Sir Cecil Beaton at Reddish House, his home near Salisbury. He was recovering from a stroke, but with that driving willpower—masked by apparent insouciance—he had trained himself to draw with his left hand and continued to work. He was a venerable figure, having been knighted for his achievements, which included most recently two Oscars for his costumes in *My Fair Lady* and *Gigi*. I met him in 1937, when he was the Poet Laureate of Fun, and photographed his "Fête Champêtre," *the* ball of the season. When we talked about the party, Sir Cecil started to reminisce:

"Michael Duff and I decided to give a 'Fête Champêtre' at Ashcombe. For weeks beforehand preparations got under way. We had enormous paper cotillion flowers flown in from Paris to decorate both the house and the garden. Drawings were made of costumes that various groups of friends should wear. On the day of July fixed for the celebration, the skies were still gray. The rains came down and our hearts were heavy. Doggedly we continued our *al fresco* preparations. Early guests were given jobs to do. The marquee went up in a trice. There were many hitches. Karinska, a Russian with a genius for executing theatrical costumes but with the reputation of delivering her works of art a few minutes before the curtain rose on the first night, had not sent the dresses expected on the last train

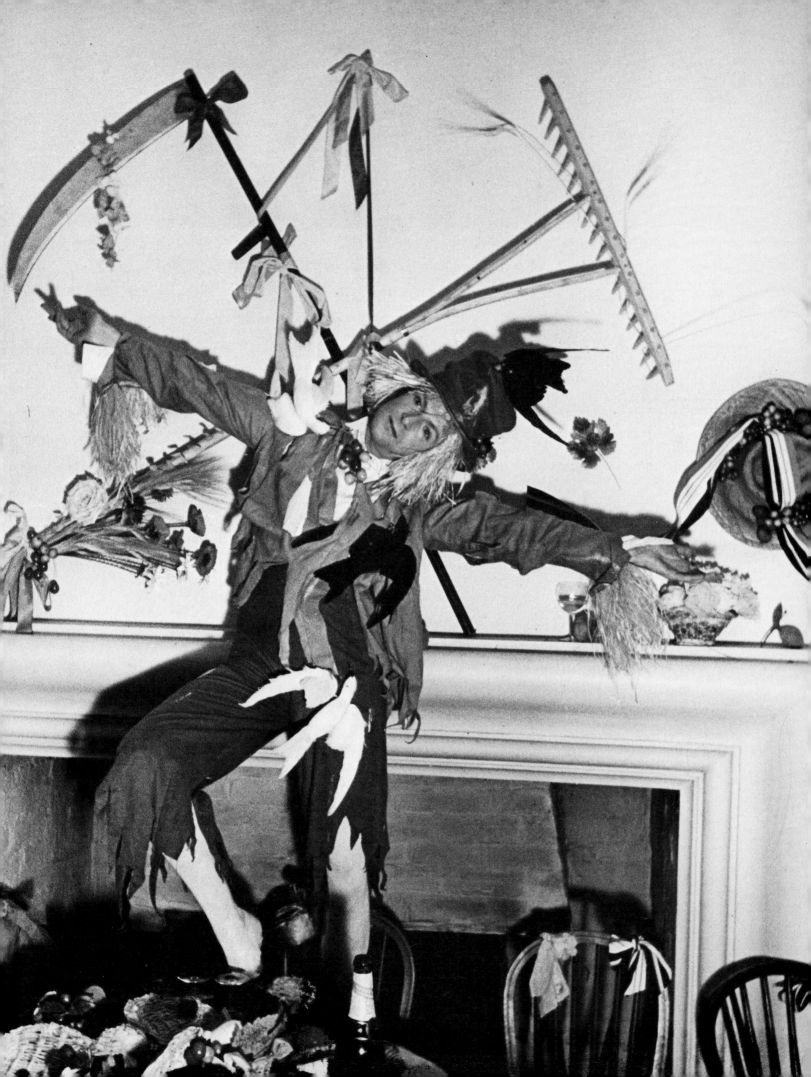

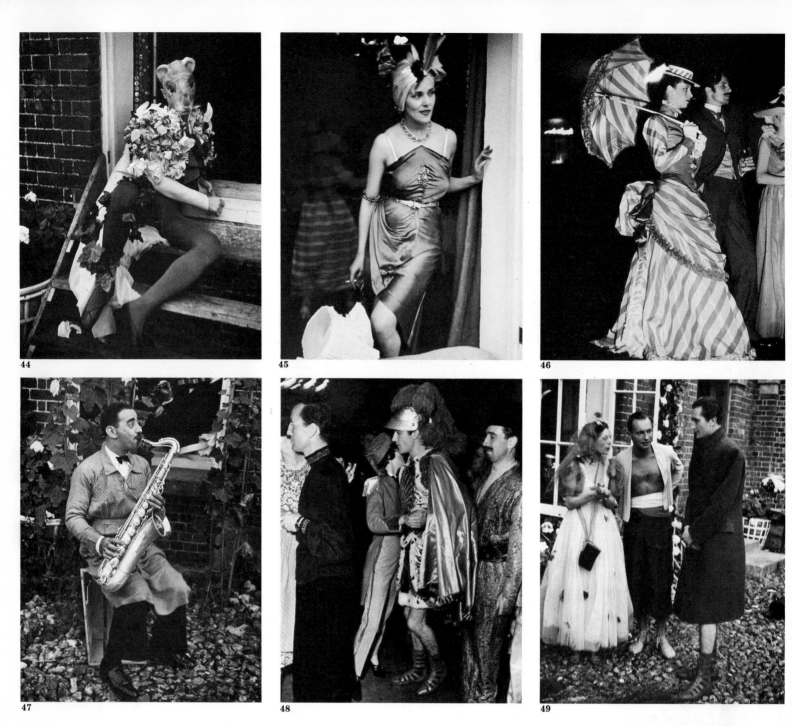

(44) *Waiter wearing a mouse head designed by Dali.*

(45) *Lydia Macy, an American.*

(46) *Rex Whistler and Lady Caroline Paget as Victorians.*

(47) *Sax player from the Embassy Club.*

(48) *Left to right: Ian Fleming, creator of James Bond; Michael Duff dancing; Christopher Sykes, author of a biography of Evelyn Waugh.*

(49) *The party's over; left to right: Lilia Ralli, Jean Schlumberger, Michael Duff.*

from London. Still the rain came down. The Embassy Club band was lost. Suddenly the rain stopped. After a long cross-country tour, band and dresses appeared from nowhere. From far and wide, cars filled with people in fancy dress sped through the countryside. Papier-mâché figures and floating draperies pointed the way to Ashcombe. The party began. In the garden flares burned brilliantly on the posts that linked the flower garlands; the arc lights illuminated the dairy house; the Phaeton looked white and ghostly under its burden of meadowsweet; the waiters, encumbered but compliant in their sheep, goat, horse, and bird masks, were like Tenniel's illustrations from *Alice in Wonderland*. Our servants dressed as peasants circulated among the guests dressed as shepherds and shepherdesses. The evening went by in a series of such quick kaleidoscopic flashes that there was no occasion on which to take leisurely stock of the proceedings. Michael Duff, the co-host, was most handsome as Apollo. His mother, Juliet, in a Wingerhalter shepherdess costume, Mona Williams as a frail and delicate Flora in pink tulle and convulvulus, Rex Whistler and Caroline Paget as a pair of extremely romantic Victorians, were among the revelers. At seven we ate breakfast and enjoyed the spectacle confronting us of the garlanded house and the ilex trees with bird cages hanging from their dark moss-green branches in the light of the early morning sun."

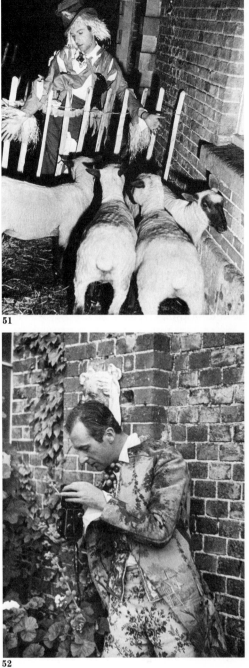

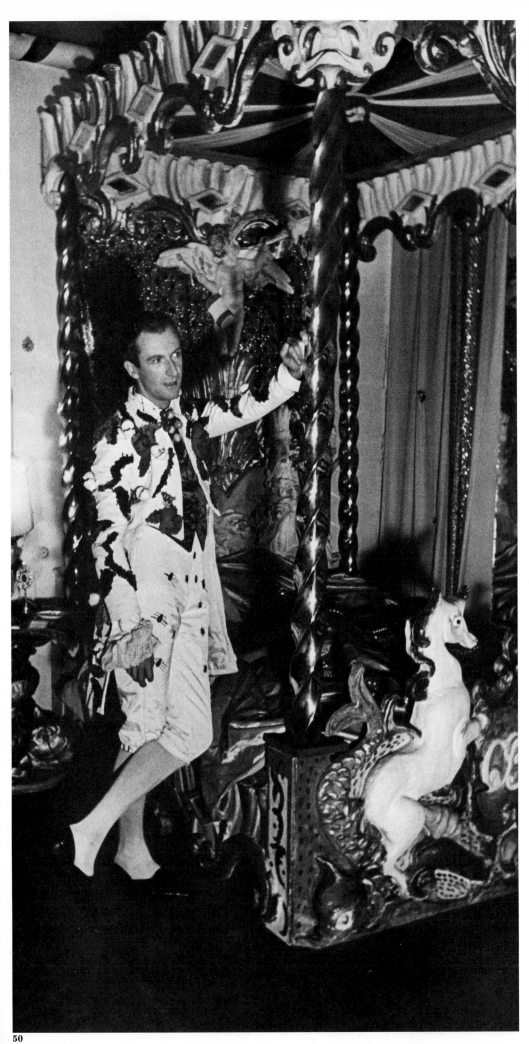

(50) Cecil Beaton in his bedroom.

(51) Beaton with sheep.

(52) Beaton, in Regency costume, shoots his party.

51

52

50

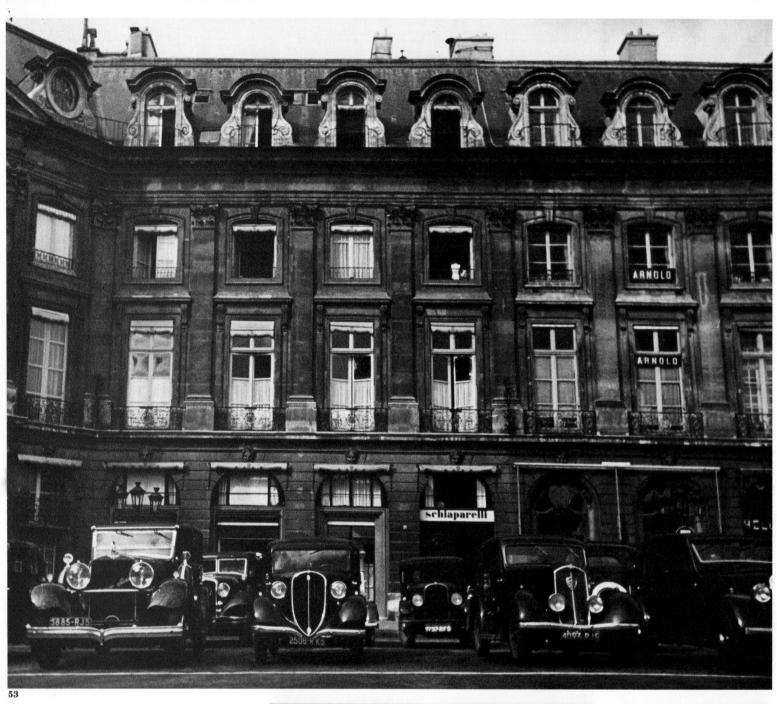

53

La Maison
Schiaparelli

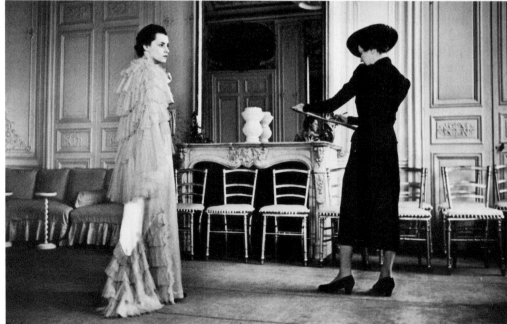

54

38

The career of Elsa Schiaparelli, the Italian-born French couturière, was triggered by her daughter Gogo's contracting polio. The expenses of Gogo's illness gave "Schiap" the incentive to seek the backing of a large Paris department store in order to open a *maison de couture*. She was an instant success. The explosive Italian's only rival was the formidable Coco Chanel — when she brought out Chanel Number Five, "Schiap" came up with Shocking Pink. In the spring of 1937, *Life* picked Schiaparelli for its Paris fashion story. I was given complete freedom to photograph whatever I wanted in her luxurious five-story building on Place Vendôme. Schiap herself remained elusive for the first week. One day at noon she appeared wearing a wide-brimmed black hat of her own design. It was clear that Bonaparte's famous bicorne had been the inspiration.

"The shadow of Napoleon," I remarked as she swept past.

Madame Schiaparelli wheeled around. "I understand, M. Phillips, that you go out with my mannequin Christiane."

"Aren't you fortunate?" I replied.

"Fortunate?" she demanded.

"Why, yes. What would people say if the *Life* photographer doing a story on Schiaparelli was going out with one of Chanel's models?"

"You may take my picture after lunch," Schiap said before she swept on.

(53) In 1937 Elsa Schiaparelli's maison de couture on Place Vendôme was the Mecca of fashion.

(54) Schiaparelli sketching a new creation.

(55) Elsa Schiaparelli.

(56) Albert, Schiaparelli's delivery man, making his daily rounds with the designer's latest creations.

(57) Model waiting to enter showroom.

39

The French Riviera

58

59

61

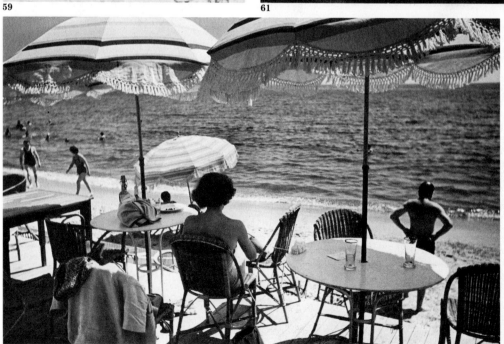

60

(58) *Comedienne Bea Lillie (Lady Peel) with her son, Sir Robert Peel, sixth and last baronet, on the French Riviera in the summer of 1937. Sir Robert was killed in action during World War II.*

(59) *Sunbathing at Eden Roc.*

(60) *Cannes' Carlton Hotel beach.*

(61) *Gala benefit dance.*

(62) *Luncheon at Lady Mendl's villa in Antibes.*

40

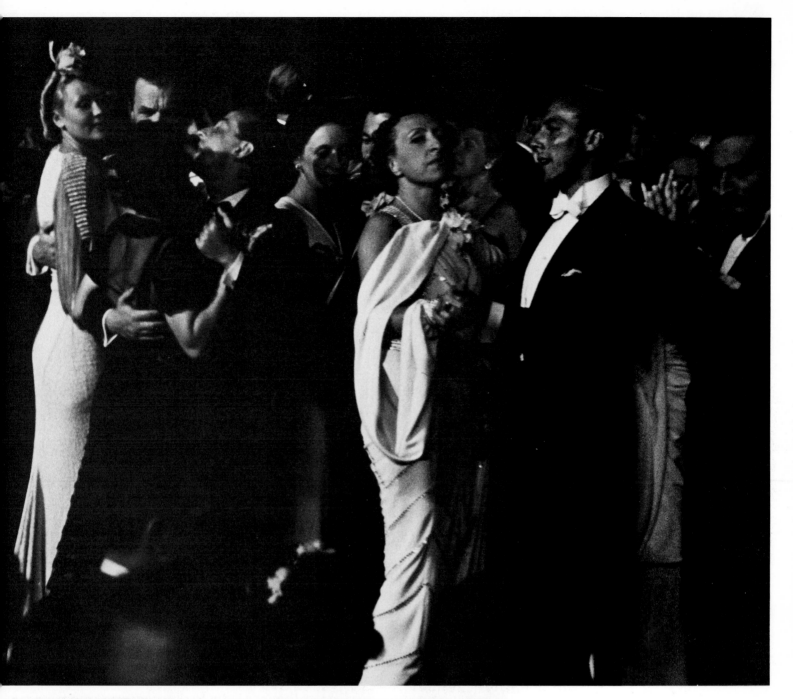

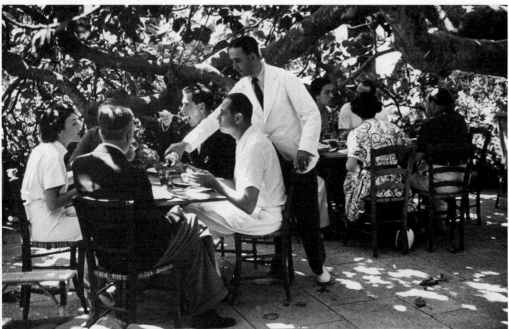

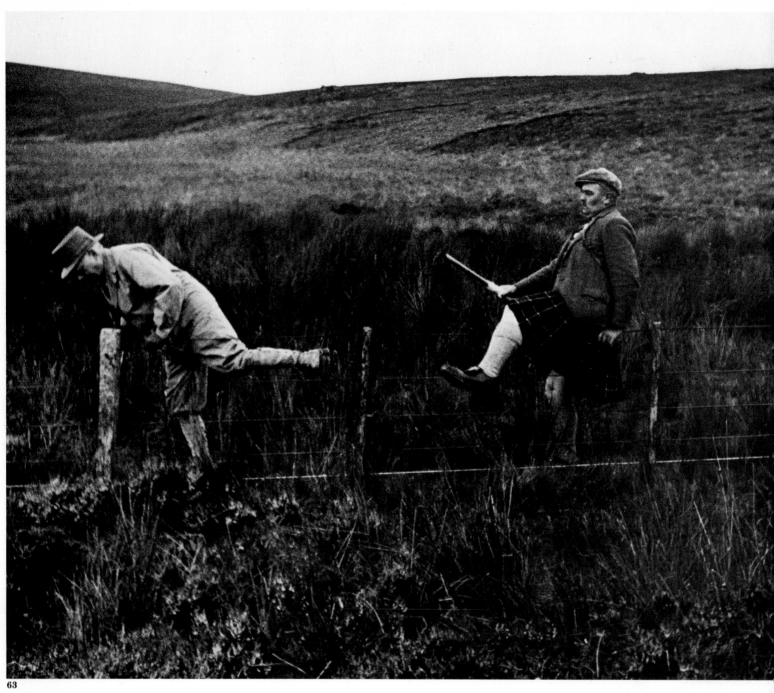

63

Grouse Shooting

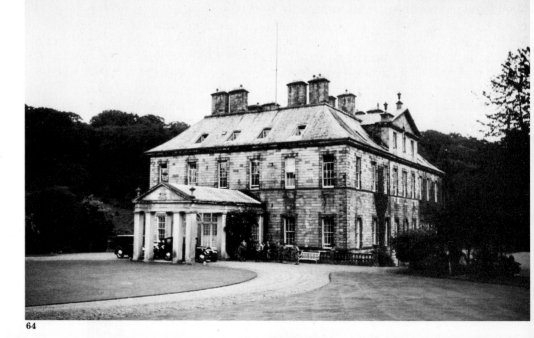

64

42

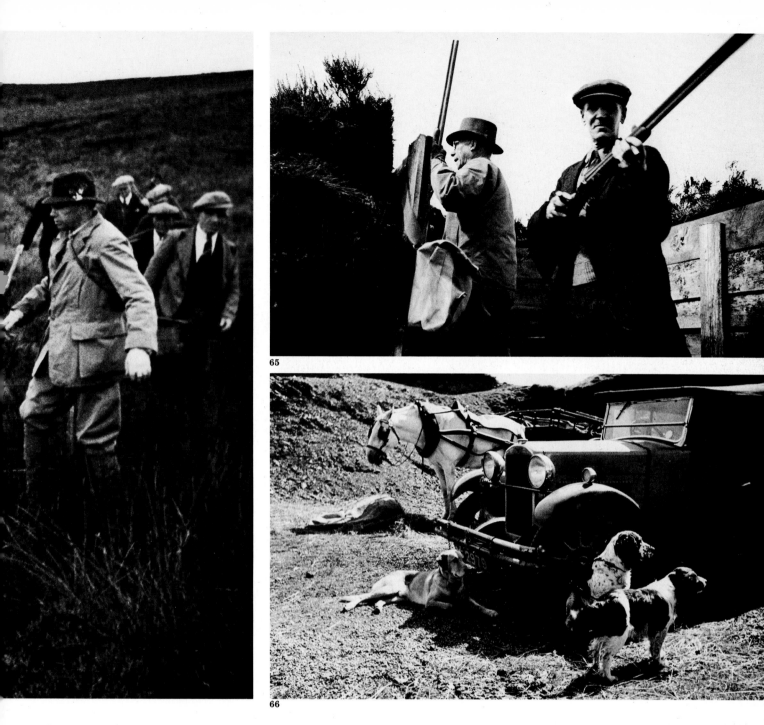

Noël Coward once remarked that the most costly sport was chastity. A close runner-up in 1937 was grouse shooting in Scotland as practiced by Mr. Herbert Lee Pratt of Long Island, whose "millions and millions" came from Standard Oil. I photographed Mr. Pratt and his party at Yester House, Lord Tweeddale's eighteenth-century mansion on one of the finest grouse moors of Scotland. Renting moors to wealthy American and English sportsmen had become a ten-million-dollar industry employing thousands of Scots. Grouse shooting being chic, sportsmen paid no rent for the mansions they resided in during the sixteen-week season—they simply contributed five dollars for every brace of birds the moor contained (a figure derived from records of previous seasons and gamekeeper reports). A moor like Lord Tweeddale's brought in as much as twenty thousand dollars a season, a fortune in prewar days.

To make sure his party of ten was comfortable, Mr. Pratt hired a staff of twenty: one butler, one cook, two footmen, two valets, three chauffeurs for the Rolls-Royces, ten maids, and a servants' servant. In addition there was gamekeeper John Brown, employed the year round by Lord Tweeddale. Brown supervised the raising and later the shooting of the grouse. In his employ were some fifty beaters and their dogs, who advanced in a wide arc toward the butts where members of the Pratt party were stationed.

(63) Host Herbert Lee Pratt (left), gamekeeper John Brown, and Harold I. Pratt negotiating a fence between grouse drives.

(64) Yester House.

(65) A loader earned $2.50 a day for his ability to slip two shells into a hot gun in one second.

(66) Horse-drawn cart and antiquated car brought a hot and cold buffet, while beaters' dogs enjoyed a break.

43

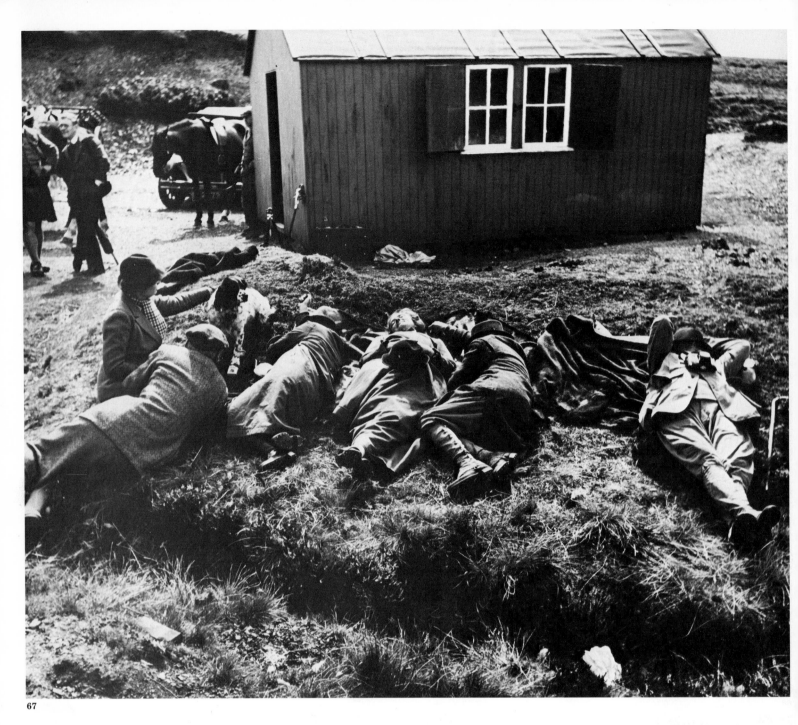

67

While the gamekeeper got a five-dollar tip daily from each guest, the gunloaders received $2.50 a day for slipping two shells into a hot gun barrel in one second during the heat of the drive. There was a ritual to grouse shooting, a sport invented in 1808 by Mr. Spencer Stanhope of Yorkshire when he decided it was more agreeable to sit in a sand pit while his sons drove the grouse toward him than to tramp the countryside. For the Pratt party, grouse shooting started at nine A.M. Escorted by gamekeeper Brown, they sallied forth for the first of six drives that would take them some eight miles across the moors. At lunchtime a horse-drawn cart and an antiquated Austin brought a buffet lunch. While the party sipped beer and Coca-Cola, the gamekeeper and his beaters enjoyed Scotch toddies. After a nap on the grass, the Pratt party resumed the shoot.

Dinner, served at eight, was formal. While his guests put on evening clothes, Mr. Pratt wore his red hunting jacket. A favorite was the grouse cooked by Mrs. Brown—wrapped in bacon and served on thick slices of toast smeared with *pâté de foie gras*. After dinner the gentlemen retired to the library for coffee, brandy, and cigars. Meanwhile, gamekeeper Brown explained to me the logistics of grouse shooting. "Up goes a guinea," he said, referring to the cost of breeding a grouse, "bang goes half a crown, and, if you don't miss that grouse, down comes sixpence."

44

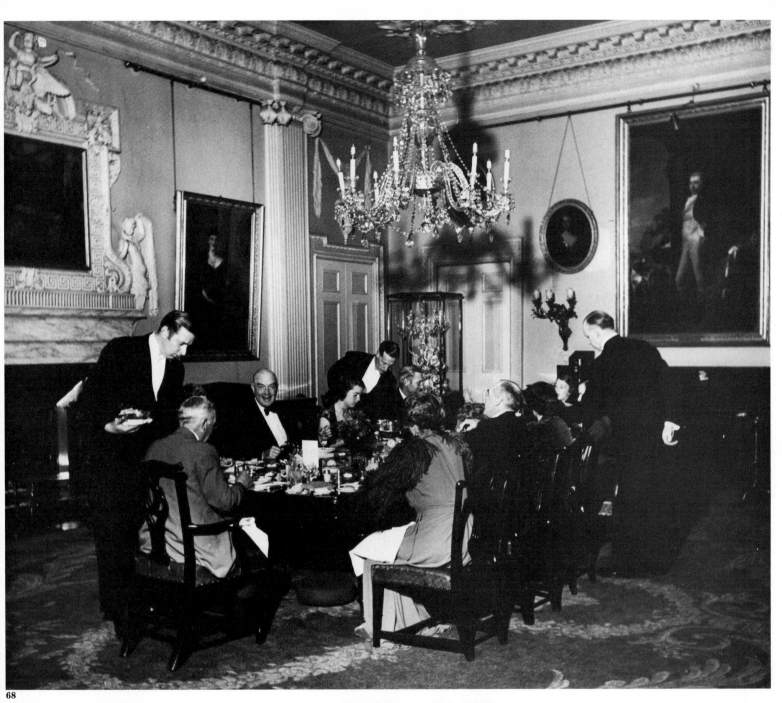

68

69

(67) *After lunch, guests lay down for a little rest before more shooting.*

(68) *Grouse were served for dinner in Lord Tweeddale's elegant eighteenth-century dining room.*

(69) *After dinner, the gentlemen retired to the library with host Pratt (left), his brother Harold, R. Schley, and C. D. Barnes. Next day's shooting started at nine A.M.*

Salzburg, 1937

70

71

72

(70) *Fashionable Lanz Sport was the tourists' first stop in Salzburg, where they were outfitted in local dirndls and lederhosen.*

(71) *Schloss Leopoldskron was home of Max Reinhardt, famous Austrian director and guiding spirit of the music festival.*

(72) *The Countess of Oxford and Asquith, widow of Britain's wartime prime minister, enjoyed a beer at the Mirabell Garden.*

While working on this book, I was going over the pictures I had taken of Archduke Eugene, Lady Oxford, Toscanini and all the personalities of the 1937 music world, and was reminded of my 1972 correspondence with the playwright Sam Behrman. The letter reads in part: "Recently our mutual friend Marcia Davenport spent a weekend with us and I showed her some pictures I had taken in Salzburg. She especially liked the one of you. I'm sure you'll remember that day in 1937 when the picture was taken at Raimund von Hofmannsthal's summer home. On our return to Salzburg we gave you and your wife a lift at a reckless speed down mountain roads, unaware that she was pregnant until later that day when we heard she had been rushed to a clinic. After dining together the following day, we drove you back to the clinic, cheerfully thinking up first names for your son. Since he had been born in Salzburg at the height of a great festival at which Maestro Toscanini was conducting, I volunteered 'Arturo.' As you walked toward the clinic you said, 'Arthur Behrman doesn't sound at all bad.' Now that I've learned your son's name from Marcia, please give Arturo David the picture I took of his father on the day he was born."

Mr. Behrman responded: ". . . your letter has given me a tremendous lift and takes me back to a moment when life had more possibilities than it has now. I thank you and thank you."

73

(73) *Archduke Eugene of Austria, Royal Prince of Hungary and Bohemia, Field Marshal, Grand Master of the Order of Teutonic Knights, chatting with a young friend during the birthday celebration of Archduke Otto, exiled pretender to the Hapsburg throne.*

(74) *American playwright Sam Behrman.*

(75) *English novelist-playwright Somerset Maugham.*

74 75

(76) Maestro Arturo Toscanini and Eleonora Mendelssohn, a descendant of the composer Felix Mendelssohn.

(77) Max Reinhardt and his wife, Helène Thimit, in their home at Leopoldskron.

(78) Bruno Walter conducting Mozart's Marriage of Figaro.

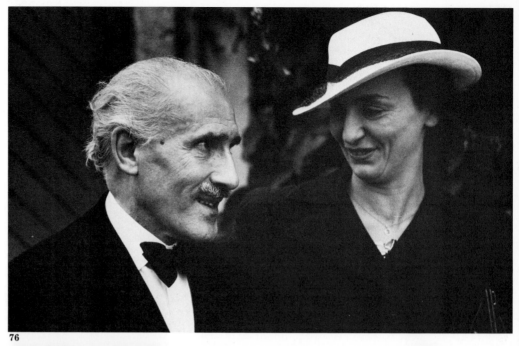

76

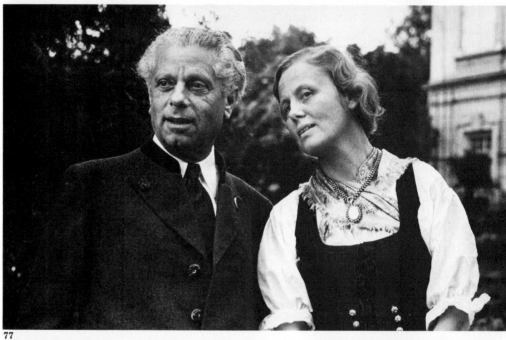

77

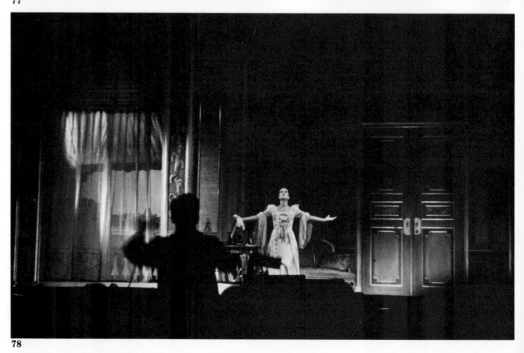

78

(79) Opera props arriving at Cathedral Square.

(80) Guests in evening clothes leaving the Österreichischer Hof on their way to attend a performance of Verdi's Requiem conducted by Arturo Toscanini.

(81) Performance of Hugo von Hofmannsthal's Jedermann on Cathedral Square.

79

80

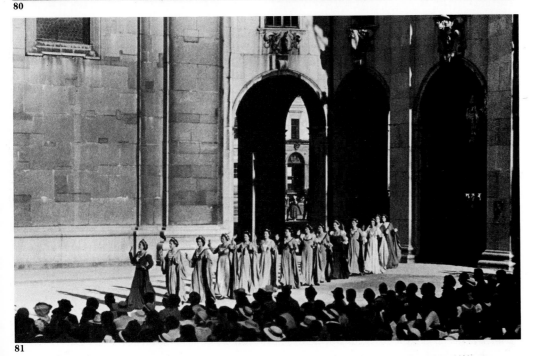

81

49

"God Protect Austria"

Salzburg's 1937 season ended with Max Reinhardt's production of *Faust*. In his usual grand manner, the Austrian director had converted the famous Felsenreitschule—the riding school built against a rocky cliff—into an open-air stage facing a covered grandstand.

Reinhardt resided at Leopoldskron, a baroque castle of imperial proportions and cold, impersonal furnishings, where I photographed him and his wife, the actress Helène Thimit. There was something forlorn about this elderly couple, lost in the magnitude of that palace. They struck me as survivors from another age.

Faust would be Reinhardt's last production in Salzburg, a music festival he, more than anyone, had helped bring about after World War I. At the performance I attended, the Austrian chancellor, Kurt von Schuschnigg, had dropped in unannounced and was given the seat reserved for the house doctor.

The evening performance opened with a dramatic prologue: floodlights revealed a row of angels standing on the high rocky cliff, and then followed Scene I, for which the lights swept down to Dr. Faust's room on the stage. Well into the play a violent storm that had been building up all afternoon broke out and brought the performance to a halt. Rain lashed the rocks as flashes of lightning illuminated in harsh relief the chancellor's security forces who had replaced the angels on the cliff. The storm grew in intensity—it seemed as if the elements were out to destroy Austria, a portent of things to come within the next six months. I had often wondered thereafter what the chancellor was thinking.

Thirty-seven years later, after sending him a portrait I had taken at the performance, I found out. I mentioned the storm in my letter. The ex-chancellor, a courtly Austrian with Old World manners, took the trouble to reply in great detail: "How strange to remember days when one looked considerably younger enjoying life, though this was not always really enjoyable. I remember very well the *Faust* performance in the Felsenreitschule, partly because it was an extremely well done production by Max Reinhardt with stage arrangement by Clemens Holzmeister, with Paula Wessely an excellent Gretchen, partly because in the days before we had quite some trouble to get a reliable hold of our Mephisto (Werner Kraus) who lived in Germany and needed a special exit permit from Mr. Goebbels, partly also—an entirely unpolitical sideline—because Werner Kraus was not only an extraordinary actor, dedicated to Melpomene, but also in an unpredictable way dedicated to Bacchus. However, as I remember, everything went well. I would guess the 'streaks of lightning that revealed silhouettes of soldiers' could have been men from the fire brigade or just 'cops' in festival outfit."

To my great surprise the chancellor did not recall his soldiers who guarded him, during the storm, against the kind of Nazi plot that had led to the murder of his predecessor and that was to bring about his resignation, followed by years of imprisonment. On March 11, 1938, with his same courtly manner, Kurt von Schuschnigg made his farewell broadcast to the Austrian nation: "I declare before all the world that the reports which have been spread in Austria, that there have been workers' riots, that rivers of blood have flowed and that the government was not in control of the situation and was unable to maintain order on its own are pure invention from A to Z. The Federal President has instructed me to inform the Austrian nation that we are yielding to force. Because we are resolved on no account, even at this grave hour, to spill German blood, we have ordered our armed forces, in the event of an invasion, to withdraw without substantial—without any—resistance, and to await the decisions of the next few hours. The Federal President has entrusted the leadership of the armed forces to General Schilhawsky, the Inspector-General. All further instructions to the armed forces will be issued through him. And so I take my leave of the Austrian people at this hour with a German word and a heartfelt wish: God protect Austria!"

82

(82) Kurt von Schuschnigg, the Austrian chancellor, attended a performance of Max Reinhardt's Faust.

(83) Then came the Nazis.

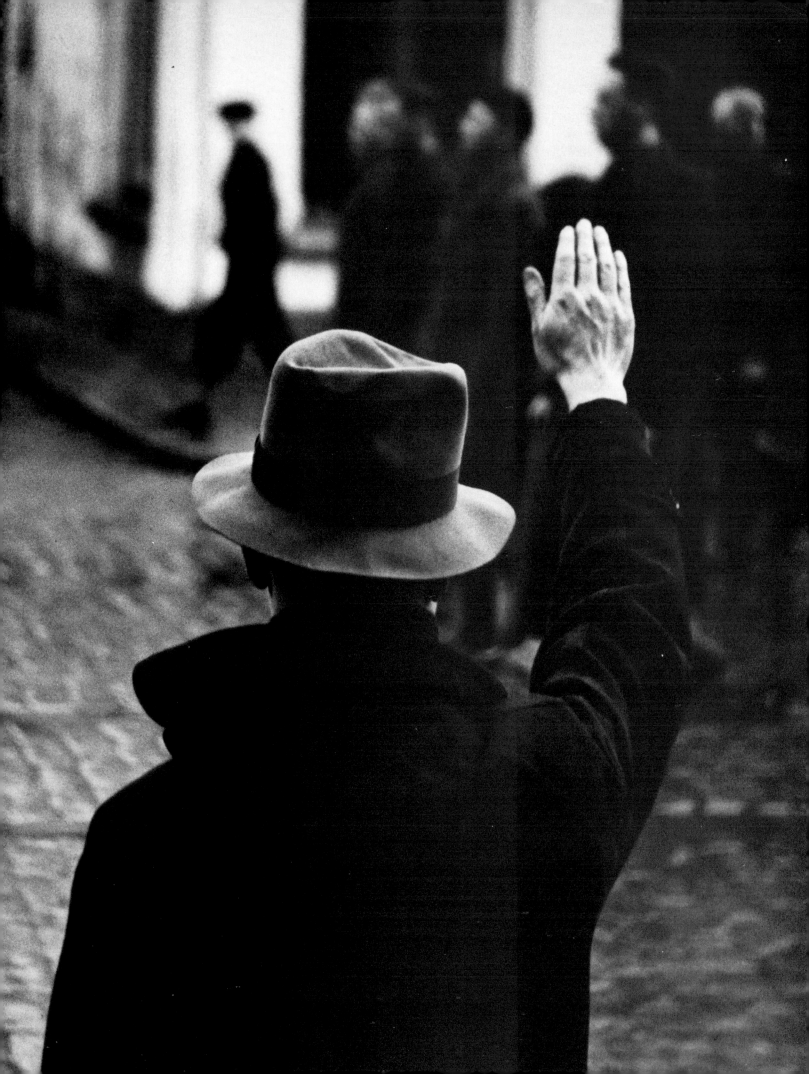

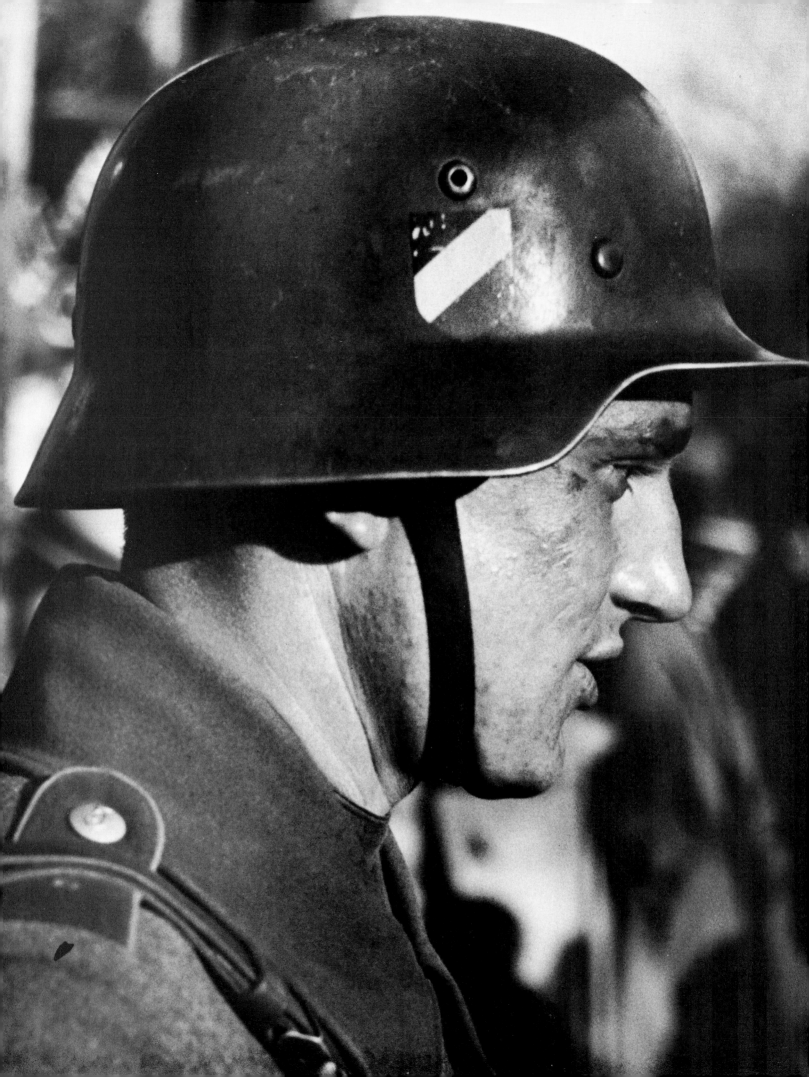

On the evening of March 12, 1938, Bob Best, of the U.P., and I gazed down at the tumultuous crowd below my window at the New Bristol Hotel in Vienna. That morning at dawn the German army had invaded Austria. Now loudspeakers ordered everyone into the streets to listen to a broadcast of "your *Führer*, Adolf Hitler" for the fifth or sixth time that day. Hitler's raucous howls whipped his listeners into a frenzy. From my balcony the huge, dimly lit crowds seemed to overflow the streets like a surging ocean on a storm-lashed night. The persistent chant *"Deutschland sieg heil!"* was like the shrieking wind, and the thousands of outstretched arms in Nazi salute the rolling foam of the waves. To observe human beings turned into a destructive force of nature was terrifying. What made it even worse was that I had to go down into that seething mob and take pictures.

Bob Best had just briefed me on the new press regulations. Now that Hitler had turned Austria into a German province, photographers needed a special permit. He discouraged me from applying for one. The Nazis had developed an aversion to Time Inc. ever since "The March of Time" had released the newsreel "Inside Nazi Germany," which had been banned in that country. "If they catch you taking pictures, you'll be in real trouble," he said. Best's eyelids drooped when he spoke, giving him a sententious manner. He had been so long away from home and was so involved with a countess addicted to cocaine that he had become somewhat of an expatriate. This may well have influenced a fatal decision he was to make several years later.

At the time Best was helpful and went out of his way to find me a guide. "I've got a young Jewish journalist," he told me.

After Best left, I turned to the French "March of Time" crew who had traveled to Vienna with me and said, "Let's go down and see what we can do." Rebière, the cameraman, had lost a finger on his right hand to an Austrian shell during World War I and had since lumped Austrians and Germans together in one bunch. He viewed the present situation with considerable distaste.

Mass hysteria swept the people lining the sidewalks and sitting in the trees, waving and cheering themselves hoarse as they watched the local brown-shirt battalions march past. It was hard to believe that sixty hours before the same throngs had applauded the parading Socialists.

"Humanity is not very consistent," I thought as I took pictures of the new fervor.

A well-dressed elderly gentleman, his eyes red from weeping, stopped me "What is Eden going to do?" he asked.

"Haven't you heard?" I said. "He's resigned as foreign secretary."

The old man shrugged his shoulders in despair and hurried away. By midnight the exhausted Viennese had gone home. Vienna was deserted except for the Hitler youth dutifully drilling and a few solitary figures patrolling the streets.

So far it had been easy. I had been inconspicuous among the ecstatic Viennese. No one had paid any attention to me. But the methodical Germans would be something else, and the first units of the Wehrmacht were approaching and would be in Vienna by morning. I tried to figure out how I could take pictures without a permit and avoid getting pinched. Based on the German regard for authority, I devised a plan that I hoped would work while the confusion prevailed during the first days of the occupation— just long enough for me to take the pictures I needed and get out.

At seven in the morning I watched the first units of the Wehrmacht ride up the Kertnerstrasse from my hotel window. By the time Ernst, the Jewish journalist Best had recommended, showed up, I had hired an aristocratic black limousine the Duke of Windsor had once used during a visit. Two large swastikas fluttered from the mudguards. My chauffeur was in a severe livery. Ernst, whom I had hired on condition he keep a low profile, as much for his sake as mine, sat next to the driver. We were so conspicuous I hoped we would be seen as of sufficient importance to make any official hesitate long enough for me to take my pictures before he dared ask for credentials I did not have.

Feeling that the best was to find out the worst, we drove to the palace

Prelude to War: Vienna, 1938

(84) German sentry outside the New Bristol Hotel on March 14, 1938, the day Hitler entered Vienna.

(85) Nazi enthusiasts cheering the arrival of German troops in Vienna.

85

(86) *This Jewish-owned store in Vienna was singled out for boycott with the word* Jude *(Jew) scrawled across its plate-glass window.*

(87) *Young Nazis parading on Vienna streets.*

(88) *Units of the German army driving down The Ring at night to public acclaim.*

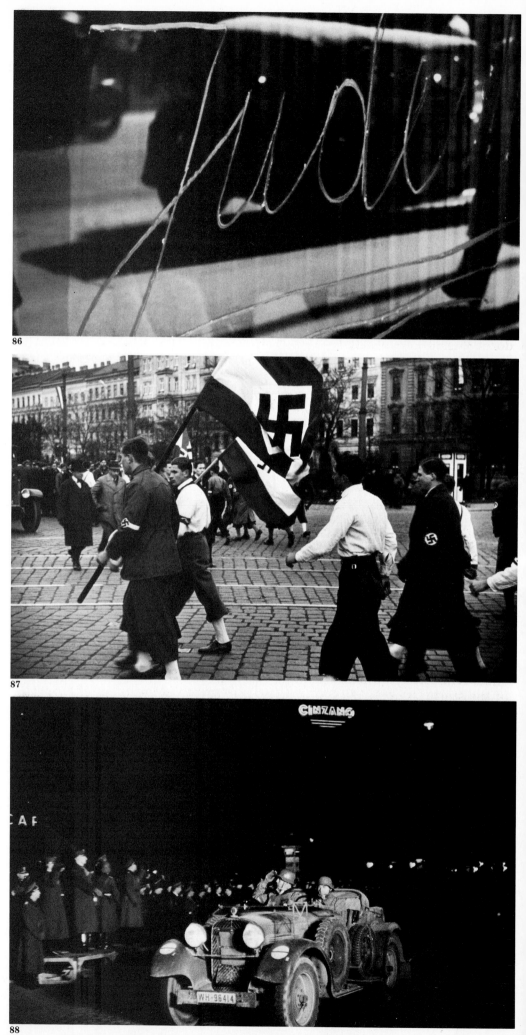

86

87

88

where Chancellor Kurt von Schuschnigg was held prisoner. Getting out of the car with great deliberation, I took a shot of the young Austrian Nazis stationed at the gate. The moment they started to take interest in me I made for the car and told the driver to step on it. For the next two days I drove around photographing the Nazification of a city. On the afternoon of March 14, Hitler drove into Vienna. I got a shot of him from my hotel balcony. The next morning I stood on the roof of the Museum of Natural History to photograph German armor lined up seven floors below for that afternoon's parade.

Back at the hotel I found things had changed: a German sentry stood guard at the revolving door; the reception desk had been taken over by the SS; a storm trooper stood at the foot of the stairs while another went up in the elevator with me. At each landing two more patrolled the floor, throwing doors open and peering in. Remembering Bob Best's warning, I collected my exposed films and hurriedly air-expressed them. I had made it a practice to send all my negatives to London via Berlin. I had heard that the Nazis tampered with mail to Czechoslovakia and gambled they would never suspect incriminating material traveling via the German capital. Unaware of what was about to happen, I kept the waybill for the photographs on me. Since my room had a good view of the parade, half a dozen guests — including the American military attaché and Bob Best — dropped in on me. I shot pictures of Hitler as he drove past before the parade started and was observing the efficient way the Nazis controlled the huge crowds when I noticed a photographer standing on top of a car that was inching its way through the mob. The photographer was familiar — it was Ernst. He had taken the limousine to shoot pictures on his own. I shouted at him and ran downstairs, but arrived too late. Three storm troopers had hauled him down and he was frantically pointing at my hotel room.

I ran back to inform my guests we could expect visitors. Two minutes later the storm troopers shoved Ernst into the room while he screamed, "Ask him! He'll tell you I work for him."

Everyone had to produce credentials before he could leave. I sat in an armchair and waited. The two Frenchmen from the "March of Time" film unit were also in the room. They were in as much trouble as I.

"Don't worry," Best said, "I'll notify the American consulate."

I asked one of the storm troopers why we were being detained and got a volley of abuse about the *Schweinerei* of the foreign press. Hoping to get rid of the storm troopers before they unhooked the phone and cranked up the police machinery, I tried to mellow them by showing a cable from my office which read: GET WILD SCENES OF JOY VIENNA. This was having some effect when Ernst, completely hysterical, made a scene. That settled it. One of the storm troopers got on the phone. To my great surprise I did not get scared, but found I was angry. The storm trooper on the phone seemed to be describing us as "four Jews." When I mentioned this to the French cameraman, he had an inspiration. He unbuttoned his pants, whipped out his uncircumcised penis, and shouted, "Do you call this Kosher?" It took the storm troopers by surprise and almost gave the cameraman time to reach the bathroom to flush his trade union card down the toilet, but not before one of the storm troopers flung open the door to watch him. I demanded why this boorish invasion of privacy.

"He might try to dispose of some incriminating documents," the storm trooper said.

"Why not search us, then?"

"Because you're not under arrest."

"Then we're free to go?"

"No. You're under observation."

I knew I was in trouble. But how much trouble? All the Nazis would have on me were a couple of shots of Hitler driving past, unless they found my waybill or discovered my hidden map. That might complicate things. Of course there was my guilt-by-association with "The March of Time" people and with Ernst, an Austrian national now regarded as a German Jew. I kept wondering why Ernst had taken the limousine and defied the Nazis

by standing on the roof of the car to take pictures of Hitler when he was so obviously a target. He knew better than I that the Nazis were rounding up Vienna's Jewish population. "It must be desperation," I thought, somewhat resentfully.

I looked at my watch. In half an hour my films would be leaving Vienna and, unless I was searched and my waybill found, they would be safe. But there was also the map, and it was hidden in my room. Through a stroke of Fate I had got hold of a Nazi map that had been withdrawn from circulation because it showed a Germany that had absorbed not only Austria but also Czechoslovakia, Poland, and Soviet territory. I had tucked this document inside my dress shirt (having brought my dinner jacket to Vienna out of an old-fashioned idea about an Austria that no longer existed). At about the time my films should have been reaching Berlin, two SS took over from the storm troopers. "How many pictures have you taken?" one asked.

"Several of the *Führer.*"

"Anything else?"

"Nothing else," I said, praying I would not be searched.

"Good thing, because you have no authorization to take pictures."

Two American consulate officials arrived looking like seconds for a duel and announced they would take the matter up with the authorities. I found this extremely generous on their part, considering my limited links with the United States. After this visit the SS put through some phone calls before they ordered us to follow them. Taking advantage of the confusion, I slipped into the bathroom and flushed my waybill down the toilet. Under curious stares we were led across the hotel lobby. A bellhop handed me a wire: ADVISE IMMEDIATELY IF ANY MORE MATERIAL DUE PICK UP CROYDON AIRPORT AS QUEEN MARY SAILING DEADLINE 7 AYEM TOMORROW.

"Mind if I send a cable?" I asked the SS. They certainly did.

The police car was held up by a wall of people. One SS stood on the running board and bellowed "*Platz machen!* — Make room!" as we slowly drove through the throng, which was shouting "*Deutschland sieg heil!*" We could have been crushed like an eggshell. I felt like throwing up. We wound up in a very large building and were marched through moldy halls and chilly corridors past an open door. Looking in I saw several hundred naked men lined up with their arms in the air while storm troopers searched their clothes. "Think we'll catch cold?" I asked the French cameraman, who glared at me.

We were kept waiting in a crowded anteroom before being led into an office where an official in uniform studied our passports. He took my film, promising to return it if it proved to be harmless, which was the last I saw of it. He then told us we could leave.

"What about my guide?" I asked.

The official shrugged. "He's a German now. Why worry about him?"

In spite of his getting us into this mess, I felt pity for Ernst when I thought of the lineup of naked men.

Once in the street I sighed with relief and hurried off to cable London that my film was on its way.

During the next two days I continued to take pictures. Then, as I could no longer trust the air-express service now that the Germans had got a good grip on Austria, I decided the time had come for me to get out, and take the films I still had with me. I booked a reservation aboard the Mitropa express which crossed the border at four A.M., an hour when customs officials are generally sleepy.

I had the upper bunk in the compartment. The lower was occupied by an influential member of the Nazi party who had been seen off by a delegation. I had slipped my films into my pajama pocket and was wondering where I could hide them. Noticing my traveling companion's heavy overcoat, I thought, "Why not? He's much less likely to be searched than me." In the dark I lay back and waited for him to fall asleep. After his heavy breathing turned into snores, I leaned over, fished around for his overcoat, found a pocket, and dropped in my films.

The customs officials were diffident with my Nazi companion but made a

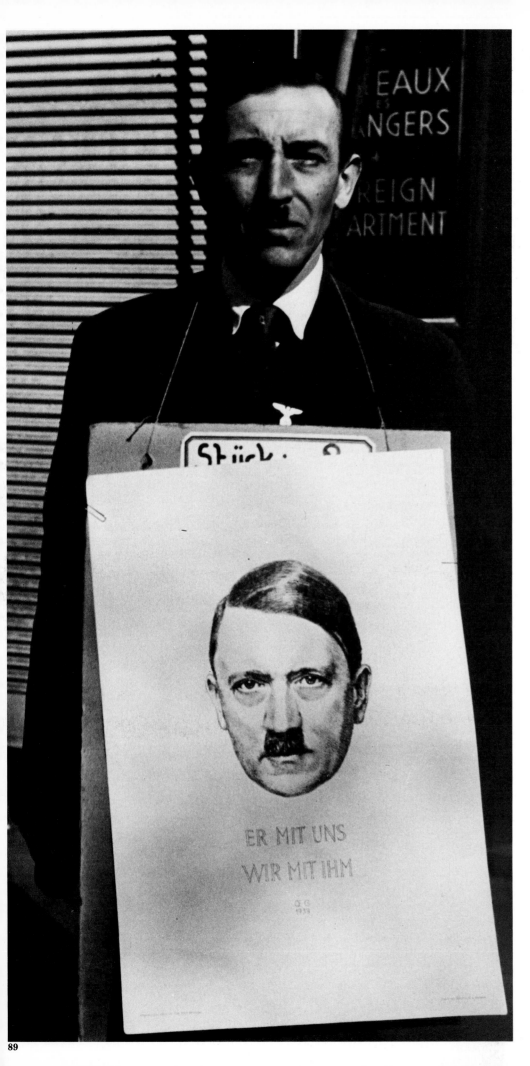

(89) An Austrian sporting a Hitler mustache sold portraits of the Führer with the inscription: "He's with us, we're with him."

(90) German armor lined up for March 15 victory parade, shot from roof of the Museum of Natural History.

(91) Newspaper vendor peddling the latest edition, which announced: "The Führer in Vienna Today."

(92) Hitler driving down The Ring as he entered Vienna on March 14, 1938.

(93) Two members of the SS — the muscles of Nazi power — patrolling Vienna's streets.

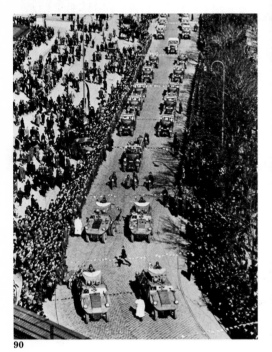

90

91

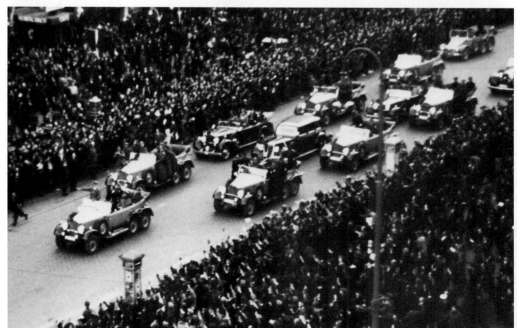

92

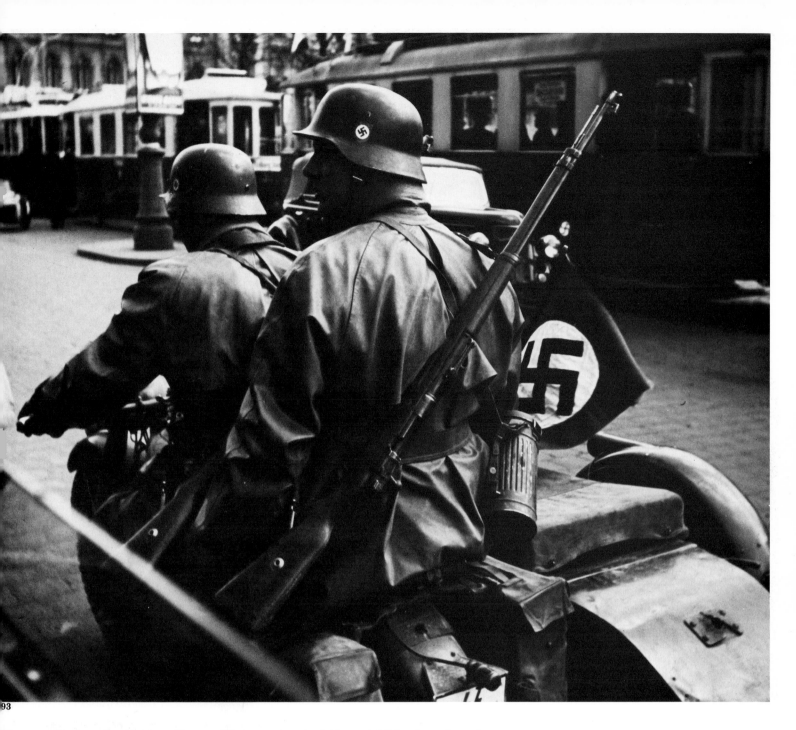

thorough search of my suitcase. They respected the seal I had replaced on the wrapper of my dress shirt and did not find the map. My cameras were examined at length, but as I had no film nothing was said. Finally they moved on to the next compartment and my traveling companion and I returned to our bunks.

It took a long time for him to get back to sleep. In the dark I reached out for his overcoat. My clammy hand felt around for the pocket and found it. The train was lurching violently. I was groping around for my film when suddenly the compartment was flooded with light. Clutching my films, I threw myself backward and banged my head against a partition. Then it was dark again. We had passed a small wayside station and, since our window shades were up, the lights had cast a glare into the compartment.

Several months later Ernst was released from prison through Bob Best's intervention and allowed to leave Germany. Incomprehensibly, Best stayed on in Austria after the United States declared war and made broadcasts for the Nazis, villifying his native country and "American Jewry." Arrested at the end of the war, Best was locked up after an American court declared him insane.

Poland

(94) *The Warsaw ghetto in spring of 1938.*

(95) *Three sisters in the Warsaw ghetto.*

"You'll never get a Polish visa if the government has any suspicions of what you're up to," our Warsaw stringer said when he called me in Prague. "The government hates photographers even more than reporters. They don't want any pictures taken of their German minority since Hitler has taken over Austria. They're also dead set against anyone photographing Jews, as they know that in New York the Warsaw ghetto is synonymous with pogrom. They're against everything you want to photograph."

"Your friends sound pretty high-handed," I said. "Right," our stringer agreed. "High-handed," I thought, "well, I'll go along with that." First I exchanged ten hundred-kroner bills for an unwieldy thousand-kroner bill used only in important transactions and then set off jauntily for the Polish consulate. There I found a line patiently waiting. Impatiently I demanded to see the consul. Ushered into his office ahead of everyone else, I tossed my British passport on his desk. It had been issued while I was still a student, so the heading "Profession" had been crossed out. "I'm a gentleman," I announced, "one of those fortunate few who travel for pleasure. I wish to see Poland." On this, I produced my thousand-kroner bill to pay for the visa. Although it put the consulate to a certain amount of trouble getting change, it did establish me as the type of person I claimed to be. I got my visa and photographed Warsaw's ghetto.

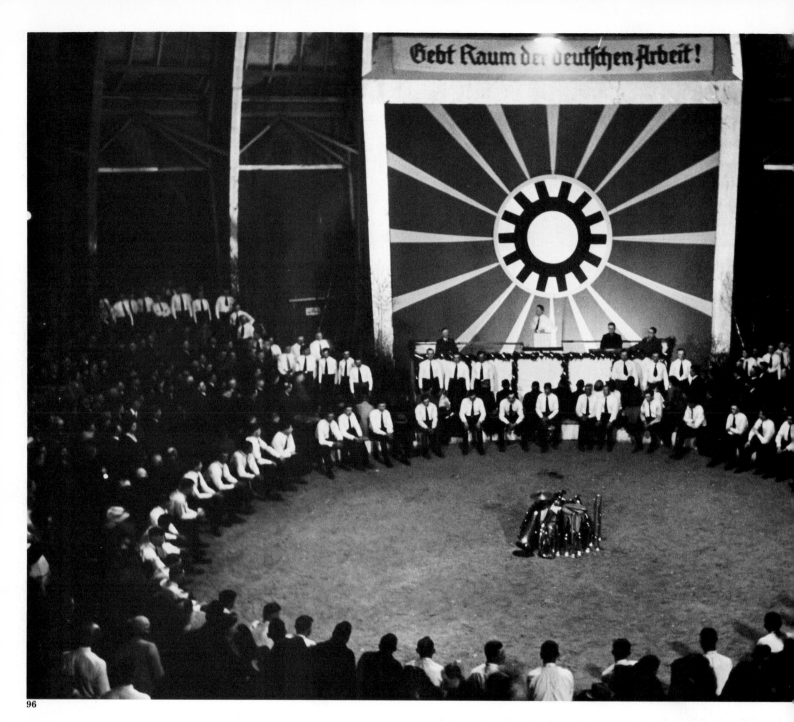

After getting pictures of Warsaw's ghetto, my next assignment was Poland's German minority. Like every other German minority in Europe, they had started to make impossible demands on their government after Hitler took over Austria. The Germans living in the Polish corridor, with their Nazi-style organization, started provoking the Warsaw government. I flew to Poznan after hearing this group was to hold a rally there. My hotel porter responded with "What rally?" when I asked him about it. I got the same answer from every Pole I met. By chance I ran into a German only too happy to direct me to the circus building where the rally was being held. The neighborhood was cordoned off by tough Polish police. Inside, Germans dressed in the same uniform as their counterparts in Czechoslovakia— white shirt, black britches and jackboots— were seated around the circus ring. The shiny brass instruments of a German band were stacked in the center of the ring. "Can you imagine?" a self-appointed guide informed me. "The Poles have forbidden us to play the German national anthem." Speaker after speaker incited the audience to acts of sedition. Back at my hotel, the formerly evasive porter pumped my hand. "Why didn't you tell me you were a foreign correspondent? I would have been only too happy to help you." "How did you find out?" I asked, to which he replied, "I listened in on your phone call and liked what you said about the Germans."

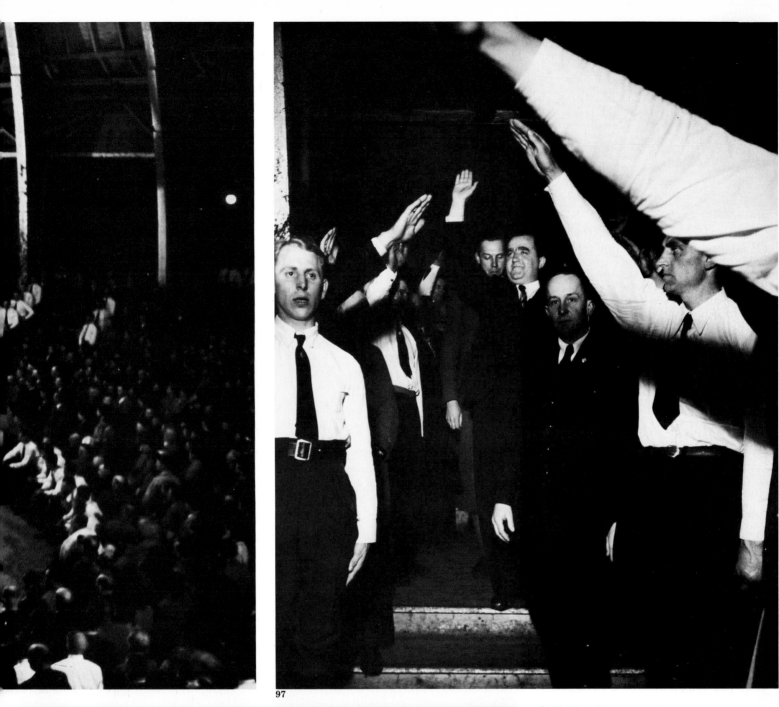

97

98

(96) The German minority living in the Polish corridor held a pro-Nazi demonstration in Poznan. Musical instruments were stacked up in protest, the Polish police having forbidden the playing of the German national anthem. The slogan in the background reads: "Make room for German labor!"

(97) Boleslaw Piasecki, leader of the German minority, arriving to address the Nazi rally.

(98) Group of Nazi women singing. The slogan reads: "We want to be a nation and brothers together."

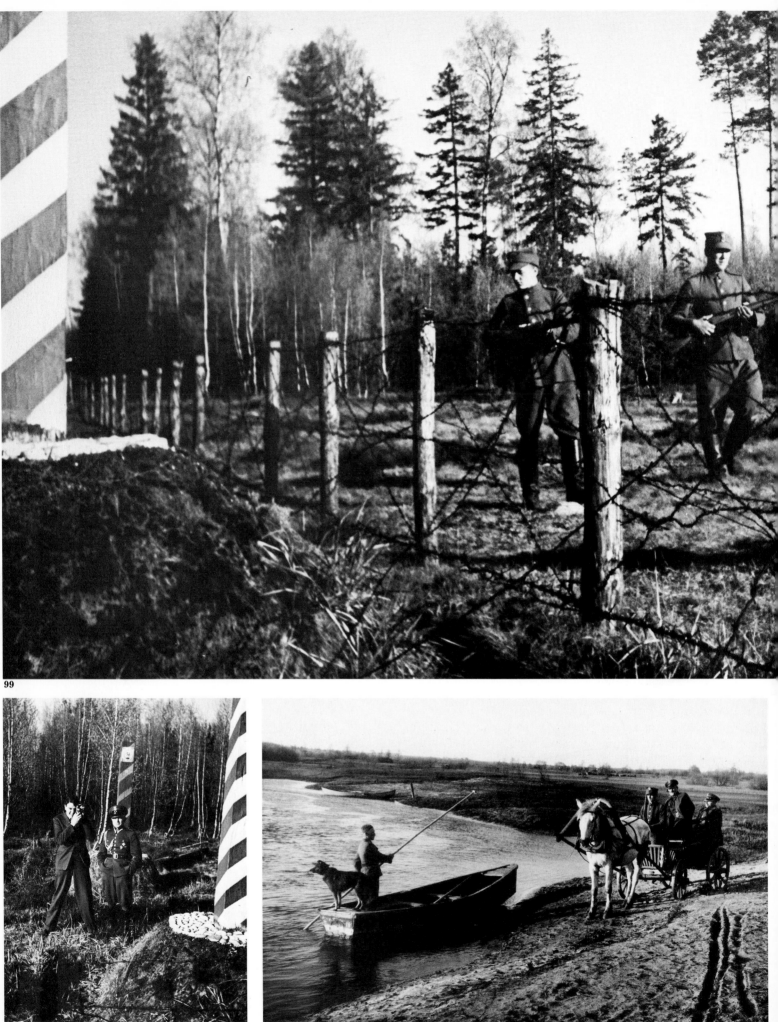

99

100 101

A lieutenant from the KOP—Special Border Force—escorted me to a Polish observation tower from where I could watch the Nord Express, linking Moscow and Paris, cross over into Polish territory. "Please hide your camera until you're out of sight," the lieutenant said. "We have an agreement with the Russians that neither side take pictures of the border. As far as I'm concerned you can take all the shots you want from the tower as long as they don't see you. Otherwise, they'll complain. They're a nuisance that way." The border was heavily wooded and a great forest spread out to the horizon, leaving me with a feeling of immensity I was to experience again only when I saw the Grand Canyon in the States. Next, the lieutenant drove me to a block post where a sumptuous meal had been prepared by the commandant's sister. "It's so boring here," the commandant said, "that we love to have guests. It gives us an opportunity to celebrate." Celebrate we did, tossing down much wine. We then set off to take pictures of a border patrol along the Polish-Russian line at a point where the two countries were separated only by a barbed-wire fence. Wanting a shot of the Polish patrol from the Russian side, I crawled through the barbed-wire entanglement, followed by the commandant. "What do you think the Russians would do if they caught us here?" I asked. "We'd have a border incident," the Polish commandant shrugged.

(99) Polish patrol on Russian border seen from Soviet territory.

(100) To take this picture, I crawled into Russia through barbed wire, followed by a Polish officer. Note the Soviet hammer and sickle.

(101) Members of Polish border forces on the Pripet River.

(102) These army maneuvers, which took place in Warsaw in 1938, give an idea of what Poland went to war with.

(103) General Slawoj Skladkowski was the Polish prime minister when Hitler invaded that country without warning on September 1, 1939.

104

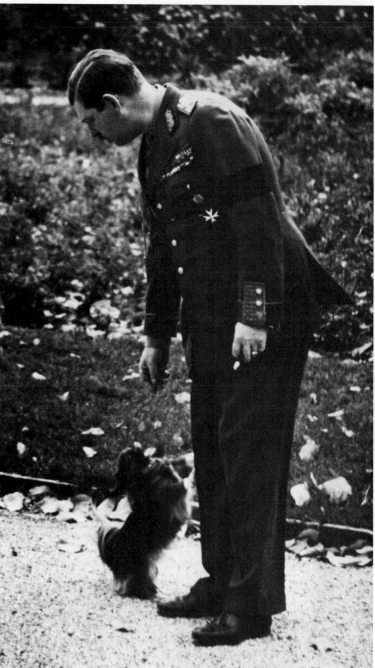

105

Rumania

"Don't ever forget what the tsar said about Rumania," a friend remarked before I left for Bucharest in 1938. "It's not a nationality, it's a profession."

On arrival, Mr. Eugen Titianu, the royal Rumanian government's undersecretary for propaganda, greeted me with asperity, declaring, "*Life* magazine is in the clutches of the Hungarians." His accusation was based on *Life's* having published a story on Hungary ahead of the one I was assigned to do on Rumania. "I have come to set matters straight," I said soothingly. A government aide had been appointed to make a report on my picture requests. Within five minutes he had given me to understand that the tone of his report would depend on my generosity. *Bakshish* in the Balkans saved time, I had found, and brought results. Thanks to an active black market in foreign currency, I could be generous with my newfound friend. His report was so favorable that the Department of Propaganda not only granted us the use of a car and driver but also provided a substantial sum to finance the trip. Although my friend kept the money and let me pay the bills, it was a reasonable arrangement because he allowed me to get pictures of the Swabian German minority, who had officially ceased to exist after Hitler's threats against Czechoslovakia on behalf of the Sudeten Germans living there. Later Mr. Titianu agreed to my taking pictures of King Carol and his son on condition I give him a set of prints for release to

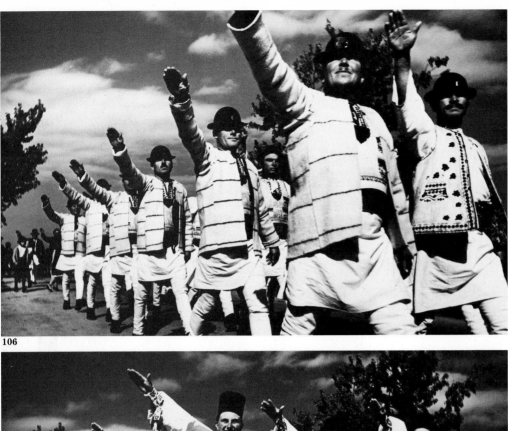

106

107

(104) While Rumania's Crown Prince Michael's pet was a sturdy Great Dane, his father, King Carol (105), preferred the more dainty Pekingese.

(106) Eight hundred thousand Germans lived in Rumania. They had been imported at different times over the previous seven hundred years from the Rhineland and Saxony to till the land and fight off the barbarians. By 1938 these pro-Nazi men and women (107), seen marching in Mercurea Sibiu, were a source of anxiety for the Rumanian government.

(108) Peasant wedding in Transylvania.

the British press when the Rumanian monarch made his forthcoming state visit to London. The royal palace stood out in the center of Bucharest like a hippopotamus among chickens. Compared to the sumptuous dress of his Rumanian army officers, King Carol's uniform was modest. After getting pictures of him and Crown Prince Michael with their pets, we took an elevator the king operated himself. By the time I had all the pictures I needed of him, the king was so absorbed in his paperwork that I left his office and walked down the three flights of stairs in search of someone to show me the way out. I peered into a gaudy banquet hall where a footman in black breeches with platinum piping rescued me. "I have just left His Majesty," I said in French, "and would like to find my way out," hoping it would not sound too suspicious in the palace of a monarch obsessed by fears of assassination. "Where would you like to go?" the footman asked. "Hotel Splendid," I replied. "This way," he said, taking my camera case. I followed him through several rooms until we reached a wing of the palace under construction. Exiting through a ground-floor window, we climbed onto some scaffolding and proceeded along a temporary catwalk until he kicked out two planks and, as I stepped onto the street, I saw my hotel across the way. The footman carried my camera case to the porter's desk, bowed, and vanished back into the palace the way he had come.

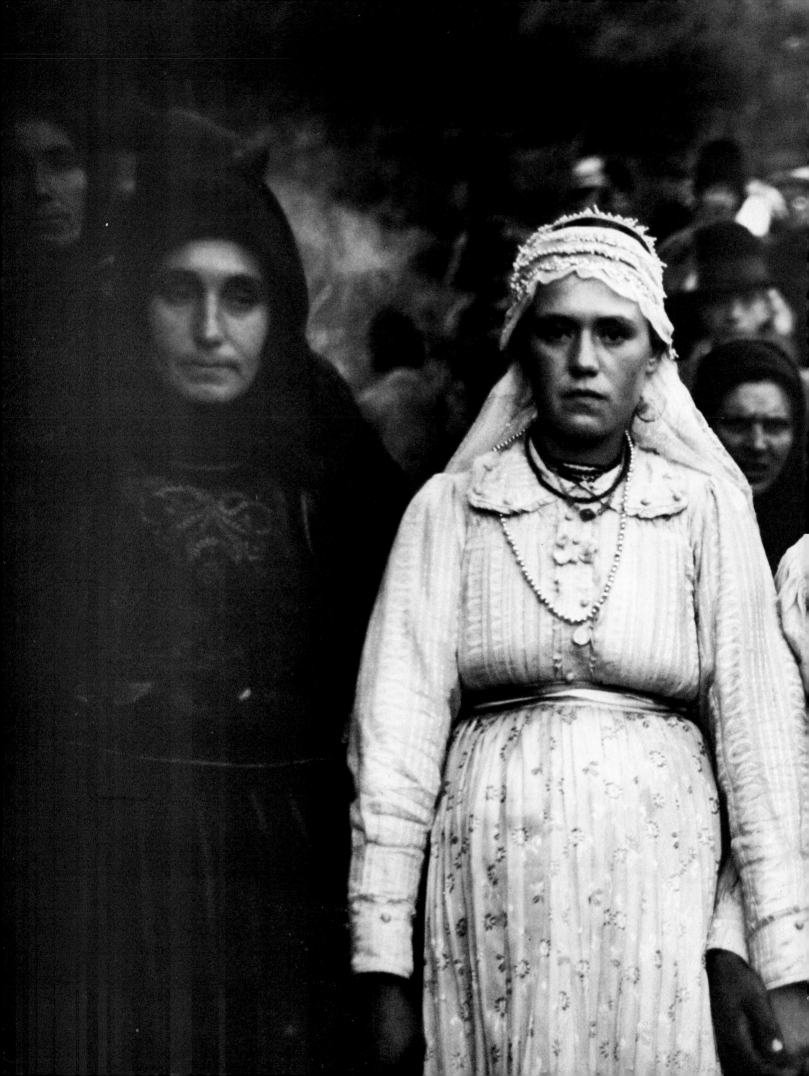

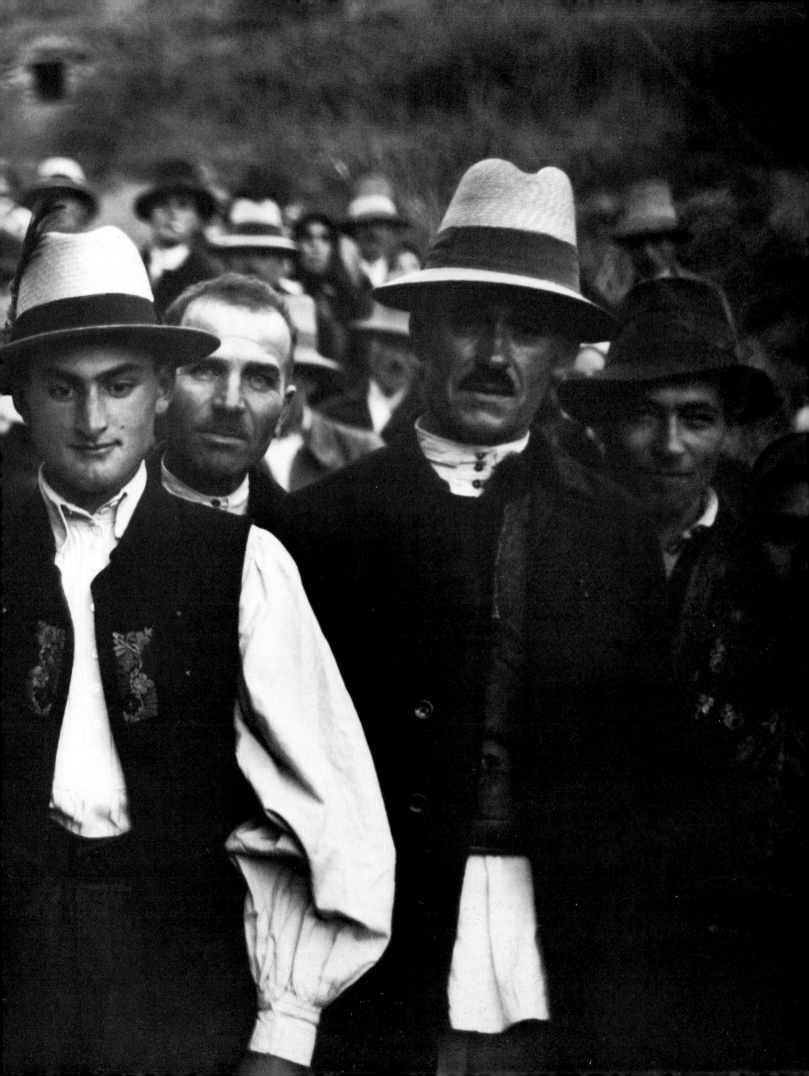

109

110

111

112

Czechoslovakia

After occupying Austria, Hitler turned his attention to Czechoslovakia's German minority. As I shuttled in and out of Prague throughout the spring and summer of 1938, I realized the effectiveness of Hitler's big lie. "Germans," he howled, "are treated like niggers!" A Sudeten said to me, "I can't understand what has come over the Czechs. We always got on well. Now they're murdering us." When asked for specifics, he could only quote hearsay. The Southern German Party had stepped up its seditious activities, demonstrating how easy it was to brainwash an entire people. Throughout the crisis we were never more than half a dozen English-speaking foreign correspondents in Prague. H. R. Knickerbocker, the well-known INS correspondent, had a large room at the Ambassador Hotel where we all gathered. It became something of a press club. We were there on September 26, the night Hitler screamed during his fevered speech that he would have the Sudetenland by October 1 — four days away. Later, after it was all over for Czechoslovakia, the other correspondents heard about my adventures getting pictures of the German takeover there and wanted to do a story on me. I declined. I was keeping a low profile after the Nazi map I had smuggled out of Austria had been published, creating something of a furor. As my old friend Cornell Capa was to tell me years later, "You don't know how to promote yourself."

(109) Army leaders are (left to right):
Inspector General Jan Sirovy, Chief of
Staff Emil Ludwik Krejci, and War
Minister Frantisek Machnik. Defense of
the republic would have rested on their
shoulders had Czechoslovakia resisted
Hitler.

(110) President Eduard Beneš of
Czechoslovakia.

(111) Members of the SDP (Southern
German Party) in their Nazi-style
uniforms at a Prague rally.

(112) SDP members listening to
seditious speakers.

"We Wanted to Sing with the Angels . . ."

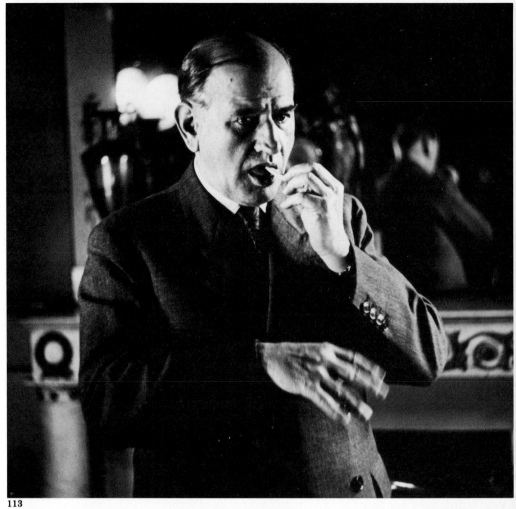

113

(113) The men of Munich: Prime Minister Edouard Daladier of France thoughtfully lit a cigarette; Mr. Neville Chamberlain (114), clutching his umbrella, prepared to board a Munich-bound plane to negotiate a peace settlement.

114

At an hour when it was still today because not quite midnight but already tomorrow because the morning papers were out, I caught sight of a headline: "CHAMBERLAIN FLYING TO HITLER." The announcement had been withheld until after the BBC's late evening news broadcast so that Mr. Chamberlain could be on his way to Munich before the British public heard about it. The official purpose of the British prime minister's visit was to inform Hitler of the grave situation in Czechoslovakia's Sudetenland, rather like advising an arsonist the house is on fire.

Just back from Prague, I had watched how successful the Nazis were in their drive to annex the Sudetenland and dismantle a democratic country with its important heavy industry and well-equipped army. I was convinced that Chamberlain intended to sell out the Czechs, his aim being to point Hitler to the east and bring on a confrontation with Stalin. Unfortunately, Chamberlain was no Talleyrand.

On that morning of September 15, 1938, I drove out to London's airport to photograph Mr. Chamberlain's departure for Munich. "I am flying to see the German chancellor," he announced, clutching his umbrella as his prominent Adam's apple bobbed up and down between the wings of his butterfly collar. Prime Minister Stanley Baldwin had uprooted a king in eight days; in fourteen, Neville Chamberlain destroyed the only democratic country in central Europe.

While Messrs. Chamberlain and Daladier were in Munich on September 30 putting the final touches on an agreement that was to link the name of that city to appeasement, I was deep in the Sudetenland — halfway up a hill in the middle of the night in a broken-down car with the driver and George Mucha, the son of Alfonse Mucha, the well-known Czech painter.

Earlier in the day I had paid a visit to the newly created censor's office to find out how censorship would affect my work. There I had met George. "As a poet I disapprove of censorship, but as a Czech I wanted to help my country," George said, adding, "I believed there would be war, but as you can see I was an optimist. Now we've got peace — and censorship. Don't you think all this lends ridicule to our tragedy?"

George's English was so good I told him, "You could pass for an Englishman, if you don't feel insulted by my saying so on a day like this."

"So you want to hire a car and drive into the Sudetenland to photograph its Nazification," George said. "Of course, I'll have to censor your pictures." Then his face brightened. "I'll come with you," he suggested, juggling his censor's stamp. "As a government official, I can be very helpful."

Such an open-minded censor as a traveling companion was a guarantee that no photographer would get a picture out before I did. "Won't you get into trouble if the Germans find out you're a Czech?" I asked.

"I can pass for an Englishman," George laughed. "You said so yourself."

He might well have been an arrogant Englishman later that night when he got us out of trouble after our car broke down. Finding a Czech driver to go into the Sudetenland was asking the impossible, but George managed to locate one. There was, the driver told us, one small problem about the car. . . . Convinced we would never find another Czech driver crazy enough to venture into the hostile Sudetenland, we did not give him a chance to explain his problem. We drove down Prague's main thoroughfare as loudspeakers announced the terms of the Czech capitulation — the occupation of Sudetenland — to a stunned people. Motionless and silent, men and women lined the sidewalks, tears streaming down their cheeks.

"We wanted to sing with the angels," George said, "but now we must howl with the wolves. We always believed we belonged to the West, but the West doesn't want us. I guess we'll turn to the East now — to Russia. What else can we do?"

Roadblocks were scattered along our route. The Czech guards who stopped us said they were eager to fight the Germans. They had not yet heard the news. When told, some were incredulous; others felt betrayed.

"Save your loyalty for your new masters," George told him.

The castle where George thought we could spend the night with some friends of his was in total darkness. We banged on the gate. The beam of a flashlight shined in our faces. It was pointed at us by a Czech sergeant. A

great part of the castle had been requisitioned by the army. Guiding us with his flashlight, the sergeant took us through long hallways filled with sleeping men and then up a creaking wooden stairway. We knocked on a door, which was opened by a stout elderly woman who recognized George.

"Come in," she said. A Swede, she was the mistress of the house, and she was hysterical. She had just heard the news and expected the Germans at any minute. "I will seek shelter at the Swedish consulate," she announced. Her elderly Czech husband limped in. Sinking into an armchair, he spoke about the castle, which had belonged to his forefathers. "They will be here in a day or two," he said, "but they will not find me. They will turn this old house into a pigsty by their presence. We will take it back but, unfortunately, not in my lifetime."

George and I looked at each other and mumbled our goodbyes.

On the road again, we found a small restaurant where a few sullen Czechs were drinking beer. Our driver joined us. He intended having a large helping of *knödliki*, a Czech dumpling eaten at every meal. When his plate arrived, he peered at it like a child. There were no *knödliki*. He let out a howl. "First the Germans take our country away and now we have no *knödliki!* What's happening to Czechoslovakia?"

Several miles outside the town of Plana we discovered the problem with the car—the water pump leaked. While we waited for help, George and I paced the road in the dark. He began to recite: " 'In these few contradictions you have the whole of Czechoslovakia. It is a country old and yet new. Great, yet small. Highly civilized, yet very simple. It is rich, but there are wealthier lands. It has a high level of culture but there are states with higher. Still, there is perhaps no country in the world which displays such vital determination and capacity as this small nation which has held its own and will continue to hold its own in central Europe.' That's by Karel Čapek," George concluded. "Let's get in the car. It's chilly."

Hearing the sound of a motor, we ran into the middle of the road. Czech voices ordered us to raise our hands and identify ourselves. After a brief exchange George dropped his hands. "The Germans have been ambushing our soldiers," George explained to me. "They weren't taking any chances. They'll give me a lift to Plana, where I can get some help," he said, climbing in with them.

Hours later George returned with a surly Sudeten, the only mechanic in town. "I talked him into coming," he said with a chuckle, "by telling him I was a stranded English gentleman and it was the least he could do after Mr. Chamberlain's generosity."

Nothing—not even the magic of Mr. Chamberlain's name—could induce the mechanic to tow our car back that night. He dropped us off at a hotel and promised to make the repairs next morning. Instead, we found him and his wife stringing swastikas in their kitchen. "It's unthinkable that my husband would repair a Czech car on a day like this," the wife told George.

While he sought help from the Czech military commander, I photographed the Nazification of this small town. The local ranking Nazi found me on the main square and, on learning I was English, was most cordial. "I'll find you a car," he said. While he was arranging for our transportation, George and I escorted our driver to the barracks. He and his car were to be evacuated with the troops that night. We were at the barracks when a phone call came through. The commandant stared at his boots. "We have just been issued orders to blow up the fortifications," he said. These fortifications were the Czechs' only defense against a German invasion of the rest of the country.

"Tell him I want to take pictures," I said to George.

"It's impossible, because the fortifications are secret," George said.

"But they're soon going to be turned into rubble," I protested. "Don't you want to show the world you were prepared to fight?"

"Red tape," George said in disgust.

With the car the Nazi had produced, we reached Carlsbad, the Sudetenland's famous spa, just as the Czech withdrawal was practically completed. The last truck was leaving that night because the Germans were expected the next morning. We decided to take it. The truck was

115

(115) Photographing a Czech World War I siege gun at the Skoda Works in Pilsen.

(116) Plana, a small southern German town, was renamed Plan and became Nazified within hours of the Munich Agreement. Nazi flags appeared everywhere.

(117) A Southern German garage mechanic who refused to tow my stranded car stringing Nazi flags in his kitchen.

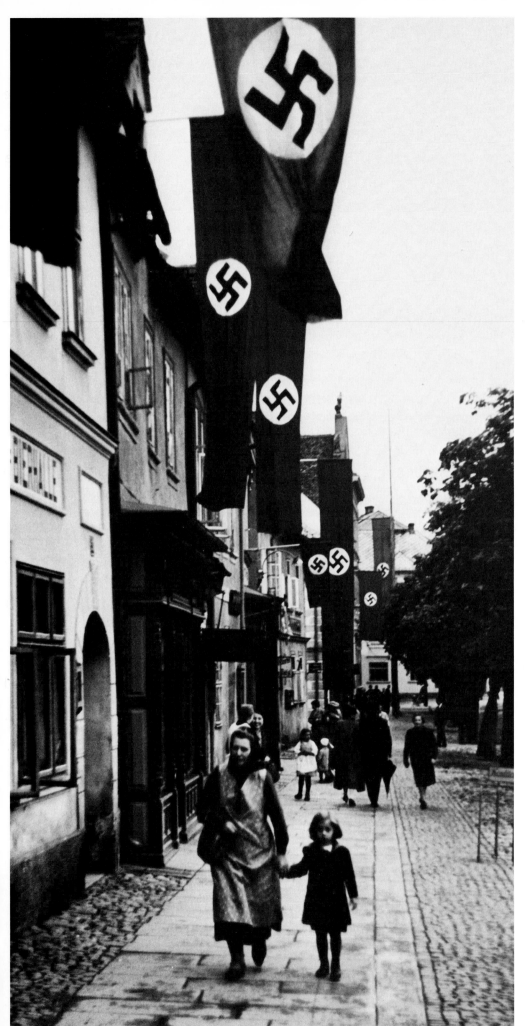

116

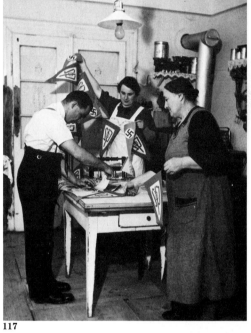

117

(118) Just before the German army entered the Sudetenland, George Mucha and I evacuated Karlsbad in the last truck bound for Prague. The army driver gave Mucha his gun to protect the convoy since Sudetens were sniping at Czechs in retreat. Ironically, this picture has frequently been taken for a movie still.

(119) The last Czech official to evacuate the Sudetenland with his worldly possessions.

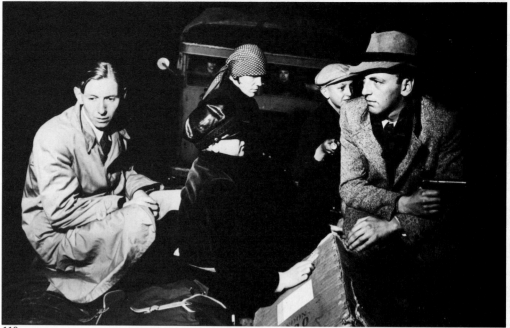

118

loaded with barrels of gasoline, which rocked, rolled, and leaked. An old woman with her small grandson sat next to the driver. She had carried the child twelve miles to catch the truck. The driver was a soldier. He handed his automatic to George and told him to shoot anybody who tried to stop us. "Keep an eye on the houses along our route because the Germans are tossing hand grenades out the windows at passing convoys," he warned.

We stopped at the city limits long enough for a small figure to leap out of the shadows and climb on the truck. A Sudeten German, he immediately produced his Social Democratic Party membership card. Nazi rabble-rousers had broken into his apartment and to escape he had thrown himself out the second-story window. "When Hitler enters Karlsbad, there won't be one anti-Nazi Sudeten left," he said.

Six hours later we drove up in front of a small hotel. The dining room was brightly lit. The driver climbed out of his cab and, grinning, stretched his arms. We were back in Bohemia.

George made arrangements for a car to Prague. We took the Sudeten German with us and ran into trouble at the first roadblock. "No Germans!" the guard said. "We let them into our country once before and look what happened. No! Nothing doing!"

"The Nazis will kill him. We must help him escape."

"If we can't sneak him in," George said, "he'll never survive." Finally he succeeded in mollifying the guard.

"Thanks," the German said as we drove through the roadblock. "I won't be a bother. I'll go to Russia. That's the only place left."

"Remember what I told you?" George said to me.

The next morning George called and apologized for not censoring my pictures at the hotel. "You must come over to my office," he said, "otherwise it won't look right, especially as I've lost that confounded stamp and am being accused of treason." (Five years afterward I ran into George in Cairo and asked about his treason charge. "I sneaked off to London," George said, "and when I got back the charge had been dropped, but the bureaucracy remained. I was fined five crowns for loss of government property.")

I left Prague a few days later, having spent my last evening with Monika. She was a friend I had met when I first got to Prague five months earlier. We sat in a café listening to a popular tune. "You've left many times, Johnny," she said, "but you always came back. Now I know you never will. It's all over with us, without even a fight."

The band stopped playing. "What's the name of that tune?" I asked, to change the conversation.

"It's French," the violinist said as he handed me his sheet music. The song was called "*Avant de mourir.*"

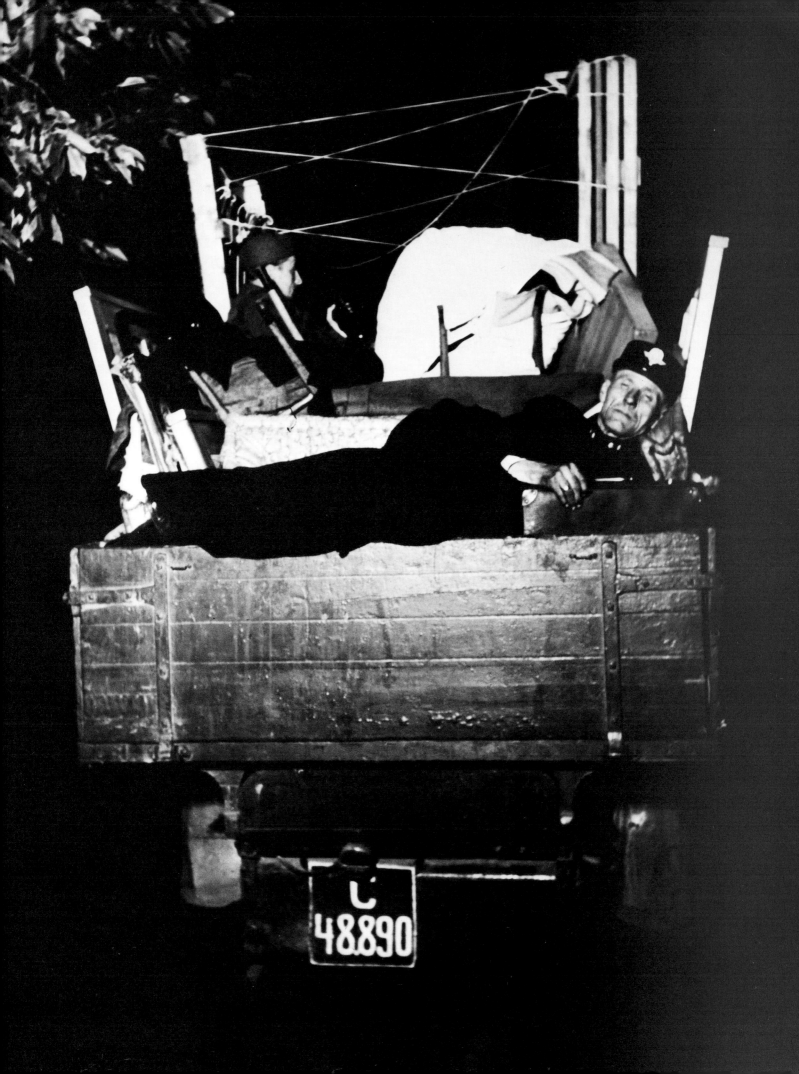

A Farewell to Europe

The betrayal of Czechoslovakia had discouraged me deeply. Decency was being systematically trampled. Only brutality succeeded. It was obvious from what I had seen in central Europe that nothing short of total surrender could avert disaster. Though Chamberlain claimed "Peace in our time," Europe was slowly slipping into war.

Everything in my lifetime had been shabby. I could not manage to earn a living in the country that had issued the passport I carried. The self-respect I had acquired was through my work, which was for an American company. *Life* had paid me to do what I enjoyed most. This magazine had had the temerity to let a twenty-three-year-old misfit loose in Europe during two of the most tragic years of history. But I was still very young. I had beliefs and had seen them mocked and defeated. At home everywhere, I belonged nowhere. I felt there must be a place for someone like me.

Therefore I was grateful to *Life* for the opportunity to get away from Europe during that dismal winter of 1938. The magazine wanted me to travel around Latin America. I was to go via New York, where I would meet *Life*'s editors. A room had been reserved for me at the Lexington Hotel—the tallest building I had ever entered.

Being given a room on the third floor came as a surprise because, as a foreigner, I had imagined living on the upper floors of a skyscraper. "Might as well be staying at a European hotel," I thought.

A radio in a hotel room was definitely not European in those days. I switched it on and got dance music. Dance music at 7:15 in the morning! The BBC did not believe in coddling us like that. It rationed out jazz with a first small helping at 5:15 P.M.

I stopped at a drugstore for a cup of coffee. A big fellow who had been tearing up the street with a pneumatic drill walked in and sat down next to a lady in a mink coat. In England this burly workman would have been called a "navvy" and the coffee break he was taking, his "elevenses." A navvy would sit on a pile of stones and eat his lunch from a greasy paper bag. He did not perch on a bar stool next to a lady in mink—but here was his American counterpart smearing mayonnaise on a fat turkey sandwich.

After I saw large Christmas trees blooming with tinsel on the streets, I thought, "Nothing else will surprise me." Then I came upon Rockefeller Center. Amid skyscrapers, couples waltzed to Strauss music, giving me the feeling I was in some Alpine resort. A skating rink in the heart of Manhattan! It hardly fit the European conception of Americans as interested solely in money.

Mr. Wilson Hicks, *Life*'s picture editor, asked me if I had any objections to flying. When I told him I did not, he handed me a yard-long plane ticket that would take me all over South America. With Christmas a week away, I asked to remain in the States for the holidays. Hicks's tone conveyed the urgency of my assignment, and I regretted the frivolity of my request.

Shown around the office, I watched a chap from the layout room trim a Christmas tree with photo-montages while Whistler's Mother, disguised as Santa Claus, perched on top. Admiring the tree, I nearly got run down by a writer on roller skates. One of the young secretaries in the picture department kept an aquarium with goldfish. The thought of working in such an atmosphere appealed to me. It was alien to anything I had known before. In Europe employees approached their work very much the way they lived: diffident to their superiors and according to the old maxim—What you don't like is good for you.

That night I peered down on New York from the Empire State Building. I looked at the *Bremen*, the ship I had arrived on and my link with Europe. It was only a speck in the immensity below. Blazing lights illuminated the night—a gaudy spectacle of contrasting colors accompanied by the sound of fire engines and police sirens, which echoed among the skyscrapers like banshees. I was in the presence of a colossus. In Europe any such colossus would have been a grim figure of brawn, steel, and guns. This one laughed, and I heard the rumble of his laughter come up from deep in the earth as the subways rushed by. Then I took a last look at the *Bremen*, as yet unaware it had brought another immigrant to America that morning.

(120) Actress and inveterate traveler Lillian Gish blew a kiss to friends as the Vienna-bound express pulled out of the station. For those who saw her off during that fateful summer of 1938, her kiss was a farewell to an era.

81

122

123

(121) *Loading coffee for the American market on a ship in Santos harbor, Brazil.*

(122) *Laborers on a coffee plantation in the state of São Paulo.*

(123) *Brazilian dictator, President Getulio Vargas, on Rio golf course.*

(124) *Futebol (soccer), Brazil's most popular sport.*

Brazil, 1939

83

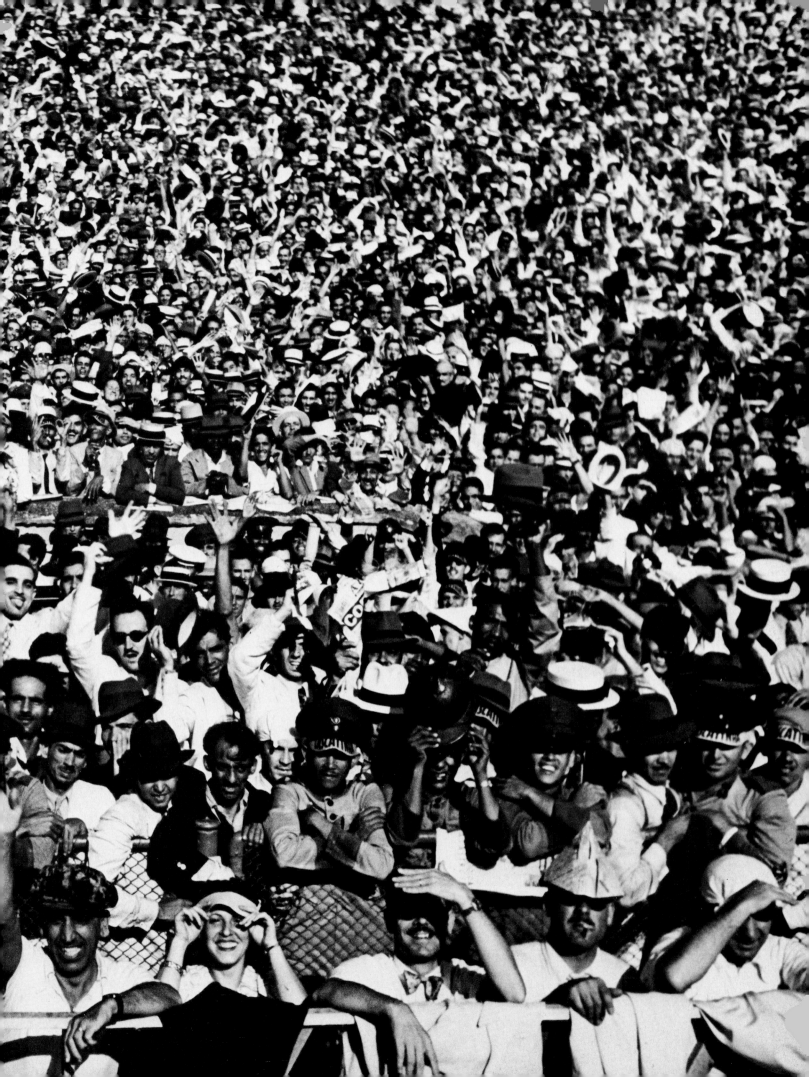

Argentina

I found that everything was bull in Argentina. It was impossible to escape the baby beef in Buenos Aires. He was on postage stamps. He crept into conversation and emerged sizzling on a platter. He was the justification for the Argentine's inherent dislike of Americans, who refused to import their beef. He was the soul and symbol of Argentina. The rich *estancieros* were probably the only wealthy class left which existed without benefit of stocks and bonds. They had nothing to do with industry and no regard for it. At the time I was there, in 1939, they were the *gente bien* of a four-class system that made Argentina the wealthy and self-satisfied country it was. The other classes were represented by the *peones* (descendants of the *gaucho*, who became an extinct species when the cattle were fenced in); the *porteno*, sole representative of the middle class in all of South America, whose habitat was Buenos Aires and whose entire career was bureaucratic; and lastly, the immigrants who worked hard and developed the country, when left to themselves. Argentines were frustrated that Nature had the poor taste to place them closer to the penguins of Antarctica than the Ritz in Paris. London they considered their spiritual home. I was warmly greeted on my arrival in Buenos Aires after it was learned that *Life* had picked me for the job because I was an Englishman. I was forgiven my connection with an American publication. "Americans are so vulgar," a

125

126

(125) *Champion short-horn bull was auctioned off for 10,000 pesos — a record sum — predicting 1939 would be a good year for sale of Argentine beef.*

(126) *Argentine army parading through Buenos Aires.*

(127) *President Roberto M. Ortiz and wife arriving for a gala performance at the Colon Opera House in Buenos Aires.*

wealthy Argentine said. "Whenever they mention a skyscraper they have to remind us it's the tallest in the world. We find that so ostentatious."

While I was there, the Spanish civil war was going on and the rich *estancieros*, worried about possible repercussions, were ardently pro-Franco. At a luncheon where several of us were foreigners, the subject came up when a Frenchman mildly remarked that the Republicans were the legal government there. "And what about their raping nuns?" the hostess demanded. "Why, that's an old Spanish custom," the Frenchman replied, adding, "remember Don Juan."

Argentina was a man's country. A society woman's life followed a well-regulated schedule. Sent to the fashionable Sacré-Coeur school, these women were taught that a man was the most perfect of creations. Married young, they went to live on the *estancia*. With nothing to do, they entertained, read, and went to lectures — the two latter activities producing the disastrous result that they realized their husbands were not the godlike creatures they had been brought up to believe. Visiting celebrities became the center of a social tug-of-war and usually ate free throughout their stay. But celebrities were sometimes ungrateful. An Argentine socialite got a shock when she gushed at a French writer, "You must admire my mind, *cher maître*," and he replied, "I assure you, madam, I don't aim so high."

Patagonia

128

(128) Sunken ship in the Strait of
Magellan.

129

(129) Sheepherding in Chile's Tierra del Fuego.

Assignment in the U.S.A.

130

(130) *Coney Island.*

(131) *Army Day in Chicago.*

I worked in the States for three and a half years. In 1940, not having seen my parents for eighteen months and learning that Mother was very ill in wartime England, I decided to bring them both over. It was not as simple as I had anticipated. On the one hand I had to guarantee the authorities I had a thousand dollars in the bank; on the other there was the ocean fare. My salary for the past two years had been paid in London, and I had turned over the entire amount to my father to be used for emergencies. Now that the money would come in handy to pay for the trip, I discovered my father had spent it all. I had to go to *Life* for a loan, most obligingly granted.

My parents landed in June. In marrying a British subject, Mother had taken on his nationality, so she had to register as an alien. By then she was so ill she could not leave the house. Still under the influence of European bureaucracy, I called the Alien Registration office and asked what documents I had to produce. "No need for any," I was told. "We'll send somebody over to your house. As your mother is ill, we'll always find her at home, so we don't have to tell you when we'll be coming." To me this was America—decency combined with common sense.

After Mother's death I put my father up at the hotel where I had stayed on arrival in the States. When I got his bill, I discovered he had spent more than I earned. "This can't go on," I said. "But I was so bored," he sighed.

132

133

During the years I worked in the States I shot 172 stories and got married twice. Through the kaleidoscope of pictures I took I got to see something of the country. Through my marriages I learned something of myself. After eight months in the vast and underpopulated countries of Latin America, I was less surprised by the size of the United States than impressed by how Americans had overcome the barriers of long-distance communication, a problem whose solution had eluded all other countries that were large enough to stretch across a continent. Americans had managed to create a sense of national unity—a feat the Russians have never achieved in spite of their centralized government. A striking picture in *Life* attracted the same attention from New York to San Francisco the week the issue appeared. Working in the States was much easier than working in Europe. Americans welcomed the *Life* photographer and allowed themselves to be photographed in poses Europeans would consider undignified. If you were a *Life* photographer in those days, you were considered the best in the world. There was a disadvantage, however. Each news agency cameraman blatantly duplicated whatever he saw a *Life* photographer shoot. Since the plagiarist's work appeared the next day, it frequently spoiled the story for the *Life* photographer. My defense was to overshoot banal pictures with a camera that had no film, then sneak whatever really interested me with another camera.

Because of *Life*'s prestige, American photographers were no longer looked down upon by reporters as they were in Europe. Of course there were exceptions. I can remember one preposterous occasion when I covered a Halloween party with a staff writer. After completing the assignment, I drove back to New York with one of the guests, the actress June Havoc. Unbeknown to me a rumor began circulating around the office that I had had an affair with her. The writer came thundering along, demanding to know if it was true.

"I only wish it were," I told him.

"I knew it," he exclaimed, "because if she was going to have an affair with anybody, it would have been me, the writer!"

In the States I finally got to meet colleagues I had known only by their work. The one photographer I knew up to then was Margaret Bourke-White, with whom I had worked in Europe. Maggie and her husband, Erskine Caldwell, invited me to see his play, *Tobacco Road.* Still accustomed to British ways, I showed up in black tie and felt a damn fool.

Carl Mydans invited me for lunch a few days after I arrived in New York. When he asked what struck me most about Americans, I said, "Their gruff kindness," explaining that I was very touchy about my accent. A day did not go by in England without someone asking about it in a tone that made me feel I should not be there.

"Here no one inquires about my accent," I said.

"You're absolutely right," Carl said. "I noticed your accent was Polish, but what the hell."

In Washington I met Tom McAvoy, *Life*'s White House photographer, and confided that I was eager to get a glimpse of President Roosevelt, who represented the last hope of the world to a European like me.

"That's easy," Tom said. "Wait outside the White House gates at two-thirty this afternoon."

I did. Out came a convertible with President and Mrs. Roosevelt. Wedged between the driver and a Secret Serviceman in the front seat was Tom McAvoy, who waved at me.

On President Roosevelt's birthday in 1941, I got a chance to observe the friendly irreverence of Americans when a number of parties were given at the larger Washington hotels to raise funds for the March of Dimes. Anna Sklepovich, a fourteen-year-old girl with the same birthday as the president, had written him mentioning they were both born on the same day. She had received the usual White House form letter bearing the president's signature. However, her letter had a postscript that invited her to come to Washington as Mr. Roosevelt's guest. Thinking it perfectly natural, Anna's parents put her on the bus for the four-hundred-mile trip to Washington. Realizing Anna had been the victim of a hoax after seeing

her letter, the White House guards notified the president's secretary. Mr. Roosevelt received Anna briefly and asked her to be his guest. Arrangements were made for Policewoman Rose Myrtle Richards to chaperone her, while Commissioner George Allen was to act as her escort.

Anna Sklepovich became my assignment. I followed her as she was taken to the Lincoln Memorial, the Washington Monument, Arlington Cemetery, and the Library of Congress—where she was impressed that blacks were allowed in the reading room. She visited Congressman John Kee of West Virginia, who gave her passes to the House and Senate, while his wife presented her with a black fur jacket. That evening, escorted by Commissioner Allen and trailed by two reporters and me, the "Cinderella Girl," as she had become known, toured the hotels where birthday celebrations were in progress. Introduced to the public at each stop, she steadily gained self-confidence. At the Wardman Park Hotel, where we wound up the evening, a stage had been set up for Mrs. Roosevelt, various celebrities, and a huge birthday cake. Deadpan as ever, Anna Sklepovich got the autographs of movie actresses Deanna Durbin and Lana Turner, then upstaged Turner by standing next to the First Lady while the birthday cake was being cut for the benefit of photographers. Back at the Mayflower by midnight, "Cinderella Girl" was matter-of-factly signing autographs herself. At nine the next morning, Anna Sklepovich boarded a bus back to Gary, West Virginia, and oblivion.

Being new to America often provided me with fresh insights on a story, but sometimes it led me astray. While photographing Joe Martin, the minority leader of the House, I thought I had a gastronomic scoop when he ordered ice cream with his apple pie. On my first trip to Atlanta, I sat in the back of the airport bus, much to the annoyance of the driver, who asked me to move up front. I refused. Being tall, I could stretch my legs where I was sitting. I sensed animosity but could not understand why. Finally a passenger more sophisticated than the rest broke the deadlock: "Can't you see he's a foreigner and doesn't know that nigras sit in the back of the bus?"

I missed an interesting picture but got a breath of Americana during some military maneuvers in 1940. Part of the exercise I was covering took us to Vicksburg, Mississippi. Having often heard the expression "like Grant took Vicksburg," I went to look at his statue. An American officer was gazing at it when I got there. "Not a bad picture," I thought, and was about to take one when he yelled, "Don't!," then stalked off before I could recover. A couple of days later in Shreveport, Louisiana, when I went to a bar I recognized the officer who had shouted at me. "You must think me rude," the colonel said. "Why, yes, sir," I replied. "Normally I'm not," he went on to say. "Have a drink with me and I'll tell you why I didn't want my picture taken. You see, Robert E. Lee was my grandfather."

I was assigned to cover "Wild" Bill Donovan while he organized a new government agency in Washington. Trailing behind him I went from the secretary of the navy to Archibald MacLeish at the Library of Congress and on to Nelson Rockefeller at his Department of Latin Affairs; I was present at business breakfasts and dinners and even photographed the installation of Colonel Donovan's first telephone in his new offices.

As I listened to what was being openly discussed I grew increasingly nervous. I was still enough of a European to be taken aback by the candor with which the colonel explained the tasks of his new agency. A memo from the Washington bureau confirmed my views. It noted that "the Donovan outfit will never make headlines." The outfit did, but much later. I had photographed Colonel Donovan organizing the OSS.

Not long after that I married a charming young nisei during my summer vacation. Our marriage did not last long. Peggy died of septicemia, a fatal illness in those days. Loneliness, I expect, got me to marry a husky Californian who could not abide Florida citrus in the house. In the five years of our marriage we spent only about six months together, as I was overseas most of the time. Foreign correspondents do not always make good husbands. I knew we were quits when she closed our joint bank account. I was now left, at thirty-one, with one suit and my father's bills.

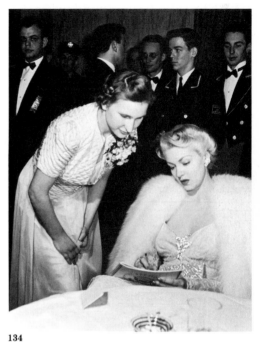

134

(132) Photographing Clyde Beatty's lion Atlas. When I found out Atlas had mauled Beatty, I asked, "Why did you let me get that close?" Replied Beatty, "Didn't you say you wanted to get a close-up?"

(133) Taking advantage of a free ballooning assignment, I learned how to navigate a balloon before I could drive a car.

(134) Anna Sklepovich got an autograph from Lana Turner.

The U.S.A.,
1939–1943

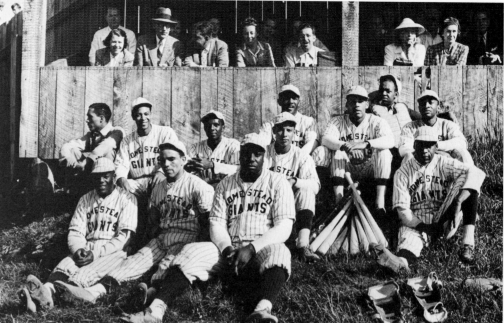

136

135

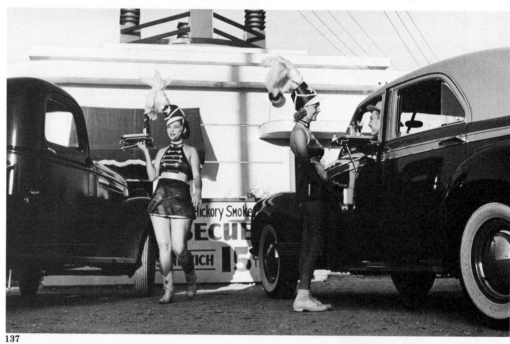

137

*(135) "A salesman has got to dream,
boy. It comes with the territory."
(Arthur Miller,* Death of a Salesman)

*(136) Homestead Hotel baseball team
in West Virginia.*

(137) Car hops, Corpus Christi, Texas.

(138) Doing the Lindy Hop.

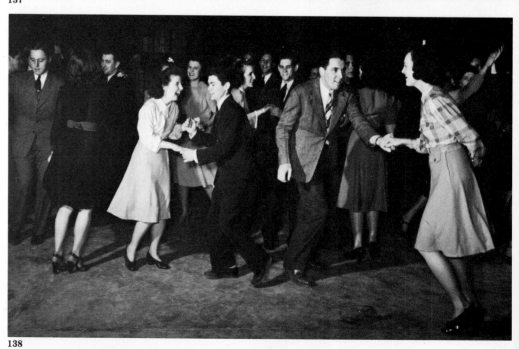

138

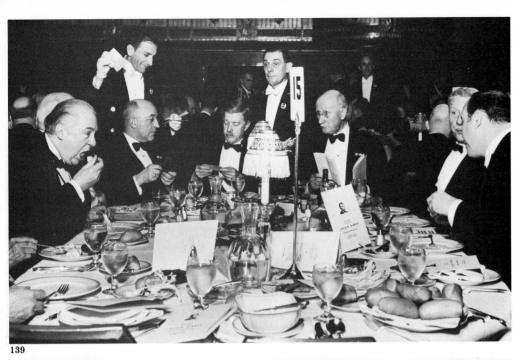

139

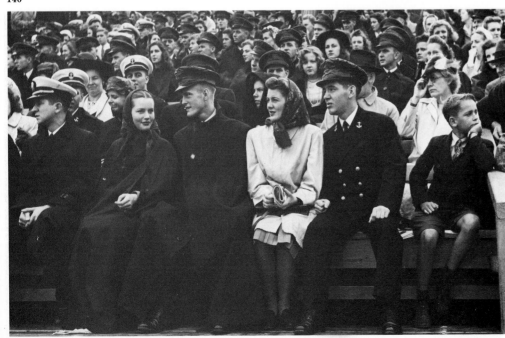

140

141

142

(139) *Lincoln's Day dinner at the Waldorf.*

(140) *The Peters sisters at a Harlem film premiere.*

(141) *Football game at Annapolis.*

(142) *Seniors' "cube" at Lawrenceville prep school.*

95

143

144

145

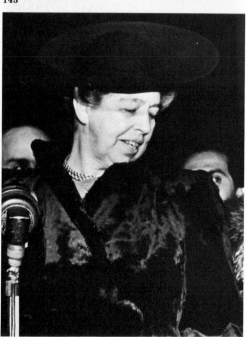

146

147

Roosevelt's Third-Term Draft

(143) The president's men who worked on his draft: Harry Hopkins (left) conferred with Ed Kelly, mayor of Chicago. (144) Postmaster General James A. Farley (right) listened dubiously to Senator Pitman. (145) Senator Jimmy L. Byrnes (left) got the glad hand from Arkansas governor Bailey. (146) F.D.R.'s most effective campaigner was Mrs. Eleanor Roosevelt. (147) The president's portrait not only adorned convention hall, but was on display in Chicago stores (148).

I was assigned to cover the 1940 Democratic convention in Chicago with Will Lang, *Life*'s Washington bureau chief. Roosevelt was expected to run for a third term and break with the tradition of a two-term presidency. With the star of the show in Washington, all we could get were pictures of Roosevelt's men preparing the "third-term draft." Harry Hopkins directed the operation from his hotel suite with a direct line to the White House. My assignment was to get a shot of the idealistic Hopkins and Boss Kelly, the mayor of Chicago. Obviously Harry Hopkins did not want such a picture taken and I never saw the mayor, although he operated out of an adjoining room. I had been in and out of the Hopkins suite for several days when he got a call he must have deemed so important he forgot all about my being there and called in Boss Kelly. I got my picture, but the flash reminded Hopkins of my presence. He turned to me and said curtly, "I think you'd better leave now." Off I went. Lang notified New York I had the picture the magazine wanted, while I caught the first plane back to New York, went straight to the lab, left my films to be processed, and went home. An hour later I got a frantic call: the Hopkins-Kelly picture was missing. Missing! I called Will Lang in Chicago, who went to see if I had forgotten the film in my hotel room. By chance it was still vacant and had not been cleaned. On the bed was my missing roll of film.

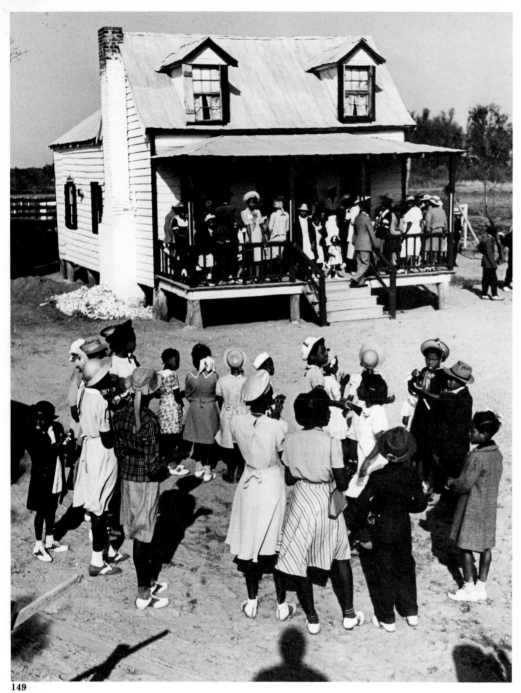

149

Black Wedding in
the South

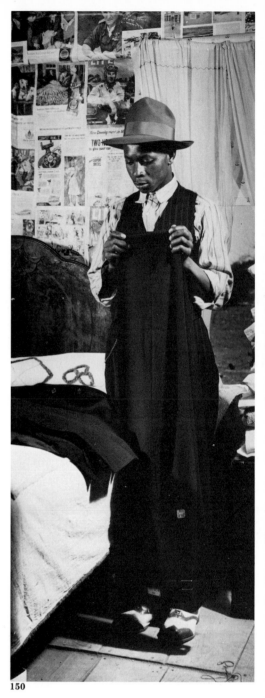

150

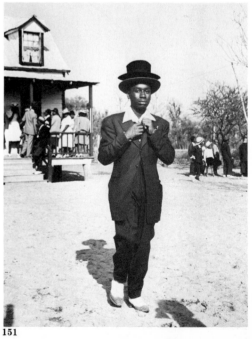

151

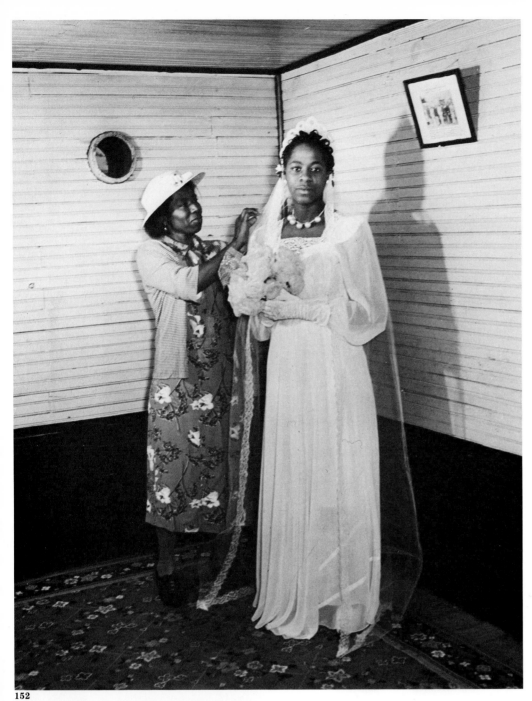

(149) Wedding guests outside the bride's home.

(150) The groom getting dressed for the wedding.

(151) The arrival of a youthful guest.

(152) Mother gave the last touches to her daughter's wedding dress.

(153) The official wedding picture.

(154) Newlyweds leaving for their honeymoon.

(155) Association of Machinists float on Defense Day, Birmingham, Alabama, 1940.

152

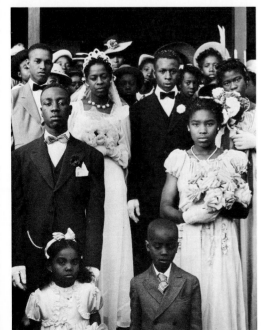

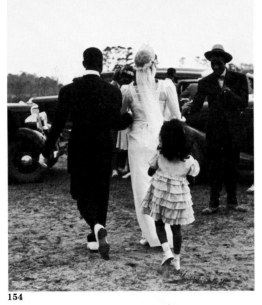

153

154

156

159

157

158

Fund-Raising Was Fun

(156) Bourbon prince balancing a soup bowl on his head at China Relief party in New York.

(157) Mimi Sagan won first prize for most original costume at a chic Boston scrap iron party.

(158) The "HOOPLA" booth at an RAF benefit given at La Guardia Airport.

(159) John D. Rockefeller III with Mrs. Dwight Morrow at China Relief party.

(160) Gypsy Rose Lee stripped for Britain during a star-spangled benefit at the Astor.

Photographers frequently get ripped off by having their photographs reproduced without permission; occasionally they do find out. I did in Wroclaw. Once the city of Breslau in German Silesia, it was turned over to Poland as a result of the Potsdam Conference in July 1945. Soon after, I was driving down a wide avenue there lined with stolid four-story stone façades covered with creepers. It was all reassuringly residential and well-to-do. However, there was something uncanny about the silent and deserted streets. I stopped to find out what was so unsettling and discovered the buildings were roofless shells. The doors were wide open. I walked up the stairs of one of the houses. Little had survived. The stuffing from slashed mattresses spilled out like guts; tattered books and piles of magazines were strewn across the floor. Fishing around with the tip of my boot, I uncovered a paperback, the title of which was *U.S.A. Nackt.* The cover picture was one I had taken of Gypsy Rose Lee stripping at a benefit for Britain some five years earlier. Turning the pages I came across a picture of an RAF benefit party I had also taken. The last photograph in this Nazi exposé on American decadence was one I had taken of Charles Lindbergh while he was addressing an Isolationist meeting. The only American in the book treated with respect, he was quoted as saying: "The Americans exceed the Germans in anti-Semitism because they are more violent."

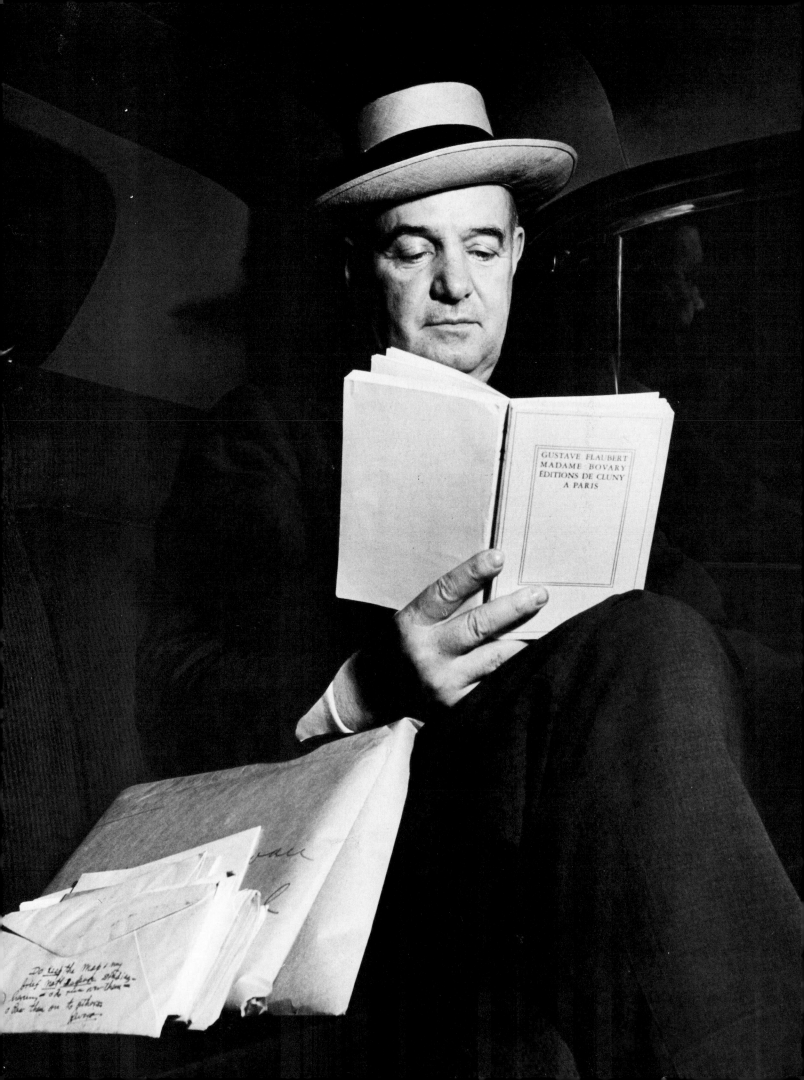

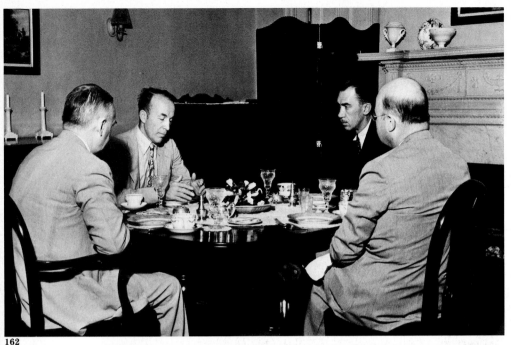

162

Birth of the OSS

163

164

(161) On his way to the office, Colonel William J. Donovan appeared to be reading Madame Bovary *in French, a language he was unfamiliar with, to deceive the enemy in the event of publication of the photograph.*

(162) Working breakfast at Donovan's Georgetown home: Donovan (left), Archibald MacLeish, the Librarian of Congress, Robert Sherwood, playwright, and (far right) Donovan's deputy.

(163) Donovan with Nelson Rockefeller, head of the Office of Inter-American Activities.

(164) Donovan presiding at a conference in the Executive Office Building.

Patton on the Chattahoochee

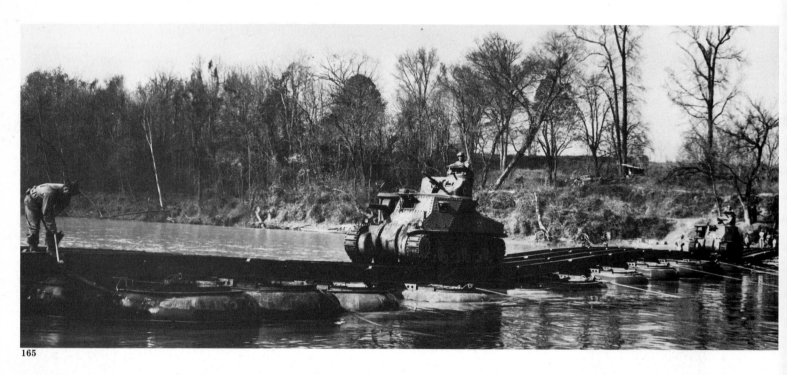

165

(165) *The Engineer Corps testing a newly devised type of pontoon bridge, which General George S. Patton was to make brilliant use of when he established a bridgehead across the Rhine.*

(166) *With obvious satisfaction, General Patton watches the bridging of Georgia's Chattahoochee River.*

Late in 1941 I went down to Fort Benning, Georgia, to photograph a new type of pontoon bridge devised by the army engineer corps. "You must know," the conducting officer told me, "the U.S. army boasts the best bridge-building techniques in the world." To demonstrate, the army engineers bridged the 315-foot Chattahoochee River for me. It took a little over two hours from inflation of the first rubber pontoon to assembly of the last treadway section before a twenty-eight-ton tank rumbled across the bridge. Aside from the speed with which the pontoon bridge could be put into operation, it could be built quickly, cheaply, and had a great load-bearing capacity. Its compact sections were easily transported by ordinary truck convoy. Best of all, its few simple parts could be concealed easily in transit. While shooting, I had observed an officer in the distance. He was following every phase of the operation with keen interest and apparent satisfaction. Although I had no idea who he was or his rank, I took his picture. He presented the perfect image of a military man. I then went up to him and asked his name. "Patton," he said.

On March 22, 1945, General George S. Patton reached the Rhine. With him was the pontoon bridge equipment. In a brilliant surprise assault, he established a bridgehead. Within forty-eight hours Patton had moved four divisions across the Rhine and was on German soil.

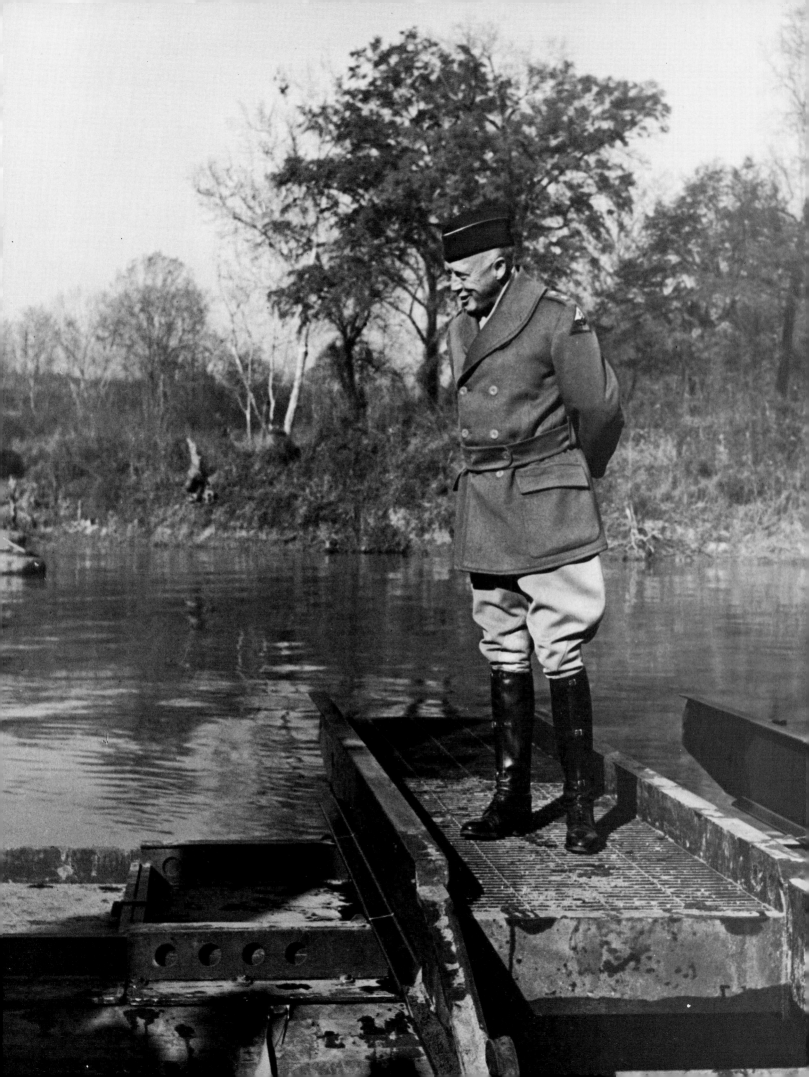

Warriors and Pacifists

(167) A determined isolationist at an America First rally in New York, 1941.

(168) Mascot of the Fifth Artillery Regiment leashed to howitzer.

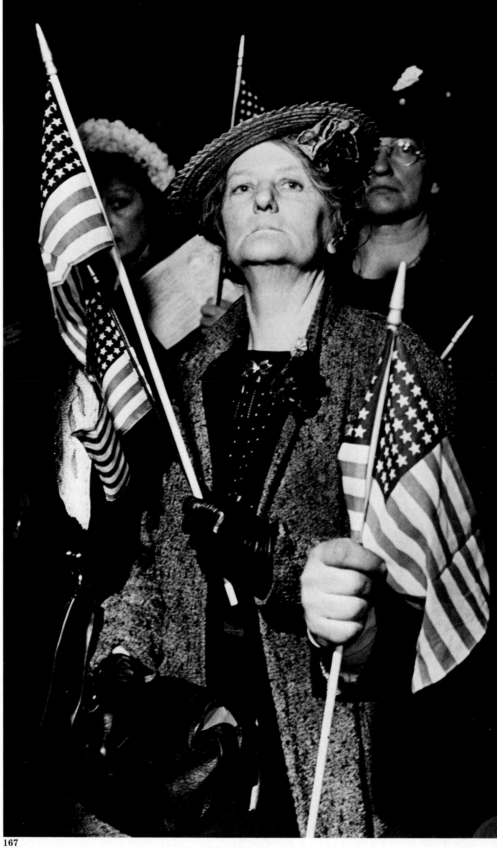

167

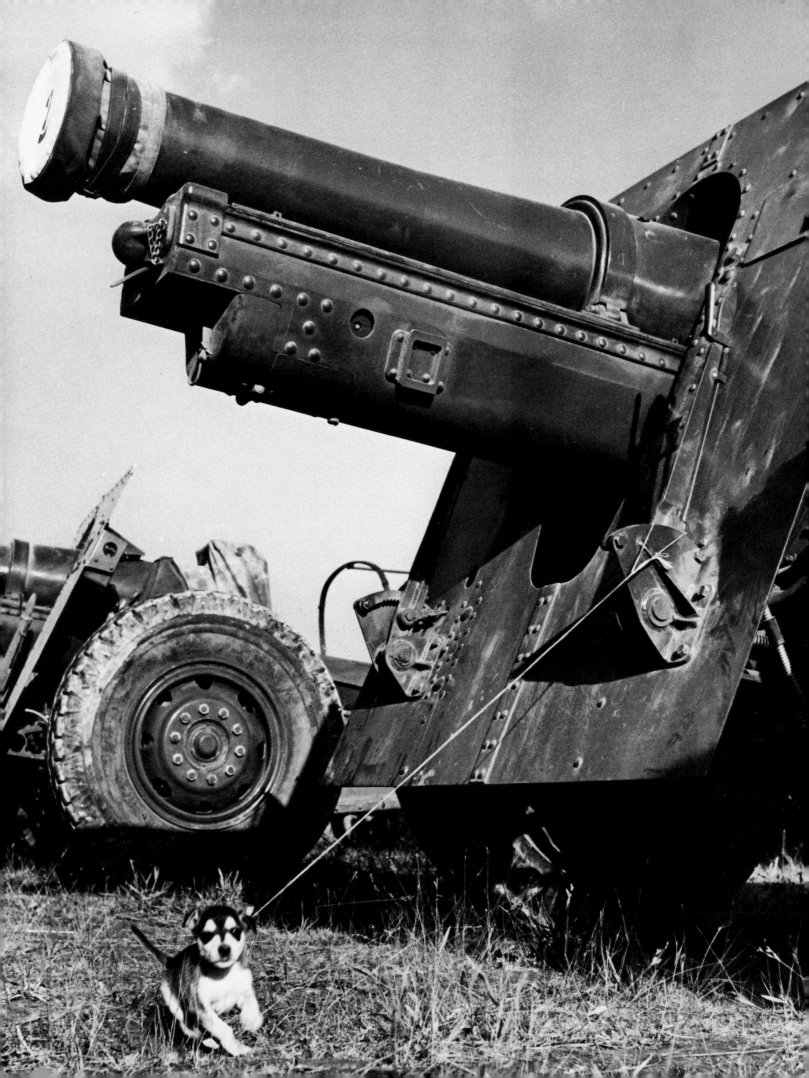

Seventy Days to Cairo

The Dutch freighter M.S. *Tabian* sailed out of New York on March 8, 1943, bound for Egypt. As the Straits of Gibraltar were still closed to Allied shipping and the east coast of South America was infested with U-boats, the *Tabian* had to go through the Panama Canal, along the west coast of South America, around the Horn, the Cape of Good Hope, and into the Red Sea before reaching its destination—Port Taufiq, Egypt. The journey took seventy days. We were twenty-five passengers: a team of ten field officers in charge of civil affairs in occupied areas (whose mission—their commanding officer was indiscreet enough to tell me—would be the administration of Italy after the Allies invaded that country); two captains, archaeologists in civilian life, with the OSS; nine lieutenants specializing in radio communication; Rabbi Bension, going home to his wife in Haifa; Mr. Russell, a Presbyterian missionary returning to Ethiopia; a Lend Lease official en route to Teheran; and I, on my way to Cairo to cover the final stages of Montgomery's western desert campaign.

Our backgrounds varied, from Lieutenant Young, who asked why no ice cream was served with the *boeuf à la mode,* to Colonel Weber, a San Antonio judge who explained to me that what was regarded as lawful or unlawful was simply a matter of the moment. "In 1925," he told me, "you could own a thousand gold coins, but buying a fifth of bourbon was a federal offense. Today you can stock a thousand gallons of bourbon, but owning one gold coin is a crime."

For all our differences we did have one thing in common—a shared apprehension. The *Tabian* was a munitions ship loaded down with eight thousand tons of high explosives. "The enemy," Lieutenant Frank Pickard, in command of the armed guards, warned us, "is the German U-boat." He instructed us to be on the lookout for periscopes.

"What do they look like?" I asked.

"To be honest," Lieutenant Pickard said, "I've never seen one myself, but if you notice something that resembles a glass watermelon floating around, you're in the ball park."

The day we boarded ship, our skipper, Captain Prinse, informed us: "If you're torpedoed on a munitions ship it's all over in three seconds." We were being issued life jackets at the time. "They'll come in handy on chilly nights," he added, "but what you really need are parachutes."

Unlike other vessels, where boat drill was taken seriously, we did not hold one until we were more than three weeks at sea, and then only because of regulations. It was during this drill that Lieutenant Young pointed out "the nervous gunner" to me. "Just tap him on the shoulder while he's asleep," he said, "and he's up the companionway before he opens his eyes."

The gunner had been on the Murmansk run transporting war materials to Russia. He had been on watch when a munitions ship in his convoy was torpedoed. As he put it: "One minute it was there. Then all of a sudden there was a huge ball of fire. Then there was nothing. And you have no idea how nothing nothing can be."

The *Tabian* had not been designed for twenty-five passengers. The deck was cluttered with heavy-duty equipment, which I continually stumbled over in the blackout. The ward room could accommodate only half of us at mealtimes. Our living quarters were even more cramped—the rabbi, the missionary, the Lend Lease official, the two captains, and I shared a cabin intended for two. We simply had to find ways to kill time. On alternating Sundays Rabbi Bension and Mr. Russell held nondenominational services at which hymns typed out on flimsy pink paper by the missionary were sung. I gave French lessons daily and wrote skits along with the two captains, who turned out bawdy lyrics for the shows we put on. When we crossed the equator I photographed a "*Life* Goes to a Party" story. It never ran. (When I saw the pictures twenty-five years later, I understood why. The fact that they were shot on a munitions ship in wartime did not come through at all—a good example of how the tensions we were living under could be better expressed in words than pictures. If there is no action, you have no story. If there is, you have no photographer.)

At Guantánamo our convoy was cleared in seventeen hours. We reached the Canal Zone under a bright full moon. Unable to seek the shelter of the

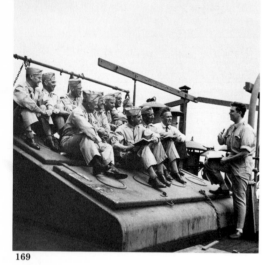

169

(169) I gave French lessons to a group of American officers aboard a munitions ship bound for Egypt.

port of Colon because the mine fields were activated at night, the entire convoy took antisubmarine action by circling round and round, as a U-boat pack was reported in the area. I spent much of that night on the upper deck listening to a Civil Affairs major, the financial expert of the group. He had got hold of the three bottles of sacramental wine the Catholic Church put on board every ship and drank them on his own. That night he told me about his financial activities with Joseph P. Kennedy, with whom he had had business dealings. His candor was embarrassing. As I listened I realized he was not talking to me but making confession. He must have thought he was going to die that night. As we went through the canal next morning, he sheepishly avoided me.

We could not smoke on deck at night so instead crowded into the ward room until a blue haze made our eyes sting. The only place to find privacy was the toilet, bathed in its ghostly blackout light. Our cabin could hold the six of us only when we were all in our bunks. Mine was the top one on the upper left, a foot beneath the bulkhead. Every night I slept in that bunk I had the recurring thought: "What if we're torpedoed?" Lying on my back as the ship pitched and rolled in the dark, I ran my fingers over the rough surface of the bulkhead and wondered whether I would end up splattered against it or, as I hoped, it would blow apart before I shot through. I could not forget the captain's words—"It'll all be over in three seconds"—and imagined the crunch of the torpedo as it struck the ship and saying, "This is it!" We must have been at sea a month before it dawned on me that I had always taken it for granted I would be aware of being torpedoed. I had never imagined dying without being aware of it. That I could be snuffed out that way was hard to accept. The discovery must have affected me because I do not think I have been quite the same since.

In wartime one's sense of values changes. I stole a cat. Our chief electrician was a bore, endlessly telling pointless jokes. One evening I jumped all over him. He blinked at me and said, "Be patient with me. I'm half blind, I can't swim, and I'm stuck on this boat." I felt awful about the way I had acted. Later the electrician's small pregnant alley cat died. The electrician was inconsolable all the way to Capetown, where we anchored next to a freighter. Perched on a capstan was a proud tabby. No one was around so I sneaked on board, grabbed the cat, and put him in the electrician's cabin. (Only now has it occurred to me that I stole someone's pet.)

Two days before we reached Aden where Mr. Russell, the Presbyterian minister, was to leave, a group of us decided to do something for this man whom we had all grown to respect. When I had first asked him what a missionary was doing on a munitions ship, he had said, "Ethiopia's heathens are in bad need of help." I had put Mr. Russell down as one of those devout souls I would never understand. On first meeting I had felt much closer to the down-to-earth rabbi. By the time we reached Aden Mr. Russell had shown himself to be such a good sport we decided to show our appreciation by holding an auction to raise money for his mission. As we had nothing of value, we auctioned off the hymns he had typed up for us on flimsy pink paper. The captain affixed the ship's seal and we all signed each copy. By methods Mr. Russell would certainly not have approved of, we raised $125. "A body blow to Satan" was what he called it. When I saw him off at Aden, he offered me a drink. Knowing he was abstemious, I said I would have a lemon squash. Mr. Russell ordered me a large gin. "I don't think it will hurt you," he said.

When we dropped anchor at Port Taufiq, the officer who came aboard told us we had not been expected, the German radio having reported the *Tabian* had been sunk, a rumor probably based on our having been chased by a U-boat off Durban. The explosives destined for "Monty's" Eighth Army which we had been sitting on top of for seventy days were no longer needed. Montgomery was in Tunis and I was without an assignment.

I must have been under a greater strain than I realized. After getting hold of a bottle of Scotch I did not even bother to open it but simply held it over my head so that one of the blades of the slow-turning tropical fan sliced off the neck. Then I poured myself a large tumbler without even thinking about the dangers of swallowing broken glass.

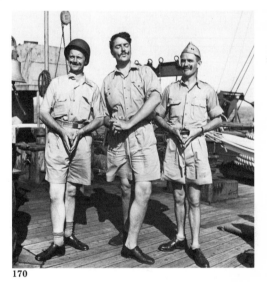

170

(170) Captain James H. Oliver (left), assistant professor of ancient history at Columbia in civilian life, Captain John D. Daniel, assistant curator at Philadelphia Museum, and I (center) singing "Why don't they do it at Harvard the way they do it at Yale" during a skit aboard the munitions ship.

(171) On arrival in Egypt, the American Military Government team assigned to Italy had their pictures taken in front of the Sphinx and the great pyramid of Cheops.

111

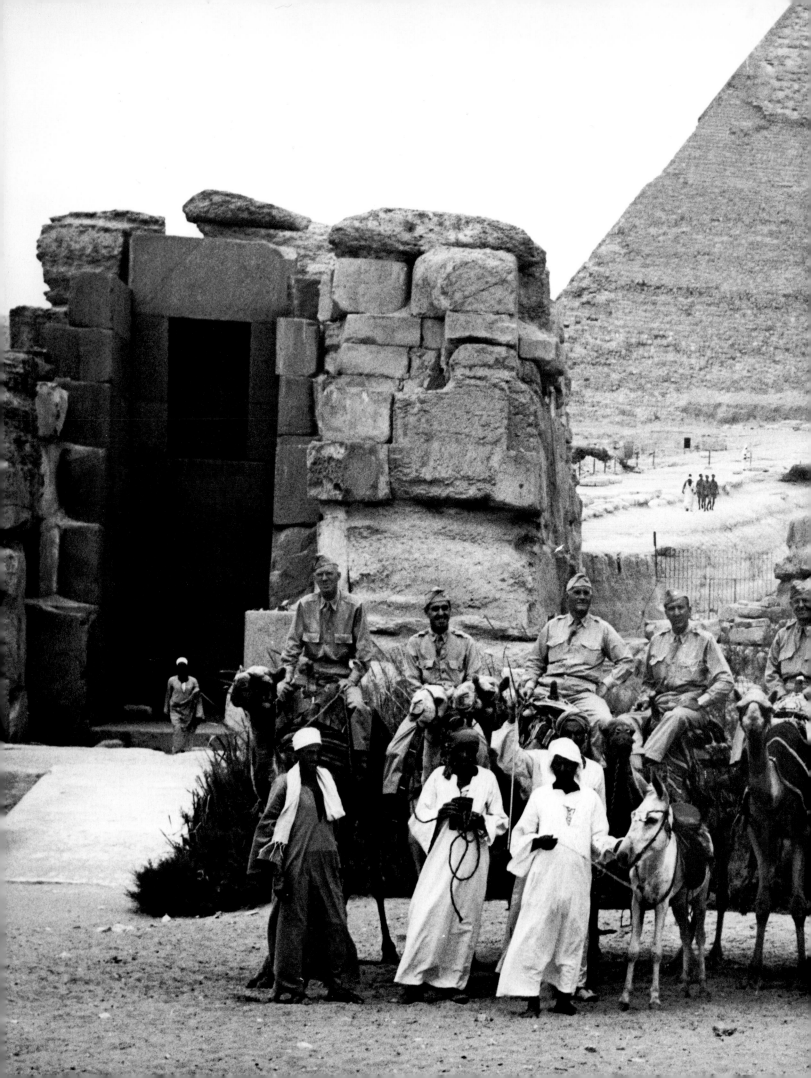

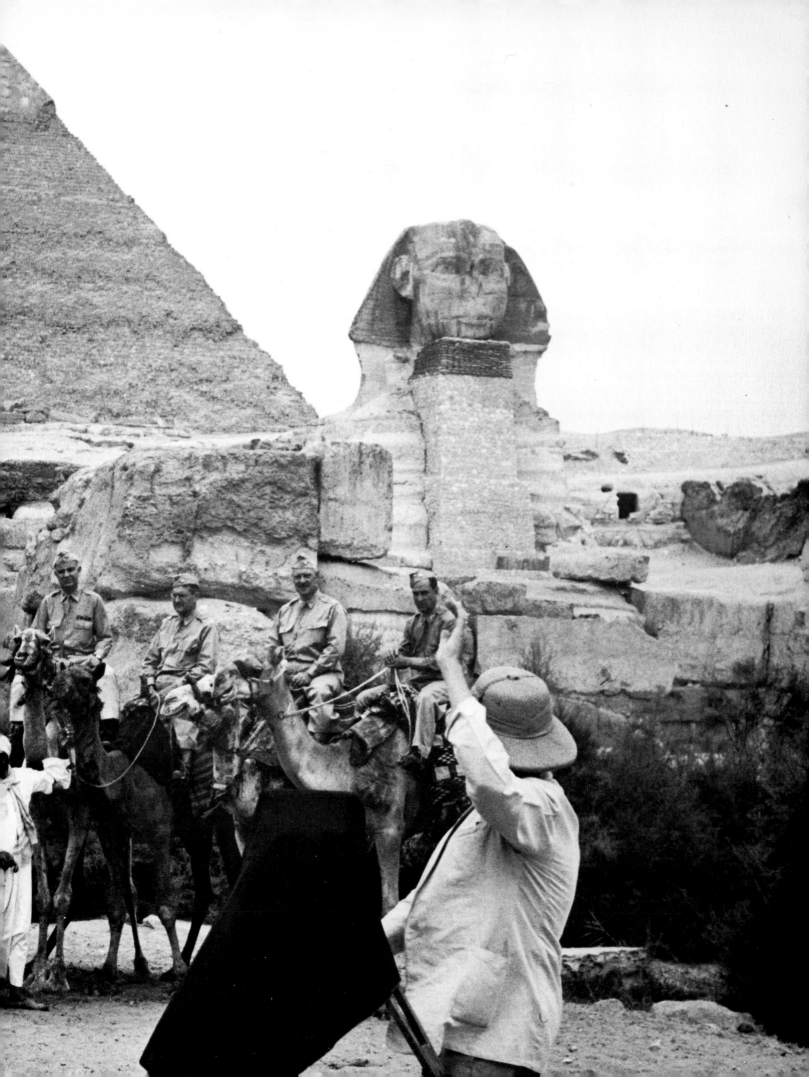

The Middle East in 1943

173

172

174

(172) Reading the Palestine Post *while floating in the Dead Sea.*

(173) Arab sweeping a desert highway leading to Damascus.

(174) Syrian shopkeeper napping in his store on "Street called Straight," the Damascus souk.

(175) Two urchins running up Sharia Gazi street in the town of Deir-ez-Zor, Syria, to go for a swim in the Euphrates River. Twenty-liter gasoline cans were used as water wings.

I reached Cairo in the spring of 1943. By then the Nazi threat to the Middle East was at an end and the British colonials could sigh with relief. Suez was safe. The Egyptians no longer expressed pro-Axis sentiments—at least not openly. Due to severe censorship and the British army, Palestine was still manageable. The colonials were disgruntled, however. The Atlantic Charter had "developed foolish notions among the Moslems and encouraged talk of pan-Arabism." An old Middle East hand complained to me: "It was naughty of Roosevelt to insist on the Atlantic Charter. All that rot about self-determination simply won't work here, old boy."

The British foreign secretary, Anthony Eden, felt the need to state: "His Majesty's government will view with sympathy any movement among Arabs to promote an economic, cultural and political unity." Arab sovereignty, I noticed, was not mentioned, hardly surprising in light of the British and French having reneged on promises to recognize Arab independence after the previous world war. The French found themselves putting down rebellions while the British inherited the Palestine problem. The colonials' "sympathetic" view toward the Arabs was a gambit in order to play the field and curtail any Arab ambitions of sovereignty. "*Les Anglais* are scheming to take Syria and Lebanon away from us," a French officer said to me.

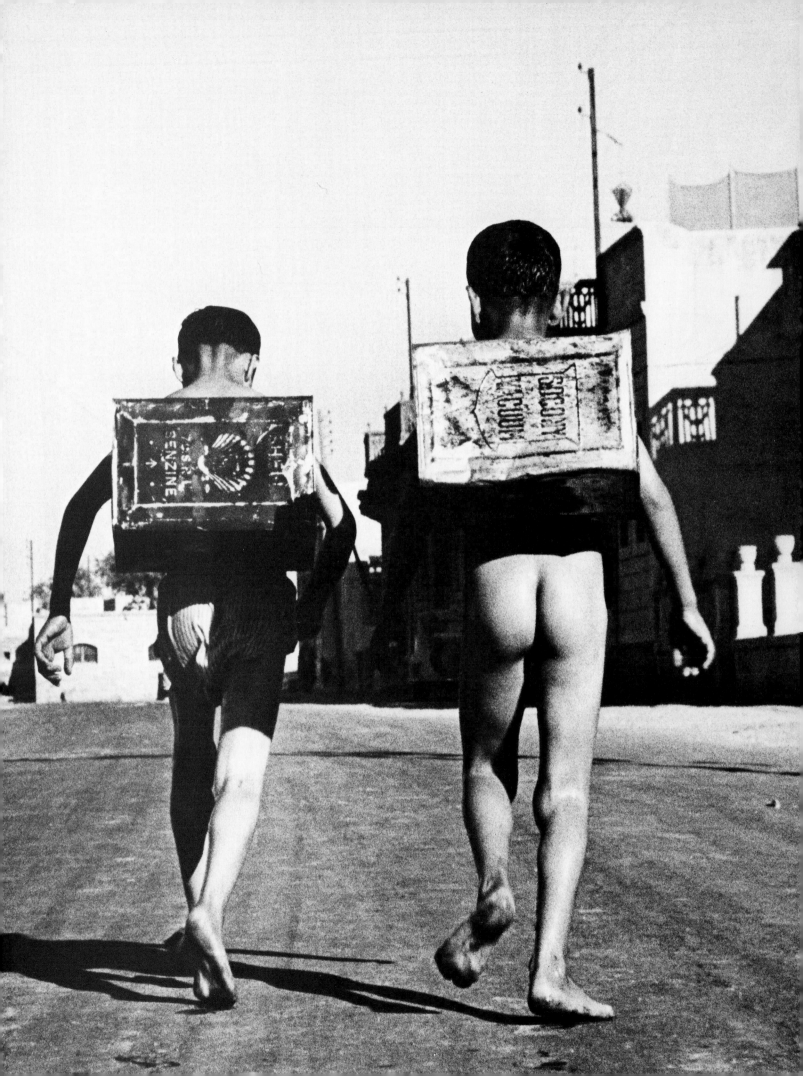

They were actually in a position to do it, having had troops in Syria since 1941 when they defeated the Vichy French who were letting the Germans take over Syria's airfields. What made the French suspicious were the activities of the Spears mission. I felt that French suspicions might well be justified after meeting Major General Sir Edward Spears, a personal friend of Winston Churchill's and a director of thirty British corporations, who had assumed military and diplomatic control over the Levant. Sir Edward looked quite capable of taking over Syria and Lebanon.

The French were not the only ones suspicious of Sir Edward's motives. An anonymous member of his own mission—in that typically English way of expressing criticism through a ditty—composed the following:

An Empire once,
A Caliphate,
A Satrapy,
A See,
A Kingdom and a Sultanate
Each and successively.
Syria—
Is simply now the thirty-first
Directorate of Spears.

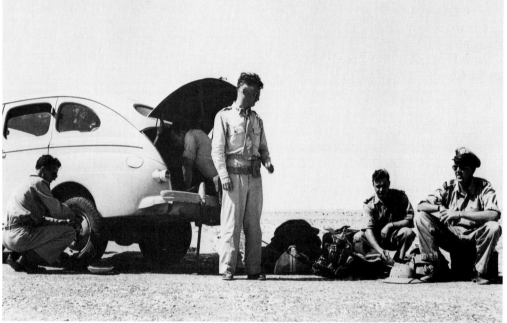

176

The French were also disturbed to see Syrian tribesmen serving in the British army and marching to a new tune, the lyrics of which translated as follows:

May ye be permanent, ye strongest of kings
May ye be victorious, ye whom the troops adore,
You are the guardian of democracy, hence the sword of God.
May ye be permanent, King George,
Ye guardian of the country.

This proselytizing was the work of an old friend of mine, Colonel William F. Sterling, once chief of staff to Lawrence of Arabia. Sterling was organizing another Arab revolt, this time against the French, and was considered by them to be a British agent. Though Sterling was ostensibly a foreign correspondent, I never knew whether the dispatches he filed were for the general public or a more selective audience. I do know that he was the best-informed man in Syria. In any case, he was having trouble with "them." "They" wanted him back home and, according to his wife, Marigold, "they" had no gratitude for services rendered. Marigold was a delightful eccentric. When I went to dinner at the Sterlings' during Lent I brought along a bottle of gin, her preference. "I've given up gin for Lent, dear," she told me. "I drink only brandy now."

The crisis in the Levant came to a head in the summer of 1943 after the presidential elections in Lebanon. They would trigger an unrest still felt today. Recently, as I was looking over one of my stories which appeared in the November 22, 1943, issue of *Life*, I noticed the headline was: "TROUBLE IN THE MIDEAST — Syria Simmers as Lebanon Boils."

The British candidate for the presidency in the Lebanese election was Bechara el-Khoury. To no one's surprise he defeated the French candidate. El-Khoury declared the French Mandate at an end. In response, the French military arrested him. A press conference was promptly called in Cairo. Correspondents were told that the Lebanese president had been arrested "by Senegalese." Violence was also suggested. This was neither an official handout nor a communiqué, we were told — it was merely for our edification. For once, Cairo's political censorship was broad-minded. Everything the correspondents filed was passed immediately. The mention of the president's arrest by Senegalese raised loud protests abroad. The French general's denial that he had used Senegalese went unnoticed. Exaggerated versions of the riots and casualties piled up. British censorship in Palestine denounced French censorship in Lebanon. Arab demonstrations took place in Cairo. It was a touching spectacle to see Moslem Arabs so upset over the fate of Christian Arabs.

"You can always find a mob willing to break windows," an Egyptian diplomat claimed. "It's simply a matter of a few pounds plus carfare."

The crisis was temporarily halted by Sir Edward Spears and George Wadsworth, the American diplomatic agent. They asked the French to release and reinstate the Lebanese president. Soon after, Syria declared its desire for independence. "The British," a Frenchman said, "always want to be the referees in a conflict where they have a direct interest."

If the British colonials believed that the Levant would be moving within their orbit, they were mistaken. France's loss of the Levant had simply started the countdown on the foreclosure of the Palestinian Mandate.

I traveled about Syria and Lebanon during this crisis. While in northeastern Syria near the Euphrates, our staff car broke down. Harry Zinder of *Time*, our British conducting officer, and I were stranded in the desert until the French found us and put us up at an army camp. With our luggage back in Aleppo, a barber was produced the next morning to give us a shave. Zinder went first. He had a peculiar look when he arose from his chair and made way for the conducting officer. When my turn came I noticed the other two exchanging glances. The barber's cutthroat razor swept across my face and throat in broad strokes. It was the fastest and most unpleasant shave the three of us ever had and I said as much to a French sergeant. "I suppose the barber was nervous," he said, and shrugged. "He's about to be executed, but I thought in the meantime he could still be useful."

British officialdom in Cairo did not restrict its activities to the Middle East. It also tried to exert its authority in occupied Greece and Yugoslavia by backing pro-monarchy forces with the view of reestablishing monarchs sympathetic to England once the war was over. The symbol of this officialdom in the Middle East was the British ambassador, Lord Killearn — Tweedledee to Sir Edward Spears's Tweedledum. While walking along a crowded Cairo Street, I once had occasion to see Lord Killearn perform. The shrilly persistent sound of a car horn rose above the Oriental street din. A yellow Rolls-Royce with massive headlights and two large Union Jacks flapping from both mudguards roared past, escorted by outriders on motorcycles. Lord Killearn was on official business. Still a British subject — although an American correspondent — I was embarrassed by this Victorian display of power. That no longer impressed the natives.

The censor's office use of power was much more subtle and effective, as I found out at my own expense. On hearing that Colonel Vladimir Dedijer, a member of the first partisan mission to come out of Yugoslavia, was recovering from head wounds at the British military hospital, I sneaked in to see him. Vlado Dedijer impressed me by the sincere way he talked about the partisan war. When I showed up at the censor's office with the Dedijer pictures, the censor said amiably, "You do get around, Phillips." Then he put a stop on my pictures.

177

(176) Time *colleague, conducting officer, and I, stranded in Syrian desert.*

(177) Riding a camel in the Roman ruins of Palmyra, Syria.

117

Syria and Lebanon

178

(178) *The most powerful man in Lebanon was Mar Antoun Arida, Greek Orthodox Maronite Patriarch of Antioch and the Orient, in his summer residence, the monastery at Diman. At left is his bodyguard and on right his secretary.*

(179) *The second most important man in Lebanon was Moslem leader Mufti Toufik Kaled, a longstanding opponent of the Maronite Patriarch. Within forty years, enmity between Christian and Moslem Arabs would reduce Beirut — once a Mideast Monte Carlo and banking center — to a no-man's-land.*

(180) *Newly elected Syrian president Sukri Bey Kuwatly making his maiden speech in August 1943. Main points: Syrian independence from France and alliance with other Arab states. The inscription above him reads: "Affairs shall be arranged by consultations among ourselves."*

179

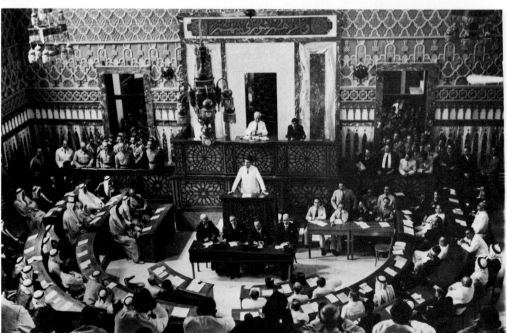

180

181

(181) Lieutenant Pierre Courquet saluted by Mehariste (Camel Corps) honor guard while leaving French desert post in Syria.

(182) Pro-British Sheik Hammaudi (left), a friend of Lawrence of Arabia and crony of Colonel William F. Sterling (right), whom the French accused of fomenting an Arab revolt against them.

(183) Major Virgil A. Jackson, U.S. military attaché to Syria and Lebanon, showed a Garand rifle to Emir Fawas Shalaan, leader of Syria's largest Bedouin tribe, which numbered 500,000, including slaves. Shalaan's annual income, collected from tribesmen, was $750,000.

182

183

119

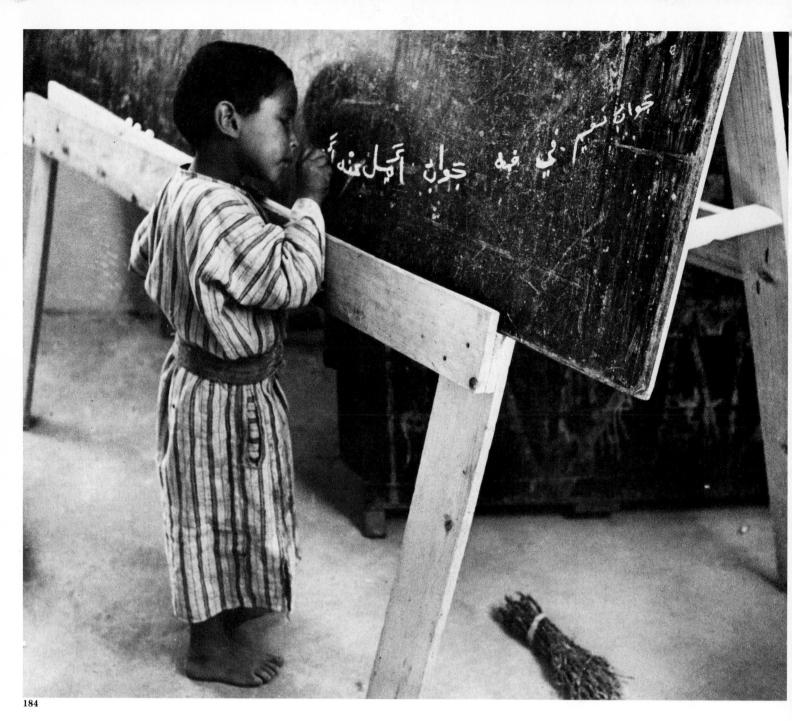

Palestine

Palestine in 1943 felt just like home. I had grown up among Arabs and Jews and had an affinity for both. My Algerian upbringing had taught me what it was like to be a minority. The only English boy in a school of over six hundred, I knew how lonely it could be when your classmates gang up on you for what "perfidious Albion" did to Joan of Arc and Napoleon Bonaparte. The result had been a broken nose and a lifelong sympathy for minorities. In Algeria, as in Palestine, the pattern of hate was similar. Although the French looked down on the Arabs, they were in hearty agreement with them when it came to the Jews. The same held true in Palestine. The origins of the modern Palestine problem, which has plagued the world for so many years, dates back to the Ottoman Empire's decision to side with Germany in World War I. British strategists in Cairo decided that the quickest way to knock "The Turk" out of the war was to encourage the Arabs under Turkish rule to revolt by promising them independence. In 1917, in recognition of Dr. Chaim Weizmann's contribution to the war effort, Arthur Balfour, the British foreign secretary, promised a national home for the Jews in Palestine. Overriding these two idealistic but loosely worded promises, the French and British made a secret agreement to keep the Turkish provinces for themselves. The Arabs and Jews, in today's terminology, had been double-crossed. But by the Victorian criteria that

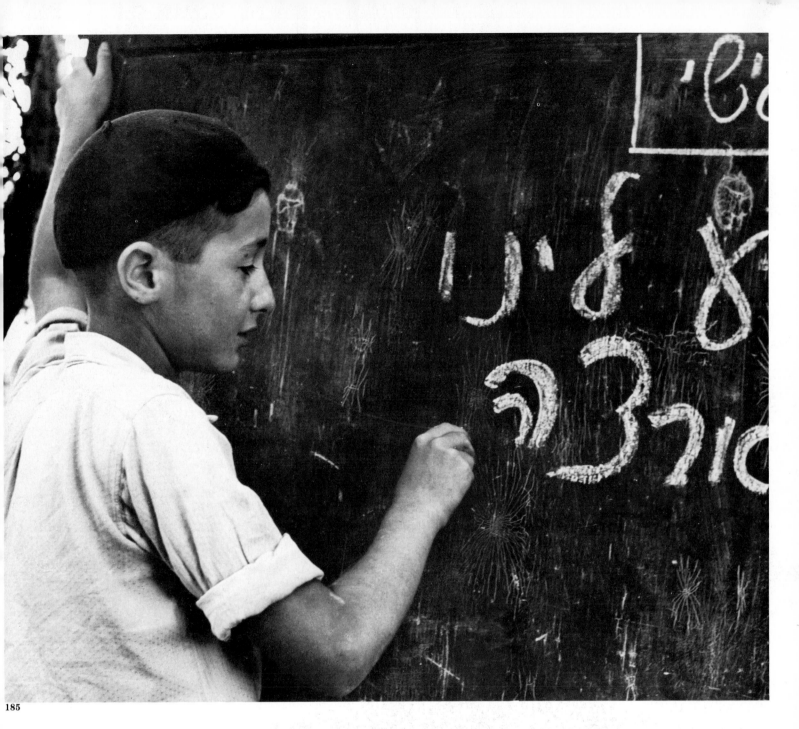

185

guided colonial England, this deception was considered legitimate, since performed for King and Country. By the early thirties there was such violence in Palestine that it required a world war to keep the peace there.

While traveling around the country I ran into the last person I expected to find in Palestine—Polish prime minister Slawoj Skladkowski. After Hitler overran Poland, Skladkowski escaped and had to seek asylum abroad, which explains how it came about that the prime minister of the most anti-Semitic country in Europe became a refugee in Tel Aviv. "I'm learning Hebrew so that I can become an air raid warden," Skladkowski confided. He resided at Number One Appreciation Street and had fallen on hard times. Skladkowski had been put on half pension by the Polish government-in-exile, just as his government had put the opposition now in power on the half-pay list. The hardest hit by Skladkowski's hard luck was his landlord, Dr. Fisher. To increase his meager earnings, Dr. Fisher had leased Skladkowski half of his four-room apartment in 1941. By 1943 prices had risen to the point that Skladkowski's monthly income was the exact amount due Dr. Fisher, who tried to raise the rent. Refusing to have an ex-premier put out on a Tel Aviv street, British officialdom had his rent frozen. "Who would have thought I'd be discriminated against in Tel Aviv?" Dr. Fisher wailed.

(184) Jewish and Arab children can look very much alike, as illustrated by these two pictures. The Arab child attended class at Bersheeba.

(185) No less dutiful a student was this young Jewish boy at the kibbutz of Hain Hashofet.

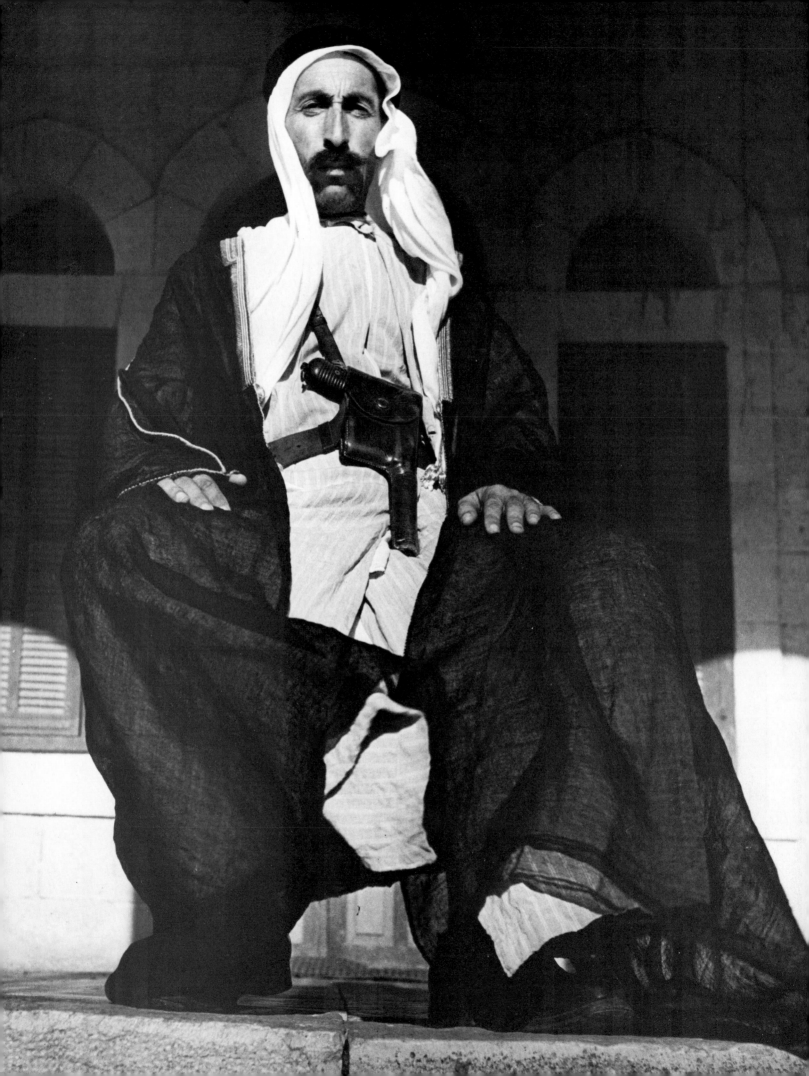

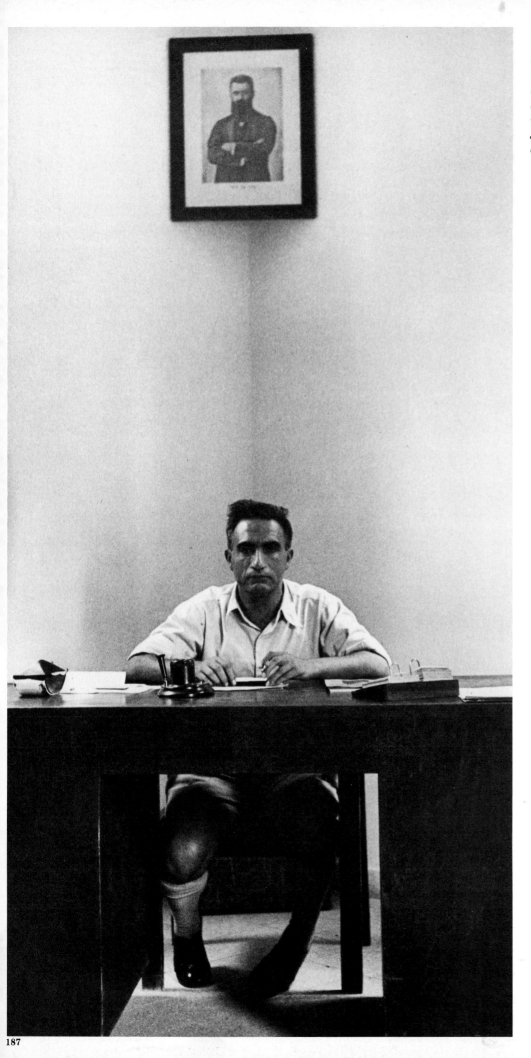

(186) *The implacable differences between Arab and Jew arose with maturity, as can readily be seen in these 1943 portraits of an Arab sheikh and Moshe Gold (187), the commissioner of Betar youth, a revisionist group founded by Vladimir Jabotinsky, whose most successful disciple is Menachem Begin.*

187

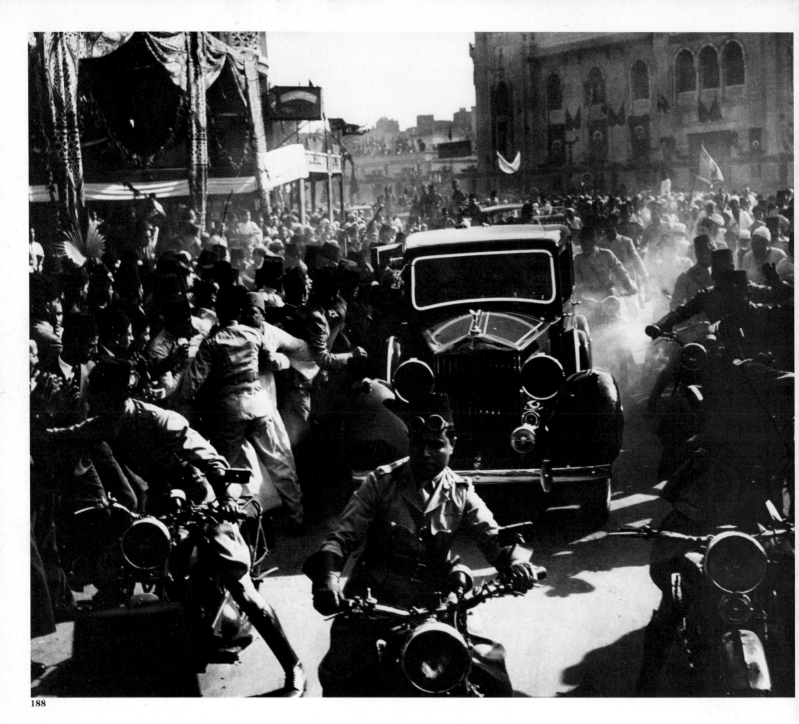

188

King Farouk

(188) *Uncontrollable Egyptian* fellaheen *trying to get close to King Farouk as he was being driven to Lower Egypt.*

(189) *King Farouk gazing out on Cairo from Abdin Palace.*

"Put on a tarboosh and try to look Egyptian," said Atif Bey, King Farouk's ADC. "H.M. doesn't want the British to know he's taking you along." I donned a fez, remained mum, and presented myself at Abdin Palace, the royal residence in Cairo. In those autumn days of 1943 Farouk was tinkering with the notion of becoming the Caliph of Islam, a position no one had presumed to revive since the collapse of the Ottoman Empire. It had all started with a facial eczema that prevented him from shaving, so he had grown a neatly trimmed beard. Told by courtiers of his striking resemblance to the illustrious Ismail the Magnificent, Farouk decided to keep his beard after his eczema was cured. His counselors having insisted that a bearded monarch was out of fashion, Farouk decided to take his beard to the people. Shrewdly he chose the Moslem New Year ceremony at the University of El Azhar, the world center of Koranic learning. Farouk appeared solemnly fingering his amber beads. The gathering, which filled the auditorium, rose, while a voice was heard to shout: "*Allah akbar, Allah akbar*—God is great." Thousands picked up the chant. They had seen in Farouk's beard what he had intended—a bid for the caliphate.

To demonstrate his piety, Farouk led noonday prayers every Friday in large mosques throughout his kingdom. On this particular Friday our cortège was led by my convertible, followed by Farouk's bright red Rolls

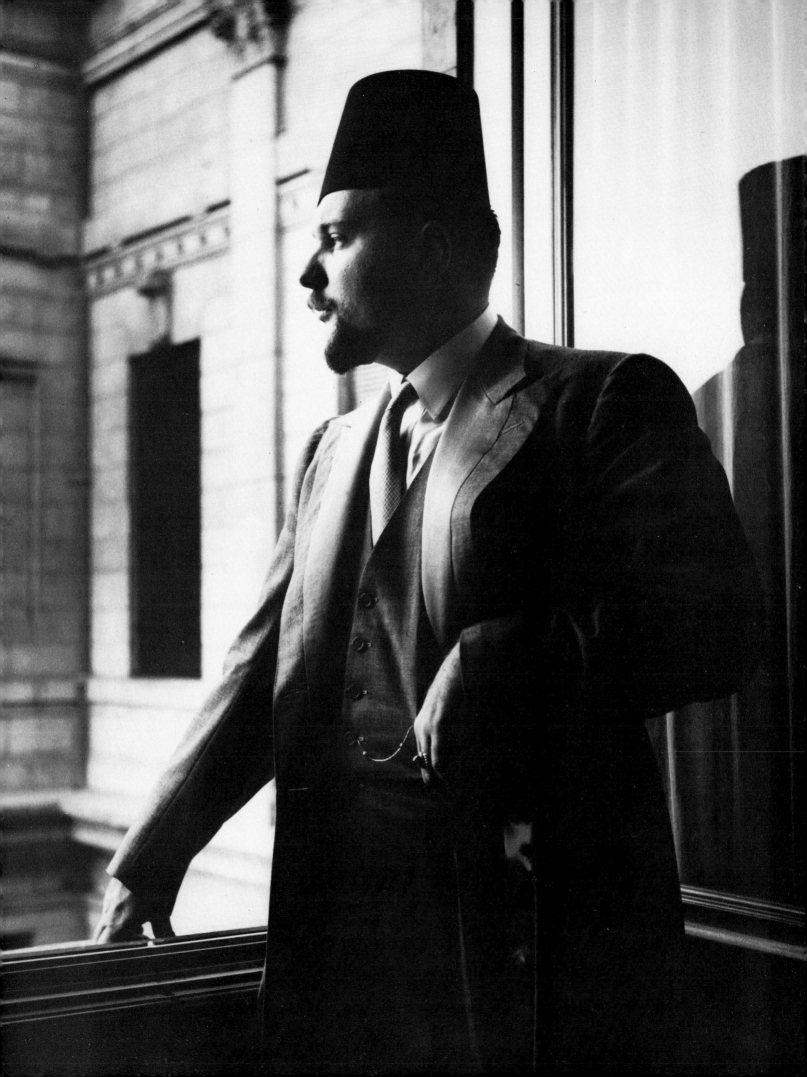

sedan guarded by two convertibles filled with armed aides and brought up in the rear by a truckload of soldiers waving rifles. This procession was flanked by outriders on bright red motorcycles looking like curried shrimp as they leaped along. Our destination was lower Egypt.

All along the way we were swamped by screaming, prancing, dancing mobs unable, or unwilling, to contain themselves. They waved green banners with white Arabic squiggles praising both Allah and Farouk, while bands blared the exuberant national anthem to the shrieks of *"Ash el malik! Ash el malik!—*Long live the king!," a cry we could not escape for the rest of the day. In the small towns we drove through on our way to Alexandria we passed water buffalo pinned down by *fellaheen,* their legs thrashing wildly in the air. At the sight of Farouk's Rolls, butchers hacked at the beasts' throats to the chant of *"Ash el malik!"* The buffalo were gifts from local pashas to the *fellaheen* in honor of *Malik* Farouk. Our first halt was in front of a gold and blue marquee specially erected on the side of the road to provide shade and refreshments—iced lemonade in frosted pitchers, pastries, and Turkish Delight stacked on trestle tables behind plush red armchairs and bowing notables. No sooner had we pulled up than throngs broke through the police lines and surged toward Farouk. The soldiers in the truck fired wildly in the air while aides just managed to get Farouk back into his Rolls before the *fellaheen,* sweeping aside the pashas, hurled themselves against the car.

This fanatic devotion was officially explained by the British as a demonstration of the people's desire that their monarch live in splendor. Indeed, Farouk's life-style surpassed fiction. Aside from Abdin Palace, he owned Koubbeh Palace in the outskirts of the city—with imposing walls any modern high-security jail would envy; two palaces in Alexandria—Ras el Tin, overlooking the Mediterranean, and Montazah, lost among acres of pines; a hunting lodge where he kept his white racing camels and dancing horses; and a pagoda at the Cairo zoo where he rested after feeding the animals. Farouk could commute to these places by land, sea, or air by using any one of a fleet of ninety-eight cars, five planes, three yachts, or a diesel train painted silver.

In actual fact the king's popularity rested on Egyptians' long-term resentment of British colonial rule and their recent anger over the public humiliation inflicted on Farouk by Lord Killearn, the British ambassador. With Rommel's Afrika Korps threatening Alexandria and Britain's position in the Middle East precarious, the Egyptians and, it was rumored, Farouk himself were gloating over the prospect of a British defeat. Taking advantage of a crisis in the Egyptian cabinet, Lord Killearn showed Egyptians that the British were still the masters by means of a conspicuous display of power. He had the royal palace ringed with tanks and then sped there in his yellow Rolls, Union Jacks flapping, flanked by a motorcycle escort. Stomping into the palace, he waved two documents in Farouk's face. One dealt with the king's abdication, the other appointed a pro-British prime minister.

"You will regret this day," Farouk said to Lord Killearn as he signed the prime minister's appointment. This nineteenth-century demonstration of imperialism backfired, infuriating "the natives." Farouk's waning popularity was restored, stimulating the explosive crowd scenes I had been photographing.

At a stop we made that day in the town of Tanta, I found him reclining in the shade of a cool veranda stringing his amber beads. He was wearing a tarboosh and his dove-gray *stamboline* with matching silk lapels. Whenever Farouk was dressed in Oriental garb, his movements became rigid and his expression changed. His heavy drooping lids were more conspicuous and his pouting lips gave him a sulky despotic look.

"Well, am I popular with my subjects or not, John?" he demanded.

"Dangerously so, sir."

Farouk sat up, slapped his thigh, his face lit up, and he burst into raucous laughter. This was the other Farouk—the one the Americans in Egypt knew, the one with democratic ways. For Farouk, the appearance of the U.S. air force in Egypt had been a new experience. He had been impressed

190

191

(190) One of Farouk's ninety-eight cars standing in twenty-four-hour readiness at the palace's rear entrance. A fickle monarch, Farouk's choice in cars varied from day to day.

(191) Entrance to the royal palace at Abdin in Cairo.

126

by the representatives of a mighty nation who were not arrogant. There was genuine admiration in his voice when he said to me, "America has no foreign policy but she has awfully powerful hind legs—and with them she can kick!" Farouk set out to woo the United States. His charm stopped at no one. He called President Roosevelt's roving envoy, General Patrick Hurley, by the diminutive "Pat" and greeted the sergeant from Baton Rouge, Louisiana, who trained the royal bodyguards, with a cheerful "Hi ya, Sarge." Determined to impress the Americans, Farouk let me take pictures of the interiors of Abdin Palace, something he had never allowed before. For weeks I roamed his vast and empty palace where hundreds of servants catered to their monarch's every whim. (His wife, Queen Farida, was living in Alexandria.) Treading heavy red carpets, I visited the throne room, its intricate inlaid woodwork making me feel as if I were inside a fruitcake, then photographed the enormous Red, White, and Suez salons, filled with paintings of the dynasty's male representatives; the four-hundred-seat theater where Farouk's favorite magicians performed; the dimly lit state dining room, with its richly upholstered leather armchairs, where Nubian waiters in red livery served dinner on gold plates; the wing of the palace where buffet dinners for six hundred were held; the private dining room for twenty-eight; and Farouk's emergency snack bar located just off the kitchen. The royal kitchens, with their white-tiled splendor, were presided over by chef Beta Ali. When I mentioned that his kitchens were more imposing than those at Buckingham Palace, he agreed. "You're right," he said. "We've been there." In Farouk's kitchens there were those who prepared vegetables, those who cooked seafood specialties, those who butchered entire sides of beef, those who baked croissants, those who decorated pastry, and those who did nothing but make Turkish coffee.

Later, after having sampled Beta Ali's culinary achievements, I praised him to Farouk, who gave me sound advice on how to handle a chef. "I hold on to them as long as they own only two houses and three cars," he said good-naturedly. "First house, first car after that—out they go."

The vaults for the gold-plated dishes, silverware, and Baccarat glass were on the ground floor. Just off the vaults was Farouk's hobby room where he would pore over his treasures, contemplating the world's finest collection of automobile license plates, his numismatic collection, worth ten million dollars, or his stamp collection, valued at seventeen million. I noticed he was sorting out stamps from Nazi-occupied Europe. My surprise made Farouk burst out laughing. "Hitler sends them to me," he explained.

Farouk improved his own collections by reviving an old Koranic law which stipulated that whatever a guest admired, the host was obligated to offer. When visiting others' homes, Farouk accepted these "gifts" with great charm and was even considerate enough to bring along his own packers. Yet money was no object when he really wanted something. Unable to purchase Loretta, a champion German Shepherd bitch, at a dog show in Aix-les-Bains because its owner refused to part with her, Farouk casually got the dog by hiring its owner.

The king's ninety-eight cars were neatly lined up in the royal garage. There, a team of mechanics buffed and serviced the two red Rolls-Royce sedans for state functions, the two red and black Rolls-Royce cabriolets for desert trips, the bulletproof Packard kept for times of national unrest, the maroon Mercedes (a present from Hitler), the green Alfa Romeo (a gift from Mussolini), a brace of jeeps from his British and American allies, and a whole line of American and Continental cars, gifts from local dealers anxious to remain in the good graces of their monarch. With the exception of state functions Farouk regularly used the back entrance to the palace where, at the foot of the stairway, stood a car in twenty-four-hour readiness, wrapped like a mummy under its protective cover adorned with a large initial "F." Depending on his whim, Farouk picked one car from this vast array and would drive at reckless speed along deserted highways. At dawn one morning he collided with a British army truck. At the hearing the cockney driver explained that it had all happened very fast: "The next thing I knew," he said, "there were three wogs spread out on the highway and the one in the middle was King Farouk."

192

193

(192) In his hobby room Farouk studied his coin collection estimated at ten million dollars but would not let me photograph his stamps because "I'm still collecting stamps and don't want to send the prices up."

(193) Farouk with champion German Shepherd Loretta, acquired by hiring her owner for as long as she lived.

194

195

196

(194) Chef Beta Ali and one of his assistants (195) preparing Farouk's lunch. (196) Menu: cold lobster and chicken, sole, vol-au-vent, mutton chops, mashed potatoes, peas, rice, artichokes, fruit compote, fresh peaches, pomegranates, mangoes, jellies, caramel custard, exotic-flavored ice cream, and a carafe of chilled almond milk.

When Farouk the autocrat grew bored by the lonely immensity of his palace, he would summon Pulli Bey, his secretary for *les Affaires Privées de son Majesté*, to seek out suitable company for him. Once at Shepheard's I ran into two Swedish beauties who told me in awe, "Monsieur Pulli has arranged a midnight audience for us with His Majesty." Antonio Pulli had been the son of an Italian electrician employed at the palace during the reign of Farouk's father. The old king refused to allow his heir to play with the sons of the pashas, whom he saw as no better than servants, so young Farouk was reduced to playing with the servants' children. This led to Pulli becoming Farouk's confidant as they grew up. The British viewed Pulli Bey with distrust. Lord Killearn, whose wife was Italian, told Farouk that Pulli had to go.

"I'll get rid of my Italian, Lord Killearn, when you get rid of yours," Farouk replied.

When Farouk the democrat got bored, he spent his evenings on the town. It was a standing practice for every nightclub in Cairo to hold its best table in case he showed up. In those happy days Farouk did not require two tables—that came later when he grew fearful of being assassinated and traveled with a bodyguard. Though table lights were always removed so as not to make him conspicuous, his raucous laughter would give him away.

197

198

199

One evening at the Club de la Chasse Farouk summoned a group of us — who were in the company of several USO entertainers — to his table. He remained seated while greeting us, to the annoyance of a brassy blonde singer. "Hasn't that king of yours got any manners?" she grumbled. When Farouk asked her to sing, she turned him down. "Nah!" she said.

"You won't sing for me?" he exclaimed. "Why, it's a royal command."

"Not if you don't get up for me," the blonde snapped back, sending Farouk into a burst of laughter.

At other times he would pay unexpected visits to General Ralph Royce at his apartment, where he would listen to the latest American records while sipping Coca-Cola. He also raided the general's refrigerator and would sit on the kitchen table munching a chicken wing. Whenever Farouk kept the general up too late, he would bluntly tell the king, "I'm sorry, but I work for a living and I've got to get up early."

In 1955 I was at a Roman restaurant when I heard an unmistakable burst of loud and mirthless laughter behind me. Turning around, I saw Farouk seated with an American film actor and a blowsy blonde. The exiled monarch blinked through black-tinted glasses. He had become deformed by obesity. At thirty-five he had not so much aged as decayed. I did not go over and speak to him. The Farouk I had once known no longer existed.

(197) Farouk's and his queen's apartments opened off this hall. Heavy sofas and chairs were Louis XIV style. When I took this picture, Farouk said to his aide, "Thanks to John you've seen more of my palace in three months than you have in the last ten years."

(198) Private theater with four seats of honor complete with small tables for casual refreshments. The queen's gallery in the rear allowed her to sit in seclusion with her attendants.

(199) The Hall of Ancestors contained larger-than-life busts of past rulers.

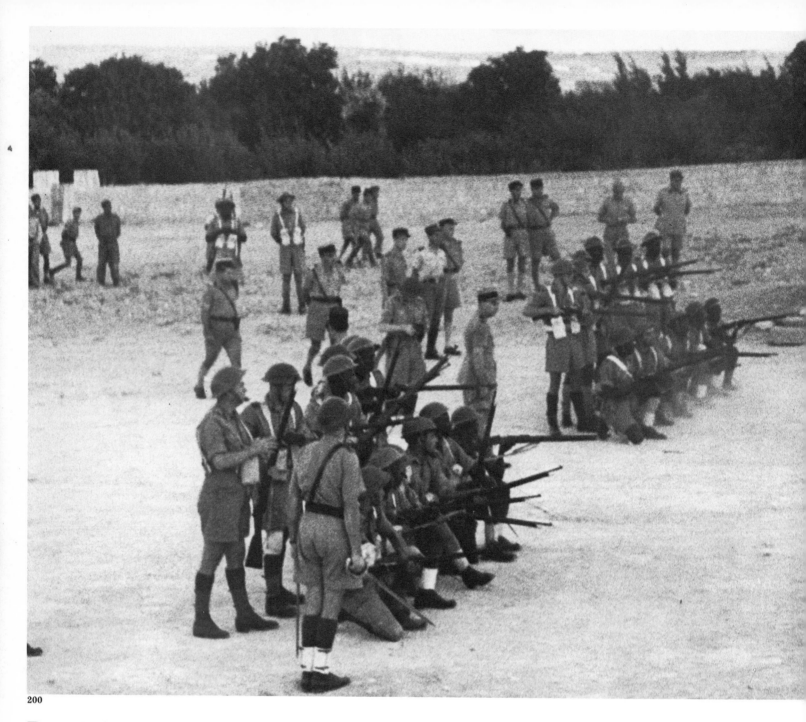

200

Death in Aleppo

At dawn on September 29, 1943, I stood with a small group of French officers at a firing range outside Aleppo, near the Syrian-Turkish border. Two Nazi spies were about to be executed. "They'll be given black coffee with several grains of morphine to help them out," I was told. The two firing squads had been issued loaded rifles. Only half in each squad had live ammunition. I was ashamed of myself for witnessing the execution even though, on hearing about the trial, I had driven all the way from Cairo to see it. A truck bumped into sight along the narrow dusty road. The tailgate dropped and a tall man in a loose brown shirt and shapeless blue pants rose from the bench, his arms bound behind his back. Before jumping to the ground, he ducked so as not to bang his head on the overhead metal stays of the truck. He still instinctively clung to life enough to think about banging his head. Defiantly he strode past the firing squads. He was followed by the second condemned man, whose legs were so wobbly he had to be helped. The defiant one, having refused a blindfold while being tied to a stake, began shouting insults. The cold brutality in his voice numbed my mind. Any sense of pity I had gave way to rage. The command "FIRE!" was lost in the volley. After the *coup de grâce* was administered, an ambulance drove up. Soldiers lay the bodies in two rough-hewn coffins, nailed down the lids, and scribbled the dead men's names on top in pencil.

130

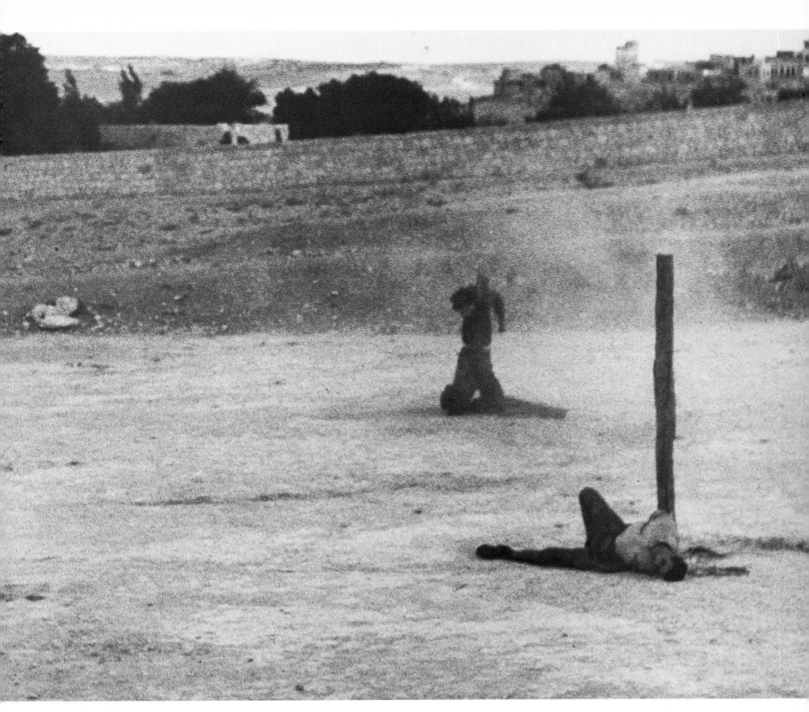

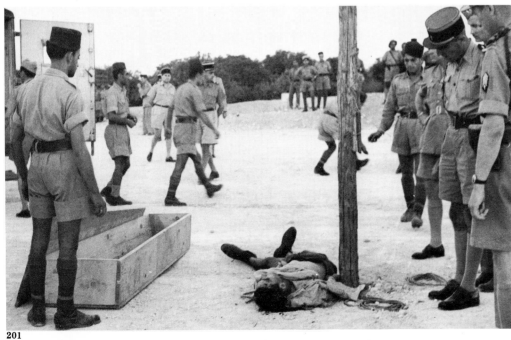

(200) At dawn on September 29, 1943, two German spies were executed at Aleppo, Syria.

(201) With casual informality Senegalese soldiers dumped the two bodies into coffins, nailed down the lids, and loaded them on an ambulance that drove off without sounding its bell.

201

131

Teheran Conference

On Monday, November 29, 1943, I photographed Churchill, Roosevelt, and Stalin at their first summit meeting in Teheran. The setting for this "historic picture" was the front porch of the Russian embassy, a Greco-Marxist temple with six white columns topped by a hammer and sickle.

Colonel General Arkadiev, Stalin's chief security officer, whose importance was immediately apparent by his imperious manner and the high quality of his uniform, picked me up at the British legation and led me across the street to the Russian embassy, tucked behind a twelve-foot wall guarded by Russians in funereal black. A few hundred yards along a winding road we entered the American zone, guarded by MPs, which led to the main building.

In a burst of hospitality Stalin had turned over the residence to the American president while he himself moved to a small house on the other end of the grounds. Due to this unorthodox arrangement, Roosevelt did not have to commute to and from the American legation, which was out of the way. Not only were security measures simplified, but the three statesmen could meet more frequently and informally.

At the foot of the thirteen steps that led to the front porch of the Russian embassy was a gravel driveway where lesser members of the conference who had yet to see Stalin hung around. Stalin himself showed up unobtrusively through a side door. What immediately struck me about him was his small stature and the rigid way he moved, almost to the point of clumsiness. His pockmarked face had the quality of rough-hewn granite. His hands were those of a laborer. Only the fingers of his shriveled left arm peeked out from under the wide cuffs of his beige uniform, which hung on him stiffly. Unlike his marshals, who were festooned with decorations, Stalin was satisfied with Russia's highest award, the Order of Lenin. He mingled with the onlookers, seemingly unaware of the curiosity he awoke. Watching him I was reminded of an Eastern European peasant in his Sunday best strolling through a market, slow-footed but shrewd. "Delightful old gentleman," a British officer behind me observed. "Looking at him you'd never believe the old boy has done in four or five million people, would you?"

Winston Churchill, in his RAF air commodore uniform, stepped onto the porch.

Before President Roosevelt appeared, Mike Reilly, head of the White House guards, said, "No one is to take pictures of the president before I give the word."

A gasp came from those who were unaware of the extent of the president's infirmity when he was carried out onto the porch by two guards. A long cigarette holder jutted jauntily from the president's mouth, which was set in a fixed grin. His right leg, which had been crossed over his left by a guard, swayed helplessly until held in place. The men surrounding the president moved back and Mike Reilly gave permission to take pictures. Completely relaxed, Mr. Roosevelt held a pince-nez in his left hand while he laughingly chatted with Churchill. Though the steel braces around his ankles were visible, we gazed at one another in amazement, having watched this almost helpless cripple once again become the strong leader the world knew.

President Roosevelt sat in the middle, with Stalin on his right. The chairs the three statesmen sat in were different from one another and reflected each occupant's outlook on life. Churchill slumped in a well-padded armchair. Stalin sat on a bureaucrat's dream chair of solid wood—stiff, ungainly, and uncomfortable. Roosevelt's armchair was a compromise between the two—it lacked the comfort of the one and the rigidity of the other. The seat was padded but the back firm and unupholstered. Each posed in his own way. Churchill looked like a bad-tempered cherub; the inscrutable Stalin gazed straight ahead; Roosevelt, the image of geniality, chatted with both.

I was taking pictures when Mike Reilly leaned over the president's shoulder and whispered in his ear. Often I have wondered what could have been that important—or was it that trivial?—for him to intrude at this historic moment.

(202) Stalin, Roosevelt, and Churchill, seated on the front porch of the Russian embassy, were about to pose for an official picture of the historic meeting in Teheran when Mike Reilly, head of White House guards, came up to the American president and whispered in his ear.

(203) One of the official pictures taken at the Teheran Conference. Behind the Big Three are (left to right) Harry Hopkins, Vyacheslav Molotov, Averell Harriman, Sir Archibald Clark Kerr, Anthony Eden, and General George C. Marshall.

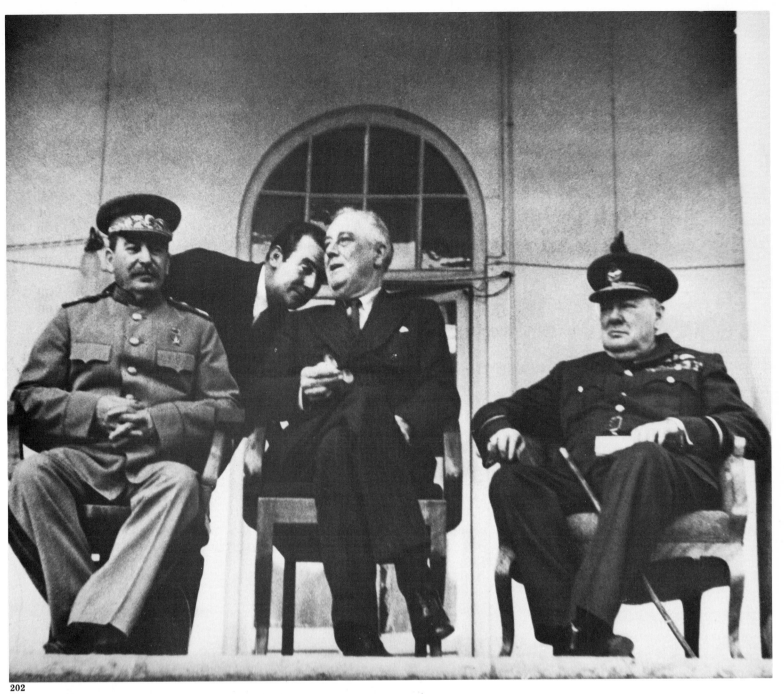

202

203

(204) Roosevelt, Churchill, and Stalin celebrated the British prime minister's sixty-ninth birthday with a dinner at the British legation.

(205) Churchill inspected the birthday cake shortly before the first guests arrived.

Across the street from the Russian embassy was "the compound," as the British legation in Teheran was known. Ever since I had driven through its gates two days before I had been living within the magic circle of utter power, having left behind the rumors and confusion that gripped Iran. Our arrival had been so secret that the shah himself got his first hint of the impending conference only after a fleet of twin-engine Dakotas landed in his capital. Gossip was radiating out from the bazaar that Churchill, Roosevelt, and Stalin had come to divide up the country, especially after Teheran's radio went off the air, trains were held up at the station, and pedestrians were forbidden to leave the city limits. There was no such restraint within the magic circle. We all knew that Churchill and Roosevelt were at last meeting with Stalin to plan the Second Front and lay the groundwork for world peace.

A blend of crumbling past glories and present-day hand-me-down shabbiness, Teheran hardly seemed appropriate for such grand endeavors. But in view of what has happened since, the choice was symbolic. At Teheran East and West meet — and clash.

None of us was harboring such thoughts on that first day. Expectancy prevailed as convoys of cars swept down the legation's driveway unloading military brass while Foreign Office types hastened after Anthony Eden, who hurried by. Sikh sentries sprang to attention with a rattle of hardware as Winston Churchill alighted from his car, followed by daughter Sarah and son Randolph.

A mild-mannered man with beetling brows attracted my attention. "Six should about see us through," Beetlebrows said to himself.

"I beg your pardon?" I replied to his cryptic remark as I followed his gaze, which was focused on a street peddler's strutting turkeys.

"I'm a state secret," Beetlebrows volunteered after a lull. "It would never do for the Germans to know where I was because Hitler knows that wherever I am, Mr. Churchill can be found. Take the name on my passport, K-R-A-M. That's not really my name. Oh dear no! My name is M-A-R-K, if you see what I mean. So now I'm Mr. Kram," Mr. Mark said.

I admitted that although no one had fiddled with my identity, I was not the British civil servant I was supposed to be. Oh dear no! My metamorphosis had occurred the night before in Cairo when Churchill had asked that a photographer be attached to his mission. I became the seventy-seventh and last member of his delegation to the Teheran Conference, listed under the category "Advertising & Miscellaneous."

Mr. Kram was a petty officer in the Royal Navy seconded to Churchill. Officially a valet, he kept the prime minister in Havanas and brandy, besides supervising receptions whenever the prime minister traveled abroad.

I did not see Mr. Kram again until the evening of Churchill's birthday party on November 30. Half an hour before the guests were due I found the residence ablaze with light. British sentries had replaced the Sikh guards. Stewards in white mess jackets fluttered around the Yellow Room where cocktails were to be served. Across the hallway was the dining room. Below a painting of Edward VII stood Mr. Kram. "If it doesn't sound too blasphemous," I said to him, "this must be the most important feast since the Last Supper."

"The Teheran dinner," Mr. Kram replied, surveying the long dining table set for thirty-four and lined with a brittle hedge of gleaming stem glasses, "is indeed the most important of my career. My favorite, though, was the Atlantic Charter dinner served aboard the *Prince of Wales* in honor of President Roosevelt. We had grouse brought all the way from Scotland. Tonight, we will serve oyster patties, consommé, boiled salmon . . ."

"Brought all the way from Scotland?" I asked.

Mr. Kram refused to be interrupted. ". . . as I said, boiled salmon, roast turkey, ice cream, and cheese soufflé for savory."

"Surely not the turkeys that were loafing outside the compound."

"As I mentioned earlier," Mr. Kram went on, "six would see us through."

We were interrupted by Mr. Churchill. Carefully he scrutinized each place setting, making a few changes. Then, without a word to Mr. Kram, he ambled off to the Yellow Room.

"I sent out a local lad to purchase those turkeys," Mr. Kram said, "because they would have overcharged a foreigner." He paused while a "local lad" carried in the birthday cake. "The Teheran dinner will be English," Mr. Kram pointed out, "although I have made one concession." On hearing his birthday cake was in the dining room, Mr. Churchill trotted back in and beamed at it. An "austerity cake" had been decided on so that I could photograph it, for "it would not do if pictures were taken of a really splendid cake" in a country where sugar cost twelve dollars a pound. Spotting me, Mr. Churchill inquired in a whisper, "Are you planning to photograph Marshal Stalin?"

"Why, yes," I replied, noticing I was whispering, too.

Quickly the P.M. drew up a plan. On receiving Stalin he would find out if the marshal had any objection to being photographed. If not, he would transmit the message to the British colonel at his side. The colonel would then wave his handkerchief to signal that I could carry on. With that, the P.M. departed, leaving me in doubt he would even remember.

"My one concession," Mr. Kram continued after Churchill's departure, "is the toasts. They will be proposed all through the meal. That will make the service a bit awkward because the courses must be slipped on and off without interrupting the rhythm of the meal."

At eight sharp the guests started to arrive. One of the first was Averell Harriman, who was struggling with the president's birthday gift, a fragile thirteenth-century bowl, and his own present, a seventeenth-century brocade tucked under his arm. While Harriman was explaining that the gifts should be placed on the dinner table without Churchill's seeing them, the P.M. rushed up. Harriman clamped his old felt hat over the bowl while Churchill, his eyes tightly shut, announced loudly, "Haven't seen a thing." At that moment he looked closer to six than sixty-nine.

A flock of Secret Servicemen accompanied President Roosevelt. With the exception of the Russians, all the guests had arrived. Finally Colonel General Arkadiev appeared and, unsmiling, looked us over. Soon after his departure there was a commotion in the hallway—Joseph Stalin had arrived. Churchill greeted him, the colonel frantically waved his hanky, and I tried to keep cool.

Now, over forty years later, I can still feel the wonder of standing in the doorway and gazing at these famous men—the most powerful in the world—gathered together for the first time. It is eerie to recognize people you have never met. In those days it was only a few who, like me, were able to witness this historic moment: the patrician figure in the wheelchair mixing martinis was President Roosevelt. The ruddy-cheeked gentleman in black tie tossing one down was Churchill. The stocky fellow slowly sipping his martini was Stalin. The nearsighted man who blinked behind his pince-nez was Molotov, and the fashion plate with him, Eden. The gaunt man talking to a young sergeant, his GI pants tucked into leggings, was Harry Hopkins chatting with his son Robert. Churchill's daughter, Sarah, conversed with Admiral King. Colonel Elliott Roosevelt stood in the company of Captain Randolph Churchill, near Generals Eisenhower, Marshall, Arnold, Ismay, and Dill. Everyone was in a good mood, especially Stalin. From time to time he let forth a belly laugh, his jaw snapping closed while his eyes remained open.

I got only one shot of Churchill, Roosevelt, and Stalin at table after dinner was announced. The oyster patties were being served and the first of seventeen champagne toasts proposed as I watched the double doors close on the scene. The three chief security officers placed themselves in front of the doors.

"Why don't you take a picture of us?" Mike Reilly said, adding, "and don't forget to send a print to the White House."

"While you're at it, send me one at Number Ten Downing," Churchill's bodyguard said.

Arkadiev pointed to himself, smiling for the first time.

"I guess he wants his picture, too," I said. "Wonder where I should send it?"

"The Kremlin," Mike Reilly suggested.

"Kremlin," Arkadiev exclaimed. "Da. Da."

206

207

(206) My birthday gift to Prime Minister Churchill was a Persian lamb hat, which I tried on before presenting to him. (207) As can be seen, the P.M. had a larger head than I.

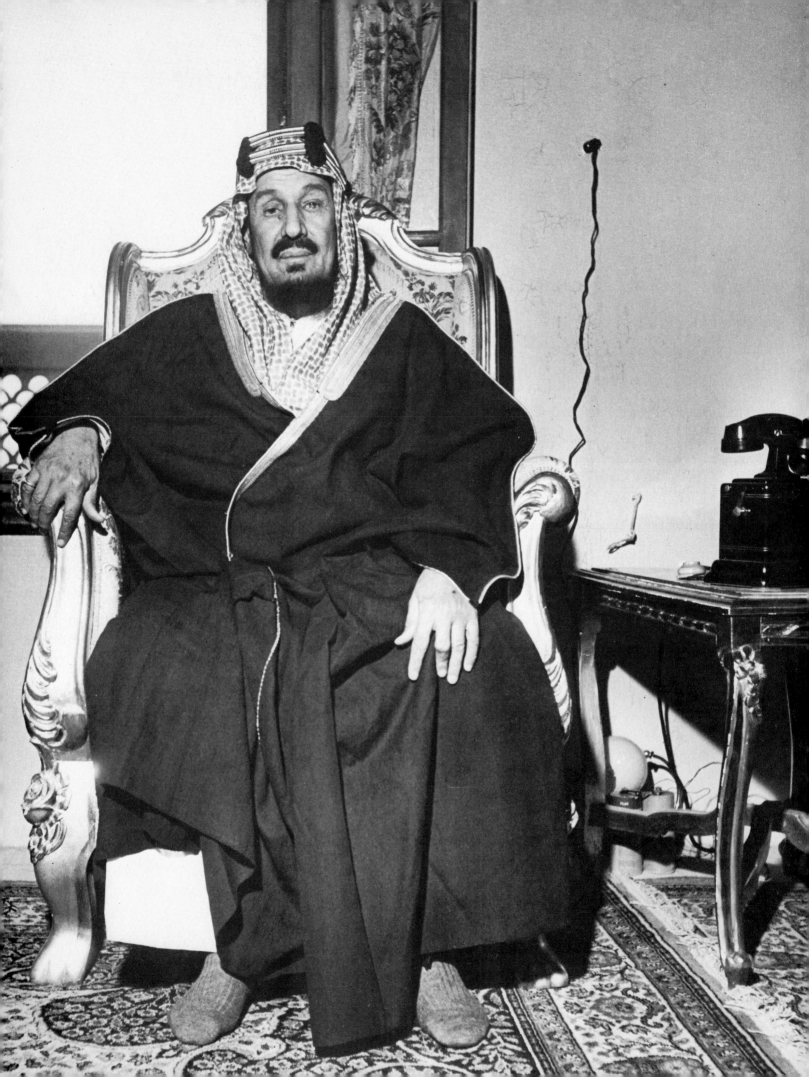

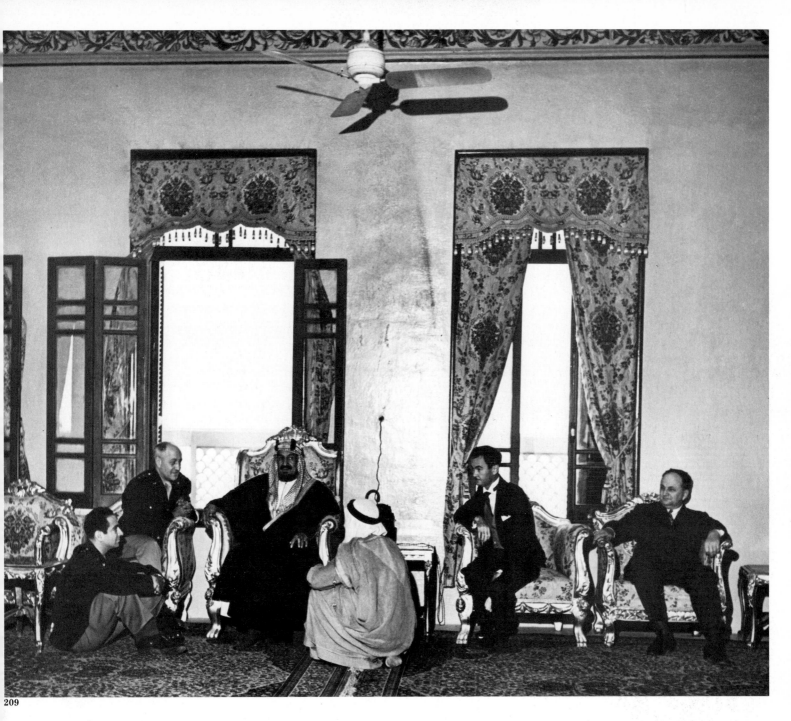

I first met Ibn-Saud in the winter of 1943 under unusual circumstances. It all started with a phone call from USAFIM — the United States Air Force in the Middle East — whose headquarters were in Cairo. "Beat it right over here," said the aide of General Ralph Royce, commander of USAFIM.

At headquarters I found a group of officers with General Royce and learned we were members of a hush-hush mission to Saudi Arabia. Few foreigners and even fewer journalists had ever met the mighty Abd-al-Aziz ibn-Saud. All I knew of this monarch was that he ruled over a desert kingdom he had carved out of a large chunk of the Arabian peninsula and named Saudi Arabia after himself.

Solemnly a State Department official briefed us on this country, its monarch, and the purpose of our mission. After unifying this desert wasteland through a series of wars in which he had personally slaughtered several hundred enemies, Saud had kept a grip on his kingdom by marrying the leading chieftains' daughters, a tactic that had provided him with strong family ties and some three dozen sons. The administration of this kingdom had presented no problems to a man of Ibn-Saud's stature until the recent discovery of huge oil deposits.

Although he had never been out of Arabia, Ibn-Saud had a very realistic vision of world affairs. Well aware that his kingdom was surrounded by

Mission to Saudi Arabia

(208) Portrait of Abd-al-Aziz ibn-Saud, better known as Ibn-Saud, the mighty ruler of Saudi Arabia — a large chunk of the Arabian peninsula he conquered and named after himself. He is seen here in stocking feet at his royal palace in Jeddah.

(209) Conferring with Ibn-Saud: (left to right) Major General Ralph Royce, commanding general, USAFIM, and King Saud (with interpreters at their feet); Mr. James S. Moose, Jr., the American minister to Saudi Arabia; and Mr. James Terry Duce, vice-president of California Arabian Standard Oil.

210

211

(210) General Royce and two aides look out from Ibn-Saud's Jeddah palace at a desert wilderness that oil revenues would turn into a bustling town.

(211) Major General Ralph Royce and the two welcome mats at the royal palace.

minions of the British Empire (Iraq, Transjordan, and Aden), he had decided to grant oil concessions to American companies, assuring both revenue and autonomy. Shrewdly, Ibn-Saud speculated that the United States would never allow Britain to take him over, as had happened to other Arab states. This was the reason for General Royce's mission.

With war in the Middle East over, Iraqi tribesmen had been equipped by the British with Italian rifles salvaged from the battlefield at El Alamein. The Iraqis were attacking Ibn-Saud's tribesmen along the border and occupying large stretches of desert, beneath which oil flowed. The purpose of the Royce mission was to strengthen Ibn-Saud's army and recapture territory lost to the Iraqis. Ibn-Saud's tribesmen were to be equipped with Italian rifles the United States planned to purchase from the British.

We were briefed on how to behave in the presence of the Moslem monarch. Our breath was to be free of tobacco and alcohol. As the briefing broke up someone said, "And be sure to bring your passports."

Fate had got me into a predicament: asked if I had brought my passport along I said, "Yes," but did not mention it was British. I had become an American war correspondent while still a British subject, a detail General Royce ignored and I was not prepared to bring up. Although bound by the secrecy of our mission, I did not relish the prospect of a misunderstanding over my passport.

All the way down to the Red Sea during our flight to Jeddah, General Royce played gin rummy. The general was a remarkable man in many ways. He could never understand why the Egyptian and other Arab leaders made such a fuss over him. He was an army man temporarily stationed in Cairo on account of the war and did not see himself as the Arabs did—the representative of United States military power, a new force in the Middle East. The general went about baffling Arabs by an amiability they did not associate with one so powerful. I watched the general playing cards. Here was a man with roots deep in Michigan who was playing a part thrust upon him, a part he would certainly not have requested.

General Royce had not given me a clue as to why he had assigned me to the mission. He simply satisfied himself that I had my camera along, leaving me in doubt as to whether I would be able to send pictures back to *Life*. If not, I could always write this trip off as educational.

The major next to me was nervous and talkative. He knew why he was going to Saudi Arabia. A medical officer, he had taken care of King Saud. The monarch had decided to add his entire harem to the major's practice, an unprecedented honor as well as a big job. The very thought of it made the major fret. "I'll be here for months," he groaned. The major seemed totally unaware of the diplomatic importance of his task.

"Reluctant conquerors," I thought as I considered how differently the British would have reacted in similar circumstances.

As we neared the mainland, General Royce left his card game. The general always landed his own plane. He flew us in low so that our profane eyes could not contemplate Mecca, the holiest spot in the Moslem world. We landed on a stretch of desert where a colorful honor guard was lined up.

A Saudi official seated at a rickety table propped on the desert sand was ready to inspect and stamp our passports. Surrounded by the seventeen members of our mission, he was so intent on thumbing his way through all the passports that I easily slipped by him and joined a group of officers who had already been cleared.

The landscape was nothing more than sand and scrub, with one solitary building in the distance. The architectural style was early Miami hotel. It could only have been the royal palace. Out of nowhere a limousine appeared with two Union Jacks flapping wildly. "Guess we caught the British ambassador flat-footed," someone remarked.

Taken to our billets, we brushed our teeth, gargled, and with untainted breath were driven off to meet the king.

The mighty Ibn-Saud stood in stocking feet before his throne. This gilded armchair was upholstered in brocade with a floral pattern, as were all the smaller armchairs that lined the walls of the room. General Royce introduced us. As I shook Ibn-Saud's hand I took a good look at this

212

(212) Ibn-Saud's palace in Jeddah looked to me like a displaced Miami hotel out of season.

(213) Ibn-Saud's guards.

(214) With members of the Royce mission on the steps of Hotel Jeddah.

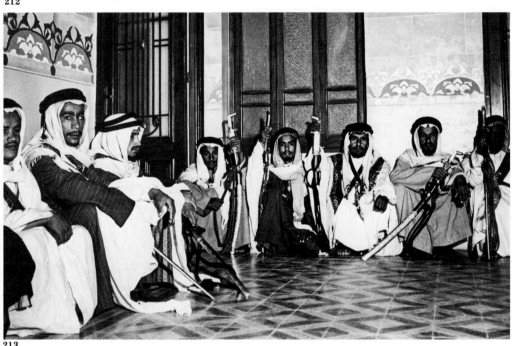

213

214

impressive six-foot man, who at seventy-three stood proudly erect. He was dressed in Bedouin clothes and wore a heavy gold-woven *agal* on his head like a crown. Like all men of the desert, he was gaunt and impassive. His dark face, heavily scored by deep lines, gave me the feeling he rarely smiled. In spite of an obvious blind eye, he had a searching gaze. We took our seats in order of precedence. General Royce, on the king's right, made small talk while their interpreters, seated crosslegged at their feet, translated the conversation. Mr. James S. Moose, Jr., the American minister to Saudi Arabia, sat on the king's left separated from the monarch by a low gilded table on which rested a telephone. He was in formal dress, from top hat to white kid gloves. Although no one paid the slightest attention to him, he was poised on the edge of his chair ready to join the conversation. Mr. James Terry Duce, vice president of California Arabian Standard Oil and probably the most important person present after Ibn-Saud, sat back in his chair with an amused look. When Ibn-Saud complained that he had difficulty standing on account of an old leg wound, General Royce told him he should not have got himself into so many wars. This made Ibn-Saud giggle like a schoolboy. In his bluff way the general had made a hit.

I slipped out of my armchair and, tiptoeing around, started to take pictures. Although Mr. Moose had his doubts, General Royce had told me to

139

215

216

go ahead. Each time my flash went off I felt like someone coughing at a concert. Members of the mission watched me with amusement as I stood alone in the center of the vast emptiness of the throne room. The king was following me with deep attention. I watched him rest both hands on his cane and lean toward the interpreter sitting crosslegged next to the general. In the silence the interpreter spoke to General Royce, who leaned over and nodded. Both he and Ibn-Saud looked in my direction, and the general beckoned. Although I was the only one in the center of the room, I pointed to myself as if to say "Me?" General Royce nodded impatiently. I started to tiptoe toward the side of the room but, noticing the general's scowl, decided it was no time for protocol and clattered directly over to him.

"The king would like to have his portrait taken, Phillips," he explained. "That's why I brought you along."

I glanced at the formidable face of Ibn-Saud and was granted a beatific smile.

"Now?" I whispered.

"No, tonight at the state banquet."

We departed, leaving the principals to confer among themselves.

We arrived for the banquet after gargling away traces of bourbon and were led to a large white terrace overlooking the desert. In the pale green

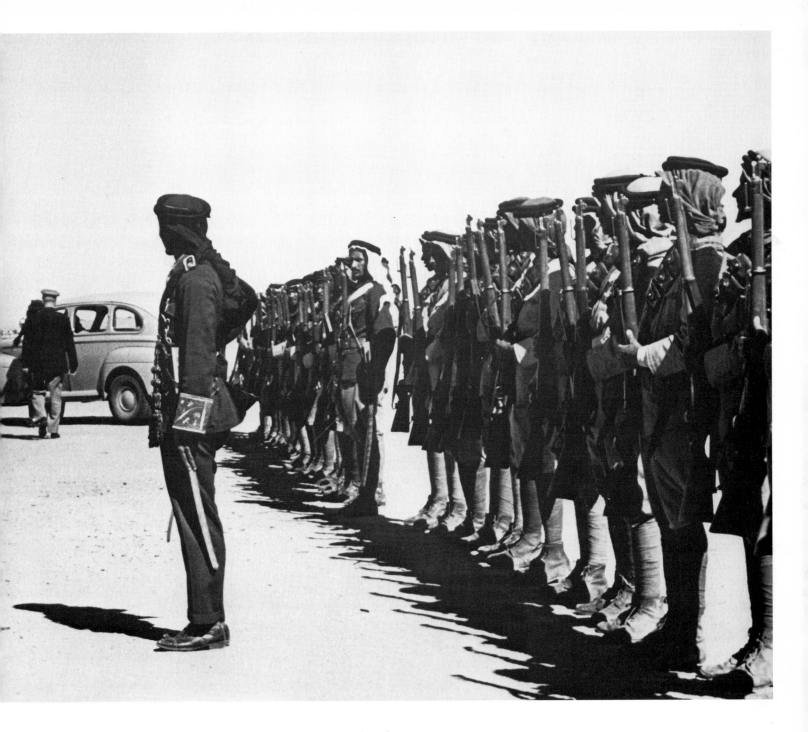

night the blood-red full moon looked so big it seemed to hover over our heads like a lantern. Ibn-Saud sat facing the moon. He was enclosed by chairs in a square formation. His ferocious guards, wearing green and red uniforms and rattling cavalry sabers, faced their monarch inside the square. The British ambassador sat on Ibn-Saud's right. General Royce was on his left. The rest of us sat in wide-eyed wonder. In this Arabian Nights atmosphere my flash equipment made me feel like a displaced Christmas tree under the sky of Islam. Guards served us coffee, disdainfully flicking the dregs on the heavy carpets. Again the king nodded to me. Again he felt the time was unsuitable for taking his portrait and told General Royce to bring me along the next morning. The feast was like being at an Oriental cafeteria. Forgetting all about my appointment in the morning, I took far too many pictures.

While the members of the mission left for the airstrip, the general and I drove to the palace to see the king. I did not confide to the general that I had only three flashbulbs left.

At the palace I proposed three shots — a portrait, a full-length study, and one of the king on his throne. Ibn-Saud beamed in agreement, drew himself up to his full height, stared straight into the camera, and waited. I shot the three pictures in quick succession.

(217) Residence of Algiers governors.

(218) View of the Casbah.

The airport in Algiers where I landed in February of 1944 had changed considerably since I had last seen it twenty years before, when my father had taken me out to a deserted field on which stood a small shack and a fluttering windsock. We had come to applaud a pilot making a test flight across the Mediterranean. The biplane never showed up and I was a very disappointed ten-year-old.

Now Maison Blanche airport was the hub of the Italian campaign and the runways were crowded with transport planes.

A GI in a recon car drove me to the Hotel Aletti, which had not existed in my youth. It was now an American billet nicknamed "the rich man's Casbah." I checked in with an American sergeant. An Italian prisoner of war carried my luggage up to my room and a colleague showed me around. The restaurant Le Berry had been converted into an army mess. The PX was at Les Dames de France, which I remembered as a department store.

Nothing reminded me of my childhood. Though the town was Algiers, I was living in a superimposed world imported by Liberty ship. It might have been any spot on the globe where the American army was stationed in wartime.

I took a stroll and stepped into a dream. I began to recognize certain places and guessed where streets led, though there were gaps in my memory. The long narrow arcades were familiar. I knew they would lead me to a square where Mother used to take me and on special occasions buy me a balloon. I would get very excited as the vendor lowered the broomstick from which blossomed a multicolored bouquet. When I pointed to the one I wanted, they would all flutter nervously as though trying to resist. Snapping the white thread stem, he would hold it in his teeth as he fumbled through his pockets for change while the balloon, now reconciled to its fate, lolled indolently overhead. Only when the financial transaction was completed would he attach the thread to my wrist. Once a large red balloon slipped away from the vendor and slowly drifted over the square heading for the open sea, a cherry in the blue sky. I chose another one

A Native's Return

through my tears, but it was not the same thing. Thus, gently, I became acquainted with sorrow.

The balloon vendor was no longer there, but donkeys with ribbons round their necks still trudged around the square with short, determined steps, nodding as they went. Just as in my time, donkey boys led them while parents walked proudly alongside, gripping their terrified children. Crossing the square I reached the boulevard that overlooked the harbor where Mother had taken me to meet my father when he came back from France after the war. And suddenly I recalled the bright yellow wooden spokes of the carriage we drove home in.

Streetcars of a more recent vintage than those I had known traveled the same routes into the outskirts of the city. One line rattled along past Barberousse prison, where on Thursdays convicts' wives visited their husbands bearing Arab baskets crammed with food. I used to like that ride because it led to the old Moorish palace where the deys of Algiers once resided. It was there one of these Turkish governors slapped the French consul with his fly swatter, which led to the conquest of Algeria. Another route headed toward Bab el-Oued and the Casbah, an awesome place from the descriptions of the Arab maid who led me to school.

The Casbah remained a maze of narrow twisting streets jogging uphill. The smell of sweat, leather and honeysoaked cookies drifted down toward me. Arabs sat crosslegged drinking Turkish coffee from small cups, arguing in their harsh guttural from which occasional phrases like "jerrican," "Hershey bar" and "six by six" escaped. The main trolley line traveled up rue Michelet. Our old apartment was somewhere off that street, so I started walking along it. When I reached the old photographic shop where Mother had my picture taken, I remembered there was an intersection ahead leading to my school. First I stopped to look around the square, framed by tiny shops once filled with marbles, water pistols, tops, candy, and slot machines. Here we used to hang around waiting for the school gates to open. The school building had not changed, though it had been converted into a venereal disease hospital for the duration.

I picked my way along the streets by guesswork, because much had changed. The movie house was no longer the converted stable of my youth, but I could still imagine the smell of film and hear the projector grinding away, barely drowned out by the pianist.

The public garden had a merry-go-round now, while our big sand lot had made way for a tiled pond. I saw the bench where my aunt had let me take my first picture with her vest-pocket camera. She had died in Algiers, and I suddenly realized I could not remember where she was buried.

I found the English library in the grounds of Holy Trinity Church. A sign read "RING THE BELL AND COME IN, BOYS." I did. The room was small and dark in the early winter evening. Servicemen leafed through magazines. A middle-aged lady walked up, smiling. "I was here as a boy," I told her. "I'm just looking around."

Going up the steps leading to the church, I felt the need to talk to someone and found a padre. "I was here as a child," I explained, "and was christened in there."

Like the librarian, he smiled politely. "In that case you will want to attend Sunday service," he said.

That was not what I wanted. I watched him hop into his jeep and drive off and then gazed down on the bay of Algiers crowded with Liberty ships and realized what had happened. I was living my memories. To the people I talked with Algiers was impersonal, just another stop, another town on their march to victory. Tomorrow, elsewhere, I would be like them. But today I was a native.

I finally reached a five-story building with a wrought-iron doorway. The second-floor balcony had been ours. I went in and read the names on the brass-plated letter boxes and found that the family who had lived a floor above us was still there. I rang the doorbell. A white-haired woman opened the door. "Your face is familiar," she said. "Do come in."

We talked for a while. As I was leaving she remarked, "Where have you been all these years? Oran?"

(219) With actor Jean Gabin, then first mate in the French navy. I acted as postman for Gabin by seeing to it that Marlene Dietrich got his letters. Said Gabin when he gave me his mail, "This is my fourth letter to Marlene in three and a half days."

219

220

(220) Square Bresson, where children rode ponies and colored balloons were on sale.

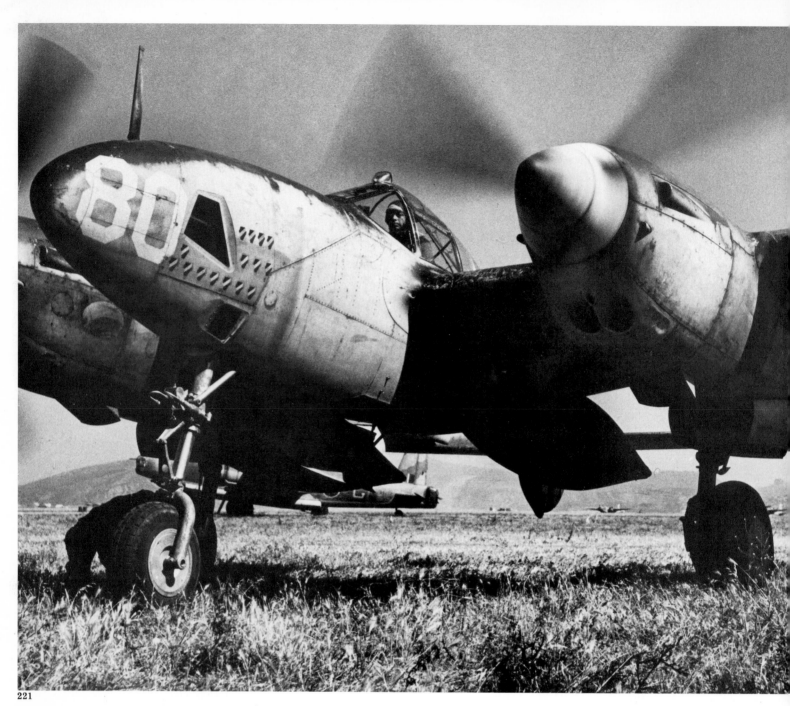

221

Saint-Exupéry's Last Flights

(221) Major Antoine de Saint-Exupéry about to take off on one of his last photo-reconnaissance missions over France.

(222) Saint-Ex, as he was known, in his bedroom in Alghero, Sardinia, where the Anglo-American-French photo-reconnaissance squadron was stationed.

(223) Portrait of Saint-Ex back from a war mission.

(224) Saint-Ex coming in for a landing with his P-38 "Lightning."

(225) Playing a word game with Saint-Ex.

(226) The last paragraph of Saint-Ex's "Letter to an American."

144

222

223

224

225

226

145

227

228

On the night of May 29, 1944, Saint-Exupéry wrote what has become known as "Letter to an American"—the American being myself. On July 31 he set off on a photo-recon mission over Nice and the Alpes Maritimes in preparation for the Allied landings in the south of France. Major Antoine de Saint-Exupéry never came back.

I first heard about him during the summer of 1939 while in Buenos Aires. An Argentine friend had told me about the young French pilots who, on a shoestring, had pioneered an airmail service that linked Paris to Patagonia. As I was about to leave for Patagonia myself, my friend brought me a book written by one of them. "Take it along," she said. "It will make good reading during your trip."

In the harsh light of the airport waiting room I started to read Saint-Exupéry's *Wind, Sand and Stars.* Looking up, I noticed that a stocky man in a leather flying jacket was peering at my book.

"Saint-Ex was my boss," he said. "He was very strict. Once when I was flying the mail south I saw him make a forced landing on the pampas. I landed to see what was wrong. He greeted me with an angry, 'I'm fining you two hundred pesos so you'll learn proper respect for the mail you carry.' According to Saint-Ex, I should have flown to my port of call, turned over the mail, and then reported his position instead of taking a chance myself."

The memory of this anecdote came back to me in the winter of 1944. I was in Algiers and had learned that Saint-Exupéry was there, too. I called him up. "Colonel de Saint-Exupéry . . ." I began.

"Major," he replied.

I told him I would like to meet him.

Looked at full-face, Saint-Exupéry displayed little sign of the many plane crashes that had broken almost every bone in his body. His worst crash was one in Guatemala where, as he liked to put it, he "learned about gravity" and was in a coma for eight days. One scar from this accident raised an eyebrow into a permanently quizzical look, while another gave his mouth a wry smile. He told me about pilots like Mermoz—lost in the south Atlantic—and Guillaumet—shot down over the Mediterranean—men he had felt close to and written about, men who came from a generation when aircraft, in their imperfections, still had human qualities, when pilots did not yet look like spacemen.

"I'm the last of them and it's a very strange feeling, I can assure you," he said pensively. He did not complete his thought but looked out toward the Mediterranean. Sitting there in the dusk, he was little more than a silhouette against the window. In profile his nose stood out with the mocking and insolent air that had earned him the nickname "*pique la lune.*" He shrugged his large shoulders and led me into the kitchen, where he prepared drinks. Mixing sweet muscatel with a harsh distilled wine, he set fire to the concoction instead of shaking it.

I asked him if he was doing any writing, as I knew that *Life* had long been trying to get him to do a piece.

"I can't," he said. "I have no right to say anything. I'm not participating in the war because I'm considered overage."

In 1940 he had flown reconnaissance missions recorded in *Flight to Arras.* While defeat roared through France, Saint-Exupéry was on a mission to gather information that was already worthless before he took off.

Now, in 1944, his old squadron had been reequipped with P-38s, known as "Lightnings," and they heralded a whole new age in aviation. Along with his friend René Gavoille, he was the last of his old squadron. Saint-Exupéry had recently been grounded for a crash landing. In his husky voice and humorous way he blamed an American officer for his misfortune. "He was anti-French," Saint-Exupéry complained. "You don't ground a man for that." The way he pronounced the word "ground" gave it a terrible implication: obsolete at forty-three.

He peered thoughtfully at his glass. "I want to write about what's happening. If you can get me reinstated in my squadron, I'll donate the text to your magazine."

I promised to do what I could, finding it unthinkable that Saint-Exupéry

was compelled to sit out the war in a gloomy Algerian drawing room. I knew Colonel Tex McCrary, who was on General Eaker's staff—and Ira C. Eaker was the one person with the authority to get Saint-Exupéry to fly again. Hoping Tex would present Saint-Exupéry's case to the general and somehow convince him, I flew to Naples. Saint-Exupéry came with me—he was AWOL as far as I could tell. In Caserta I saw Tex. He promised he would speak to General Eaker.

While awaiting the verdict, I got to know some of the various aspects of Saint-Exupéry's character. An outstanding mathematician, he would have been crestfallen if any of his friends solved the brain-convulsing problems he devised. His competitive spirit was such that he not only disliked losing but refrained from taking part in games which he seldom won. Yet he never got carried away by any game he excelled in. A chess prodigy, he had given it up for years after deciding that to be a chess master did not lead to anything beyond that. He was fascinated by biology, physics, astronomy, and philosophy, had patented a number of inventions, and was an accomplished magician. When in the mood, he could roll two oranges up and down a piano keyboard, producing sounds his listeners would have sworn to be Debussy.

229

During one of our word games, Saint-Exupéry told me how, quite unexpectedly, a delightful little creature with a sword and green cape had appeared in the upper right-hand corner of a sheet of paper on which he was writing. Others with less fantasy would have called this apparition a doodle. Not Saint-Exupéry. The small boy became "The Little Prince."

With great reluctance General Eaker cleared Saint-Exupéry for five more war missions. We took off together for Sardinia, where his squadron, the 2/33, was incorporated into the Anglo-American Third Photo-Reconnaissance Group based at Alghero.

Saint-Exupéry, delighted at being back with *"les camarades,"* kept us all spellbound at mealtimes. His conversation had the lightness of a verbal soufflé. His erudition bubbled up cheerily, though beneath the surface he was fundamentally pessimistic. His happiness was mitigated by the fact that victory would only prove what he already knew: the war had shattered the values he admired in the same way the roar of his P-38 "Lightning" drowned out the drone of his old plane. He felt that Man was disappearing as an individual—the phoenix to emerge from the ashes of the old world would be a robot. Or, as Saint-Exupéry put it, ". . . a world capable of producing perfect pianos on the assembly line but incapable of providing a pianist." He visualized future civilization as an enormous ant heap peopled with robots. Once, before he was to take off on a mission, I found him near his plane moving ants from one hill to another and contemplating the frenzy he was creating.

230

On May 29, after much groaning and sighing, Saint-Exupéry settled down to write. His room was a barren cell—the only valuables were an elegant Mark Cross suitcase and several Parker 51 pens. Fitting his large body into a small squeaky wicker armchair was as much of an ordeal as struggling into his flying suit. Pressing his feet together like a studious child, he scribbled neat rows of small black characters that slanted hopefully up the page. He kept a watch next to him, which he frequently glanced at to check his speed as if it were a dial on the instrument panel of his plane. The wicker chair squeaked as he looked up.

"Isn't it remarkable?" he said. "When I fly my Lightning it's not so much that I travel from one place to another as that all places come together. I breathe oxygen from New York in the sky of France." He wiggled his fingers, lit a cigarette, and glanced at his watch before returning to his small black characters. The chair creaked again as Saint-Exupéry stood up.

"I've finished," he said.

After going over the manuscript we went outside for some fresh air. Hands in pockets, Saint-Exupéry looked toward the horizon beyond which lay the French coast he would reconnoiter the next day.

We said goodbye, as I was leaving in the morning. I watched him stroll across the terrace and disappear into his room. Though I did not know I would never see him again, I felt sad.

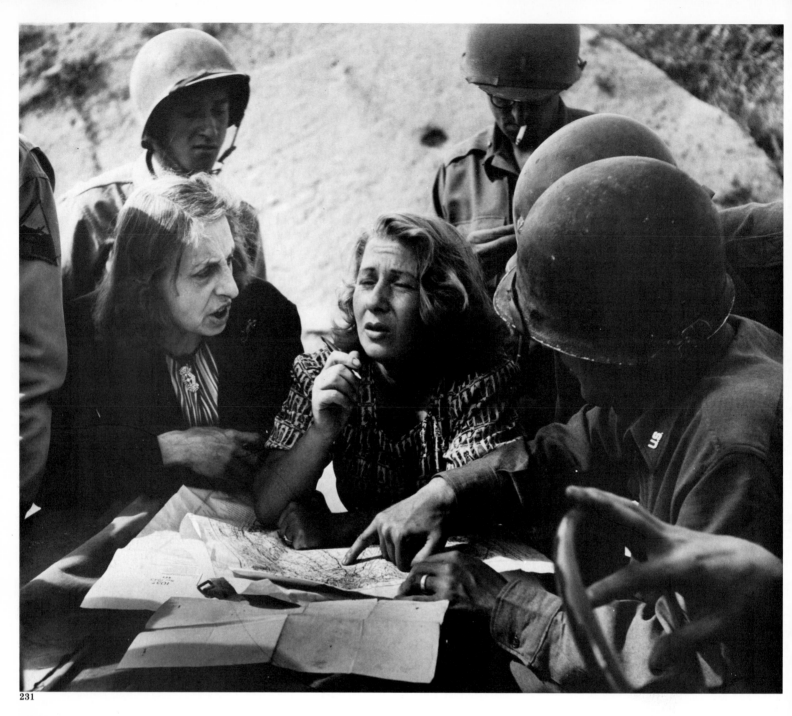

231

The Liberation of Rome

During the summer of 1943 I was with the 98th Bomber Group stationed in the Libyan desert near Benghazi. Every afternoon jeeps would drive up for the daily briefing. I always got an uneasy feeling when the briefing officer would say, "The target for tomorrow is . . ." At that very moment you knew with certainty that people about to sit down to dinner would be dead the following day. It was like reading someone's obituary before he died. One evening the briefing officer said, "The target for tomorrow is Rome." Any Catholics would be relieved from going on the raid if they wished. As the crews silently departed, the briefing officer called out half facetiously, "If one of you hits the Vatican, better not come back." These thoughts came to me later as I sat on a sidewalk in Rome surrounded by weary GIs. I could feel the tremendous excitement that lay beneath their apparent nonchalance, brought on by exhaustion. On this day, June 5, 1944, the sixty-fifth investiture of Rome was about to take place. An army from the United States was at the gates of a city that had been the center of the world seventeen centuries before America was discovered. On the same spot where triumphal processions of the Caesars started out and centurions had once stood, an American MP now waited to signal the start of the American army's entry into Rome. His name was Jimmy Declay, an Apache Indian from New Mexico.

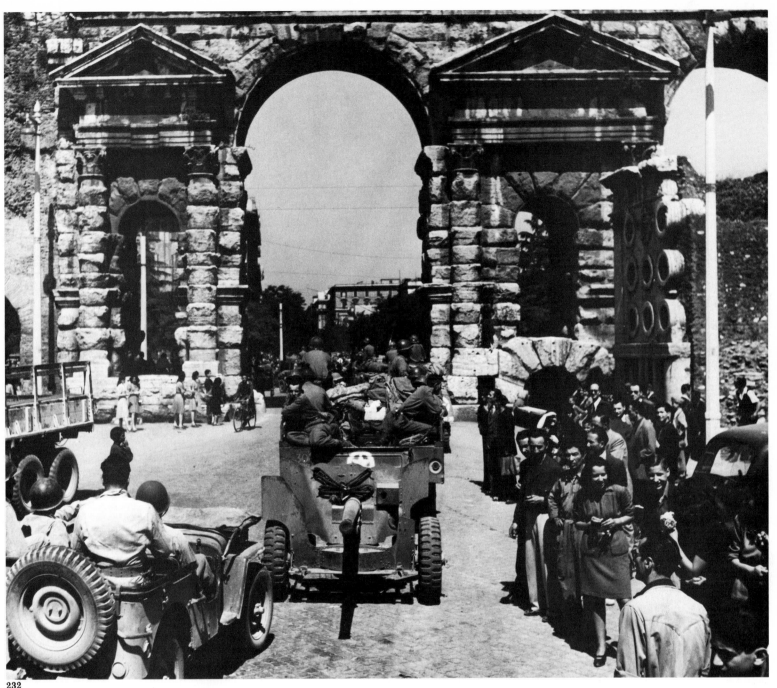

232

233

234

(231) On reaching Allied lines, two Italian women who escaped from German-occupied Rome collaborated with a U.S. intelligence unit to pinpoint enemy defensive positions in the city.

(232) June 5, 1944, at ten A.M.: the American army entered Rome for its sixty-fifth investiture.

(233) The signal to enter the city was given by Sergeant Jimmy Declay, an Apache Indian from New Mexico.

(234) A Roman boy peered from a balcony as the American army drove past.

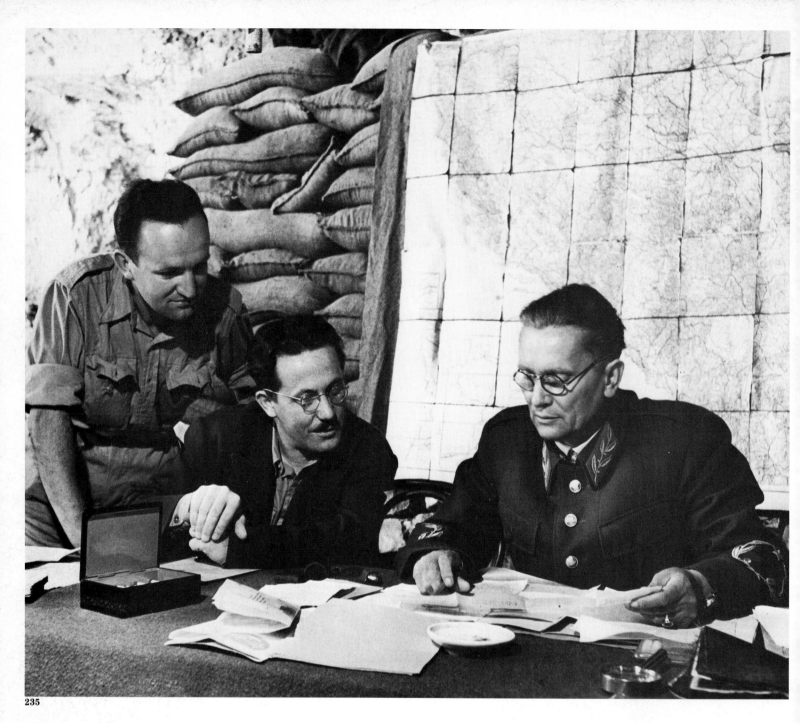

235

Tito

I first met Tito on the third anniversary of his uprising. His headquarters were located in a cave on the island of Vis, thirty miles from the German-controlled Yugoslav mainland. The cave was on the island's highest peak, accessible only by a footpath that skirted pockmarked boulders and clumps of dusty shrubbery. It was a hot July day in 1944. There was no one in sight until I came upon a sentry, who checked my credentials. I was the American pool photographer attached to Tito's partisans, or as they called themselves, the People's Liberation Army. Ahead I could see Tito's cave beneath an overhanging cliff on a natural plateau enclosed by sandbags and neatly stacked rocks. An orderly sat by the entrance. After nine months of grappling with British red tape, I was finally in sight of Tito's headquarters.

It was in Cairo in 1943 that I first heard about Tito, that his partisans led the fight against the Nazis. These reports conflicted with the royal Yugoslav government's briefings on Mihajlović and his Serbian Četniks. In typical Balkan style, there were two versions, but then there are always two answers to every question in the Balkans. I wanted to go and see which side was actually fighting the Germans. The British government had been favoring Draža Mihajlović and the royal Yugoslav government-in-exile, which explained its reluctance in allowing the press to join Tito's partisans. It had been easy for the military authorities in Cairo to keep Tito

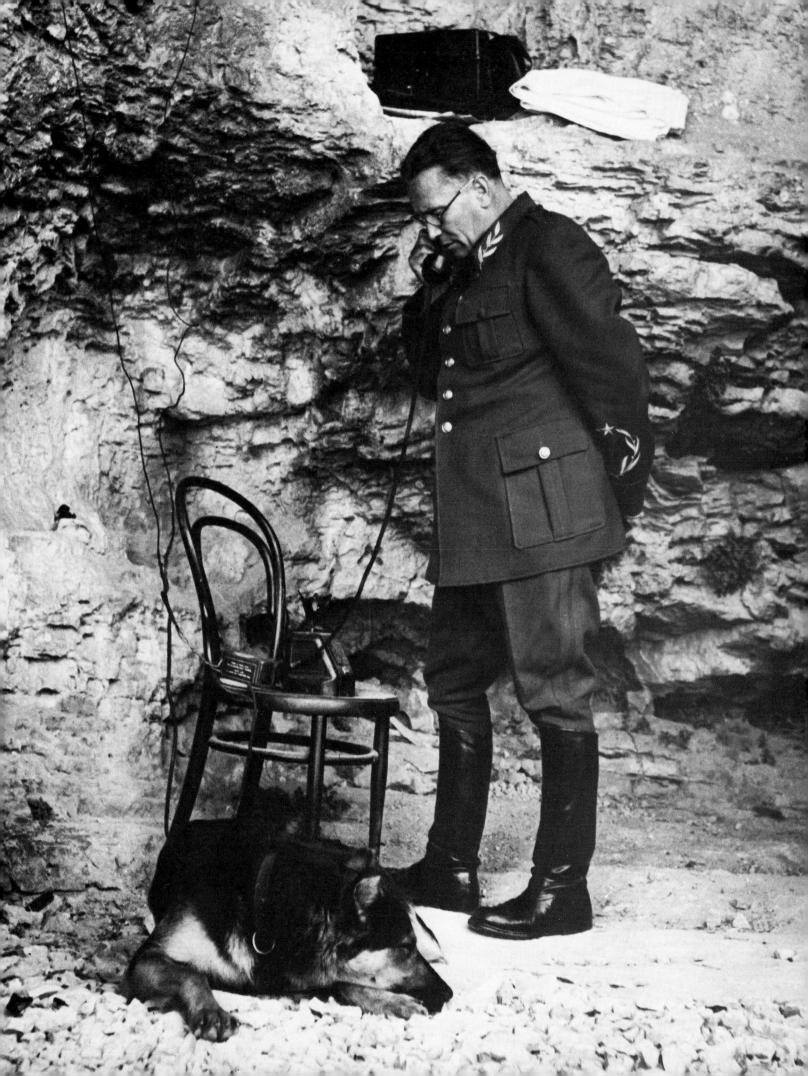

237

238

out of the news, since Yugoslavia was a British theater of operations. The situation improved after the Teheran Conference, when Churchill, having taken a fancy to the partisans, started referring to Yugoslavia as "Titoland." However, he was not prepared to jeopardize the monarchy's future.

As one disgruntled British officer had remarked, "There are three fronts in this war, old boy—the western front, the eastern front and Marshal Tito's front." It was more than a wisecrack.

I got my first glimpse of Tito through the half-open tarpaulin at the entrance to the cave. His face was gaunt, accentuating a wide brow and a strong aquiline nose. His blond hair was streaked with white. He was dressed as smartly as any staff officer. On this sweltering day he wore a heavy winter uniform—the only one he owned, I later learned. The heat did not affect his concentration. He wore a gold watch and, on his left hand, a gold ring with a good-sized diamond. (Thirty-four years later, when I last saw Tito, he was still wearing his diamond.) He was seated at a large table over which was spread an army blanket. Behind him a faded prewar map of Yugoslavia issued by the Royal Automobile Club was tacked to the wall. Above him two rolls of flypaper and two 25-watt bulbs dangled from a cord stretched across the cave. A worn leather briefcase bulging with papers rested on a nearby chair. I had expected to meet a dashing revolutionary, but the man I observed was a cool-headed chairman of the board. A German Shepherd slept at Tito's side. Hearing footsteps, the dog growled. Tito looked up. His blue eyes gave his strong, handsome face a cold, detached look that vanished when he smiled. He got up and walked over to me. A stocky man of medium height, his manner was cordial and relaxed.

"You can take all the pictures you like," Tito told me, "as long as you don't ask me to pose. They are more natural that way," he added, putting on his glasses. Then he forgot all about me until lunchtime.

Frequently he went to the map to study troop movements, made calls on the antiquated telephone resting on a chair at the mouth of the cave, pored over incoming dispatches, or dictated replies to his secretary, Olga Ninčić — daughter of the foreign minister in the royal Yugoslav government-in-exile, who considered Tito his greatest enemy. Much of the time Tito worked with his two close collaborators, Edvard Kardelj and Vladimir Bakarić. Kardelj, who looked like the schoolteacher he had once been, was a Slovene; Bakarić, whose father had been a judge who sent Tito to jail, was a Croat.

When lunchtime came an orderly cleared away Tito's paperwork, spread a tablecloth over the army blanket, and set the table. Meals were a form of relaxation for Tito. He served white wine from the island, enjoying both the food and the company. A good conversationalist, he had a flair for the telling detail and seemed to have total recall. While he shied away from personal questions, he would casually reveal unexpected facts about his life through anecdotes. At lunch he recollected the time he had been sentenced as a political prisoner to hard labor. Tito had decided to improve his education by reading the Greek philosophers. "The Greek philosophers!" the warden guffawed. "Haven't we got enough philosophers around here?" As I studied Tito throughout the meal it struck me that neither the six years in jail nor the strain of leading the partisan war had sapped his energy. He was a young fifty-two and nothing about him suggested that the hardships of his past had left him bitter or resentful. His basic strength, I felt, lay in an unshakable self-confidence and utter belief in his cause. Now that I think about it, he was the only Communist leader I ever met with a sense of humor. (Once when a journalist remarked that Yugoslavia was a bridge between East and West, Tito agreed, adding, "But there's too much traffic.")

After coffee was served, Tito talked about the time he was the most wanted man in Yugoslavia. He felt safe because the police in those days thought of Communists as being unshaven men in shabby clothes and cloth caps who traveled third class. A fastidious dresser, Tito traveled by air and used a pseudonym to match his appearance: Engineer Slavko Babić.

Late one afternoon a detective more perceptive than his colleagues trailed Engineer Babić. Noticing that he was being followed, Tito sauntered into a store and purchased a Turkish coffee set for twelve. The policeman was thrown off the scent. "Who would suspect the secretary general of the Yugoslav Communist Party of buying a coffee service?" Tito chuckled.

The conversation turned to partisan warfare and Tito remarked: "Usually when surrounded by the enemy you surrender. But in our case that was when we started to fight."

I found it difficult to associate my genial host with the shadowy person he was to the world at large. Yet Tito was then the most mysterious political figure of the time. Although he explained to me that the name Tito was common where he came from, the man it represented in 1944 was the subject of many rumors, the most preposterous being that no such person existed and that the name Tito was an acronym for "Third International Terrorist Organization."

For most of his adult life anonymity had been a safeguard. Tito's true identity would remain hidden until November 29, 1943, the day he became head of the provisional government. It was then revealed that Tito was Josip Broz, a peasant born in Kumrovec—a Croatian village across the river from Slovenia—and had been a subject of the Austro-Hungarian Empire. His formal education ended at age twelve. At fifteen, Josip Broz went to work as a waiter before becoming a locksmith's apprentice. On completing his three-year apprenticeship, young Broz traveled around the Austrian empire picking up several languages and such varied experiences as test driving Daimler cars. Broz wanted to emigrate to the United States, but his father was unable to finance it. (When I asked him what he would have done in the States, he replied, "I'd have become a millionaire.") He did his military service in a Croatian regiment of the Austro-Hungarian armies. There he put into practice his theory of always keeping busy: he took up fencing and became regimental champion. In World War I Broz's regiment was sent to the Carpathian front to fight the Russians. Severely wounded, he was taken prisoner and sent to Russia. When the October Revolution broke out in 1917, Josip Broz, whose background had been misery and rebellion and who felt a strong affinity for the Russians as "Slav brothers," joined the Bolsheviks. In 1920 he returned to Croatia—now part of a new state soon to be named Yugoslavia. During the years that followed, Broz became a union organizer for the metalworkers and on occasion displayed the cool-headedness that would serve him well in the years to come. One afternoon in 1928 Broz was standing by an open window in the trade union office when the police broke in. "Where's Broz?" one shouted.

"He went that way," Broz said, pointing to a door on the left. As the police charged through the door he leaped out the second-floor window and walked up the street.

Eventually he was caught and tried for Communist activities. His defiance earned him the maximum sentence of five years. Within days of his release he disappeared into a world of illegality. Nothing more was heard of him until he reemerged in 1943 as Tito, head of the provisional government. During his ten years of anonymity—as I was later to learn when I worked on "Tito Speaks," his autobiography for *Life* magazine— Josip Broz had traveled on Canadian, Austrian, Swedish, and Czech passports. It was during that period that he became secretary general of the Yugoslav Communist Party.

The spirit of independence Tito displayed on Vis toward the British was typical of him. Soon after the Comintern made him secretary general, Tito decided that, unlike the other Communist parties, he would no longer accept Soviet financing because it would compel Yugoslav Communists to obey the Russians. This was to be a first step in his conflict with Stalin.

Night had fallen by the time I left Tito. Turning back, I saw him outlined against the starry summer sky. "We shall meet again," he called out. Although his words had a prophetic ring, I could not have imagined then that one of these occasions would be at the White House.

239

240

153

The OSS and All That

While on the isle of Vis waiting to see Tito, I had been a guest of Brigadier Fitzroy Maclean, in command of the British military mission to Tito's partisans. The billet was a comfortable villa overlooking a booby-trapped vineyard and a beach. Copies of *Country Life, The Bystander* and *Punch* lay around. We drank gin and lime. Major Randolph Churchill and Captain Evelyn Waugh completed the country-club atmosphere. Waugh looked to me like an English schoolboy seen through a magnifying glass. Curious about this man who saw only the ridiculous side of our civilization, I joined him one evening while he was taking his "constitutional." On the subject of education he told me he considered his father better educated than he was, while he himself was better educated than his son. This he put down to the decline of Greek studies. Changing the subject abruptly, he asked me, "Have you met her ladyship?"

"Her ladyship?" I asked, surprised.

"Tito," Waugh said with the utmost seriousness. "Didn't you know?"

"But he's married and has a son," I protested, feeling foolish.

"Who's her husband?" Waugh wanted to know.

I was not the only one Waugh had subjected to what he called "his tease of Tito." The entire island had heard about it, as it turned out—even Tito.

I had mentioned my conversation with Waugh to Stojan Pribicevic, an American journalist of Yugoslav extraction. To my horror, Stojan repeated it to Tito, who burst out laughing. After removing his glasses and wiping his eyes, he said, "If Captain Waugh were not an English gentleman and I were not a Croat peasant, I'd prove to him I'm a man."

Several years ago I learned the end of the story. Soon after I left Vis, Tito came down from his cave for a swim with Fitzroy Maclean. Maclean introduced his officers. When he got to Waugh, Tito—in a tight bathing suit—studied him with his piercing blue eyes and, turning to Maclean, said, "Please ask Captain Waugh what makes him think I'm a woman."

After photographing Tito I returned to Bari in southern Italy in the latter part of July 1944. My assignment was to join the partisans on the mainland and report their war in occupied Europe. To get there I had to go through the SBS—the Special Balkan Service—which dropped men and materiel to the resistance groups in occupied Europe. Because of the kind of guerrilla warfare the partisans fought, the territory liberated by them continually shifted, making drops in the area erratic. I had to wait seven weeks for an opportunity to go in. Twice a day—at noon and six—I phoned my British contact to find out if I was "on," invariably receiving the reply, "They're in movement. We can't land planes. Call again."

After all those weeks on alert I was lulled into regarding my daily calls as routine and organized my life around them, even making plans several days in advance. I spent my evenings at the OSS bar, frequented by a most unusual clientele—men of differing nationalities and backgrounds, from professional killers to archaeologists. No one asked personal questions or was curious about your accent. By two in the morning the explosives specialists were back to their favorite topic: how many bangalore torpedoes would it take to bring down the Eiffel Tower? To these men there was an elegance in blasting and a chic in the minimum use of explosives.

The closest I ever came to being confided in was by a lusty Hungarian. "In my branch," he said, "we deal in fuck or shit. I'm in shit." He was talking about the nebulous world of propaganda, deceit, and dirty tricks performed by Allied agents in the German-occupied territories, referred to as "black activities." Although the OSS extended drinking and other privileges to me, I was not a member of that organization. Several British intelligence chaps up the street got the erroneous idea that I was using *Life* as a cover to keep an eye on their operations. (In 1974 I learned this indirectly from my dentist, Dr. Paul Baerger. While in Paris he got into conversation with a retired British major. The talk turned to Bari and the war. My name came up and the major was surprised to learn I was in fact a *Life* photographer.)

My interest in Tito's partisans was due in part to my French education. André Malraux's books, particularly *L'Espoir (Man's Hope)*, which dealt with the Spanish civil war and its politically motivated fighters, had

241

(241) As World War II correspondent.

154

greatly influenced my generation. The Yugoslavs who had fought in the International Brigade on the Republican side were in great part Tito's young generals. The more I thought about Tito's remark—"Usually when surrounded by the enemy you surrender. But in our case that was when we started to fight"—the more convinced I became that the partisan style of warfare was a new force in the world, which I wanted to photograph. This kind of warfare proved to be so unconventional that in spite of the partisans' successes, the more conventionally minded military refused to recognize its effectiveness or its implications. Had really top military minds with enough clout made a thorough study of the politico-military aspects of partisan warfare, they might have helped prevent the French wars in Indochina and Algeria, along with the American intervention in Vietnam. What I did learn about partisan warfare can be summed up in this paradoxical axiom: Partisans do not need to win a war to be victorious. All they need do is keep the guerrilla warfare going on indefinitely, thus preventing the conventional forces from subduing the country. In the long run public opinion at home will oblige the conventional forces to withdraw, as the French did in Algeria and the Americans in Vietnam.

There was another reason this war appealed to me. I am a loner and, as such, preferred being the only photographer behind the lines in the Balkans to being a member of the team covering the invasion of Normandy.

As an American correspondent about to join the partisan forces, I was eligible to draw supplies from the British, since Yugoslavia was within their theater of operations. "You Yanks have much more of everything than we do," the supply officer said to me, "but I can highly recommend our duffle coats. Unfortunately, we're out of them."

Had I taken all the supplies offered me by the OSS, I could have operated a small PX. I did put in a requisition for a gross of condoms and was told, amidst much hilarity, that this was pretty ambitious on my part, considering the notorious chastity of the partisan women. Actually, I used them to slip my exposed rolls of film into and, once knotted, they could get soaked without my work being ruined.

Everything about the OSS was secret and illegal. A staid young newly drafted bank clerk let out a howl of protest when I asked to exchange dollar bills for gold Napoleons—the only currency acceptable to Eastern European peasants. "Don't you realize this is a federal offense in the States?" the clerk complained. "But here," he added, "the more illegal things are, the better." He waved a bundle of German marks at me and shook his head. "See what I mean? I even handle enemy currency!"

In Slovenia I was reminded of him when eight Austrian Communists in American uniforms were flown into our zone. They were being infiltrated into Austria to set up communications. I could just imagine the young clerk exclaiming, "And now we're dealing with the enemy!"

I was at the OSS bar one evening during my sixth week on alert. It had been unusually quiet—no fights had broken out between the Americans assigned to Tito and the Americans with Mihajlović. The latter, for the most part Serbian American, still endorsed his cause—which was to defeat Tito and restore the monarch after the Allies won the war—even though it was known that Mihajlović was collaborating with the Germans. I was seated alone when a swashbuckling blond captain who bore a resemblance to Errol Flynn strode up to me. His name was James Goodwin. He had just come out of Slovenia where he was in charge of Fitzroy Maclean's military mission. Facing me, hands on hips, Goodwin said that if it was war I wanted instead of hanging around the OSS bar, he would gladly see that I got a good taste of it. He was soon to be parachuted back into Yugoslavia carrying instructions for a combined Allied-partisan operation. "If you've got the guts," he said, "I'll take you into Germany."

As Goodwin recalls it, he heard a knock on his door the next morning and found me standing there. At first he thought I had come to pick a fight because of his aggressiveness the previous evening.

"When do we go into Germany?" I asked him.

This is how I participated in the attack on Litija bridge carried out by partisan forces in Greater Germany, an operation code-named "Rat Week."

242

(242) Loading barrels of gasoline for Yugoslav partisans at their southern Italian base in Monopoli.

"Rat Week"

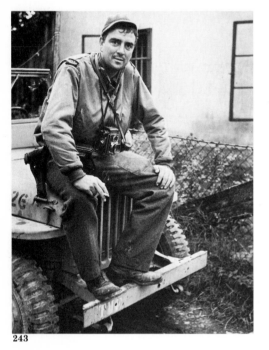

(243) *Behind the lines at Base Twenty, the Slovene headquarters in liberated Yugoslav territory, 1944.*

(244) *Base Twenty seen through the trees.*

In late September 1944, the Allied command requested that Tito's Slovene partisans make an all-out attack against a railroad line leading into northern Italy. For several years the partisans had been hacking nightly at this vital railroad network. It was a task without end, for Germany's Todt Organization, with its efficient work teams, could rebuild as fast as the partisans destroyed.

The fortified bridge at Litija, which spanned the wide Sava River, was picked as one of Operation "Rat Week's" targets. Once destroyed, it would take weeks to rebuild and, for a time at least, the strategic Zagreb– Ljubljana–Trieste railroad line would be out of commission. The line was essential to the German army in Italy.

This was the plan Captain James Goodwin had in mind when he barged into my life at the OSS bar in Bari. A week after Jim jumped into Slovenia, my contact told me, "You're on for tonight." At Bari airport I was harnessed into my chute by a cheerful cockney sergeant who warned me, "For Christ's sake, sir, be careful or you'll castrate yourself if you have to jump." I had just been stripped of my identity to become a member of the "Piccadilly Club" en route to join "Flotsam." The DC-3 I was assigned to was a cargo plane loaded with crates of ammunition, which meant our plane would land to unload its cargo and I would not have to jump. As we

took off over the Adriatic at dusk, I realized my status was the same as the crates I was sitting on: a consignment to be delivered, if possible. For the next four hours I would have no control over my life, which depended on such extraneous factors as not being spotted and picked off by a German night fighter as we flew over enemy territory.

We made a smooth landing on the field lit by the flickering lights of a line of flares. Jim was waiting for me. We drove to Base Twenty, military headquarters for all operations in Slovenia. Hidden in a pine forest and invisible from the air, it was the nerve center of partisan resistance in Slovenia: an operations division, hospital, stenographic department, workshops for all repairs from watches to weapons, an office for mimeographing newspapers, and log cabins for officers and personnel. Great attention was paid to the cooking fires so that no smoke drifting through the trees could be spotted by German reconnaissance planes.

In the operations division General Stane, a five-foot-two veteran of the Spanish civil war, drew up plans with his staff for the attack beneath the benevolent gaze of Stalin, Churchill, and Roosevelt, whose framed portraits hung above them. It was to be a major operation: three brigades were committed, and Jim Goodwin had managed to get the support of six fighter planes from Italy equipped with medium bombs to lead off the attack.

(245) *General Stane (leaning over table) planned the attack on Litija Bridge in Greater Germany as part of Operation "Rat Week."*

(246) *Partisan G-2 coordinating "Rat Week" operation.*

157

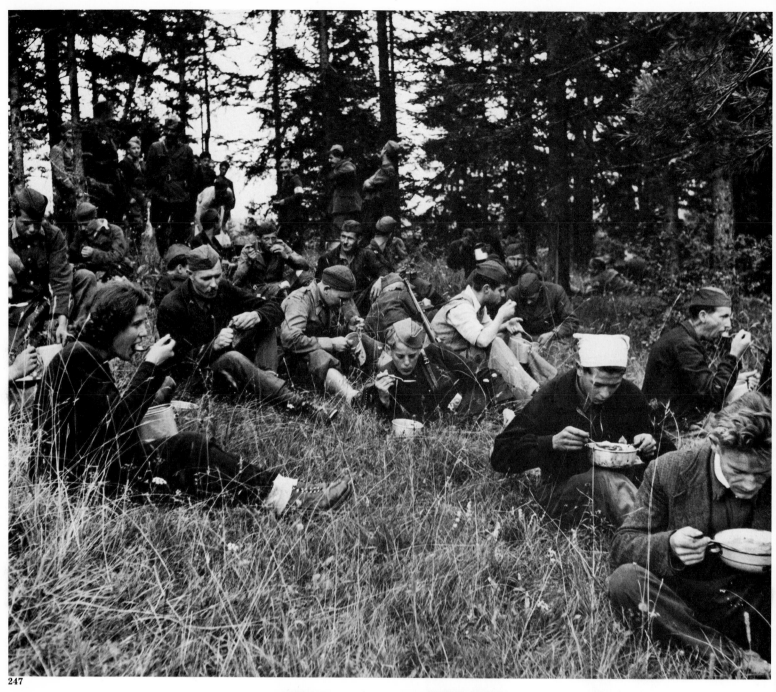

(247) Members of the partisan brigade who were to take part in the attack on Litija Bridge being served meat, an indication they would soon be in for a rough time.

(248) Partisan chow line.

(249) A partisan guards the plastic explosives required for the attack against the bridge.

(250) Partisans packing explosives.

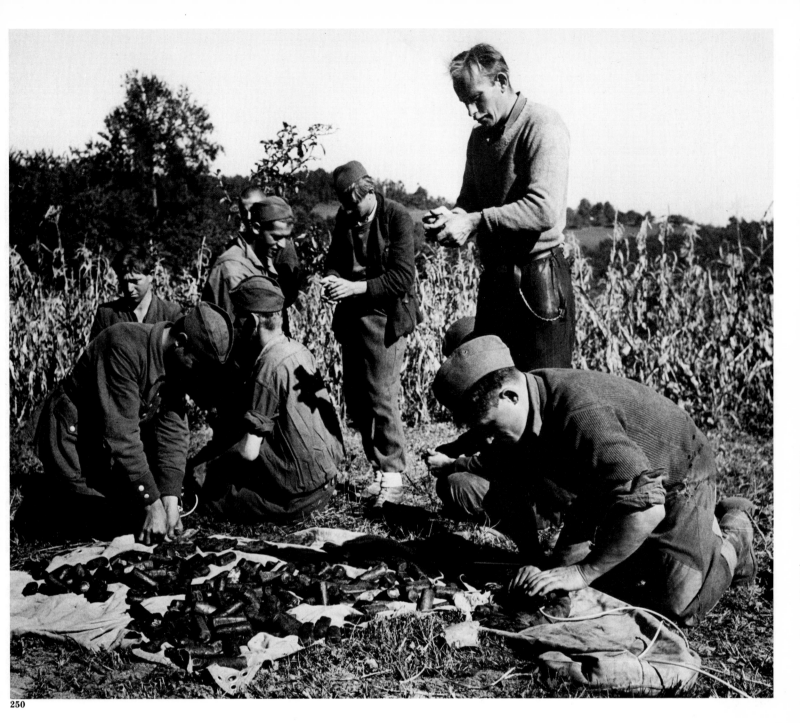

Most partisan operations were conducted at night, but for a change the attack against Litija was scheduled to take place in daylight, which meant that I could take pictures. We drove from Base Twenty to the point where we crossed the German-controlled road that led to Ljubljana. We hiked to Poljane to join the Fourth Partisan Brigade, named the Matije Gubec Brigade in honor of the sixteenth-century hero of an unsuccessful peasant uprising who was burned in Zagreb's main square. Poljane was in territory controlled by the White Guards—a Slovene outfit that collaborated with the Germans. To prevent word of our presence from leaking out, partisans patrolled the outskirts of the village. One woman caught smuggling out information was shot trying to escape. We spent two days at Poljane waiting for the explosives needed to blow up the bridge. Shaped like sausages, the translucent greenish explosive exuded a sickly sweet smell. Partisans packed the plastic around a two-meter-long fuse and shaped it into bundles that looked like loaves of bread. Only Captain Jesen, the brigade commander, Jim, and I knew our objective. Everyone else suspected something big was coming up, because they had been served meat. In anticipation of the operation, partisans cleaned their weapons, got deloused, and shaved. They had just marched seventy-five kilometers to take part in the operation. Most of their free time they slept.

159

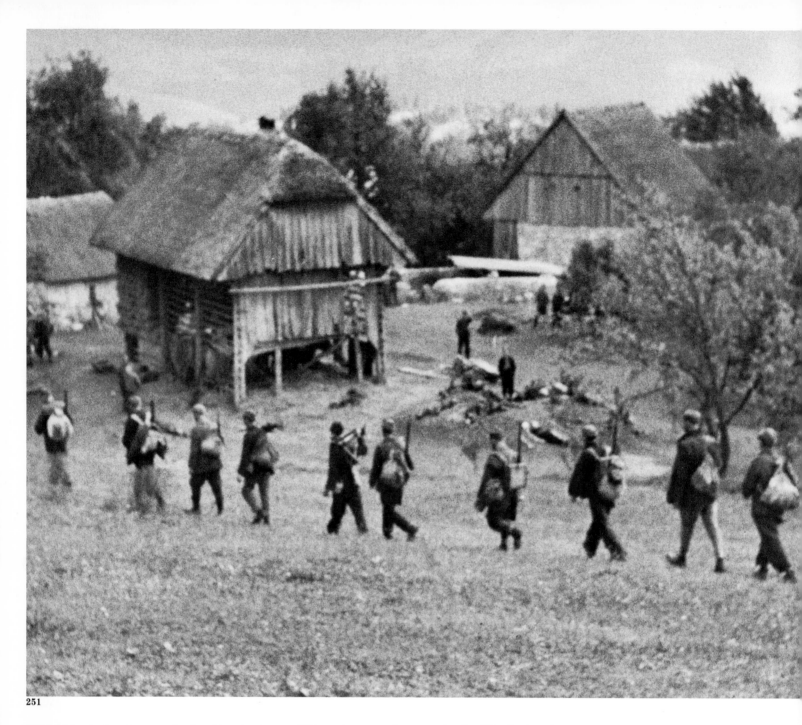

251

(251) The brigade marched off in single file toward the Greater Reich and Litija Bridge.

We got our orders at dusk. The brigade was made up of men and women of all ages and classes, with as much diversity in their uniforms. Some had been donated by the Allies, some captured from the enemy, and some were leftovers from civilian life. The same was true of their weapons. All this gave the partisans a strange revolutionary appearance, yet there was something else about the long line of marching men and women I could not place. It nagged me. "We're going to be as green as a couple of lilies fresh from the garden," Jim said. "These partisans have been at it for three years now and they believe their war will be remembered for a thousand."

"That's it!" I thought. "It's an epic they're living."

We marched side by side. Dusk was approaching and the hills took on odd shapes. The stars began to come out but we could still see the dusty white road ahead. We marched on, sweating profusely in spite of the chilly air. With nightfall we formed a single column along which verbal commands were passed so as to keep eight hundred men marching in the dark in contact: "*celo stoj*" (vanguard stop); "*kolona*" (single file); "*tisina*" (silence); and "*naprej*" (advance). We filed past the battered Italian frontier post—a hundred yards ahead of us, behind those massive open gates, lay Adolf Hitler's Greater Reich, which we had come to gnaw at. On reaching the first village occupied by the Germans, we left the road to

160

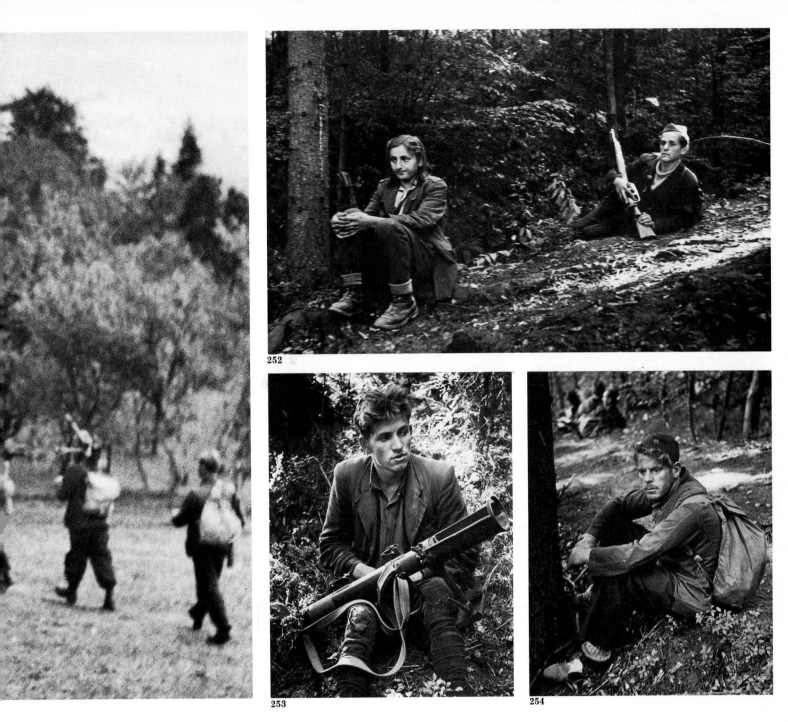

252

253

254

(252-254) Shots of partisans hidden in woods one kilometer from Litija Bridge taken only minutes before the assault, still unsuspected by the enemy.

bypass the garrison and took a winding lane, entering a forest. Suddenly feeling alone, I started to run and fell over Jim. He was holding onto the raincoat of the partisan in front of him so I grabbed the strap of his carbine while the partisan behind me seized my musette bag. I could not see where we were marching and only knew we were headed downhill when Jim's carbine would be yanked nearly out of my hands. When we went uphill, I usually stumbled over him. And so, some eight hundred of us, hanging onto one another, unable to see where we were running so fast, plunged forward in the dark. By dawn we had cleared the last German garrison. It had taken us close to fourteen hours to reach the village from which we would launch the attack. Headquarters was established in a farmhouse. I was too tired to marvel that almost a thousand men could be within two miles of the enemy without his being aware of us. Then I fell asleep. It seemed only minutes later that I was awakened. Jim and I moved into the forest where the detachments had taken up their positions. Crouching behind trees with their weapons on their laps, the partisans waited. At 4:30 the six Mustang fighters came over. From each I saw two black grapes detach themselves from the wings and come hurtling down. The crunch of these bombs mingled with the sound of German flak. The planes disappeared. Now it was up to us.

(255) *Litija Bridge.*

(256) *First wounded being carried back.*

(257) *Partisans running toward the bridge.*

(258-259) *Attack on the bridge.*

We reached a road leading to the bridge as the Germans started to drop mortar shells. After taking a picture, I flung myself down at Jim's side. As the men moved forward, we got to our feet. "Let's take the castle before they have time to get organized!" Jim shouted, moving up toward the bridge's line of defense. Mortars were covering the road and Jim vanished in a puff of black smoke. He was dazed. "If Saint Peter had said, 'Congratulations, you've made it,' I wouldn't have been a bit surprised," he muttered, getting to his feet. More mortar fire made me take cover. A shout came up: "The Amerikanec is wounded." Jim was still holding his carbine. His left pantleg was soaked in blood. He was supported by a partisan and very pale. I threw my arms around him, shouting in the midst of the din, "You're okay, Jim, you're okay."

"John," he said, "I'm going to faint. Don't let them cut my leg off."

We helped him toward an embankment and seated him there while a partisan went in search of a stretcher. A young nurse slit the leg of his pants and wrapped a bandage around the many wounds. I lit a cigarette and passed it to Jim. It was only then I noticed a middle-aged German soldier sitting next to him. He had been wounded by the same grenade. Blood streamed down his face but he was laughing, happy to be alive. I handed him a cigarette, too. A stretcher arrived and we laid Jim on it.

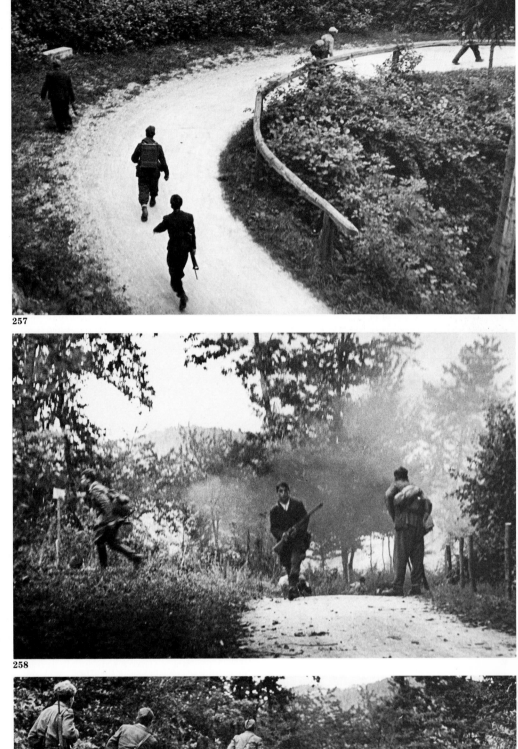

257

258

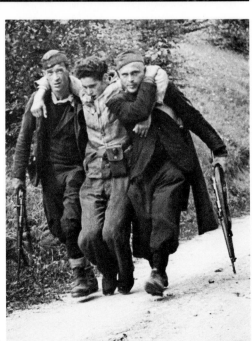

256

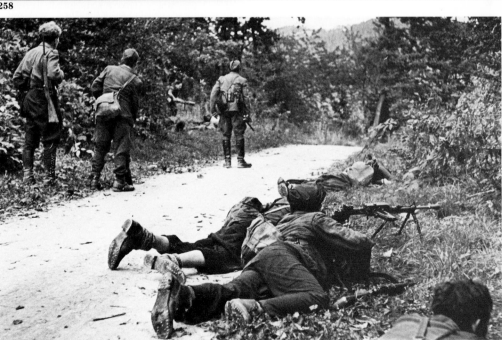

259

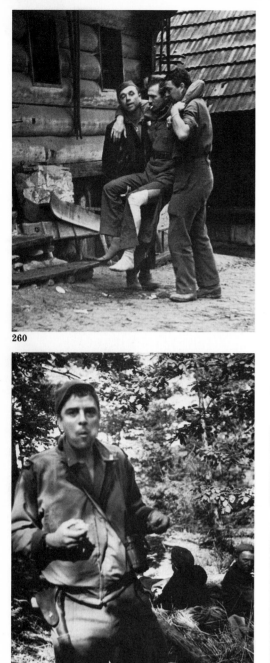

260

261

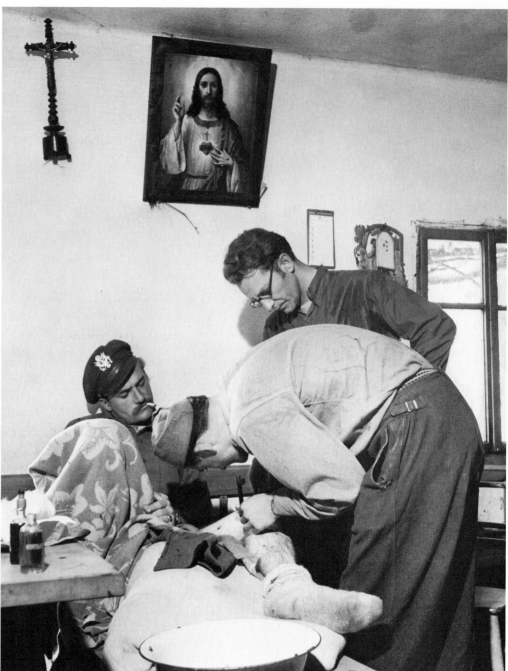

262

It seemed to take hours to reach the village. We found the first-aid station in a small farmhouse at the end of a dark lane and carried Jim in. There were two low-ceilinged rooms. A partisan followed the doctor around with a kerosene lamp. The floors were covered with straw on which lay many wounded men. The doctor, a civilized-looking middle-aged man, apologized that there was no bed for the American officer. "What can I do? I have nothing." I looked around at the unconscious figures groaning in the flickering light. "Dreadful, isn't it?" the doctor said in quiet fury. "Amputations are performed without anesthesia. Our bandages are made from old shirts we remove from the dead." Following this outburst, he blushed. "Could you please give me a cigarette?" Skillfully he proceeded to clean the twenty-three wounds in Jim's leg. Next to Jim a man in a traction splint was dying to a chorus of delirious moans.

"I can't spend the night in here," Jim said. "It's terrible." I took him outside. The cool air made him feel better. I fell asleep to the continuous sound of gunfire and slept until awakened by the deep rolling boom of explosions. Shaking Jim, I shouted, "Listen! The bridge, Jim, the bridge! They got the bridge!" Dawn came.

"We will move as soon as we've buried our dead," the doctor said. Ahead lay the long march back to liberated territory.

164

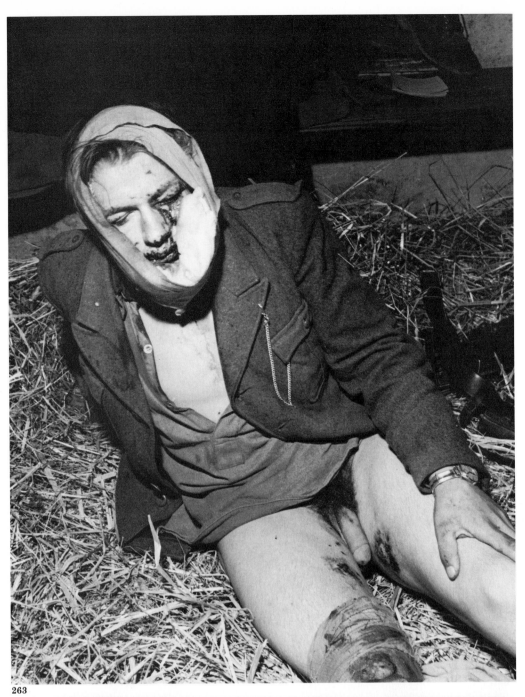

263

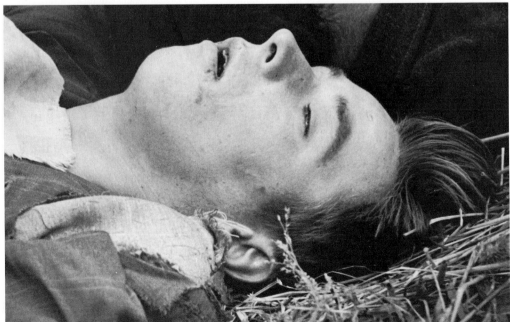

264

(260) A partisan and I carrying Captain James Goodwin—the American officer in command of the Allied mission to Tito in Slovania— who was wounded during the attack.

(261) In Greater Germany.

(262) Partisan medics tending Goodwin's leg wounds.

(263) Partisan wounded in the attack.

(264) Dead partisan.

(265) Goodwin in ox-cart as partisans retreated to liberated territory.

(266) Column of wounded partisans.

265

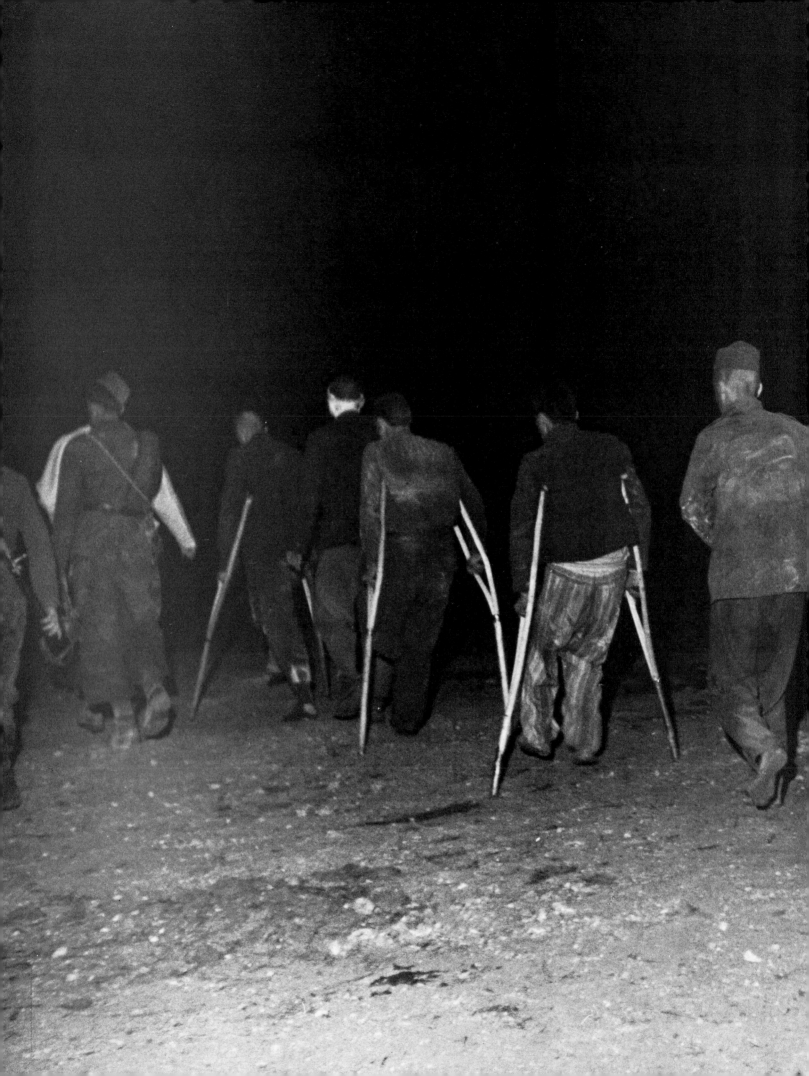

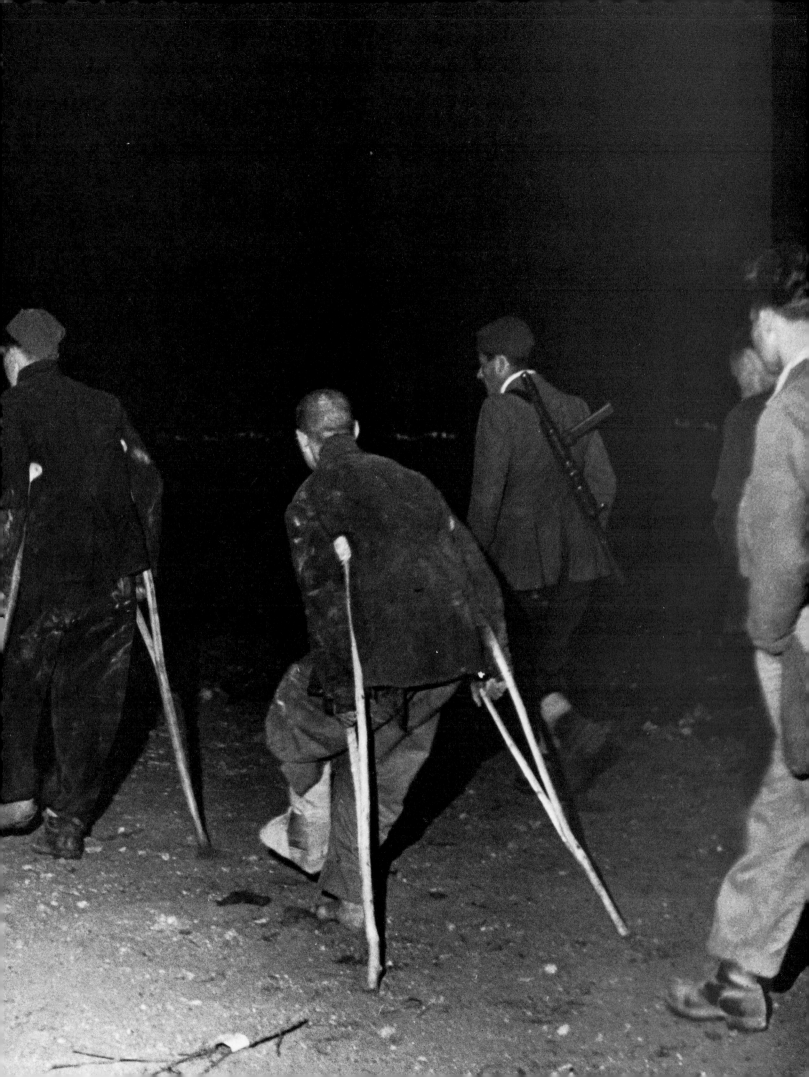

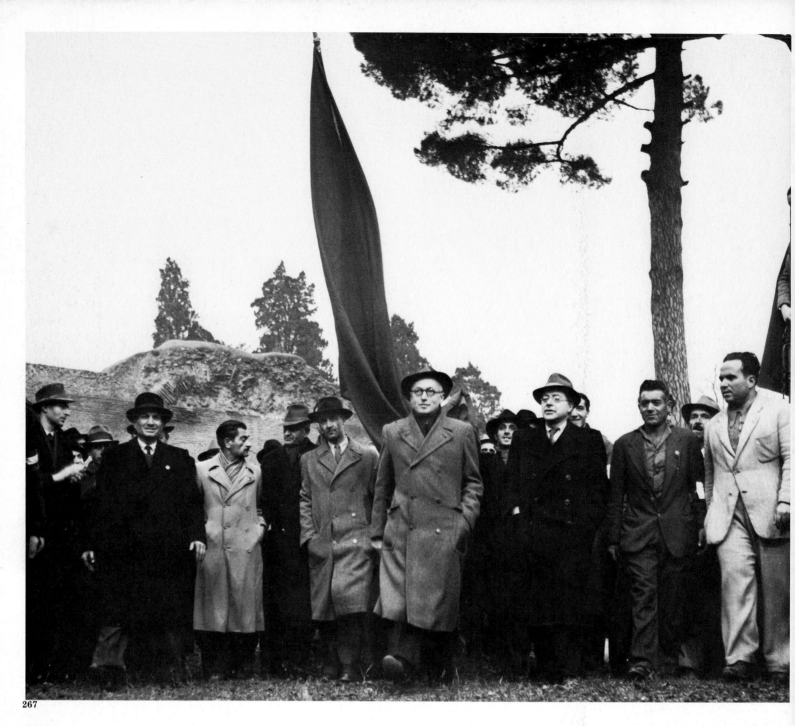

267

The Left Rallies in Rome

(267) The first joint Communist-Socialist meeting since Mussolini had taken power was held on November 12, 1944. Main speakers were Socialist Nenni (light overcoat) and Communist Togliatti (dark overcoat), who addressed crowds (268) at the Domitian stadium on Rome's Palatine Hill.

On November 12, 1944, the Italian Communists and Socialists held their first joint meeting since Mussolini had seized power. Depending upon the political affiliation, the newspapers estimated the crowds at the Domitian stadium on Rome's Palatine Hill to range from twenty-five to eighty thousand. All had come to hear Palmiro Togliatti, the Communist, and Pietro Nenni, the Socialist, harangue them. (When I photographed Togliatti during the winter of 1944 on his return from Russia, where he had lived since 1926, he boasted that nobody, not even OVRA, the Italian Gestapo, had taken his picture over the past eighteen years.) The Socialist Nenni spoke first. Out of office, he violently opposed the prime minister. Togliatti, as minister of justice, was more tactful. Tact had always been his forte. When the new Italian constitution was being debated in 1947, everyone wondered how the Communists would vote on Article 7 — that is, whether the concordat between Mussolini and the Vatican would be maintained or rejected by the Parliament. Would political ideology or expediency win out? Togliatti voted for Article 7. He justified this vote by stating that, as the Communists were an Italian party, they were mostly Catholics and he intended to maintain peace between the party and the Church. The mothers of Italy felt reassured, which explains why the Italian Communist Party was so successful with the middle class.

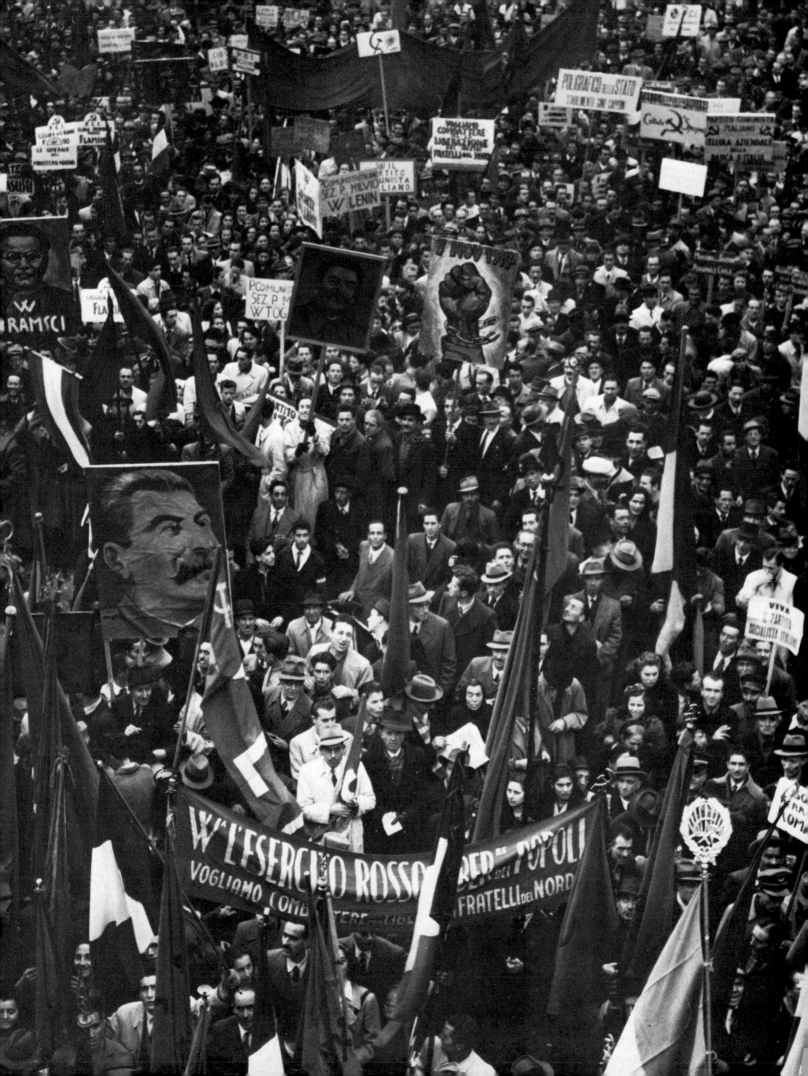

Up Front with Bill Mauldin

269

270

(269) *Bill Mauldin's cartoon illustrates how he recalls our encounter with the Roman waif.*

(270) *Mauldin sketching cartoon of Willie and Joe, the characters he created for* Stars and Stripes.

(271) *Mauldin with a couple of GIs in the mud of northern Italy.*

The day after Halloween 1944, Bill Mauldin, the *Stars and Stripes* cartoonist, drove me up to Fifth Army. This was the second winter of a campaign Mauldin aptly summed up as "mud, mules and mountains." At twenty-four, Mauldin looked a mischievous eighteen. He was the personification of Willie and Joe, the two characters he drew for *Stars and Stripes*, and they in turn were a synthesis of all GIs. We got the pictures I needed for the story at a company rest camp. Night caught us in the mountains on the way back to Rome. Around a bend we came upon a solitary figure by the side of the road. Bill stopped the jeep and backed up. A young girl was standing there without a coat, two large sacks at her feet. She had left Rome four days earlier in search of food "*per la famiglia*" and was trying to get a lift back. Bill told her to hop in. Fifteen miles from Rome we ran out of gas. I flagged down the first car I saw. It was a staff car with a two-star general. Bill casually tossed a blanket over the girl and poured the jerrican of gas the general's driver gave us into the tank. We dropped the girl off somewhere near the Colosseum and left her calling out "*Mamma! Mamma!*" Bill and I had committed an infraction by giving her a lift. It was forbidden for unauthorized people to move food to the city. We had helped her because it was obvious she was not a black marketeer. She could have earned much more selling herself on the Via Veneto.

272

Victory in Europe

273

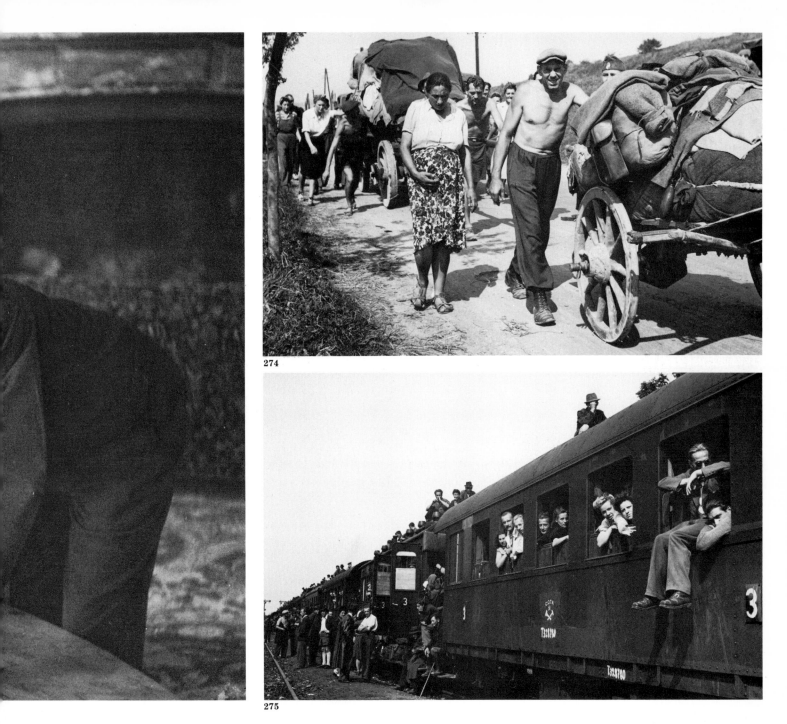

274

275

The war in Europe was over. I was back in Austria with a brand-new passport, having just become an American citizen. Lines of refugees straggled home on foot from concentration camps while others made their way aboard overcrowded trains frequently held up at sidings to make way for Russian flatcars heading east loaded with booty. Salzburg was in the American sector and, with the encouragement of the United States, the music festival opened on August 12 as usual. That weekend Mark Clark, the American commanding general, invited Lieutenant General Sir Richard L. McCreery, the British C.G., Lieutenant General Marie Emile Bethouart of France, and Colonel General Alexis Zheltov, Marshal Ivan Koniev's deputy, to attend the gala opening night. That afternoon host Mark Clark drove his guests across the border to visit Hitler's home at Berchtesgaden. After glancing at the view from Hitler's famous bay window, the generals went to see "The Eagle's Nest." Towering above the clouds, this chalet perched on the peak of a nearby mountain. It had been built by Hitler with royalties from *Mein Kampf.* They took an elevator built inside the mountain. The building had been ransacked. Nothing was left except a large circular table covered with signatures. Like the GIs before them, the generals signed their names. With no pen of his own, Colonel General Alexis Zheltov borrowed General Mark Clark's Parker 51.

(272) Like hundreds of GIs, the generals signed their names on Hitler's table.

(273) VIP visitors to Hitler's home were (left to right) General Mark Clark, U.S. Army; Soviet Colonel General Alexis Zheltov; Lieutenant General Marie Emile Bethouart of France; and Great Britain's Lieutenant General Sir Richard L. McCreery.

(274-275) Refugees straggling back to Austrian homes on foot and by rail from Nazi concentration camps.

173

The Aftermath

(276) Two members of the "Glorious Red Army" in Vienna.

(277) One who survived: Nathan Dembowsky, branded prisoner number 69926 at Auschwitz concentration camp.

"You're being detained for mocking the glorious Red Army," the Viennese translator said. The Russian officer seated behind an empty desk in his desolate office gazed in open admiration at my boots. "Besides," the translator added, "it is forbidden to take pictures at the bazaar."

"You mean to say they call that flourishing black market a bazaar?" I asked.

"Didn't you know?" The Viennese coughed, shifting nervously.

"All I did was try and take a picture of one of those tubby female Russian officers as she was about to exchange a chunk of butter for a brassiere. That's when those five Russian MPs jumped me and marched me here."

"And you don't think such a picture would make the glorious Red Army look ridiculous?" he said; then added after some hesitation, "Well, I must go now. If I asked for one American cigarette for coming along with you, would you consider that excessive?"

"Not at all," I said.

Unlike the time I was arrested by the Nazis in 1938, this brush with Soviet justice got press coverage in the United States. That was how my father learned I had safely reached Austria. When I mentioned to Mike Fodor, who had been a correspondent in Vienna before the war, that I found the city devastated, he disagreed. "Devastated? Why, Vienna is a weeping willow whose branches bend in the storm but do not snap."

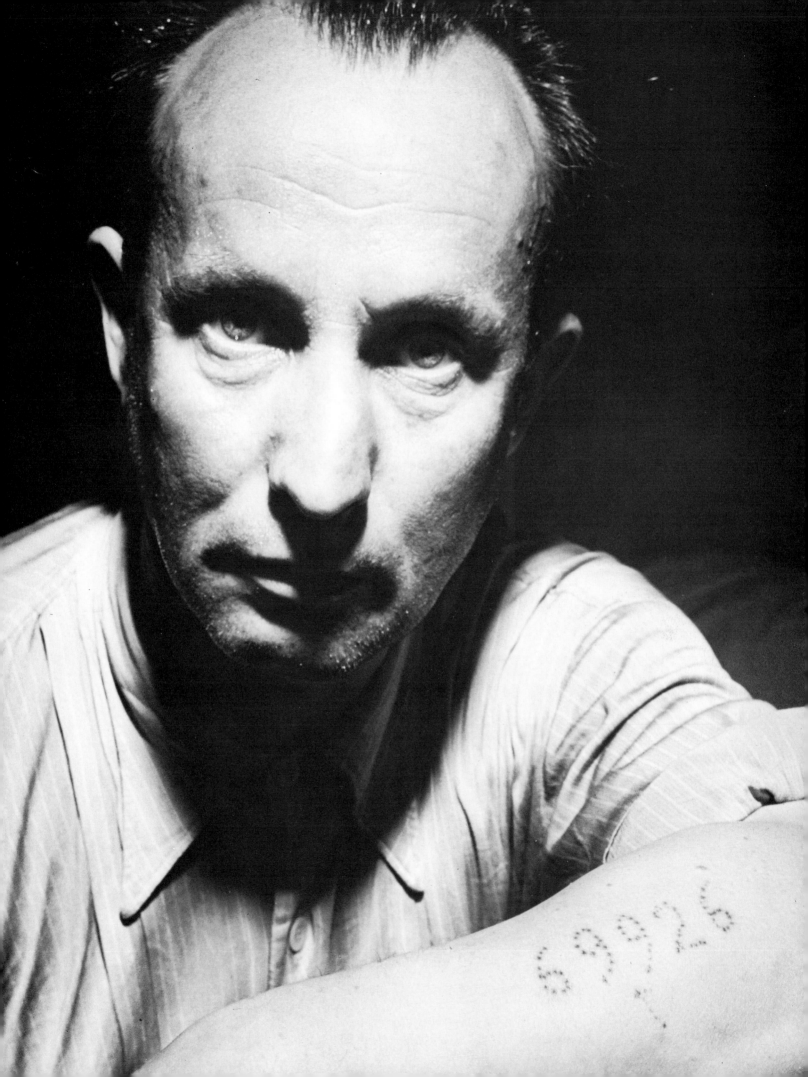

(278) I rode a stone horse at Belvedere Palace, Vienna.

278

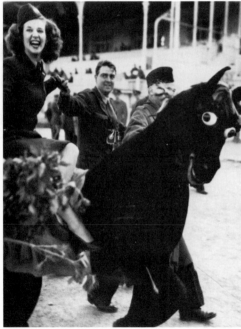

279

(279) The first horse race held in Vienna after the war was sponsored by a British general. To liven things up, I took advantage of Billy Rose's USO show by arriving with a featured act—two men in a clown horse. Said a garrulous Britisher, "Isn't anything sacred to those Americans?"

176

To illustrate his point, Mike led me to landmarks where the great composers had been born, lived, or died. "You'll notice," he said, "that all these places have survived the war." Then, with the wit of a people who can claim a thousand years of history, he concluded with a smile, "But they did not always escape reconstruction."

I decided to visit the Eastern European countries still dazed by the war and about to be assimilated by the Soviet Union, so I roamed through the Austrian and Czech summer, the Polish autumn, and the Hungarian and Rumanian winter, returning to Italy in the spring.

In Czechoslovakia I visited the site where the village of Lidice had once been. In reprisal of the murder of Reinhard Heydrich, who worked out the Final Solution, more than two thousand people were executed and Lidice was wiped off the face of the earth. "You are now standing where the old church used to be," my guide said. I looked at my feet. They trod on grass. I searched for a stone, a solitary remnant that might have survived. There was nothing. The village of Lidice had disappeared.

"I'll give you a Polish visa if you marry me," the Polish consul in Prague said playfully.

"And I'll commit bigamy to get back to Warsaw," I told her.

Then she got more serious. "You must photograph the human soap factory," she said.

"Did you say human soap factory?" I asked, incredulous.

"If you don't believe me, go to Danzig and see for yourself," she replied.

I did. As photographers can be callous while they are taking pictures, I took along an old Boston sea captain whose ship was unloading UNRRA supplies so that I could watch his reaction. The laboratory was in the basement of an old apartment house. A smell of formaldehyde prevailed. In one corner, close to a table stacked with skulls, was a blackboard with formulas written down in colored chalks. There was nothing else except concrete vats covered with metal lids that could be raised by rope and pulley. The sea captain and I stood in front of the first vat as the lid was slowly raised by a municipal employee. The sea captain turned pale at what he saw and hurried outside to vomit. The man who had hoisted the lid looked away. I asked him to close the vat while I set up my camera, aware the pictures I was about to take would never be used but should be kept for the record. I got the man to raise the lid once again and, looking away myself, took a picture. In one of the vats a dead chimpanzee had been tossed alongside the pale, bloodless, naked bodies.

After Hitler decided Warsaw was to be destroyed, the demolition squads stayed at the Polonia Hotel while the city was being systematically dynamited. In prewar days the Polonia had been listed as a second-class establishment and was patronized by traveling salesmen. By September of 1945 it was host to three hundred guests sharing two hundred and fifty rooms. The guest list included the entire staffs of the American, British, and Italian embassies; the Czech and Swedish ministers; the Belgian and Danish chargés d'affaires; the foreign minister of Luxembourg; representatives of UNRRA; visiting trade delegations; a British member of Parliament; some influential Poles—and one *Life* photographer.

One afternoon I stopped by room number 410—the "British embassy" at the Polonia hotel—to chat with Ambassador Victor Cavendish-Bentinck. Seated on the ambassador's lap was Angus, a pedigreed Scottie.

"Of course you brought Angus along from England," I remarked.

"Why, not at all," the ambassador said. "He comes from Krakow. They have a kennel there. Survival of the most expensive, you know."

It was at the Polonia that I ran out of money and became a bootlegger. My cables to New York requesting funds had gone through Moscow and never reached their destination. The American embassy had loaned me money to pay my bills. Before I left Warsaw I had to find a way to repay the embassy. I did have one asset: an army jeep and a trailer with jerricans full of gasoline. Bill Mueller, a Chicago correspondent, had plenty of money but no way of getting to Prague, so I borrowed from Bill to pay Uncle Sam. By the time we got to Krakow, I found a way of repaying my debts. I

borrowed more money from Mueller and purchased Polish vodka at $1.50 the bottle, which I loaded on my trailer and dumped at $18 a bottle in Prague. With my debts cleared, I had enough left to offer a couple of cases to my friends at 22 Corps for the loan of the jeep. I did not take up their offer to give me a 6×6 truck so that I could return to Poland and stock up on more vodka. When I told a Viennese crony how I had passed up the opportunity of making a quarter of a million dollars, he remarked philosophically, "One has to go through two wars—the first to acquire the experience and the second to make money."

I was talking to the barman at the Park Club in Budapest, once the exclusive meeting place of Hungarian nobility and now frequented by Allied army personnel and known as "The Reparations Club." The barman was recalling the liberation of the city. "The SS general in command hurriedly left his beautiful palace and abandoned his gorgeous red-haired mistress. The minute the glorious Red Army liberated Budapest, Marshal Klimenti Voroshilov took over the palace and the redhead. *Plus ça change . . .*" he concluded as he mixed an egg brandy.

Although Budapest was severely damaged, the Hungarians had lost none of their verve. The expropriated estate owners voted for the Small Holders Party to save the furniture. The aristocrats set about making money as best they could with a nonchalant grandeur. All displayed great resourcefulness in their day-to-day fight for survival. At first it meant converting whatever they still owned into dollar bills, as inflation was daily adding zeros to the local currency. One displaced count, remembering that the buttons on his valet's uniform had been solid gold, walked all the way to his expropriated estate to recover them. Others sold everything, down to their most personal belongings, without a sigh. Their wives sought regular employment, becoming barmaids or cabbies, and went to work in their mink coats until these too were sold.

280

(280) Peering out of a demolished streetcar in Danzig.

Nothing delighted Hungarian nobility more than an invitation to hunt. Driving off in the jeeps of their American army hosts, they directed the officers to their old estates, now owned by their peasants. As they were very good shots and game was plentiful, it was commonplace to see a countess making deliveries to the restaurants on Monday mornings.

"Aesop was wrong about the ant and the grasshopper—at least in Hungary," the count said. We were enjoying champagne at twenty cents a magnum at the Park Club. "I know two brothers here in Budapest," the count went on, "who inherited a fortune after the First World War. One was very serious-minded. He invested his money wisely and never dipped into capital. As for his spendthrift brother, he spent his fortune drinking champagne. He enjoyed keeping a record of all the champagne he drank over the years and neatly stored his empty bottles in the large cellars of his estate. When the war was over the thrifty brother was cleaned out by inflation. And the other brother? He goes on drinking champagne. You see, there was a shortage of bottles and he got a good price on all his empties."

In late winter of 1946 I returned to Vienna by way of a detour to Bucharest and hitched a ride to Rome in a staff car driven by an MP. On the second day we crossed into Italy and stopped for lunch in Verona. For the first time in almost a year I studied a conventional menu. In starving Poland, Hungary, and Rumania there had been an exuberant abandon about the food you ate, if you had dollars—steak in Poland, *pâté de foie gras* in Hungary, caviar in Rumania, and mayonnaise everywhere. I was enjoying being back in an orderly country until it struck me that we were in "war-torn Italy." Refreshed by spaghetti and Italian wine, the MP and I drove off. It was snowing when we reached Futa Pass that night. Trucks blocked the road, and for the last time I used the influence of my uniform to get the staff car through. We came to a strange town surrounded by brick walls. A feeling of unreality overcame me when a large pig's head on a human body leisurely crossed the street. The MP pulled out his .45 after he spotted a horse's head. As we approached the next apparition, I told the MP to pull up and asked where we were. A sad voice replied, "You're in Lucca and it's the last day of carnival."

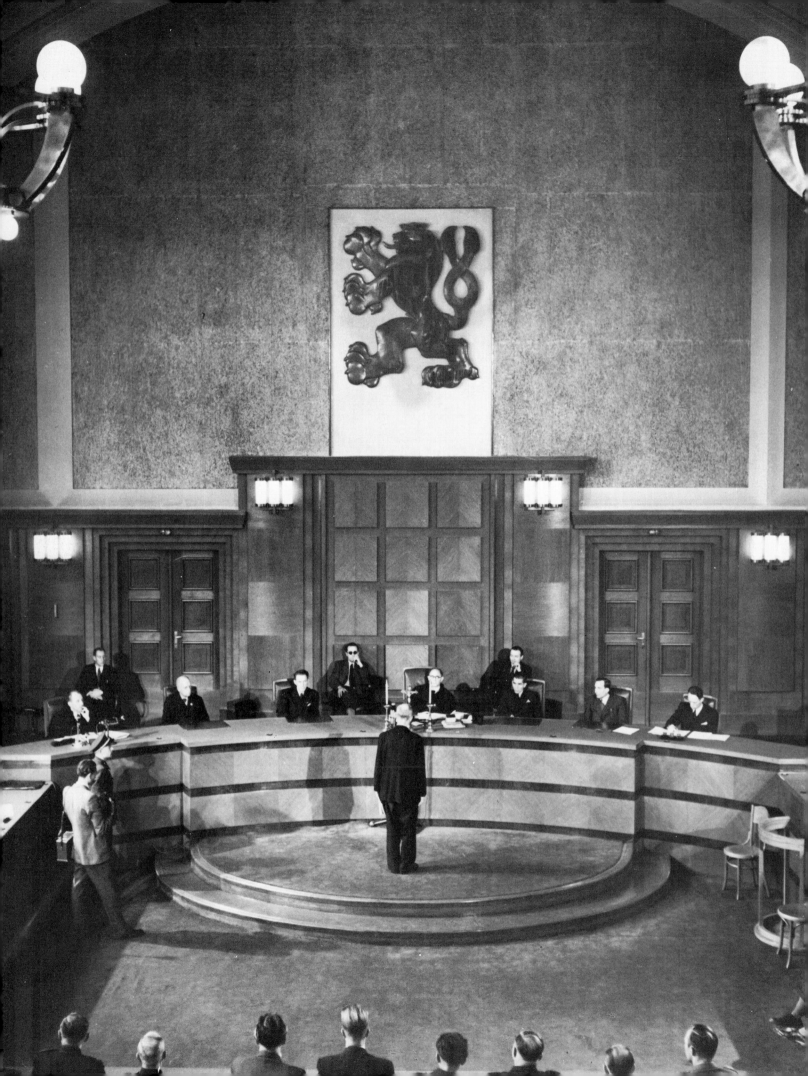

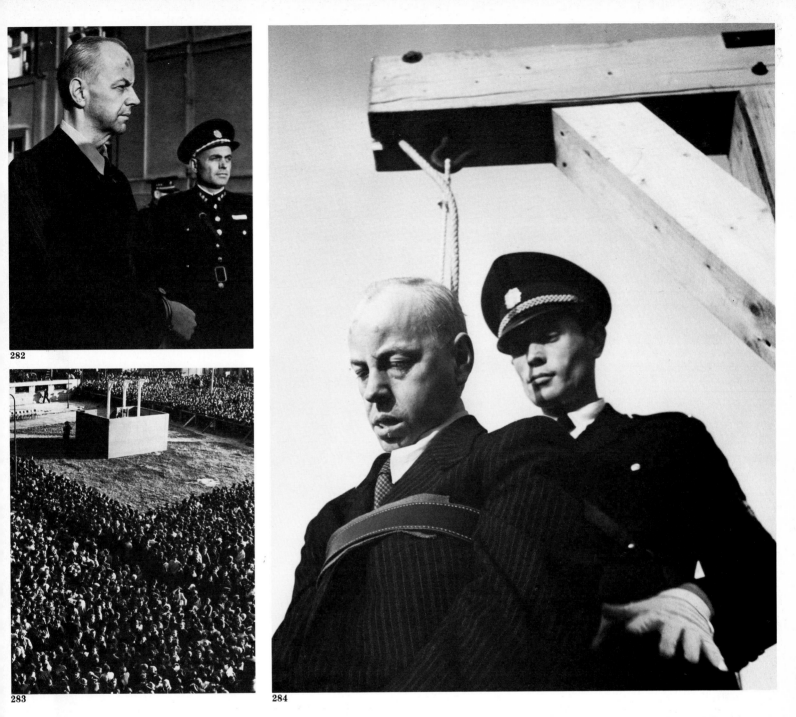

282

283

284

In the early autumn of 1945 Czechoslovakia brought its number-three war criminal to trial. Dr. Josef Pfitzner, a forty-four-year-old Slovak of German descent, served as deputy mayor of Prague during the Nazi era and, to demonstrate that this ancient Czech city was in fact German, attempted to eradicate everything that was Czech, sending patriotic students to concentration camps. What made Pfitzner especially odious to the Czechs was that he had been a professor of history at Prague's German University. A prominent prewar judge was named to hear the charges. He was assisted by a people's court of four men, each representing a different political party (one dissenting vote could have saved Pfitzner's life). The state-appointed attorney defended him ably. For fifty-two minutes Pfitzner pleaded for his life in fluent Czech. Those in the courtroom, many of whom were parents of his victims, maintained a dignified silence. The summation of the prosecutor, who had served five years in a concentration camp, was dispassionate. The evidence was overwhelming and the sentence was death. An orderly crowd of fifty-five thousand stood around the gallows. When Pfitzner appeared, a sound like the roar of the surf was heard from the onlookers. I was a few yards from Pfitzner when he shouted, "*Ich sterbe für Deutschland*—I die for Germany!" The executioner cuffed him with his white-gloved hand, then tightened the noose.

Retribution in Prague

(281) War criminal Dr. Josef Pfitzner being sentenced to death, in Prague, 1945.

(282) Pfitzner at the foot of the gallows.

(283) A crowd of fifty-five thousand attended the execution.

(284) The execution was carried out.

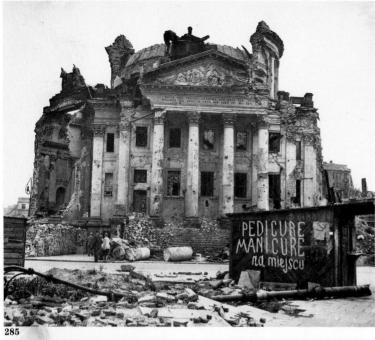
285

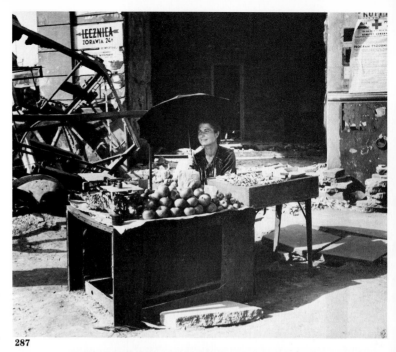
287

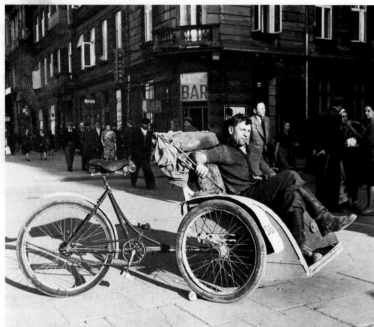
286

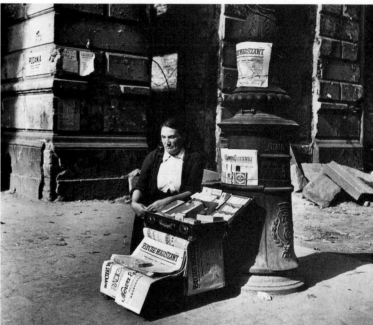
288

The Irrepressible Poles

(285) A manicure/pedicure booth sprang up in front of St. Alexander's. The church was so badly damaged services were held in the crypt.

(286) With no taxis available, this ex-driver converted a bicycle into a two-seater and charged 100 zlotys per mile.

(287) With Warsaw's shops blown up, open-air stores like this fruit and cigarette stand mushroomed. The owner took shelter from the sun beneath an umbrella.

(288) Newspapers and cigarettes being plentiful, such vendors were common.

"I'm certainly glad to see you," was the way Ambassador Arthur Bliss Lane greeted me. "I was afraid the Poles would clean up Warsaw before someone got here to photograph the destruction." It was August 1945. The ambassador was serious. The Poles had enthusiastically started to rebuild their capital with what has become known as "the Warsaw tempo." Yet there were still "some splendid ruins," a British diplomat assured me. Apart from its physical damage, the country had not changed since 1938, except that the Poles hated the Germans and the Russians more than ever and were still anti-Semitic, although a number had crawled through the sewers to join the Jewish population in their fight against the Nazis during the battle of the ghetto. I got a sample of Polish hatred when I invited Mrs. Myryla Novak out for dinner. Throughout the meal she glared at one musician in the four-piece orchestra. She hated him with all the intensity a Pole can muster. Although she did not often have an opportunity to eat meat, she toyed absentmindedly with her steak. "If it were not for that man," she said icily, pointing to the musician, "I wouldn't have to sleep on my desk at the Foreign Office. He stole my room before I could move in, by bribing the janitor. Not that it's such a hardship sleeping on the desk now that they heat the office," she continued, "but it would've been nice having that room so that Mother could live with me."

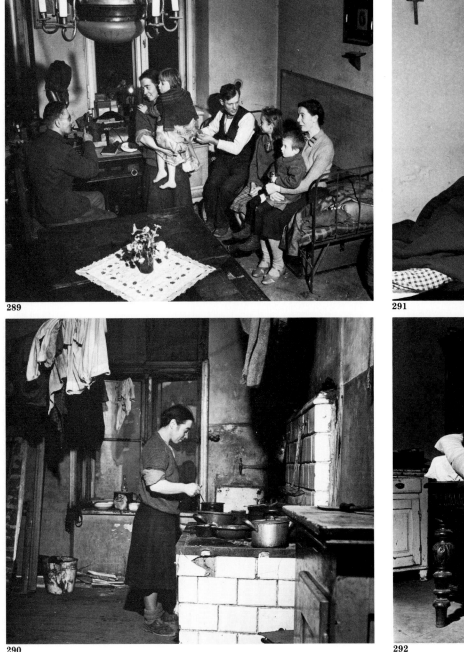

289

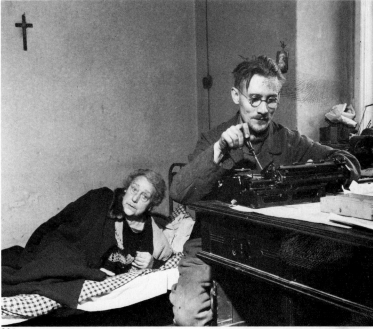

291

290

292

Stanislaw Wicklawski considered himself one of the luckiest men in Warsaw. He had survived both concentration camps and forced labor battalions. Now he repaired typewriters for the government seven hours a day at ten dollars a month, with the additional benefit of three daily meals (he ate one and took the other two home in his lunch box). Wicklawski earned an additional thirty dollars a month moonlighting and had one-quarter interest in a four-room apartment with no running water, no gas or electricity, and only a modest kitchen. The place was occupied by forty people. Nine lived in Stanislaw's room. First there was Mrs. Zagorska—the mother of Mrs. Myryla Novak, who had been cheated out of her room. Mrs. Zagorska had been a woman of means before the war, and Stanislaw's wife had been her maid. Now that Mrs. Zagorska was destitute, he gave her the best cot in the room as a matter of courtesy. Stanislaw and his wife, Irmina, slept across the room on a cot facing Mrs. Zagorska. Their two children slept on a third cot. The fourth was occupied by the Ragolski children, whose father, Alexandre, had been in the same forced labor battalion as Stanislaw. Alexandre had been sleeping on the table until Miss Antonia Emerik, who had been Mrs. Zagorska's second maid, also moved in. Gallantly Alexandre kissed her hand, offered her the table to sleep on, and moved to the floor.

(289) Stanislaw Wicklawski (left) with six of the eight people who shared his room.

(290) Stanislaw's wife, Irmina, prepared dinner in the small kitchen she shared with the other thirty-nine people who huddled together in the four-room apartment which had no gas, electricity, or running water.

(291) Stanislaw repaired typewriters at home.

(292) Family friend Mrs. Antonia Emerik slept on Stanislaw's dining table.

181

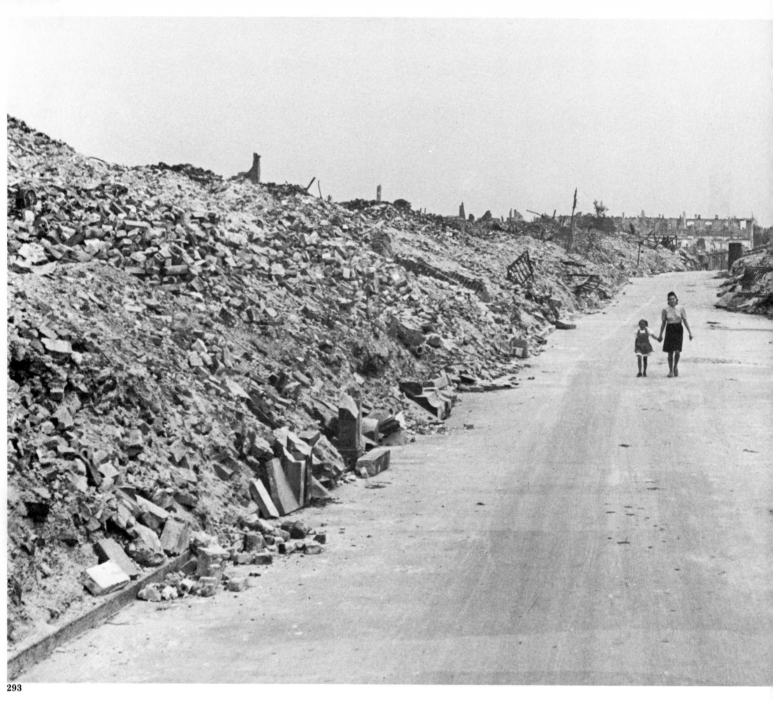

293

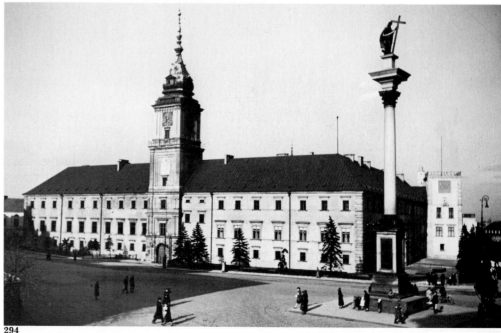

294

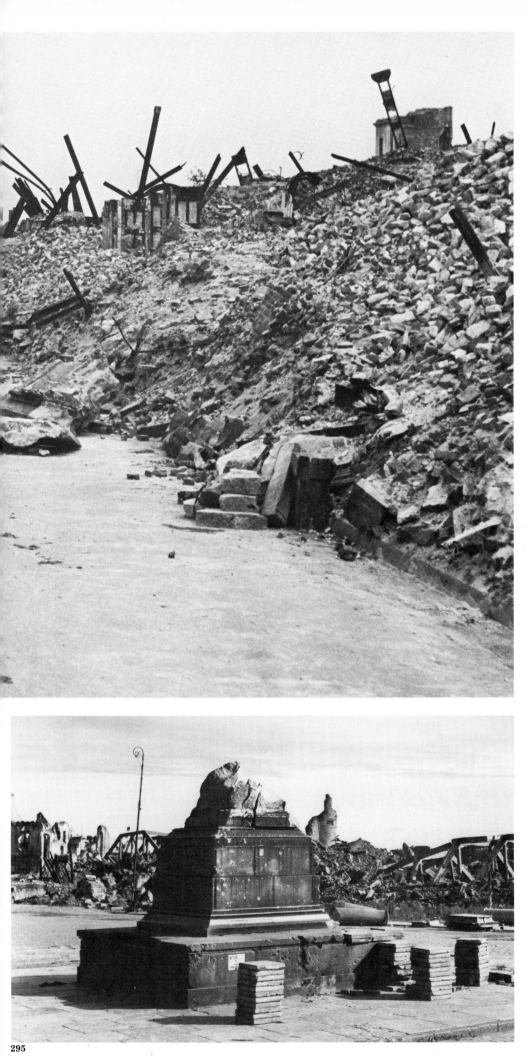

(293) The Warsaw ghetto in the summer of 1945.

(294) Zamek Palace in Warsaw as it looked in 1938 when I photographed it with a statue of Sigismund atop the column in the foreground.

(295) Except for the pedestal of Sigismund's statue, nothing shown in the 1938 picture survived the Nazi destruction. Today, Zamek Palace has been restored to its former grandeur.

295

183

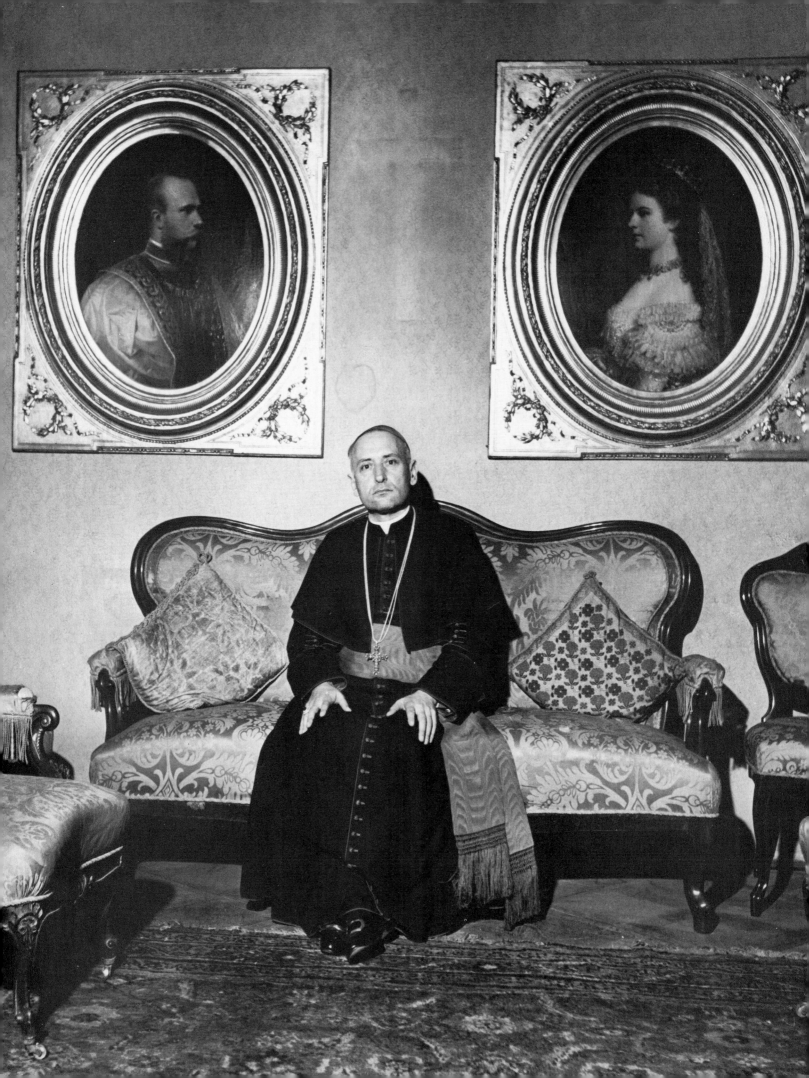

Hungary at the Crossroads

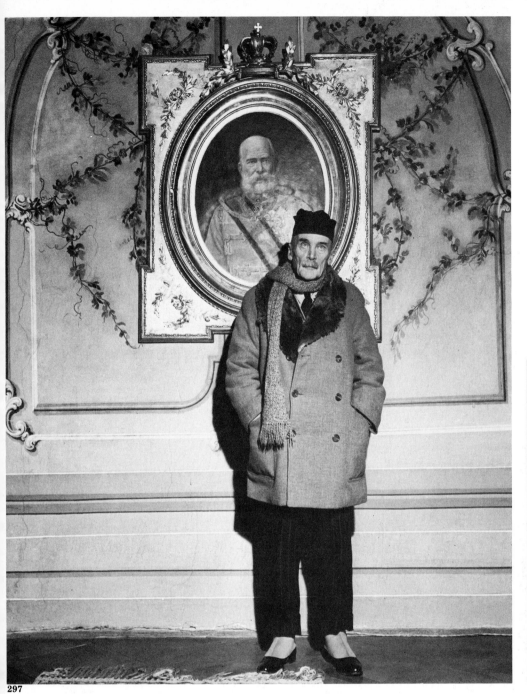

297

298

I got a fleeting impression of the old Hapsburg Dual Monarchy when I photographed Cardinal Josef Mindszenty at his palace in Buda. He sat with hands in his lap beneath the portraits of Franz Josef and Empress Elizabeth. Cardinal Mindszenty had recently delivered a sermon that had caused a furor because of his allusion to the Tartar invasion of Hungary in 1242; matters were made even more touchy by his stating that he did not have the current Russian occupation in mind. A few days later I visited the great Benedictine abbey at Pannonhalma, where the archabbot took me on a sightseeing tour. We stopped at the refectory with its baroque decor. Thoughtfully he led me from fresco to fresco, translating their inscriptions. He was very keen about one fresco, which showed wine spilling out of a cask from which the barrel hoops had been removed. "Too much freedom is bad," he said. A dashing elderly gentleman walked briskly up to us. The cuffs of his trousers were turned up, revealing his white spats. "And how are my dear friends the Goulds and the Vanderbilts?" boomed His Highness, Prince Lonyay Elemer. Prince Elemer, the archabbot told me, had married Franz Josef's daughter-in-law after the emperor's son and heir, Crown Prince Rudolf, had committed suicide with Maria Wetzera at Mayerling. When I asked Prince Elemer about Hungary, he snorted. "Hungary, my dear chap? There's no such thing. All that remains is Russian salad."

(296) Josef Mindszenty, prince primate and cardinal of Hungary, at his Buda palace, 1945.

(297) Prince Lonyay Elemer, an old friend of the Goulds and the Vanderbilts, was put up at the Benedictine abbey in Pannonhalma.

(298) Marshal Klimenti Voroshilov, Russian member of the Allied Control Commission in Hungary.

185

(299) *Matyas Rakosi, secretary of Hungary's Communist Party in 1946, spent nineteen years in jail.*

(300) *At the opening of parliament, Communist Minister of the Interior Imre Nagy (left) sat next to Gyongyosi Jano, the foreign minister. Imre Nagy was to lead the unsuccessful Hungarian uprising against the Russians, who hanged him.*

(301) *Doctor László Bárdossy, the Hungarian prime minister who declared war on Russia, just after his execution at Marko Place prison, Budapest.*

300

299

Madame Bárdossy, wife of the Hungarian premier, assured me that public opinion was in his favor even though he had been sentenced to death. Her husband had been the man who declared war on the Allies, and had plunged Hungary into postwar disaster. There were those who regretted that Bárdossy was to be shot, because, as one Hungarian put it, "The country needs statesmen like him." A countess spoke for Hungary's aristocracy when she said, "Imagine shooting a man because he declared war. Simply ridiculous." I reached the Marko Place prison an hour before Bárdossy's execution. "He's in the next room," a policeman told me. "His wife has been with him since six-thirty." Madame Bárdossy was asked to leave shortly before eight. She must have heard the shots as she walked up the street. The firing squad stood in the prison courtyard facing a brick wall that was sandbagged to prevent ricochets. Bárdossy was led out in the same plum-colored suit he had worn when he was captured in Austria. A frail man, he drew himself up with such exaggeration that his shoulder pads stuck out. When he turned toward the firing squad, I saw the effort he was making to control himself. "God preserve Hungary from these bandits," were his last words before he bounced off the sandbags. Although the afternoon press reported that Bárdossy's dying words were lost in the volley, by nightfall all Budapest knew what he had said.

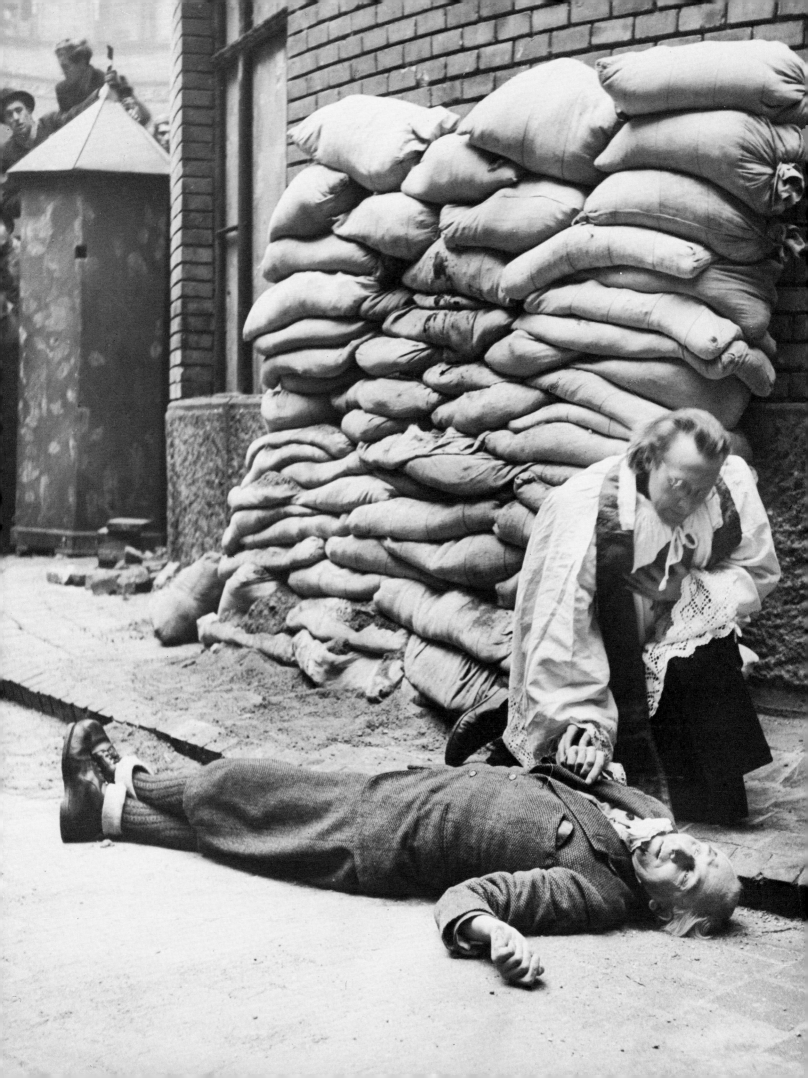

Italy before the Miracle

302

(302) *Exiled Queen Marie-José of Italy at her Swiss home with a bust she sculptured of her father-in-law, King Victor Emmanuel III.*

(303) *Crown Prince Victor Emmanuel at Quirinale Palace in Rome with a blind boy — member of a group of war orphans brought to play with the royal children — one day before the royal family went into exile in June 1946.*

(304) *Shoe vendor taking a nap at Eboli in southern Italy, site of Carlo Levi's famed novel,* Christ Stopped at Eboli.

(305) *Canonization of Mother Cabrini, America's first saint, took place at St. Peter's on July 7, 1946, during the pontificate of Pope Pius XII.*

303

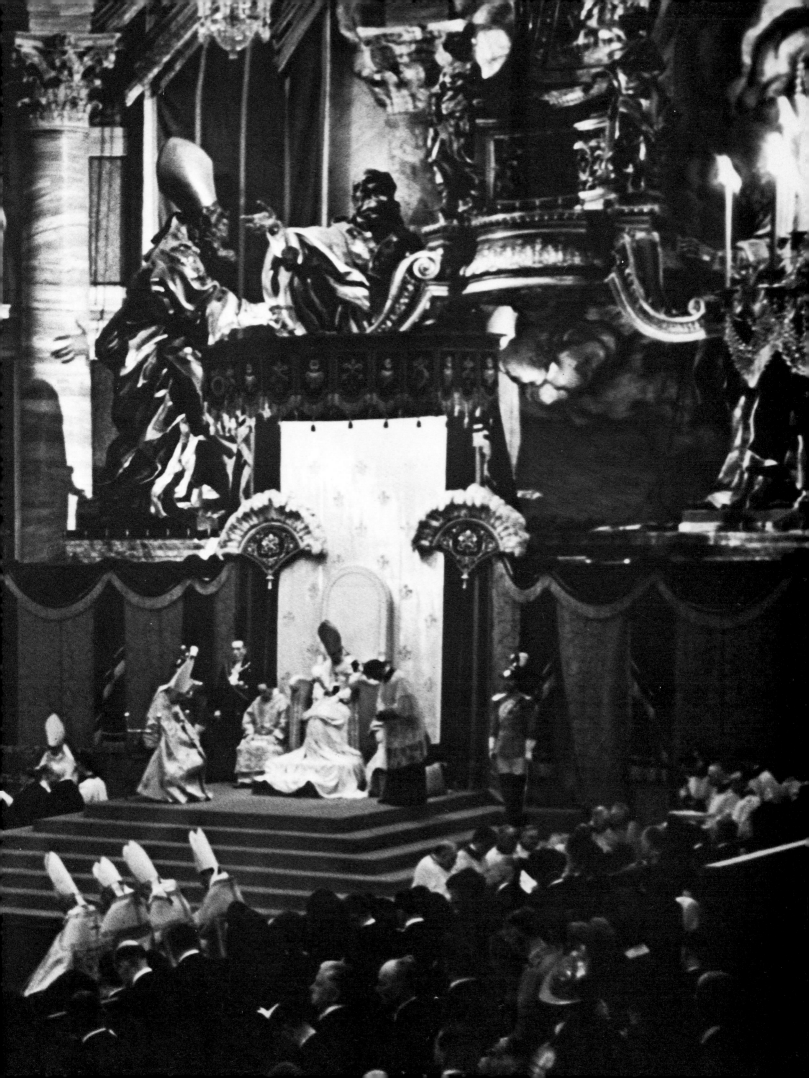

The Greek Guerrillas

"Y'know, John, we're like a couple of garter snakes in a mongoose pen," Bob Vermillion of the United Press sighed. We were in the land of the *andartes*, as the Greek guerrillas called themselves. The *andarte* Navarhos was in a rage because President Truman did not realize that the barber of the village of Kalabaka was "a Fascist."

This, I decided, was the most ridiculous mess I had ever got into. The *andartes* were as unhappy as I—two American journalists in their territory theatened to bring the Greek army down on them. The Greek government was also unhappy at our having sneaked into *andarte* country when it was strictly forbidden. *Life* would be unhappy, too, because in the past eight days I had been unable to locate the famous *andarte* headquarters or its leaders, who were accused of being in contact with the Bulgars, or "the beasts with human faces," as the rightist press in Athens called them. My third wife was unhappy for my having gone on this assignment when I could have been comfortably back in Paris, and had threatened to leave me. To make matters even worse, rain was pouring down my neck and oozing out of my shoes.

Life's interest had been awakened when, in September 1946, the *andartes* had become active again, a year after the country had been pacified. After my experience with the Yugoslav partisans, *Life* felt I was the only person for the assignment.

I found Athens a political maze with about as many parties as politicos. Expressed with great eloquence, libelous statements were the order of the day—every politician being a born orator. When I questioned George Papandreou, father of the present prime minister and acknowledged at that time as the most eloquent on the Greek situation, he said, "We are fighting another Thermopylae every second of every day."

Bob Vermillion and I decided to join forces and try to make the first contact with the elusive *andarte* headquarters. We borrowed a white jeep from Greek War Relief, an organization that made it a practice to help journalists. Our Cypriot interpreter quit after the director of police warned him that if he left town with us he would be arrested and his permit to remain in Greece would not be renewed. Luckily we ran into Tom Politis, an American painter of Greek origin, who agreed to come along and act as interpreter.

At Larissa we sandbagged the jeep to protect it against mines scattered along the road. Two MPs were waiting for us at the city limits of Trikkala. They escorted us to Division headquarters, where we were warned that the road to Kalabaka, our next stop, was mined. We were treated to coffee and a lecture on "the bandits." Two of them were produced for our edification. They were farmers arrested on suspicion of aiding the *andartes*.

"Do you think the major is trying to discourage us?" Vermillion chuckled as we left headquarters.

On hearing that the road to Kalabaka was declared de-mined after a horse had been blown up, we took it for granted we could proceed. Once in Kalabaka we made for the saloon that Trikkala's tavernkeeper had told us to visit for information on the *andartes*. After all the customers left, we questioned the saloonkeeper. Glancing outside to see if anyone was listening, he told us that if we managed to get past the MPs at Morgani Bridge and were not blown up before we reached the village of Kastania, we could make contact with the *andartes*.

Shortly before dusk the following day, soldiers stationed at Morgani Bridge reported that a white jeep had whizzed past in the beating rain. After crossing the Pinios, our jeep stopped dead in front of a primitive roadhouse owned by a Greek who had worked in the States. We were in *andarte* country. We left our jeep there, along with the message that we could be reached at Kastania. Climbing on Missouri mules sent over by UNRRA, we set off with a muleteer and reached Vassili's general store in Kastania, seventeen kilometers away, where we were put up.

About six hundred people still remained in the village—although two hundred and sixty of the two hundred and eighty houses had been destroyed by the German army during the war—trying to live on an average of $160 a year. We sat around Vassili's stove in stocking feet

306

(306) With Bob Vermillion of the United Press (left) and Tom Politis, a painter, in Athens before setting off in quest of Greek guerrillas.

drinking ouzo. All who had lived in the States trooped in to see us. After we ran out of cigarettes, Vassili produced a box smuggled out of Kalabaka for a wedding that was to take place the next day. Cigarettes had vanished in Kalabaka after the gendarmes, symbol of the government's authority, had hurriedly departed when the *andartes* became active once again. Realizing the futility of chasing guerrillas all over the Pindus mountains, the army had set up a stringent economic blockade. No one living in this zone could import flour, oil, leather, cloth, salt, shoes, wrapping paper, aspirin, quinine, sulfa drugs, or cigarettes. Hardest hit by this economic blockade was the civilian population, which had to trudge to Kalabaka for supplies, where they were frequently treated as *andartes* and beaten up.

We asked Dimitrios Kouvatis, the mayor of Kalabaka, to help us get in touch with the *andartes*. Although he had voted Monarchist during the plebiscite, he wrote a note to the ODEK (Omas Demokratikon Ellenon Katadiokemer—the Armed Group of Oppressed Democratic Greeks) and handed it to the peasant who was courier for the *andartes* that day. In the evening a small man with close-cropped curly hair sidled up to us, promising we would have word from headquarters the next night by ten.

At 10:15 Vassili rushed into our room shouting, "The *andartes!* The *andartes!*" We heard the thump of hobnailed boots on the stairs. Two men

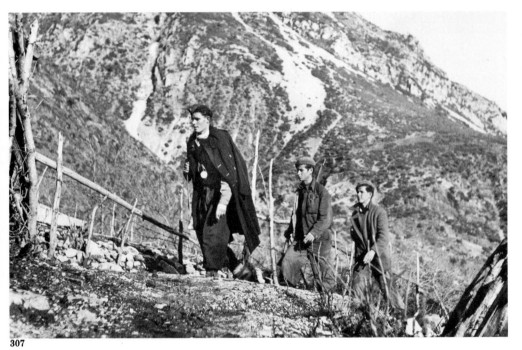

307

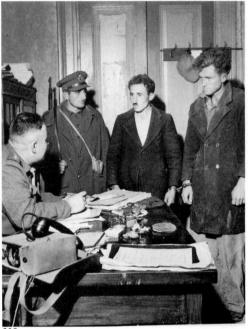

308

in their thirties, wearing British battle dress, each carrying a shepherd's crook and a rifle, entered the room. They were not the representatives from headquarters we were waiting for. The pair had dropped by to attend the next day's wedding, an opportunity to get a full meal. Vigalis was the more loquacious of the two. His story was pretty much a pattern of every *andarte* I met. He had joined ELAS—the Greek Popular Liberation Army — to fight the Germans during the occupation. After returning to his hometown, he was branded a Communist because of his association with this left-wing resistance movement. The mayor of his community refused to issue him a certificate that would enable him to work in Athens, where he could have vanished into anonymity. Vigalis told me that members of EDES—the Hellenic Democratic National Army—which included German collaborators, had been armed by the government to hunt down ELAS people. His choice was to die from beatings or return to the mountains. Reluctantly, he went back to the mountains. When I asked him about the *andartes'* spring offensive that was being talked about by everyone in Athens, he looked at me balefully and said he hoped to be back home by then.

We tracked down the small man with curly hair who had promised to arrange a meeting with a representative of headquarters. After much persuasion he was able to fix a meeting with Navarhos, the first *andarte*

(307) Group of andartes *at the village of Kastania in guerrilla country.*

(308) Two farmers arrested on suspicion of aiding the andartes *at Kalabaka.*

193

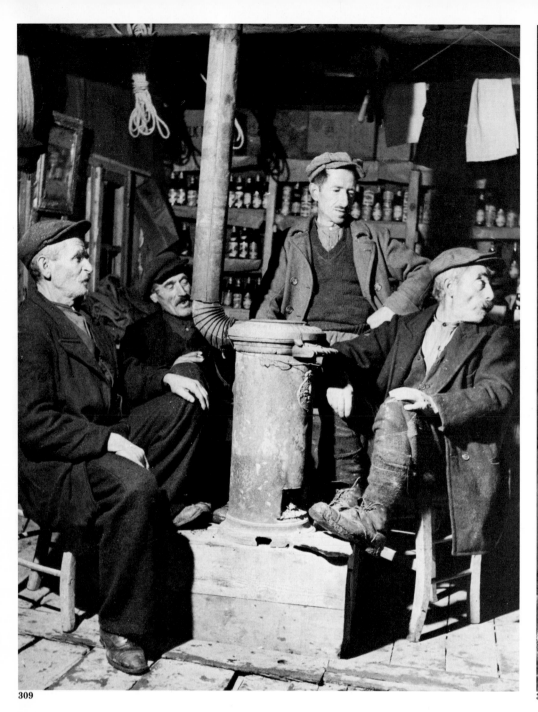

(309) *Greeks who had once worked in America sitting around the stove in Kastania's general store.*

(310) *Vermillion and I finally made contact with the* andartes Navarhos *(left) and Skoufas in the village of Louzesti.*

(311) *Young boy purchasing flour at Vassili's general store in Kastania.*

we had seen who made any claim to leadership. We met in what survived of one of seven churches the Germans had destroyed. Asked to lead us to *andarte* headquarters, he denied its existence. He told us the *andartes* had little or no organization outside of independent bands operating on their own. It was then that Truman's name came up. Told that the American president knew nothing of Kalabaka or its affairs, he no longer cared whether the American public was informed or not. Vermillion and I browbeat him into arranging an appointment with the most important leader he could produce in Thessaly.

As we rode to our rendezvous, I was thinking of the whole situation as a caricature of what I had seen in Yugoslavia, when the sound of gunfire broke out.

"Sounds as if it comes from the place where you left your jeep," our muleteer told us.

When we reached our rendezvous, we found no guerrilla leader but heard that the army had had a skirmish with the *andartes* at Louzesti, four hours away. Assuming the leader had been unable to come to us, we decided to go to him.

For hours we slithered through slush in the dark, following the sounds of our mules' bells, until we ran into an *andarte* sentry. At last we had

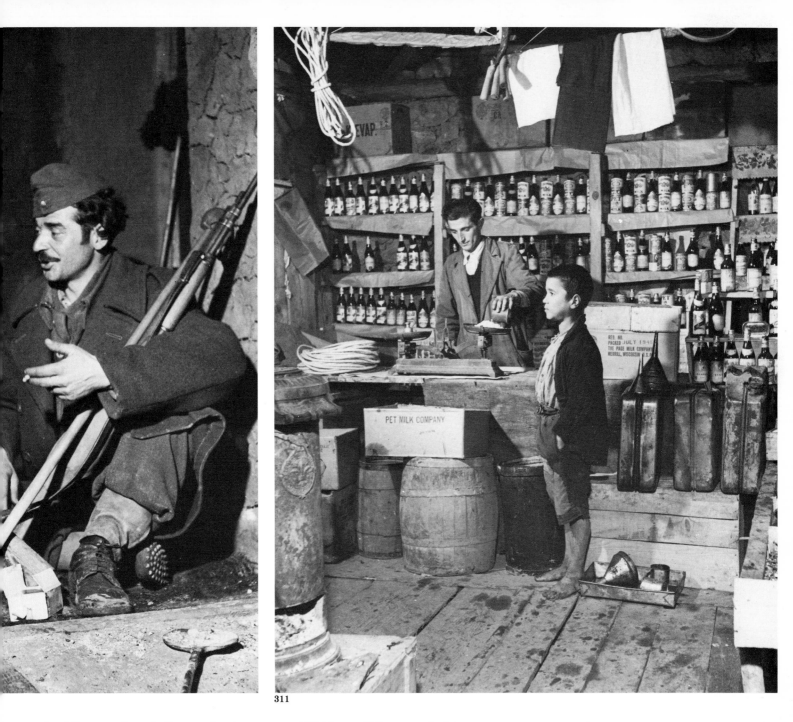

311

reached Louzesti and the *andartes* were still there. We were led to a
dilapidated house where an old widow was taking care of two
grandchildren. She served us cornbread and goat cheese. Her misery was
such that we felt embarrassed about eating her food, but if we had not she
would have been offended.

I had been sleeping when Vermillion woke me up. "Look who's here," he
said as Navarhos walked in.

I turned over to go back to sleep, wanting someone better for an *andarte*
leader. Fortunately he was followed by a tall, heavyset man wearing a
British topcoat over his battle dress. In the dim light of the fire his face
had an oily complexion and the whites of his eyes gleamed. The man was
Skoufas, one of the four recognized leaders in Thessaly. He outlined the
five points he considered essential for the *andartes'* safe return to normal
life and freedom in Greece: (1) withdrawal of British troops; (2) formation
of an all-party government; (3) a general political amnesty; (4) a purge of
the collaborationists in government; and (5) free elections. He confirmed
that he had no contact with the Bulgarians. Then he informed us he could
not guarantee our safety on our return journey.

We had to leave at once because the army had crossed the Pinios River
and reached our jeep. The brigadier in Kalabaka had sent word through a

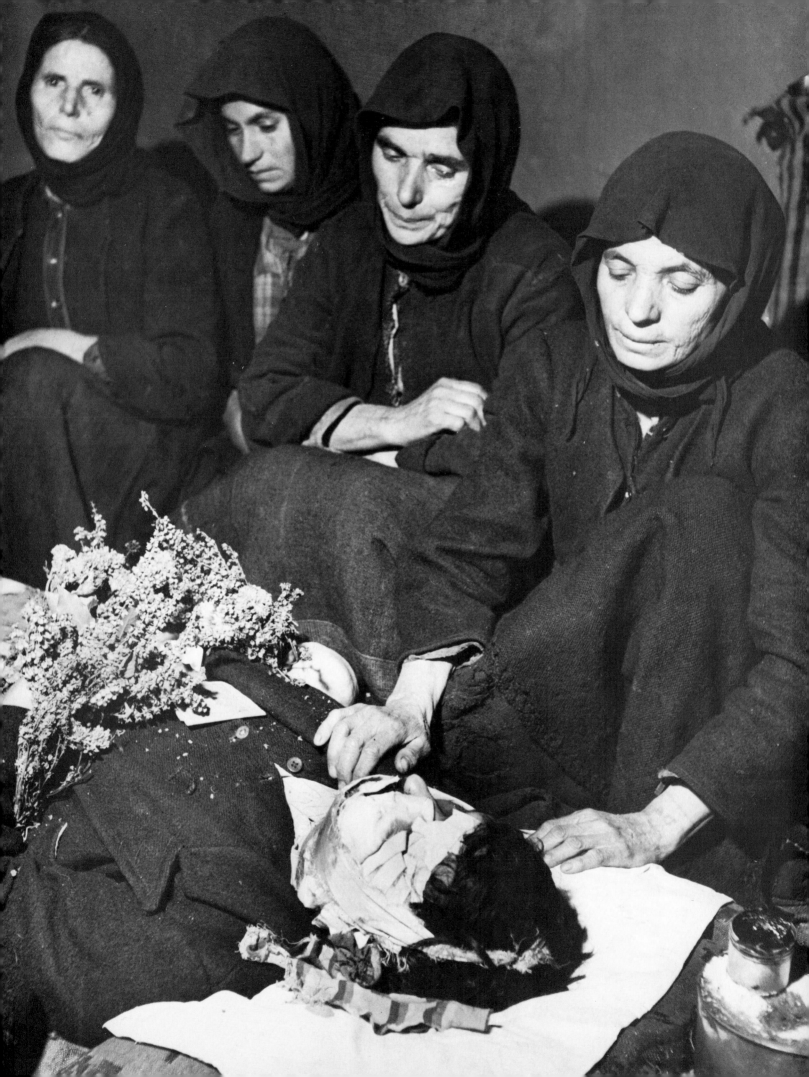

313

peasant asking for our return. Forty soldiers moving up the hill toward Louzesti had been sent in search of us and had run into *andarte* fire. The army had withdrawn and began lobbing shells into the village. One burst outside the open window of Apostole Natso's house and blew off the left side of his head.

Before we left, the mayor of Louzesti led us to the house where Natso lay. A bouquet was on his chest, along with a ten-thousand-drachma bill (two dollars) to pay for his crossing into the next world. After I took a picture of him, the chorus of mourners chanted: "Your picture is being taken and it will be published in a great American magazine. It will come back and we will have you back with us again."

Skoufas having warned that the army might kill us and blame the *andartes*, Vermillion and I wondered whether he might not have the same idea. We could trust no one.

The road leading back to our jeep ran through a cornfield. If anyone had wanted to get rid of us, that was the place to do it. With a sense of relief we reached our jeep, but the Pinios was so high the car could not ford it. On the other side of the river we saw soldiers. Wading across the Pinios on our mules, we did not know what kind of welcome to expect. The colonel in charge came up to us, offered brandy, and told us we had been rescued.

(312) Mourning Apostole Natso, killed by mortar fire.

(313) A coffin for Natso.

197

Evita Peron in Rome

On a stifling June afternoon in 1947 Maria Eva Duarte Peron, wife of Argentina's dictator, flew into Rome aboard her chartered C-54 on a self-promotion tour of postwar Europe. The first leg of her journey had been to Franco's Spain. There she described herself as "a rainbow between two countries" and was awarded the Grand Cross of Isabella La Catolica. As the "First Samaritan" of Argentina, she dispensed hundred-peseta notes to deserving mothers.

The highlight of her Italian tour was an audience with Pope Pius XII on Friday, June 27, at eleven A.M. This would be the only time Evita was punctual during her tour. She was in black from head to toe except for her Grand Cross when I photographed her, escorted by Prince Chigi, Grand Maestro del Sacro Ospizio, and the Swiss Guards into St. Peter's. After crossing La Sala Clementina to La Sala Ducale, decorated by Bernini, she was granted a privilege reserved for only certain dignitaries: to pray in front of Saint Peter's tomb. Evita's audience with the pope lasted the scheduled twenty minutes and not a moment longer, it was noted. Although she was overcome by the saintliness of His Holiness, Pius XII was the only dignitary who did not allow his picture to be taken with her.

Evita's visit was something of an embarrassment to the Italian government. On the one hand, there was resentment that a number of Fascists were granted asylum in Argentina; on the other, Italy had a large colony in Buenos Aires and the government was in no position to slight Evita—at least officially.

Shortly before her arrival in Rome, the Italian president discreetly traveled to his country home in the south. The American ambassador left town. This did not faze Evita. She offered to go all the way to Naples and pay her respects to the Italian president. This put the elderly gentleman under the obligation of returning to Rome to receive her and have his picture taken with her by Evita's ever-present photographer. As for the American ambassador, she knew he must be at his embassy on the Fourth of July. Shortly before the official reception there, Evita showed up to offer Argentina's best wishes on America's national holiday. However reluctant, the ambassador had to receive her and was photographed shaking hands with Evita. Still a novelty in Europe, this technique created the impression in the Argentine press that her tour was a thundering success.

Evita's record for keeping people waiting came at the ancient Baths of Caracalla, where Verdi's *Aida* was being performed. The second act had been delayed for half an hour before she appeared on the arm of Prime Minister Alcide de Gasperi.

"Do you like music, Madame Peron?" she was asked in an interview.

"I like all music, concerts, and operas," she said, adding, "especially Chopin."

"Do you like to read as much as you enjoy music?"

"Oh, yes," Evita gushed.

"Your favorite author, Madame Peron?"

"Why ask me such a question? I like everything I read, including . . . Plutarch. He's an ancient writer, you know."

Asked about her favorite perfume, the interpreter snapped back, "She likes them all. Can't you tell?"

I did not follow Evita after she left Rome but was told that while in the north of Italy she had ordered a custom-built Fiat. When it was delivered to her in Buenos Aires some months later, she smilingly took the bill handed her by the Italian representative and announced that, quite possibly, duty on imported Fiats would go up. Hastily the representative retrieved the bill and assured Evita the car was a gift. Some years later, the nephew of the French ambassador to Argentina told me about Evita's visit to France and to Cartier's. There she picked out the finest string of pearls. When the embarrassed director asked about payment, Evita reminded the jeweler she was France's guest. A few months later the French ambassador in Buenos Aires received Cartier's bill. He went to see Juan Atilio Bromuglia, Argentina's minister of foreign and religious affairs, explaining the purpose of his visit. "I'm very sorry," Mr. Bromuglia said, "but the Foreign Office is not responsible for Madame Peron's debts."

314

(314) In June 1947, Evita Peron toured Europe, making a stopover in Rome where, wearing print dress and wide-brimmed hat, she deposited a bouquet at the Victor Emmanuel war memorial.

(315) Dressed in black from head to toe and escorted by Prince Ludovico Chigi Albani della Rovere, Evita had a twenty-minute audience with Pope Pius XII.

Birth of a Nation

In November 1947, the United Nations partitioned the British Mandate of Palestine, thus resurrecting the state of Israel. Speaking for the Arab world, Hadj Amin el-Husseini — the Grand Mufti of Jerusalem — denounced this decision: "When the sword speaks, all else must remain silent."

Anticipating the conflict, *Life* sent me back to the Middle East. My first assignment was to photograph the elusive Mufti. Ironically, this implacable enemy of the British had originally been their own creation. Even more ironic, this rabid anti-Semite had been appointed by Sir Herbert Samuel, a Jew. Sir Herbert, Palestine's first high commissioner, wanted to curtail the authority of the Nashashibi tribe, which controlled Jerusalem's town hall. He decided to play the El-Husseini clan against them. Hadj Amin el-Husseini was appointed Mufti of Jerusalem by Sir Herbert although he did not meet the qualifications. Sir Herbert then appointed him president of the Supreme Moslem Council with complete control over its religious funds — an annual $400,000. The Mufti then parleyed his religious authority and financial clout into such a powerful political machine that Palestine was kept in constant turmoil, compelling the Mandate authorities to bring Jewish immigration virtually to a halt. During World War II the Mufti fled to Germany, where his pro-Nazi proclivities further increased his prestige among the Arabs.

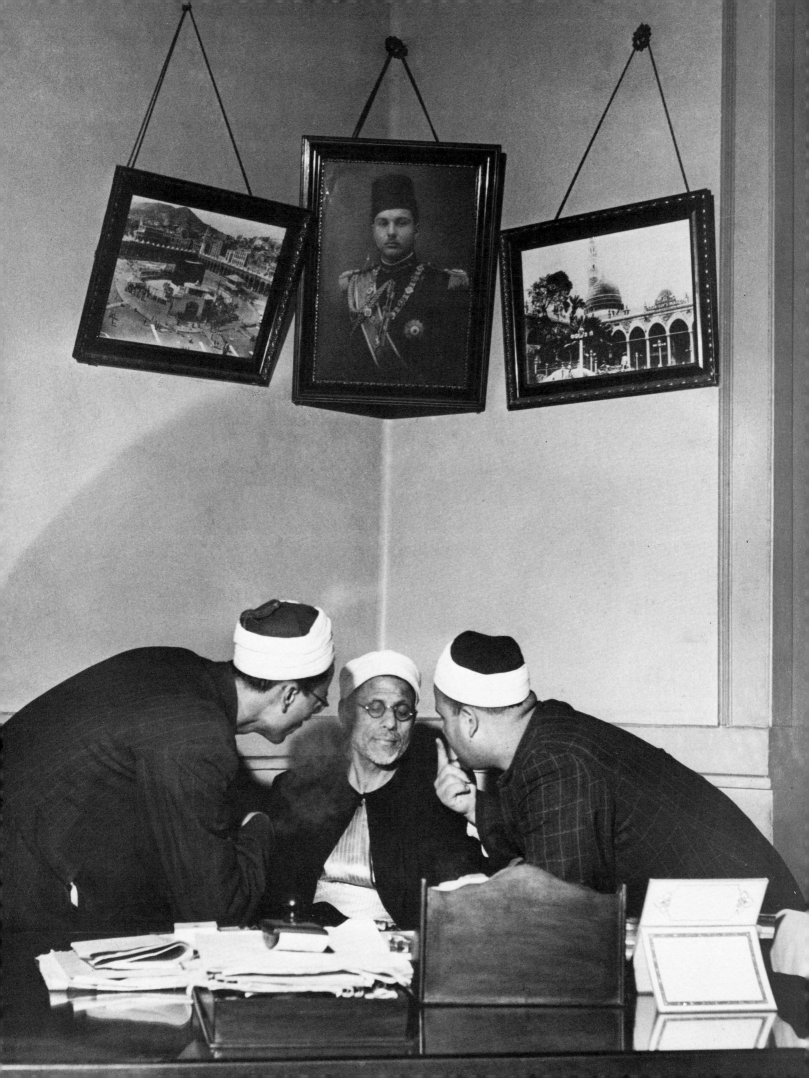

(318) Hadj Amin el-Husseini, Grand Mufti of Jerusalem and Palestine's most prominent Arab leader, made a dramatic appearance at the Arab League Council meeting held in Cairo on February 27, 1948.

(319) Sabri Pasha Taba, at his Amman warehouse, acted as contact between Palestinian Arabs and the Arab Liberation Army based in Syria.

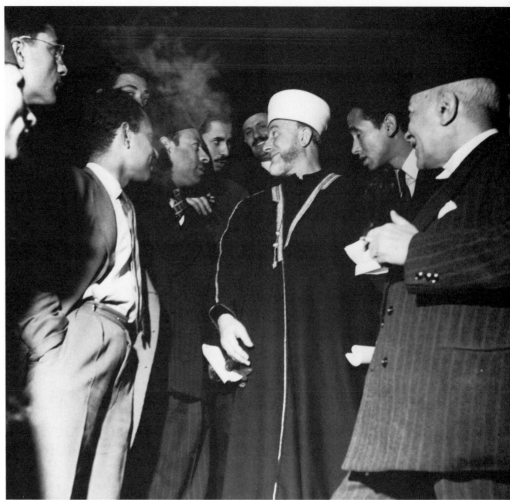

318

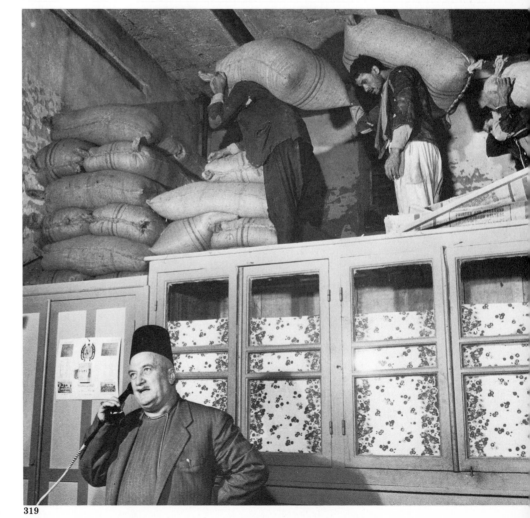

319

I learned of his whereabouts from Haganah intelligence. The Mufti, having escaped from Germany, was now a guest of King Farouk in Egypt. Photographing "Mr. Palestine," as the American press called him, presented certain difficulties because, officially, he was not in Egypt. Finally I got a tip: the Mufti was planning a dramatic appearance at a meeting of the Arab League at the Egyptian Foreign Office.

The Mufti, followed by a respectful retinue, swept into the main conference room. Never had I seen such insolent self-assurance.

I was taking his picture when a member of his entourage came up to me. "You did that *Life* story on Palestine in 1943," he said.

Flattered, I readily agreed.

". . . And you have the audacity," he screamed, "to photograph our Mufti after taking pictures of Ben-Gurion!"

Although the Mufti was recognized as the obvious leader of the future Palestinian state, he could not return to Jerusalem until after the British left. He still had a price on his head. His entire future depended upon the Arab Liberation Army being recruited in Syria. Its commander, Fawzi el-Kaoukji, was my next assignment.

Fawzi's career had been a political maze. Born in Lebanon, he served as a Turkish officer in World War I and fought against the French. This did not stop him from joining the French special services in 1920 when they took over the Mandate of Syria. Being a French officer did not stop him from joining the unsuccessful Druze revolt against France in 1926. In 1928 he became a military instructor in Baghdad. This did not stop him from joining the unsuccessful pro-German revolt against the pro-British Iraqi government he was serving. Escaping to Berlin, Fawzi joined the Mufti in collaborating with the Nazis. Less artful than the Mufti, Fawzi was caught and interned by the Russians after the Nazi collapse. At the Syrian government's request, he was released and surfaced in Damascus to assume the field command of the Arab Liberation Army, whose commander-in-chief was none other than the Iraqi general he had betrayed in 1941.

Everybody knew that Fawzi was in town, but no one would tell me where to find "the Lion of Damascus." After too many drinks with Fawzi's executive officer, I got a promise he would arrange a meeting. The Lion's den was on the ground floor of an apartment house. Ducking under his child's diapers strung out on a clothesline, I came face to face with Fawzi. "I am a man of action," the Lion roared, "and the time for deeds is near."

"How near?" I asked.

"Just you wait and see," he said.

One morning at dawn Fawzi and his staff set off for northern Palestine, where he planned to establish headquarters.

"Where?" I asked.

"Wait and see," Fawzi said, hopping into his command car. His executive officer, however, had told me to contact Fawzi's man in Transjordan.

Sabri Pasha Taba, described to me as "a Moslem with the grace and hospitality of a Bedouin uncontaminated by Western civilization," received me in his Amman warehouse. He obligingly offered me the three traditional cups of coffee but refused to give me a *laissez passer* to Fawzi's headquarters.

In spite of this secrecy, everybody knew that Fawzi's headquarters were at Jaba in Samaria. Without official clearance, I drove to Jaba. Fawzi did not seem at all surprised to see me. He led me to a veranda which overlooked the hills, olive groves, cacti, rocks, and dust of northern Palestine, announcing, "The time for deeds has come!" Then he took me to lunch. Seated with Fawzi was a group of foreign mercenaries, along with Syrian, Iraqi, and Palestinian Liberation Army officers.

Taking me aside, a Croatian mercenary expressed his contempt for them. "They have no idea what a real fighting outfit is like. I do. I was with the SS during the war." Then he told me that Fawzi planned to besiege Jerusalem and starve out its inhabitants before the Mandate ended.

"If that's true, why do Fawzi's men make such wide detours around the Jewish settlements controlling the main road to Jerusalem?" I asked.

"Just you wait and see," the SS man growled.

(320) Fawzi el-Kaoukji, predecessor of Yasser Arafat, was field commander of the Arab Liberation Army.

320

203

(321) During the last week of April 1948, Palmach, the Israeli elite force, seized Haifa to gain control of a much-needed port for receiving supplies after the British Mandate ended and open warfare with the Arabs began. Here Polish mercenaries captured during the fighting are loaded on trucks.

(322) Close-up of a Polish mercenary being guarded by an Israeli MP.

(323) A relaxed Israeli sentry sitting guard after the stunning Haifa victory over the Arabs.

321

322

I saw for myself in Haifa. Three weeks before the Mandate ended, Haganah took a calculated risk. Surrounded on all sides by Arab countries, the Israelis would have to rely on shipping for their supplies. With the only docking facilities concentrated in Haifa, it was imperative they gain control of the harbor. Haganah gambled that the British government would not risk heavy casualties defending a harbor they were about to evacuate. The gamble paid off. Notified by the Israelis of their plan of attack, Mandate authorities pulled back the Royal Marines to the dock area, leaving Fawzi's Arab Liberation Army to defend the city. The battle was over before I could get there. The Arab world was stunned.

The Haifa defeat made it clear to the Arabs that their last hope rested with Abdullah ibn-Hussein, the Mufti's enemy, who, with his Arab Legion, had been playing a waiting game.

I had first met Abdullah in 1943. Broadhurst Bey, deputy commander of the Arab Legion, had invited me to meet Abdullah, thinking I might amuse him with my stories. Abdullah had gone to Aqaba Bay to observe maneuvers. While Arab maneuvers did not interest me, Abdullah did. I found him seated on a low divan in a mud-framed building, its walls and ceiling made of reeds, allowing the sea breezes to filter through. Although Abdullah ibn-Hussein was sixty-one, a member of the Hashamite dynasty

323

who descended from the Prophet, and a prominent figure in the Arab revolt, he was irreverently called "Ab" by the British.

Ab was as short as his nickname, a fact he tried to conceal by always standing erect. His flowing Bedouin costume was a spotless white. On his shaved head he wore a *hedjazi* turban at a jaunty angle. His skin, the color of a Havana cigar, had a silken sheen. His well-trimmed beard gave him a look of authority often dispelled by an impish chuckle. While he conversed, his small elegant hands toyed with a stubby gold dagger in his belt. (I later learned that the dagger and its sheath had been soldered together to prevent his harming himself when he flew into his uncontrollable rages.)

"You look like a man from Damascus," was Ab's greeting.

"I was born beneath the sky of Islam, my lord."

"You can always tell," he observed, thoughtfully scratching his right foot.

At Broadhurst's suggestion, I told Ab about being aboard a munitions ship loaded with explosives and how the captain had warned us that what we really needed were parachutes, not life jackets. Ab listened attentively and, slowly raising his eyes to the fluttering reeds on the ceiling, asked, "How high would you have gone if the ship blew up?"

"Too high, my lord."

His Lordship chuckled.

(324) *The Ghazzawieh Bedouin tribe of Transjordan, led by their chieftain Emir Mohammed Saleh, marched on Palestine in the last days of the British Mandate.*

(325) *Emir Mohammed Saleh and his tribesmen as they forded the Jordan River to reach Palestine.*

On my return to Amman in April of 1948, the first thing he said was, "Do you remember the good times we had at Aqaba Bay? I said to you, 'How high would you have gone?' and you said . . ."

Ab had not changed, but his desert kingdom had. Once the backwaters of nowhere, Transjordan had become a linchpin in the forthcoming Palestinian drama. Created on the spur of the moment in 1925 by Winston Churchill to caulk yet another Mideast crisis, Transjordan was a desert with no natural resources, no industry, and no agriculture — all the food it consumed was imported. Nevertheless, the economy was sound, thanks to contraband and the British subsidies for the Arab Legion, Transjordan's only reason for existing. This long-term British investment was about to pay off, as the Legion was the only Arab army capable of opposing Haganah with any chance of success. Since the Legion was about to play a major role in this conflict, I had come to Amman to get accredited to Ab's army.

Taking pictures of the Arabs had become hazardous. In Cairo I had escaped being lynched by a frenzied mob for taking pictures of noonday prayers only because the anti-riot squad was considerate enough to beat off my assailants. Soon after, a group of Arab irregulars in Damascus tried to steal my Studebaker while I was still in it. They nearly broke my neck

trying to wrest me out through the front window. Several regular officers heard my howls and booted the irregulars out of the way. Accredited to the Arab Legion, I would be offered the protection of the uniform.

Appropriately enough, *The Road to Utopia* was showing at the Amirate Palace in Amman. Thanks to the benefits of smuggling, Amman had swollen from five thousand to seventy thousand. Although Transjordan was in the sterling block, dollars were overabundant. Combined with a total lack of controls, these circumstances had turned the city fathers into millionaires. Amman had everything except whorehouses, which Glubb Pasha, commander of the Arab Legion, considered immoral. In Amman goats and sheep wandered down streets filled with pedestrians wearing Rayban sunglasses. Illiterates signed their names by inking their thumbs with Parker 51 pens. American cars obeyed traffic lights alongside donkeys and camels.

The architectural style of the royal palace could have been called functional-fairytale. Its façade was studded with electric bulbs that glittered in the sun like icing. Here Ab maintained his private quarters, his harem, his throne, his collection of distorting mirrors, and the huge globe he pored over when planning extravagant journeys he could not afford. Ab's third wife was an ebony-complexioned Ethiopian. (She had been his

(326) Transjordan's Arab Legion at Wadi Rum, once Lawrence's headquarters during the Arab revolt.

(327) Abdullah ibn-Hussein, amir of Transjordan, became King Abdullah of Jordan shortly before his army crossed into Palestine on May 15, 1948.

(328) British-trained Arab Legion infantrymen on parade.

(329) The Arab Legion's Camel Corps.

(330) Playing chess with Abdullah.

(331) Abdullah interrupted the chess
game to observe army maneuvers
through binoculars.

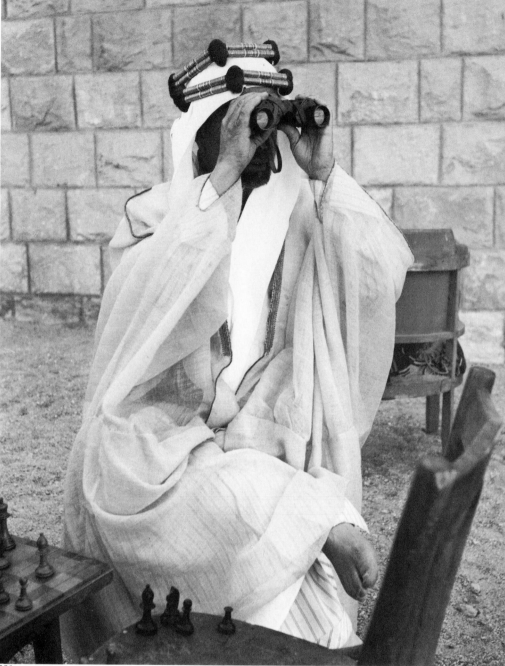

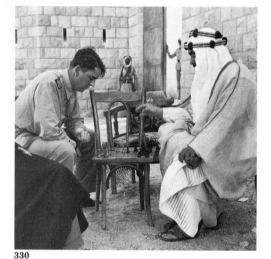

330

331

second wife's maid; the second wife had been his first wife's lady-in-
waiting.) While Ab's first two wives lived at the palace, the third had a
villa of her own. She was listed in the telephone directory as the "White
House," but, in accordance with protocol, her number followed those of the
first two wives, listed respectively as the Queen and the Princess Royal.
Daily, Ab visited his three wives, in reverse order of their marriages.

I was strolling up to the palace for a lunch date when Ab called out to
me. He was fussing over his new throne. It had been built by a Jewish
carpenter in the Old City of Jerusalem and he saw no way of getting it to
Amman before the war broke out.

"I'm sure the Haganah would be happy to deliver it to you, my lord," I
suggested.

"That would not look right," Ab sighed.

By lunchtime more than twenty guests had assembled, which caused a
domestic crisis. There was not enough china, glassware, or cutlery to serve
a six-course meal to all these people. The only four crystal glasses
engraved with the crown went to Ab and his three most distinguished
guests. The rest of us drank out of heavy kitchen glasses. Towels served as
napkins. Conversation was carried on above the gurgle of running faucets
which drifted in from the adjacent pantry where knives, forks, and plates

208

were hurriedly washed after each course and returned to table. Ab helped himself to each course as he conducted the conversation. He tweaked me over the United States' refusal to recognize his kingdom and was caustic about the United Nations, considered by him the graveyard of diplomacy. Ab felt it was ridiculous to expect nations to air their grievances publicly. He stoutly believed statesmanship was based on secret treaties and dubious alliances. For all his impishness, Ab was a realist. He knew that moderation, not violence, was the only solution to the crisis brought about by the partition of Palestine.

Sometime later, in a rare moment of candor, I was told Abdullah had admonished his older son, who was touting Arab patriotism, by screaming at him: "You don't understand! We need a strong ally. Russia is out of the question. America isn't interested in us. Only the British know us well enough to help, even though they have let us down in the past." Ab saw the approaching war as an opportunity to expand the boundaries of his kingdom. His son saw it as an expression of pan-Arabism. Abdullah schemed, his son dreamed.

"What Abdullah really wants," the French ambassador told me, "is to play both Saladin and Richard the Lion-Hearted in this twentieth-century crusade." In other words, Abdullah intended to play both ends against the middle by appearing to champion blind nationalism while actually accepting the inevitability of partition. Abdullah and Glubb had no intention of squandering the Arab Legion in a futile war against Israel. The West would recognize his moderation and the United States would recognize his kingdom. Great Britain would keep up her subsidies, and he would acquire Arab Palestine.

The Mufti, who now faced defeat, suspected Ab of nursing such plans, as did all the other Arab leaders. While each of them echoed el-Azhar's call for a Holy War against the Jews, they did so for a number of reasons. The Syrians aimed to occupy both Jewish and Arab Palestine, a first step in recreating "Greater Syria." Lebanon's ambitions were more modest: the only Arab state with a Christian majority, the Lebanese were alarmed by ever-increasing Moslem fanaticism. A war against Israel would deflect this fury and direct it against the Jews. Farouk, increasingly unpopular with the Egyptians after the British withdrawal because they were no longer around to be blamed for everything, saw in a war against Israel a way of providing his subjects with an opportunity to hate something else. The same went for Iraq's royal family. Saudi Arabia, basking in the newfound benefits of oil, merely paid lip service to fanaticism.

At the approach of May 15—the day when the British Mandate ended and the war would start—the tempo of terror grew in Palestine. Arab volunteers poured in from Egypt, Iraq, and Syria. British deserters, German SS, and Polish mercenaries were hired by the Arabs to commit acts of terrorism. The Irgun massacred the Arab population of Deir Yassin in the name of psychological warfare. In panic, two hundred thousand Palestinians flooded the road to Amman. At the same time I got pictures of Glubb Pasha as he moved units of the Legion into Palestine across Allenby Bridge.

I had first met John Bagot Glubb, commander of the Arab Legion and the real master of Transjordan, in 1943. At that time he had taken me on an inspection tour of the Legion's desert outposts. We camped at Wadi Rum, which had for a time been Lawrence's headquarters during the Arab revolt. Carpets were spread on the sand in a square formation while Bedouin legionnaires sat crosslegged staring silently at Glubb. In the center of the square a Bedouin corporal made bitter coffee, which he then passed around, with everyone drinking from the same cup. In the twilight the legionnaires spoke in whispers. I listened to Glubb's singsong voice, which his *jundis* liked to imitate. Many have considered Glubb as Lawrence's successor. Always the professional soldier, Glubb took a dim view of Lawrence, whom he considered the inspired amateur. He felt that Lawrence had thrown away a great opportunity to help the Arabs. "Lawrence did not want to risk his fame," Glubb said. "He should have rolled up his sleeves and done a job of work."

(332) With Glubb Pasha at Wadi Rum.

332

209

333

334

335

(333) Brigadier John Bagot Glubb, known as the Pasha, was in command of the Arab Legion.

(334) Abdullah's military escort.

(335) Abdullah attending noonday prayer in Amman Mosque.

(336) Battle of the Jewish quarter, May 17, 1948.

(337) The Arab Legion went into action in Jerusalem's Jewish quarter on May 18.

(338) With a British deserter.

(339) Exodus from the Jewish quarter.

210

With some fifty British officers under his command and a profound understanding of the Bedouins' macho psyches, Glubb had molded the Legion into a modern fighting force. Indifferent to his own appearance, Glubb displayed real flair in designing the Legion uniforms—the tougher the branch of service, the more dazzling the uniform, with the most sumptuous outfit going to the Camel Corps, which patrolled the Saudi border. These men got crimson coats with sheep-wool linings. Such was the Arab army I had got myself accredited to.

May 14 arrived. All that day units of the Arab Legion wound their way down into the valley. Ab, in a new uniform just completed by his Armenian tailor, watched his Bedouin warriors, pigtails flying, perform their wild war dance in the gathering dark.

At dawn on the fifteenth, my red-and-white *kouffieh* flapping in the wind, I rode across Allenby Bridge into Palestine. At last I was able to take pictures without fear. Mistaking me for a British officer, the Arabs left me alone. For the first three days the Legion manned the ramparts of the Old City of Jerusalem. On the third night the Israelis made a breakthrough at Zion Gate, reopened communications with the besieged Jewish quarter, and brought in an unknown quantity of supplies and reinforcements. Convinced that Fawzi's irregulars were incapable of preventing the Israelis

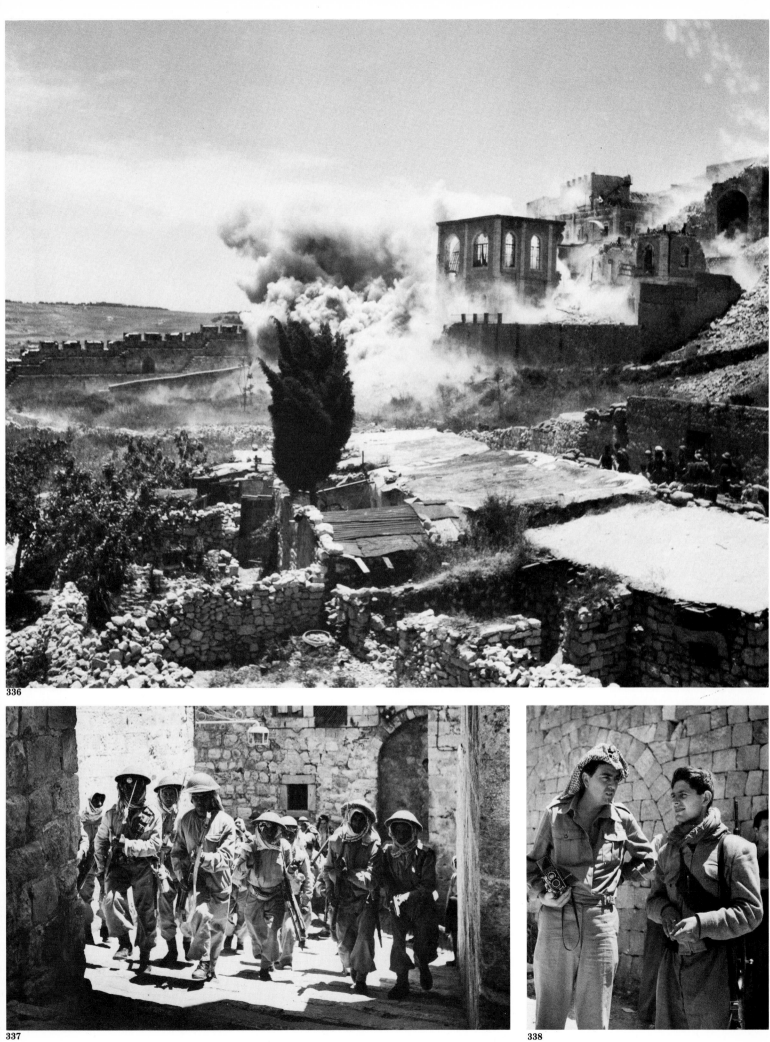

336

337 338

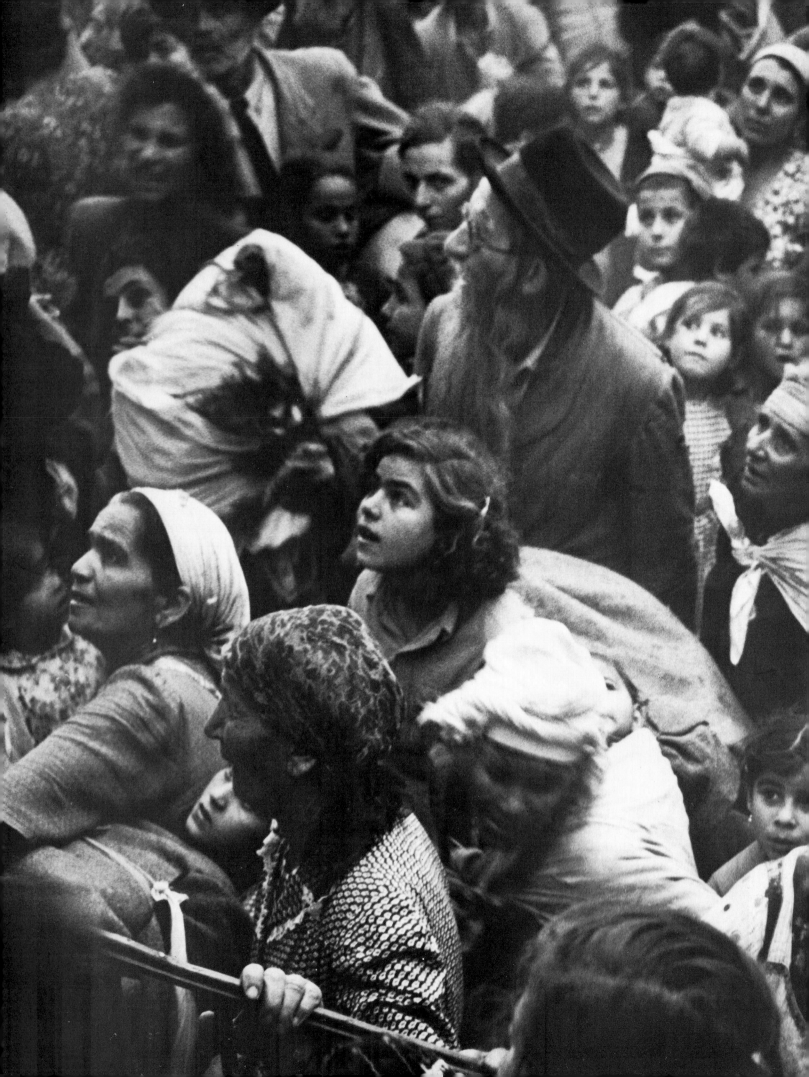

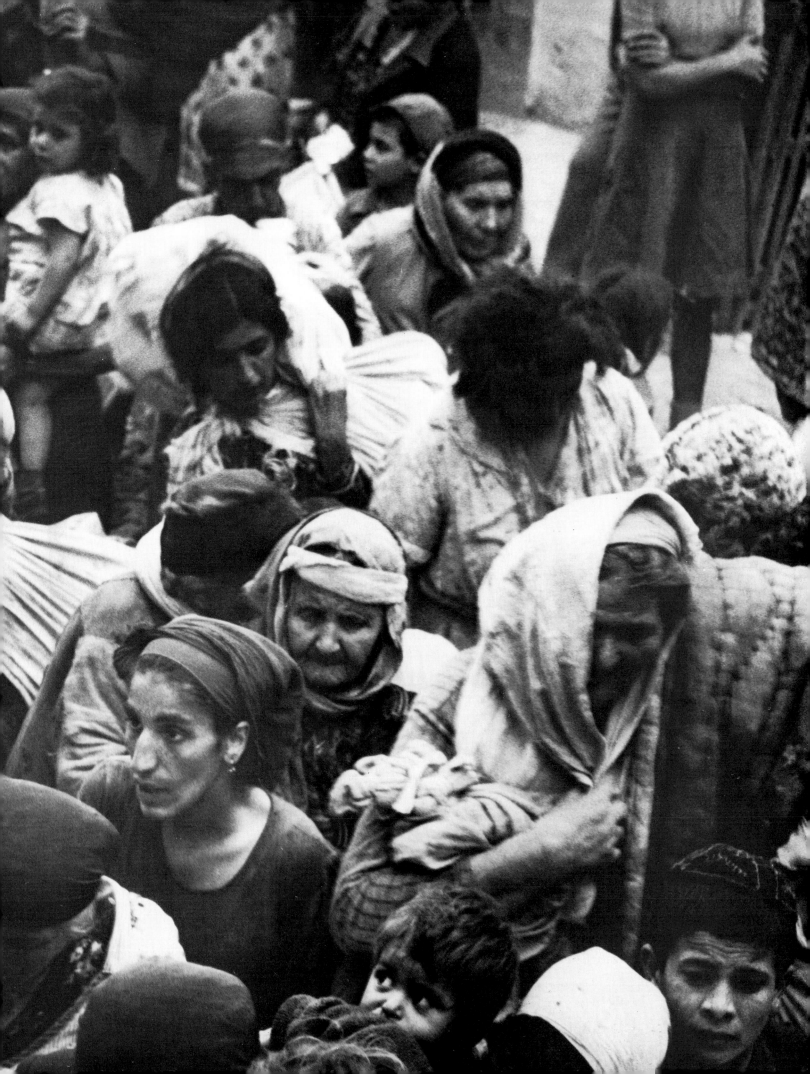

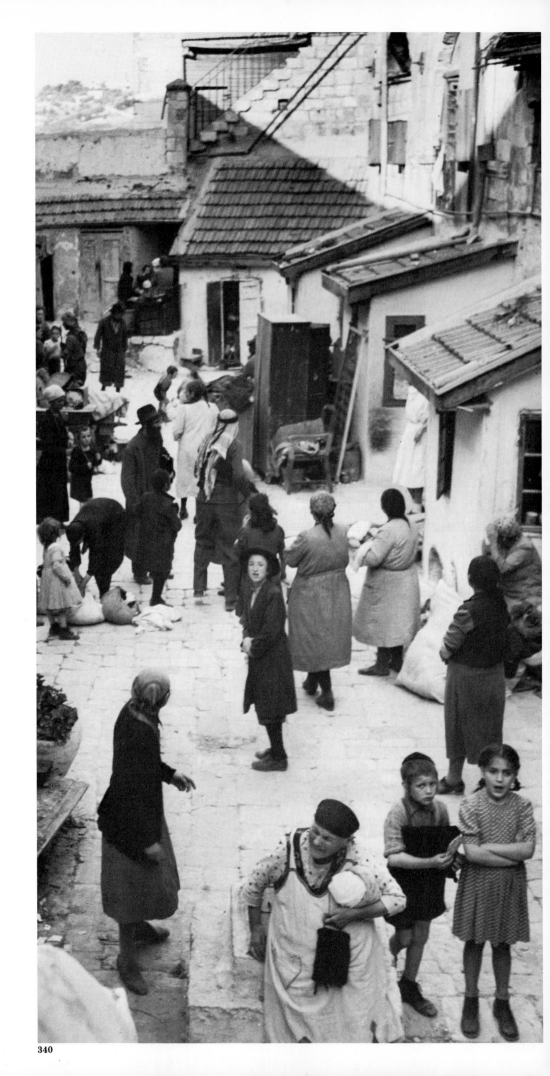

340

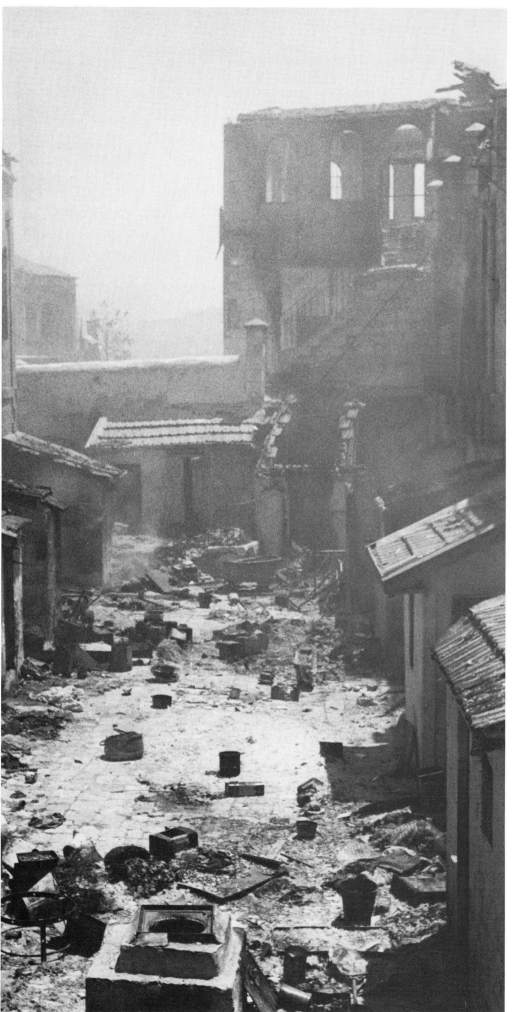

(342) Ten-year-old Rachel Levy running down Street of the Jews.

(343) Abdullah's triumphant entrance into the Old City after the fighting was over. He was on his way to Aqsa Mosque. In background is the Dome of the Rock.

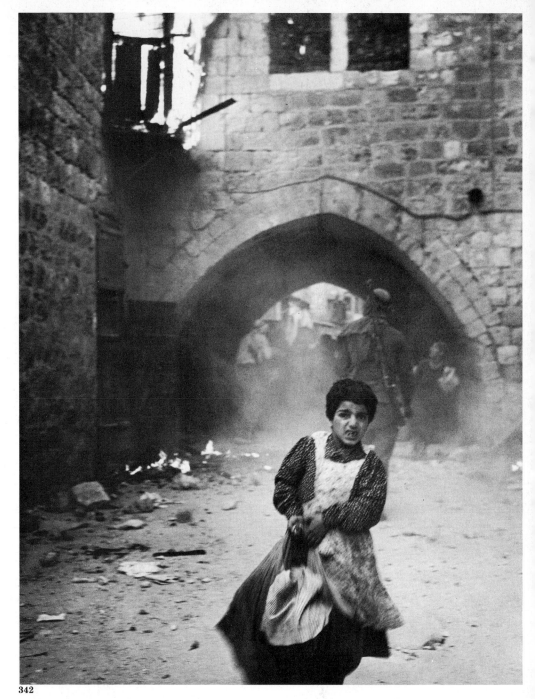

342

from taking the entire Old City, Glubb committed the Legion. For ten days the battle raged. Out of ammunition by May 28, the Israelis surrendered.

The sound of incessant gunfire which had bounced off the thick stone walls of the city's narrow streets had numbed my mind. After the electric power failed, I shamelessly walked into the Holy Sepulchre and took a lit candle in order to find my way back in the dark to the Austrian hospice where I was staying.

Though the Legion was disciplined, it was unable to prevent swarms of Palestinian civilians and irregulars from leaping over the rooftops to loot the Jewish quarter. By the time Abdullah made a triumphant entry, the Old City was smoldering. I took my last picture of him on his way to the Aqsa Mosque. He was in a flowing white robe. In the background was the Dome of the Rock. Abdullah was making his way to his father's tomb.

In 1951 an assassin's bullets killed Abdullah ibn-Hussein on that same spot because he was seen as too moderate with the Israelis. I was in Lausanne and could not have reached Jerusalem in time for the funeral, as, according to custom, he had to be buried before sunset. I could not have made the trip anyway. Our Cairo correspondent warned me that I had been sentenced to death *in absentia* for smuggling out my pictures of the looting of the Jewish quarter in the Old City of Jerusalem.

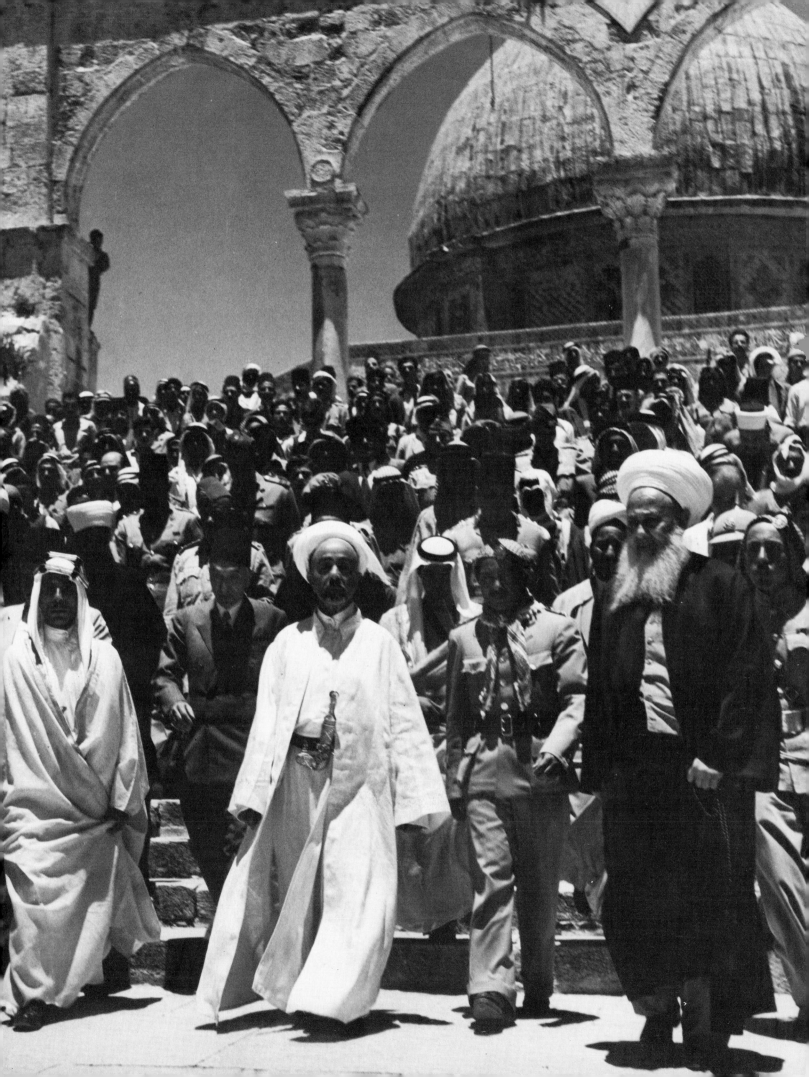

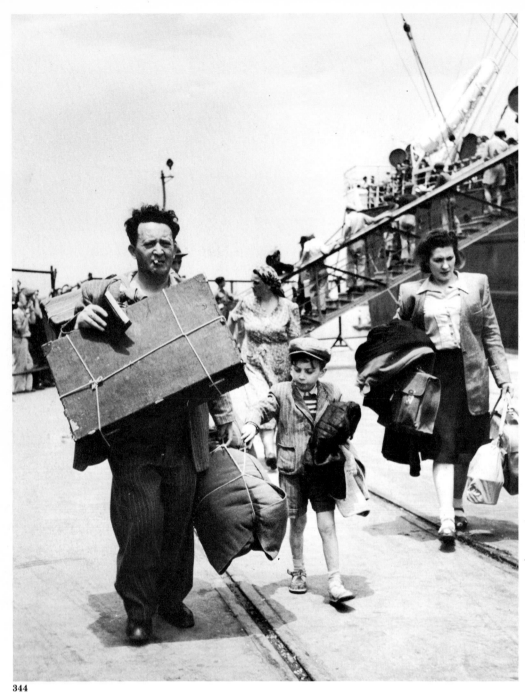

344

Israel, Year One

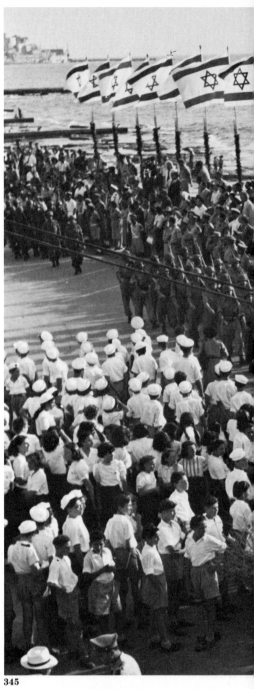

345

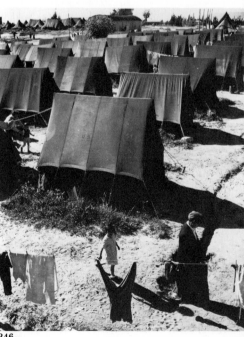

346

(344) *This family, who landed in Haifa with all their belongings, were among the waves of immigrants to arrive in Israel during its first year of existence.*

(345) *Tel Aviv's Navy Day parade seen from the Knesset (Parliament) building. Sea scouts in white shirts watched tough Israeli soldiers march past as Israeli flags fluttered in background.*

(346) *Tent cities sprang up across the country to accommodate refugees.*

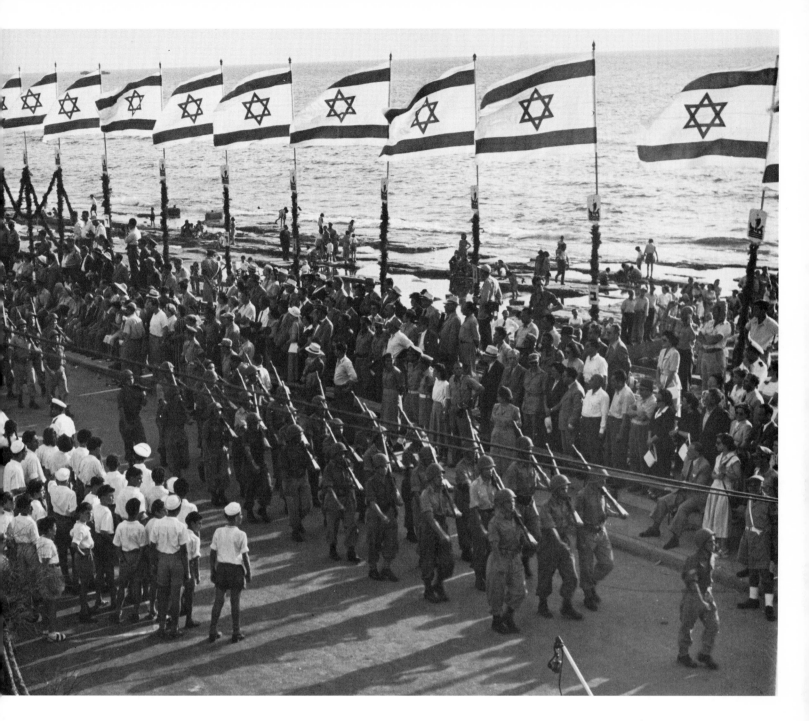

In the spring of 1949, a year after witnessing the Jewish surrender in the
Old City of Jerusalem, I was back in Israel. On first sight the country's
plight seemed hopeless — at least to foreign eyes. Immigrants were
swarming in faster than accommodations could be found. They came from
the German concentration camps, the asylums of central Europe, the slums
of North Africa, and the Dark Ages of Yemen. They spoke twenty different
languages. Many were old, ill, and illiterate. It was heartening to see how
they were all welcomed and seemed happy with their fate. Tents sprang up
in the desert to shelter the new arrivals. In spite of what any logical
person would consider insurmountable difficulties, the state of Israel,
within 365 days of its birth, managed to become the second strongest
military power in the Middle East after Turkey. The enthusiasm of the
Israelis during their first Independence Day parade in Tel Aviv illustrated
the country's state of mind. Seating space on balconies and rooftops on
Allenby Road, along which the parade would pass, was selling for as much
as fifteen dollars. A huge, good-natured crowd broke through police
cordons, climbed trees, overran the avenues, and clogged the streets, with
the result that nothing could move. Prime Minister Ben-Gurion had to call
off the parade. Although the military are embarrassed to this day at any
mention of the parade that never was, for me it was democracy in action.

(347) Menachem Begin at the Knesset in 1949.

(348) Golda Meir.

(349) Dr. Chaim Weizmann.

(350) Moshe Dayan.

(351) David Ben-Gurion.

219

347

348

349

350

351

352

353

354

Postwar England

On the evening of December 8, 1949, British prime minister Clement Attlee gave me twenty-eight minutes of his time at Number Ten Downing Street. His press attaché, Philip Jordan, whom I had known in Yugoslavia during the war, first took me to dinner at his club where I was treated to roast beef and claret decanted into a pitcher. We then went to Number Ten to select a suitable setting for pictures. Although Mr. Attlee was prime minister of the first truly Socialist government, he was not a precedent maker. He would not allow me to photograph him in the cabinet room, which he used as an office. After taking some pictures of the prime minister with his family in their drab living room on the second floor, I decided to photograph him on the staircase which, with its portraits of the kings' ministers lining the walls, conveyed more of a sense of what the British Empire had been over the centuries. Philip Jordan and I escorted the prime minister down the staircase (where, as Earl Attlee, his portrait has now joined the others). As we descended, Jordan remarked, "Without wishing to sound beastly, Prime Minister, the death of our candidate's wife this morning is bound to help us at the polls in tomorrow's bi-election." The P.M. agreed. "Of course it will, of course it will," he said. Mr. Attlee would not have been so candid in front of a reporter, but with a photographer he obviously felt it did not matter.

355

356

357

(352) Ever since the early days of Berry Brothers & Rudd — the St. James Street wine merchants who were once in the coffee trade — it has been a tradition to weigh distinguished Englishmen in the old scales. One such was Sir Roland Penrose — painter, surrealist, historian, millionaire collector, and Picasso biographer.

(353) Pre–World War I "Silver Ghost" Rolls-Royce.

(354) John Albert Edward William Spencer Churchill, tenth Duke of Marlborough, at Blenheim Palace in Woodstock, Oxfordshire.

(355) Prime Minister Clement Attlee at Number Ten Downing Street.

(356) Major James Buchanan of the Grenadier Guards hailing a taxi on leaving his club.

(357) Customer purchasing a deerstalker cap at Lock & Company, hatters, St. James Street, London.

Lord Anglesey

(358) *Henry, seventh Marquess of Anglesey, examining an ancestor's artificial limb worn after he lost a leg at the Battle of Waterloo. With him is his sister, Lady Elizabeth von Hofmannsthal.*

(359) *The Marquess of Anglesey in a replica of the uniform worn by his ancestor at the Battle of Waterloo.*

358

In 1950, curious to find out the effect World War II had had on England's great families, I visited the seventh Marquess of Anglesey. The financial fate of these families depended entirely upon the year the heir came into the title and on current death duties. When Henry Anglesey's father came into the title in 1905, he was the third richest man in England. By the time he died in 1947, he left Plas Newydd, the eighteenth-century 150-room mansion on the isle of Anglesey; a house in London; a weekend house near London; a house in France; an oceangoing yacht; and, of course, several Rolls-Royces. The staff at Plas Newydd, the family home, included a housekeeper, a cook, a stillroom maid, a butler, two footmen, four housemaids, two kitchen maids, a house carpenter, a house electrician, two handymen, five gardeners, two chauffeurs, a boatman, a groom, three gamekeepers, a crew of five for the yacht, and a groundsman for the golf course. When Henry Anglesey came into the title, the estate was valued at two million pounds sterling. With the panache he displayed while in the Household Cavalry, Henry Anglesey paid devastating death duties amounting to 1,750,000 pounds. He had to sell everything except the Plas Newydd estate, reduce the staff to five, and rent half the mansion to a naval training school which paid the taxes and covered the heating bill—an important item on an income reduced to 3,000 pounds a year. The

(360) Lord Anglesey and his black Boston terrier Mitzi in the large Gothic music room, which was no longer in everyday use. Portraits on wall are forebears of the seventh marquess.

(361) Mitzi sat before a trompe l'oeil *mural painted by Rex Whistler portraying one of her ancestors who lived in plushier times and wore a pearl necklace.*

four-hundred-acre home farm paid its own way. A horticulturist, Anglesey replanted six hundred acres of woodland which would show a profit in thirty years, not a long time for a twelfth-generation Anglesey, one of whose ancestors had been private secretary to Henry VIII. Then he plowed up the golf course and developed a market garden which sold cut flowers and bouquets. The marquess, his wife, and daughter spent most of their time at Plas Newydd, where Henry devoted his spare time to such voluntary work as being president of the Anglesey Conservative Association. He also put much time into sorting out his family archives, which go back to the year 800 and have provided him with material for six books. Of special interest is *One Leg*, the life and letters of the first Marquess of Anglesey. (The Paget family became the Barons of Beau Desert in 1549, the Earls of Uxbridge in 1784, and the Marquesses of Anglesey in 1815 after the Battle of Waterloo.) The first Marquess of Anglesey was Wellington's second in command during the battle against Napoleon. The two men, however, were not on speaking terms, Anglesey having eloped with Wellington's sister-in-law. Nevertheless, they did exchange a few words at Waterloo. A French shell having struck him, Anglesey exclaimed, "My God, sir, I've lost a leg." Turning to Anglesey, Wellington replied, "So you have."

Welsh Miners

362

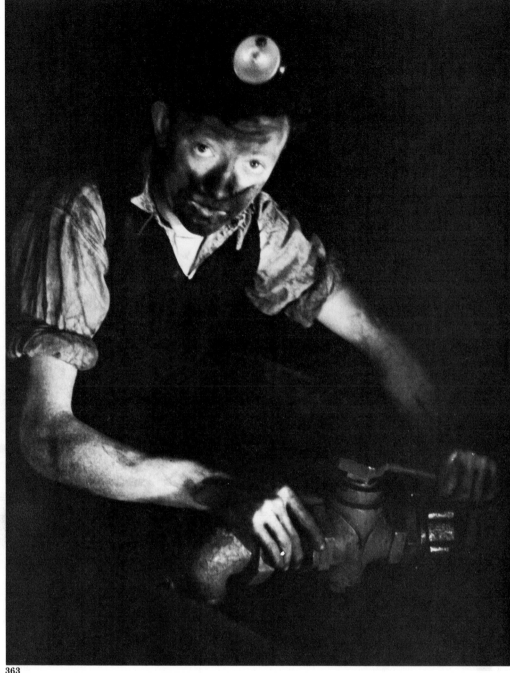

363

In 1951 I returned to North Wales to settle my father's estate and sell Tyn-y-Rhos ("the House in the Valley"), which had been the family home since my ancestors joined the British in the last Welsh insurrection. I decided to pay homage to the Welsh miners by doing a story on that extraordinary breed. In 1934 I had been in North Wales at the time of the Cresford colliery disaster. It was a Saturday morning. Fire broke out in the mines. I will never forget the families of the miners standing expressionless beside the slag heaps waiting for news which, when it came, was very bad. Through the family estate agent I met a father and son who were miners and went down the mine with them. At one point there was a cracking sound in the earth and one of the miners asked, "Feeling a bit windy?" to which I replied, "No, but I will when you do."

Working conditions greatly improved with the postwar Labour government. One of the benefits was the showers where miners could clean up and change clothes before leaving. No longer did they have to walk home covered in coal dust, as I had once seen them do, and then get on all fours while their wives sponged them off over a tin washbasin in the courtyard. When I came to write this story I found that, inexplicably, my research had disappeared. I could no longer remember the town the miners came from or their family name. My last link with Wales was broken.

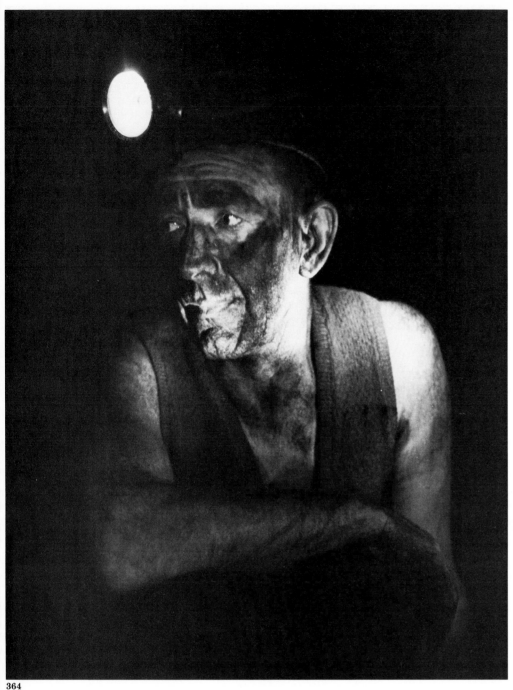

(362) After coming up from the mines, Welshmen had a shower, a postwar improvement in working conditions.

(363) Young miner and his father (364) in North Wales mine.

(365) Father and son with mine in background.

(366) Miner, his wife, and younger son shopping.

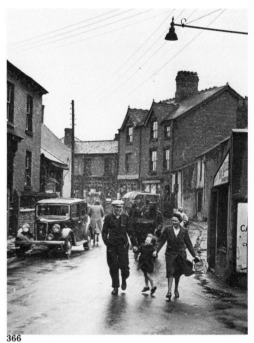

364

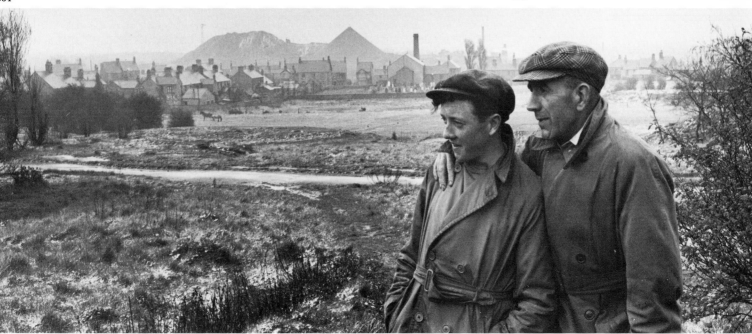

365

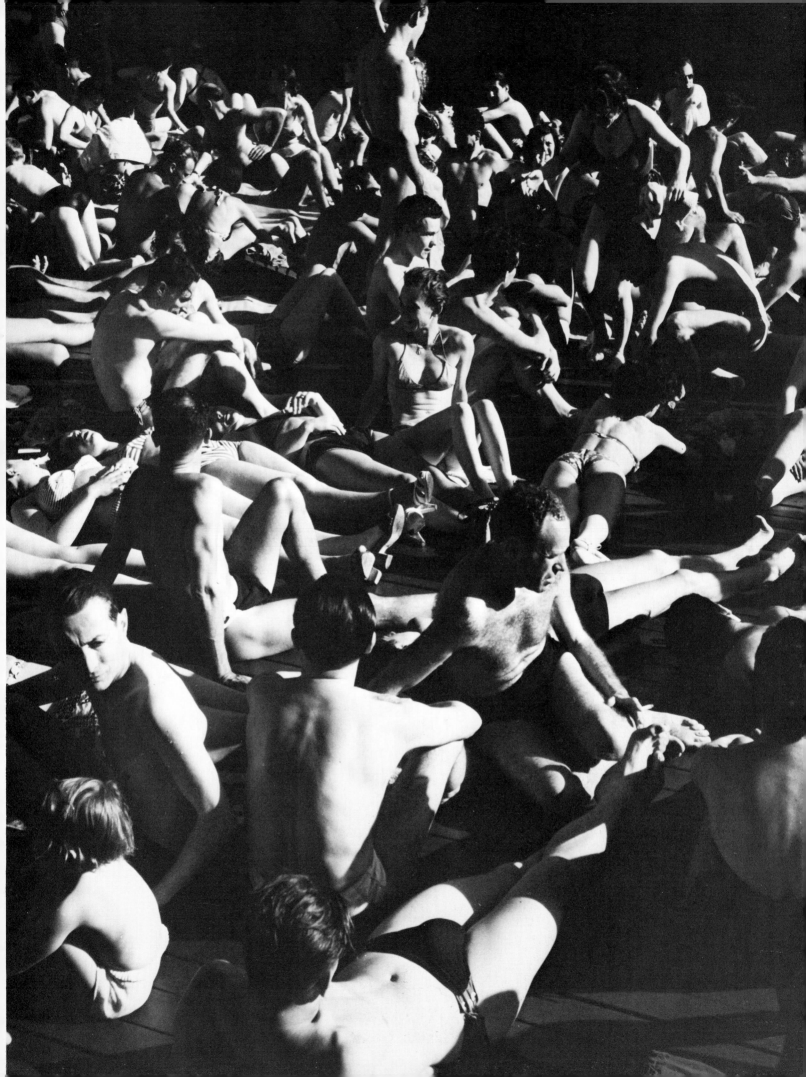

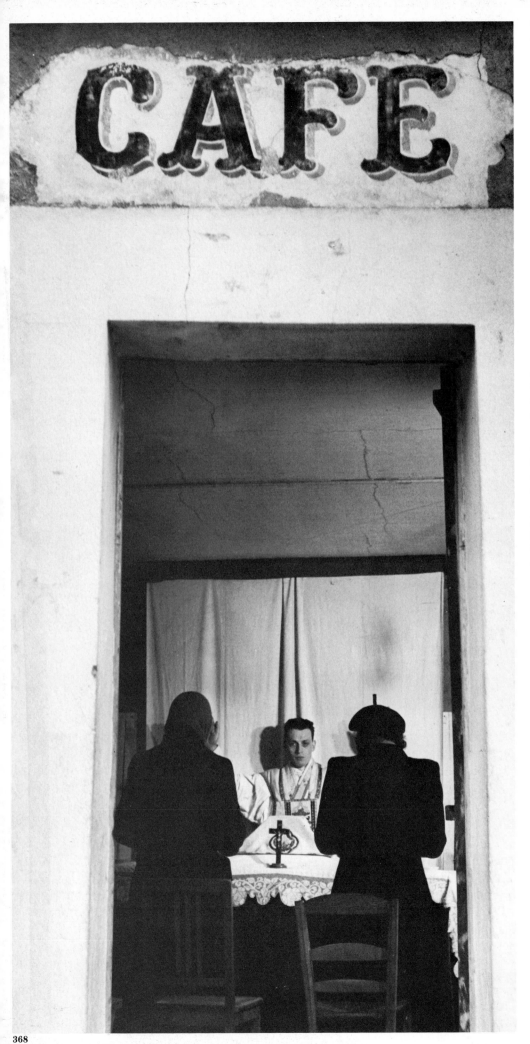

(367) *Le Bain Deligny, the Paris bathing establishment on the Left Bank of the Seine, attracted large lunchtime crowds in summer.*

(368) *Father Georges Baudry conducted mass for Mme. André Duval (left) and Mme. Roger Wilmart, the only two churchgoers in Mousseaux, 100 kilometers north of Paris. The priest rented a small café for mass on Sundays since there were no funds to restore the village's fourteenth-century church.*

368

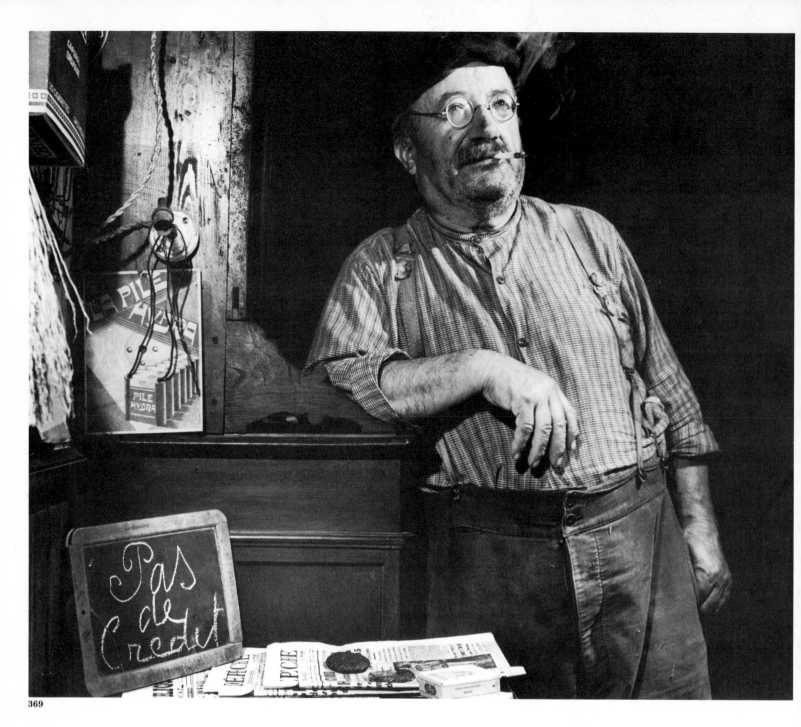

369

(369) M. Rossignol (Mr. Nightingale) was the sole tobacconist in Marsan, a small community in the heart of Gascony, from where the Pyrenees can be admired on cloudless days. M. Rossignol sold only Gauloise cigarettes and the local paper. No one paid any attention to his chalked sign: "No Credit."

Back in Paris during the fall of 1949 I became nostalgic about prewar France. One evening I figured out a way to photograph nostalgia. If Marce Proust, I reasoned, were alive and a photographer, he would surely go to see a descendant of Robert de Montesquiou, who had been his guide in the world now known as *Remembrance of Things Past*. Since I knew Robert de Montesquiou's nephew Jean, I asked him to show me his France. We embarked on a gastronomic junket during which I met Pierre de Montesquiou, Duke de Fezensac, head of the family and a descendant of D'Artagnan. Pierre de Montesquiou made Armagnac. (Thanks to my *Life* story, Pierre was invited to New York as "Monsieur Armagnac," and his appearance on television was the reason for a number of Americans becoming Armagnac buffs.) My oenological pilgrimage through France led me to Joseph Louis Gustave Leflaive and his wife Anne Marie Camille Beatrix de Villars Leflaive, makers of Montrachet, the great white burgundy. Until he took the density of the freshly crushed grapes during the vintage and found out that 1949 would be a banner year, M. Leflaive had been grumpy, because his wife forbade him, at seventy-nine, to drive on the national highway, which she considered dangerous. His protest that his mother had ridden horseback until she was past ninety simply did not convince Anne Marie Camille Beatrix de Villars Leflaive.

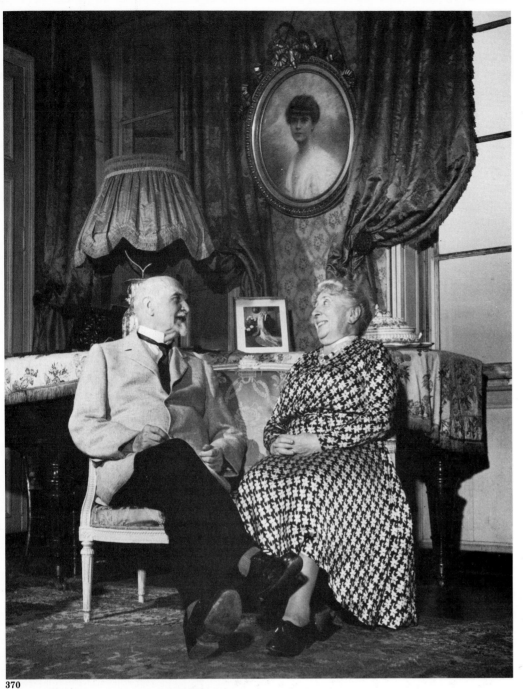

370

(370) Seventy-nine-year-old Joseph Louis Gustave Leflaive and his wife, Anne Marie Camille Beatrix de Villars Leflaive, sitting in their salon at Château Migny near Puligny in the heart of burgundy wine country. Mr. Leflaive made the famous Montrachet white wine, considered the finest.

(371) Jean Marie Pacot and his wife, Rose, could be a French version of the country couple in the famous Grant Wood painting. Pacot was hired to work at the Count of Montesquiou's château in the Morvan region.

(372) A bank in name alone.

372

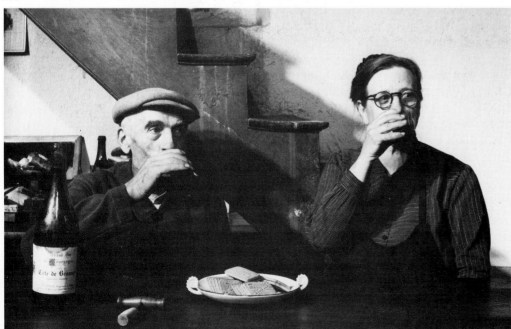

371

Upstairs-Downstairs in France

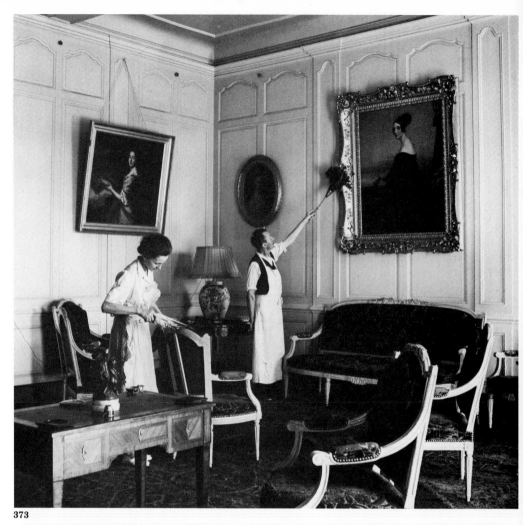

(373) *Using goose-feather dusters, Eugène and Aline spruced up a salon in the Duke de Fezensac Montesquiou's château at Marsan in Gascony. The château had been in the family since the year 1000, with only one brief disruption. During the French Revolution, the furniture was seized, auctioned off, bought back by faithful family retainers and, with the Terror over, returned to the legitimate owners. This fidelity never waned. When the duke joined the Resistance during World War II, his valet Eugène followed him. The pair belonged to "le maquis snob," so nicknamed because its members included Prince Bonaparte and Prince Murat.*

(374) *After the war Eugène returned to Marsan to take care of "his" parquet floors and the silverware. His favorite phrase was "We must do more entertaining." During a reception held two weeks after the birth of the duke's son, Eugène appeared in the dining room to announce, "M. le marquis is choking upstairs." Here Eugène is pouring Armagnac into a crystal decanter in a guest room. Armagnac was made by the duke. The difference between Armagnac and brandy: Armagnac is distilled only once and is considered superior to brandy by connoisseurs.*

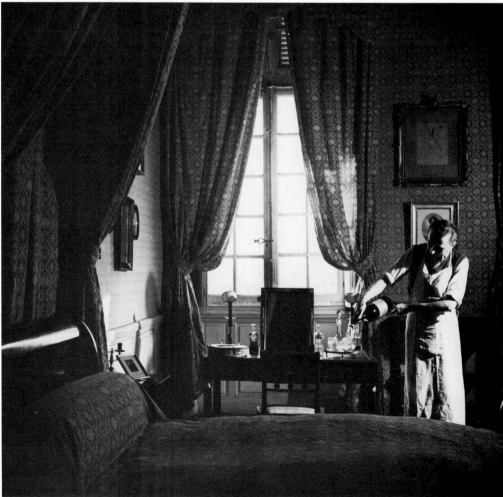

375

(375) When Pierre de Fezensac Montesquiou was in residence at Marsan he discussed the day's menu with Antoinette, the eighty-year-old housekeeper and cook. In winter, when he lived in Paris and visited Marsan in connection with his Armagnac business, the duke ate in the kitchen. Antoinette had definite rules about cooking: never use butter, use goose fat; all pots except frying pans must be copper; cooking must be done on a wood stove; Armagnac is a must in many dishes.

(376) The duke (back to camera) and his wife Nin being served by Eugène while entertaining guests at Marsan. Although the pair was considered one of Paris's smartest couples and Nin frequently adorned the pages of Vogue, she was a registered nurse who often acted as assistant surgeon at Marsan and on many occasions was called upon to wash the dead, while, for his part, the duke never felt a moat separated him from the people of Marsan. Elected mayor, he stepped down in favor of a baker to become one of his assistants. A lawyer, he also gave free legal advice to townspeople. Said one, "What else would you expect? He's a descendant of D'Artagnan, after all."

376

377

378

380

379

(377) Duke Luigi Grazzano Visconti di Modrone, once Italy's greatest jockey, enjoyed watching early morning training at San Siro racetrack, Milan.

(378) Younger brother, Count Edoardo, who turned the family business into the largest pharmaceutical company in Italy, shown hunting with his son Brandy.

(379) Youngest brother, Luchino, retired to his Roman villa to adapt the films, plays, and operas he would direct. The only author he did not rewrite was Shakespeare.

(380) The Visconti brothers (left to right), Luchino, Edoardo, and Luigi, at the Carthusian monastery in Pavia where ancestor Gian Galeazzo, who built Milan's Duomo, lies buried.

Success comes naturally to the Viscontis, like breathing to others. For the past twelve centuries mediocrity has been alien to this family. With medieval ancestors related to the crowned heads of France, they satisfy the Italian partiality for titles. The Viscontis are more a dynasty than a family, and maintain strong links with the past. The attachment is not only emotional but physical—every Visconti shares a striking resemblance to Gian Galeazzo, the hawk-beaked Renaissance man who made his family crest the emblem of the city and built the Duomo, Milan's famed cathedral. The Visconti manner matches the Visconti look. The three Visconti brothers I photographed in the early sixties were all brilliantly successful in their own fields. Luigi, oldest of the three and as such the Duke of Grazzano-Visconti, was Italy's greatest jockey, accumulating four hundred trophies and twenty-seven fractures in his twelve-year reign. Count Edoardo, the industrialist, transformed the family business into Italy's largest pharmaceutical company. Count Luchino, the opera, theater, and film director, was regarded as the forerunner of neo-realism in Italian films. His movie *La Terra Trema*, in which poor Sicilian fishermen speak an obscure dialect, was the only Italian film requiring subtitles when shown north of Palermo.

The Viscontis of Milan

The Royals Go Cruising

(381) Members of Greek royal cruise at Mykonos.

(382) Queen Juliana in the ruins of Olympia.

(383) Prince Bernhard of the Netherlands with his movie camera.

(384) Cruise ship Agamemnon anchored off Mykonos.

385

386

(385) The Count and Countess of
Barcelona, parents of the present King
of Spain, standing in front of a
windmill on Mykonos.

(386) Group of young pretenders to the
throne in 1954, who today are (left to
right) King Juan of Spain; Prince
Victor Emmanuel, a businessman;
Prince Henri of France, businessman;
ex-King Simeon of Bulgaria,
businessman; and Queen Beatrix of the
Netherlands.

In the spring of 1954 I heard about an upcoming royal cruise from the
exiled queen of Italy. In the elegant comfort of her Swiss home, Marie-José
of Savoia told me about a junket to end all junkets while sipping her Scotch
highball through a straw. The Savoias, along with Europe's other royals,
had been invited to cruise the Aegean that summer. A liner would be
chartered to accommodate them all. With Greece barely out of a civil war
and now confronting the British Empire over Cyprus, such a cruise on such
a scale at such a time sounded incredible. Who in the world could dream up
such an extravaganza?

"Frederika," Marie-José announced cheerily.

That Queen Frederika of Greece — known as "Freddie" to friend and
foe — had dreamed up such a project was closer to a Hollywood musical
than reality. I could just imagine the royals, debonair in their beach clothes,
crowding the deck. That was the picture I set out to get.

At first no one gave credence to my story. "Queen Frederika can't be
that irresponsible!" was *Life*'s reaction, until the grand marshal of the
Court of His Majesty, the King of the Hellenes, made it official. Europe's
royals were to be the guests of King Paul and Queen Frederika for a
twelve-day cruise. The liner S.S. *Agamemnon*, converted into a cruise ship
for the occasion, would sail out of Piraeus on August 20, 1954, to pick up
its royal passengers in Naples. The passenger list would not be made public.
Regarding the press, the grand marshal was adamant. No photographer —
not even the court photographer — would be allowed on board. (The only
commoners would be the ladies- and gentlemen-in-waiting.) This was to be
a private divertissement for the royals paid for from a fund set up by the
late shipping magnate Eugene Eugenides ". . . for the promotion of
international tourism to Greece."

Life's managing editor, Ed Thompson, unperturbed by the royal decree,
assigned me the story. I did not take the ban on photographers too seriously.

Confident I could do business with Freddie, I landed in Athens a week
before the cruise was to start. My attempt to endear myself to the grand
marshal was a fiasco. My audience with the queen was no more successful.
Under no conditions would I be allowed aboard the *Agamemnon*. She did
toss me a bone: I was granted permission to photograph the royals visiting
historical landmarks. The offer was less generous than it might seem. Most
of the sightseeing would take place on widely scattered islands, with no
way to get from one to another in time to keep up with the cruise ship. But
it did confirm that Freddie needed some publicity.

I was trying to figure out my next step when I got a cable from *Life*:
Paris-Match would have a photographer on board the *Agamemnon*. Could I
get on board, too? If not, the French photographer would be assigned the
story. "Hire the Frenchman," I cabled back, convinced that if I could not
get on board, no other photographer could. I was so certain *Paris-Match*
did not have the story sewed up I decided to back up my hunch by
chartering a yacht in Piraeus and chasing after the *Agamemnon*. The best
boat of the lot was the *Toskana*, a sturdy schooner with an auxiliary
engine — but still no match for the sleek *Agamemnon*.

With the help of *Time* magazine's Athenian stringer, I plotted a course
that would allow me to keep up with the fast cruise ship on an every-
other-island-or-so basis. By using the stringer's car, we could also catch up
with the royal sightseers on some of their mainland stopovers.

On August 20, the *Agamemnon* sailed for Naples while I remained at the
Hotel Grande Bretagne wondering if my gamble would pay off. The cruise
ship had put into Naples at the time I ran into King Umberto, Queen Marie-
José, and their son Prince Victor Emmanuel in the hotel lobby. Exiled from
Italy, they were to join the cruise in Corfu. Prince Victor Emmanuel, an
obliging young man, loaned me his father's confidential copy of the
passenger list. From this classified document I noted that five kings, three
queens, one imperial highness, sixty-three royal highnesses, one prince,
two princesses, one count, two countesses, and one hereditary count had
accepted Freddie's invitation. These bluebloods were listed in order of
precedence: H.M. the King of the Hellenes came first and H.R.H. Prince
Alexander of Yugoslavia last.

I had no idea who Alexander might be. It was comforting to see that the King of Italy did not know either. Alongside the prince's name King Umberto had written: "Paul's son?" Neither of us suspected then that Alexander was to become his son-in-law in the near future.

The purpose of the cruise, in Queen Frederika's own words, was "to stress the solidarity of the Continent's former and present-day dynasties." Conspicuously absent from this family reunion were Freddie's English cousins. The British royal family's lack of solidarity was not altogether surprising. Since Cyprus had become a political issue, British government property in Greece was frequently bombed.

A book of etiquette in French laid down the rules of conduct. Protocol was abolished at all times aboard the S.S. *Agamemnon* (thus solving the complexity of seating arrangements—each gentleman would draw the name of his dinner companion from a hat). Informality was *de rigueur*. The gentlemen were told to wear short-sleeve shirts and black trousers for dinner. Cummerbunds were optional. Bikinis were prohibited on the beach. Precedence would be observed only on shore for the benefit of the native population. At such times King Paul, Queen Frederika, and their son, Crown Prince Constantine, would lead the way. Although there would be no "first among his equals," some passengers got better accommodations than others. King Paul was given the captain's quarters, Queen Frederika the first mate's. The chief engineer relinquished his cabin to the Grand Duchess of Luxembourg. Queen Juliana was settled into staterooms 18 and 20. Her consort, Prince Bernhard, was located in number 16. The King and Queen of Italy rated three staterooms, as did the pretenders to the French and Spanish thrones. The ex-King of Rumania and his wife shared cabin 6. Also in the one-cabin class were the ex-King of Bulgaria, their royal highnesses of Denmark, Norway, and Sweden, a lone Hapsburg, the inevitable clutch of Bourbon-Parmas, and the Princes and Princesses of Baden, Bavaria, Hanover, Hesse, Hohenlohe-Langenburg, Mecklenburg, Schaumburg-Lippe, Schleswig-Holstein, Thurn and Taxis, and Württemberg.

On August 23, as the *Agamemnon* docked in Corfu, *Life* cabled that the French photographer had failed to deliver. The story was mine.

Early the next morning I reached Olympia, where the first Greek games were held. At ten A.M. five shiny buses drove up. Clusters of tourists streamed out in disheveled confusion. They were soon spread out along a sun-baked dirt road that led to the religious city. All wore that determined look sightseers have before exhaustion sets in. There was nothing exceptional about this group. I had to take a closer look to realize that the stout lady with espadrilles was Her Majesty, Queen Juliana of the Netherlands. The completely ordinary appearance of this group gave me an indication of why sovereignty, in its public appearances, indulged in gaudy uniforms, white plumes, and clattering horses.

I was about to take my first picture when two plainclothesmen pounced on me and would have dragged me away had not Queen Frederika called them off, remarking pleasantly, "So, Mr. Phillips, you're taking pictures."

"Yes, ma'am. May I come aboard the *Agamemnon*, please?"

My request was so preposterous the queen did not bother to answer. The royal visitors were now scattered among the ruins. Queen Frederika, protected from the sun by a parasol gallantly held by Prince Axel of Denmark, took pictures with her diminutive Minox. Smiling into her camera were the pretenders to the thrones of France and Spain. The two had much in common. The Spaniard's older brother claimed both these thrones. With the exception of Umberto and Marie-José, everybody had a camera, from a box Brownie carried by the ex-King of Rumania's wife to a 16mm movie camera wielded by Queen Juliana's husband.

"Now, let's have some cheesecake," Prince Bernhard called out gaily as he filmed the leggy Princess Dorothea of Hesse. Meanwhile, the Queen of the Netherlands listened intently to her escort's explanation that the verb "to love" had numerous shades of meaning in Greek. The younger set took souvenir pictures using headless statues and truncated columns as props. A cold buffet was set up in a shady spot. I was about to get a shot of the picnic when the two plainclothesmen stopped me on Freddie's orders.

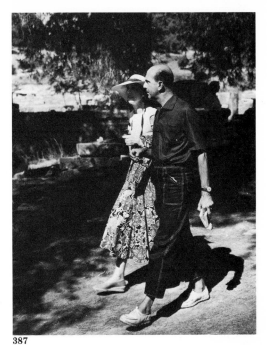
387

388

(387) Ex-King Umberto of Italy and wife Marie-José at Olympia. They were the only cruise members with a Baedeker.

(388) On the *Toskana,* the yacht I chartered to keep up with the royal cruise.

241

After lunch the Queen of the Hellenes made up for it, in her own way. To the cheerful chorus of "Oh yes, Auntie, good idea!" Frederika rounded up her son, Prince Constantine, Princess Beatrix of the Netherlands, Spain's Prince of the Asturias, Italy's Prince of Naples, Henri of France, and the youthful ex-King Simeon II of Bulgaria.

"Take a picture of these young people," Freddie told me. "They're the future rulers of Europe."

Today, thirty years later, Constantine is an exiled king. The exiled Spanish pretender is on the throne and his queen is Constantine's sister, Sofia, whom he first met during the royal cruise. Princess Beatrix, now Queen of the Netherlands, is married to a German commoner whose mother was a baroness not quite noble enough to have been invited on the cruise. The Italian prince and his cousin, the Bulgarian monarch, are businessmen. Henri of France is a banker.

Guidebooks recommend spending two days at Olympia. The royal sightseers took it all in — the religious city, the temple of Zeus, the stadium, the Hippodrome, the museum, the statue of Hermes and the buffet lunch — in four hours flat. By two o'clock the royals were ready for a swim. The beach was inviting, but I was excluded by the two plainclothesmen. It took me twenty-six hours aboard the *Toskana* to reach the island of Santorin, which looked like a giant plumcake topped with heavy whipped cream floating on the water. I had dressed ship. The *Toskana* was decked out with international pennants, code flags, and my personal ensign — a bold white *Life* on a field of red hastily stitched together in Piraeus to welcome the *Agamemnon* when she steamed into Santorin.

By the time the passengers came ashore, I was partway up the zigzagging stairway — three hundred and fifty wide, sloping steps that led to the town — to await the royals around a bend. King Paul led the procession on muleback. Arms on hips and smiling broadly, he rode up to me.

"Where did you get that dreadful thing?" he asked, pointing to the *Toskana*.

"It's the best I could do, sir," I replied. "The *Agamemnon* wasn't available."

"Weren't you afraid of drowning on such a tiny boat?" Queen Frederika asked.

"Why no, ma'am. But I'd much rather sail on the *Agamemnon*."

Prince Bernhard's mule trotted up. "Schooners are fun," he grinned.

I was trying to keep up with the mules when the grand marshal caught up with me. "Where did you get that beautiful yacht?" he asked.

Panting, I reached the three hundred and fiftieth and last step. There the two inevitable plainclothesmen pounced on me. I gasped for help, and as usual Queen Frederika intervened.

After a quick tour the royals started back down the steps on foot. Precedence made way for youth as they swiftly outdistanced their elders. Keeping in step with Simeon of Bulgaria, I gleaned information about life aboard ship. The young set stayed up past three A.M., dancing to an eight-piece band. They loved getting into costumes and once disguised themselves as sailors. Another time they all jumped into the swimming pool with their clothes on. Simeon was so friendly I slipped him two rolls of film and asked him to shoot some shipboard scenes with his Leica — in case I failed to get on board the *Agamemnon*.

The following evening the *Toskana* put in at Mykonos. The next morning when I came up on deck I found the police had roped off the esplanade to hold back the crowd waiting for the arrival of the *Agamemnon* from Delos. The cruise ship lay at anchor in the bay — glistening white, inviting, and yet inaccessible. As the *Toskana* circled around her, I waved to the passengers leaning against the rail. They waved back cheerfully but paid no attention to my pleas. I might have been a bumblebee buzzing a jar of honey.

The tour of Mykonos followed the usual pattern of threatened arrest and release. Before boarding the ship's launch, Queen Frederika allowed me as far as the gangway. There I posed her with King Paul so that they stood just above the letters NO of AGAMEMNON.

The following morning I photographed the royal junketeers at Poseidon's temple on Cape Sounion, where Lord Byron once scrawled his name on a

389

(389) My boat the Toskana *off the island of Santorin with the cruise ship* Agamemnon *in the background.*

marble colonnade. That afternoon the royal visitors drove up to view the Parthenon.

The next item on the agenda was the command performance of *Hippolytus* at Epidaurus. I was about to leave for the performance when I had a visit from a member of the shipping family that operated the *Agamemnon*. His visit was strictly P.R. and gave me a glimpse of the royal cruise through a shipowner's eyes. It cost $2,800 a day to operate the *Agamemnon* and $4.20 to feed each blueblood. The ship's cook made up the daily menu, which was then submitted to King Paul's chef, who in turn presented it to Queen Frederika for final approval. Although the fare, consisting of dolmades, moussaka and souvlakia, was hearty, the royal guests usually ordered sandwiches between meals. "The sea air is so invigorating," my visitor sighed.

He volunteered that Coca-Cola was a popular beverage but was reticent about the consumption rate of the twenty-five hundred bottles of resinated wine and the three thousand cans of beer stocked on board. My visitor now had a question: When would the story appear in *Life?*

"Never," I said.

"Are you telling me that *Life* isn't going to publish a story on Her Majesty's cruise?" he exclaimed.

"Yes."

"Why . . . that's . . . impossible," he stammered.

"Nothing's impossible with *Life*," I assured him.

"Why did you charter a yacht then?" he asked.

"Costly mistake," I sighed.

"Why isn't *Life* going to publish the story with all the beautiful pictures Her Majesty has allowed you to take?"

"Because a story about a cruise needs pictures taken aboard ship. No ship, no story."

"It's imperative *Life* publish the story!" my visitor blurted out. "You must realize that Her Majesty has promised her guests it would."

It was then I knew I would get on board the *Agamemnon*.

In Epidaurus I kept out of Frederika's way. For once she didn't have to rescue me from the plainclothesmen. I wanted her to be aware of my absence. At the amphitheater the royals were seated on rising tiers—a collection of regal figurines in a huge display case.

The next morning I drove to Delphi, last port of call and my final opportunity to get aboard the *Agamemnon*. I was once again grabbed by the two plainclothesmen before Queen Frederika intervened.

"Is is true *Life* isn't going to publish any pictures of our cruise?" she asked after dismissing the two plainclothesmen.

"Unfortunately yes, ma'am," I said, suitably contrite.

"Why?"

"I haven't got the kinds of pictures my editors want, ma'am . . . pictures aboard the *Agamemnon*," I explained.

"You want dirty pictures!" the queen exclaimed.

"Dirty pictures, ma'am?" I echoed, completely at a loss.

"You know what I mean—young people smoking, drinking, and dancing barefoot." Frederika seemed exasperated.

"All *Life* wants is a group shot on board the *Agamemnon*, ma'am."

"In that case you may come with us," Frederika granted.

At Itea harbor, where the *Agamemnon* was anchored, I was the first to scramble up the ship's gangway. As the passengers came aboard I herded them to the afterdeck with the help of a bullhorn. Europe's royals were in high spirits and either addressed each other by their first names or resorted to nicknames. Prince Bernhard was "P.B.," Crown Prince Constantine, "Tino." Prince Kraft Hohenlohe-Langenburg responded to "Stromboli" or "Plumcake."

I was much more formal, addressing the royals through my bullhorn with "Please, sir" and "Thank you, ma'am" as they arranged themselves in several tiers around King Paul and Queen Frederika.

With everybody in place, I finally snapped the group picture I had been after from the start.

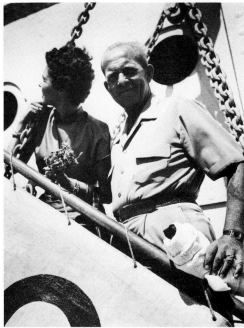

390

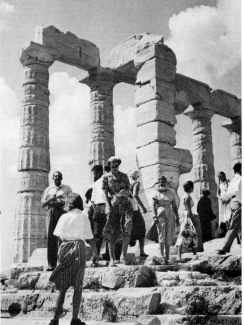

391

(390) King Paul and Queen Frederika of Greece boarding the Agamemnon.

(391) A gathering of royals at Sounion.

243

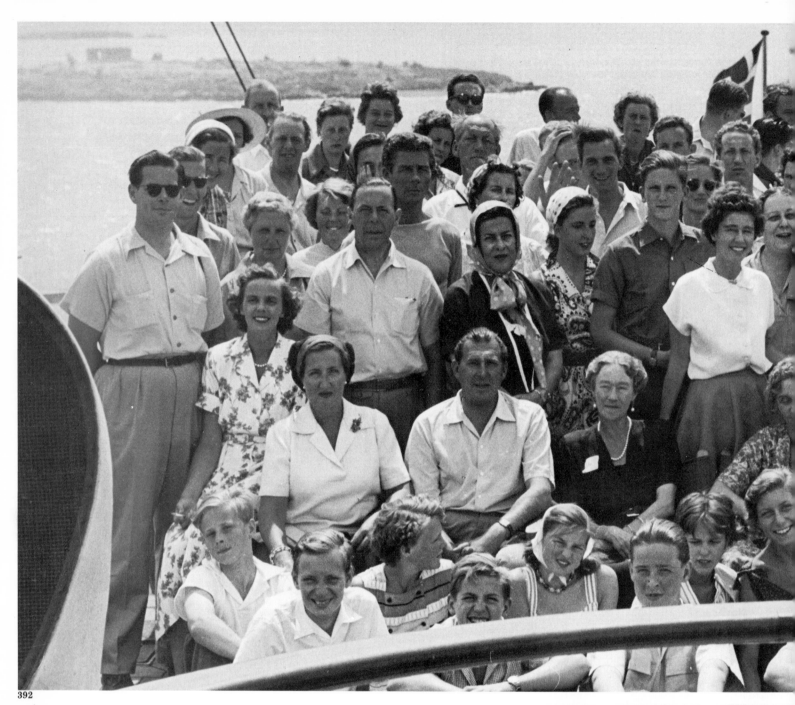

Identity chart of royals posing on afterdeck: (1) Prince Reiner of Hesse;
(2) Prince Otto of Hesse; (3) Princess Irene of the Netherlands; (4) Crown
Prince Constantine of Greece; (5) Princess Anne of France; (6) Prince
Georg of Hohenlohe-Langenburg; (7) Countess Helen Toerring; (8) Princess
Tatiana Radziwill; (9) Count Hans Veit Toerring; (10) Princess Irene of
Greece; (11) Princess Diane of France; (12) Prince Kraft Hohenlohe-
Langenburg; (13) Princess Beatrix Hohenlohe-Langenburg; (14) Prince
Ludwig of Baden; (15) Princess Sofia of Greece; (16) Archduchess Minola
of Hapsburg; (17) Princess Elizabeth of Yugoslavia; (18) Prince Karl of
Hesse; (19) Maria-Mercedes, Countess of Barcelona; (20) Don Juan, Count
of Barcelona and pretender to the Spanish throne; (21) Grand Duchess of
Luxembourg; (22) Princess Marie of Greece (née Bonaparte); (23) her
husband, Prince George of Greece; (24) Queen Juliana of the Netherlands;
(25) Countess of Paris; (26) ex-King Michael of Rumania; (27) Princess
Anne, his wife; (28) Prince Gottfried Hohenlohe-Langenburg; (29) Princess
Margaretha Hohenlohe-Langenburg; (30) Princess Marie-Louise of
Bulgaria; (31) ex-King Simeon of Bulgaria; (32) Queen Frederika of Greece;
(33) Princess Viggo, Countess of Rosenborg; (34) King Paul of Greece; (35)
Princess Eugénie of Thurn and Taxis; (36) Princess Hélène of France; (37)
Prince Bernhard of the Netherlands; (38) Princess Margaretha of Sweden;
(39) Grand Duchess Charlotte of Luxembourg; (40) Duchess Thyra of
Mecklenburg; (41) Duke Ludwig of Württemberg; (42) Duchess of
Württemberg; (43) Princess Beatrix of the Netherlands; (44) Prince Georg-

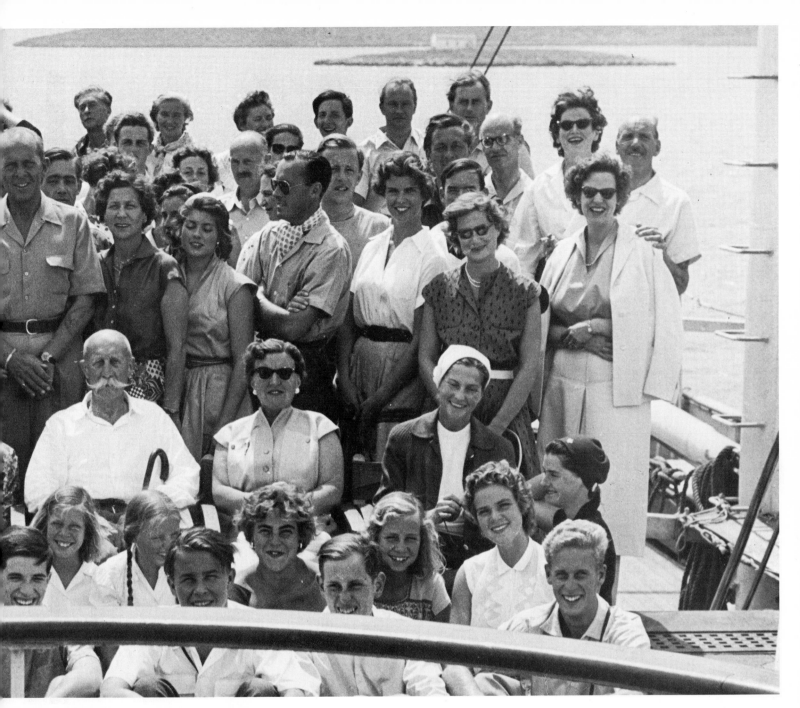

Wilhelm of Hanover; (45) Countess Charles of Toerring-Jettenbach; (46) Prince Jacques of Bourbon-Parma; (47) Countess Flemming of Rosenborg; (48) Count Flemming of Rosenborg; (49) Prince François of France; (50) Princess Georg-Wilhelm of Hanover; (51) Prince Antoine of Bourbon-Sicily; (52) Infanta Maria del Pilar; (53) Princess Maria Gabriella of Bavaria; (54) Prince Albrecht of Bavaria; (55) Princess René of Bourbon-Parma; (56) Prince Moritz of Hesse; (57) Hereditary Grand Duke Jean of Luxembourg; (58) Duchess Christian Ludwig of Mecklenburg; (59) Princess Christian of Schaumburg-Lippe; (60) Duke of Württemberg; (61) Prince Christian of Schaumburg-Lippe; (62) Duchess Elizabeth of Württemberg; (63) Princess Maria Christina of Savoy-Aosta; (64) Princess Margarita of Baden; (65) Princess Dorothea of Hesse; (66) Prince Heinrich of Hesse; (67) Prince Axel of Denmark; (68) Prince Dmitri of Russia; (69) Princess Peter of Schleswig-Holstein; (70) Prince André of Bourbon-Parma; (71) Prince Peter of Schleswig-Holstein; (72) Prince Christian of Hanover; (73) Princess Isabelle of France; (74) Prince Raymund of Thurn and Taxis; (75) Prince Franz of Bavaria; (76) Princess Elizabeth of Luxembourg; (77) Princess Astrid of Norway; (78) Prince Henri of France; (79) Prince Michael of Greece; (80) Prince Guelf-Heinrich of Hanover; (81) Prince Ernst-August of Hanover; (82) Prince Friedrich Ferdinand of Schleswig-Holstein; (83) Duke Christian Ludwig of Mecklenburg; (84) Princess Ernest-August of Hanover; (85) Prince Viggo, Count of Rosenborg.

393

394

(393) Tito riding his Lipizzaner Mitzi on the island of Brioni, accompanied by General Zezelj, his ADC.

(394) Giving Tito a picture I took of the Yugoslav leader at the time he broke with Stalin.

"What do they say about my fight with the Comintern?" was Tito's greeting as I walked into the drawing room of his villa on the island of Brioni one summer morning in 1949. As Tito's guest I was put up at the brand-new hotel, which had no name. Flowers bloomed in the places you would have expected to find the hall porter and the cashier. Tourists were not allowed on Brioni. The only visitors were Tito's guests. In spite of Tito's hearty greeting, I was aware of Russia's relentless threat to Yugoslavia. On my arrival at Tito's villa I had been detained until identified by a secretary who knew me. Most of the day was spent photographing Tito on his white Lipizzaner "Mitzi." "She's a circus horse," he said proudly. Afterwards he played billiards with his cronies, drove his speedboat, and then went fishing. Nothing in Tito's behavior suggested the great strain he must have been under. I was reminded of his wartime ability to relax. However, he was an impatient fisherman, so we sailed around under the protection of two armed Corvettes. Back on shore it was time for dinner. After the Turkish coffee was served, Tito led us into the living room to watch an American film. A movie buff, he saw at least one and frequently two pictures a day. He was liberal in his views. When the picture *Bitter Rice*, featuring the legs of Silvana Mangano, was banned, he recommended it be released to the public, remarking, "Nothing there to

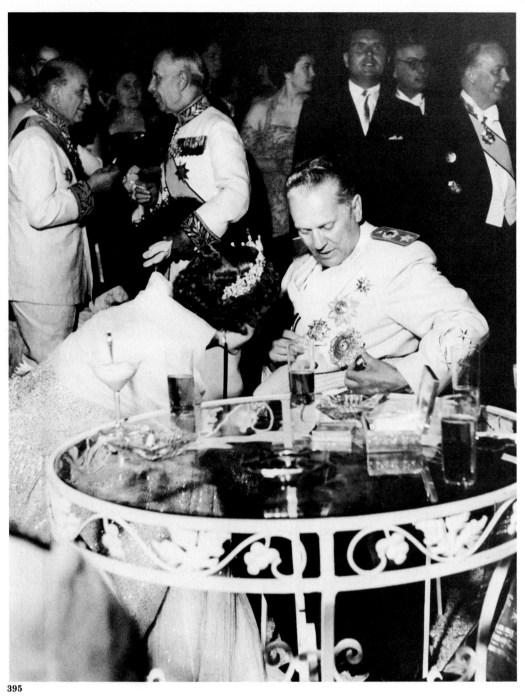

395

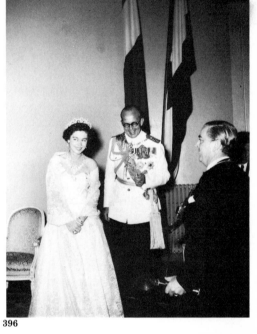

396

hurt them." That evening the film was *Mrs. Parkington*, adapted from Louis Bromfield's novel. From an American capitalist point of view it was an appalling choice. The picture opened with a wealthy woman in ermine brushing aside children singing carols in the snow. Once inside the family mansion, she sidled up to a sideboard and surreptitiously helped herself to a large tumbler of liquor. Tito nudged me and whispered, "Visky." Next Greer Garson appeared on the screen made up to look eighty. Fortunately there was soon a flashback. When Tito saw Miss Garson as she really looked, he quite literally sat up. In the following scene Walter Pidgeon came careening down Main Street in a horse and buggy. "Cowboys," Tito said hopefully. This was the last horse we saw until a fox hunt scene that took place thirty years later. Miss Garson was in conversation with a distinguished gentleman wearing a goatee. Tito nudged me again. "King Edward VII of England," he said. There occurred a terrible mine disaster due to callousness on the part of management just before the lights were switched on to change reels. I blushed while an embarrassed silence filled the room. In the following reel Miss Garson vindicated capitalism. She paid off the family debts, observing, "Power is not something to dissipate. Power must be reserved for those who know how to use it." Once again, Tito sat up.

(395) At a reception during his state visit to Greece in 1954, Tito showed his decorations to Queen Frederika.

(396) With Queen Frederika and King Paul.

247

Mr. K Goes to Belgrade

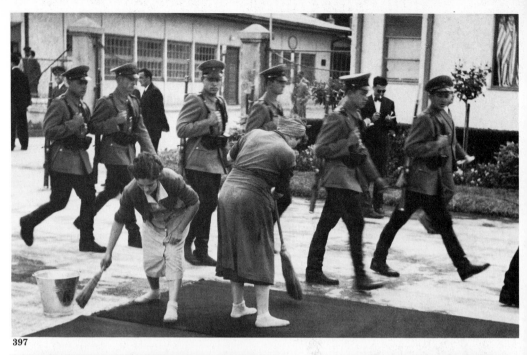

397

398

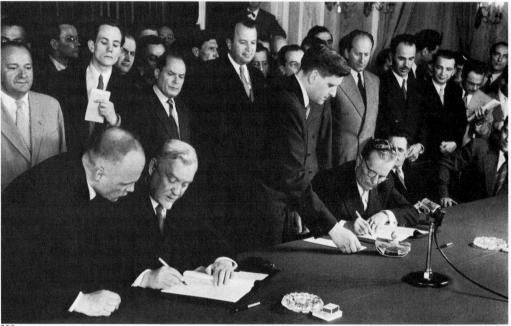

399

(397) *Cleaning women spruced up the red carpet at Belgrade's airport prior to the arrival of Khrushchev & Co. on May 26, 1955.*

(398) *Nikita Sergeyevich Khrushchev in Belgrade.*

(399) *Nikolai Bulganin (left) and Tito signing Belgrade Agreement on June 2, 1955.*

(400) *Khrushchev (seated) and Andrei Gromyko (hand in suit jacket) listened in apparent rapture to the reading of the Belgrade Agreement. This did not prevent Nikita Sergeyevich from ordering the Red Army to fire on the people of Budapest sixteen months later.*

248

Tito ignored me when I walked over to him and took his picture, which was contrary to his habit. Silent and aloof, he gazed straight ahead through half-closed lids, his face expressionless. From what I knew of him, this masked his emotions. Tito was waiting for the Russians to come. As Khrushchev, Bulganin, Gromyko, and Mikoyan got off the plane, the Yugoslav photographers clambered all over them in the best tradition of the unruly press—most probably on instructions, as I had never seen them behave that way. The Belgrade Declaration was signed on June 2, 1955. In it the Soviet government acknowledged its "respect for the sovereignty, independence, territorial equality and equality between the states . . . peaceful coexistence between nations irrespective of ideological differences and differences of systems . . . the recognition that different forms of Socialism are solely the concern of the individual countries." This did not prevent Nikita Sergeyevich from ordering the Red Army to fire upon the people of Budapest sixteen months later, in flagrant violation of the Belgrade Agreement. Historically, this action would matter no more than Pope Leo X's excommunication of Martin Luther for his Theses. What had been done in Belgrade could no more be undone than what Luther wrought at Wittenberg. Communism, like the Church 433 years before, would never be the same.

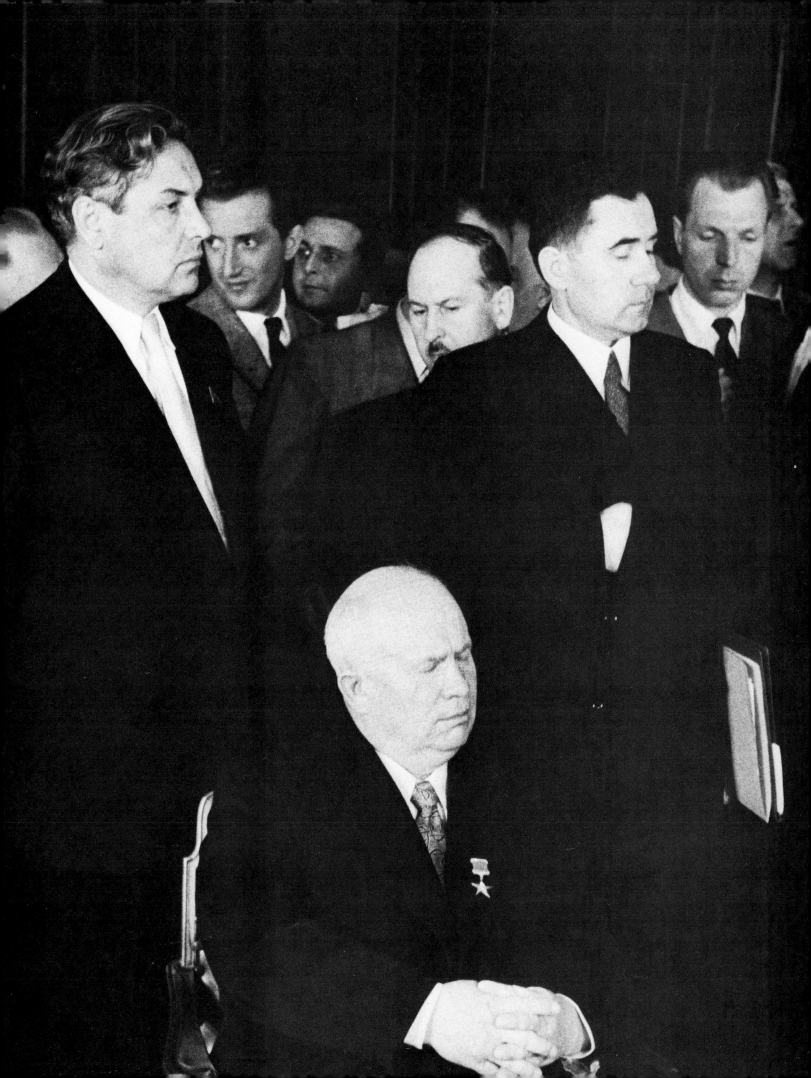

Erich von Stroheim

401

402

403

404

(401) Erich von Stroheim worked on a novel in the garden of Château Maurepas, his home outside Paris.

(402) Von Stroheim with his friend and collaborator actress Denise Vernac, eating cherries at an al fresco lunch in the château garden.

(403) Von Stroheim's drawing room, where he was fond of reading with leg slung over side of chair, was adorned with shakos, cavalry sabers, and other such Hapsburg memorabilia.

(404) Von Stroheim's drawing room included a bar. Ashtrays were from New York's Stork Club.

(405) A confirmed cavalry officer, von Stroheim converted a saddle into a desk chair. Von Stroheim's scowl was his trademark. "If I smile," he once said, "I'm ruined."

The chapel on the country lane halfway between his home and the cemetery had been decorated with sprigs of apple blossom by his old friend, the Turk. In the uncertain chapel light they reflected the cool freshness of that spring morning in May 1957. The Turk and I leaned against the wooden fence reminiscing as Denise Vernac, film people, and friends filled the chapel. The strains of "Les feuilles mortes" could be heard — the musicians from the nightclub Monseigneur were keeping a promise they had made on a night of revelry. After the service, the procession made its way to the small cemetery on the slope of a hill. A combination of threateningly low clouds against a stark blue sky and the horse-drawn hearse creaking beneath the coffin covered with wreaths and flowers as it jolted along the dusty country lane followed by a line of mourners made it look to me as though Erich von Stroheim was directing his own funeral. Then came the unexpected touch which completed the scene. Attracted by the procession, the cows which had been grazing in the fields slowly came up to the edge of the lane and gazed at us as we passed by.

The 1957 Blues

I was flying to Brussels in 1957 to see a political dissident when I found myself on the road to Damascus. Having attended Erich von Stroheim's funeral that morning, I was in a reflective mood. My thoughts turned to my father. Finally able to afford him, I had brought him back to Europe with me. On the morning of the day he died, he suddenly recalled having met David Ben-Gurion in a dining car between Bougie and Algiers in 1922. He had been reminiscing a lot about Algiers in those last weeks, but since he had never mentioned Ben-Gurion before I thought he was delirious until, with a wide sweep of his hand, he described the Zionist's enormous brow. My father died late that night. The last thing he said was, " I hate people who keep others behind bars." Then he tried to smile, winked at me, and went to sleep. I buried him at the Protestant cemetery—a peaceful garden for restless souls beneath the Roman sky.

The night before the funeral I took Dad to the cemetery chapel. There in a corner was an urn with the ashes of Sinclair Lewis, who had died several days before in Florence. His ashes were to be flown to Sauk City, Iowa, the next day. In the twenties my father and Lewis had been drinking acquaintances in Paris. They had each other's company that night.

I was thinking how much I missed him when the stewardess handed me the standard police questionnaire. One of the blanks to fill in read HOME ADDRESS. I had none. My wife and I having separated, I no longer lived in Rome. I had given up my room in Paris. Apart from a half-empty storage room in New York, a 300-SL Mercedes-Benz with German license plates, and a Jaguar with Yugoslav plates, I owned nothing, had no home, no family, no children, and no special plans for the future. I was forty-three. My wife's friends referred to me as "the stray dog without a collar."

It all went back to 1950 when I resigned from *Life*. I had quit the staff rather than be tied down to one country after the magazine put staff photographers in all the major capitals. I had enjoyed such freedom in my work that I no longer could conform to the discipline essential for a news-gathering organization like *Life*. While I was working abroad covering political crises, the war, and postwar chaos, it had been impossible for the editors to make too specific assignments. *Life* photographers had been granted great independence of action which, after Europe's rapid recovery, no longer fit in with the order of things. For years photographers like me had relied on our knowledge of the type of story the magazine was interested in. Because of wartime secrecy or the postwar communications breakdown, it was usually impossible to suggest a story to the New York office. I could hardly cable that there was to be a spy trial in a month's time followed by an execution the next day, as was the case in Aleppo. Our freedom of action had turned us into journalists—we worked out the theme of our story, made the necessary contacts, photographed it, captioned it, and found the quickest way to get it to New York. We were genuine photo-journalists, a term much abused by photographers who worked with a writer responsible for planning the story, setting it up, and doing the captions while all the photographers had to do was shoot the pictures lined up for them. I knew I could never do that. The days of freewheeling individualists like me were numbered. I decided to give myself a reprieve by resigning from the staff.

Ed Thompson, my managing editor, accepted my resignation, as he also felt I was too independent for a large corporation. We agreed that I would do the assignments he requested and that I would give *Life* first choice on everything. The arrangement worked out well because it allowed me to undertake the kind of story I could do best.

The most speculative, complex, and rewarding I got involved in was to be Tito's memoirs. The idea had come to me in 1948 after *Life* blithely assigned me to photograph Tito, who had just broken with Stalin. I did not share the magazine's faith in me. No one—not even Stalin—had seen Tito in three months. I did manage to get one of the few visas issued to cover the International Danube Conference held in Belgrade, which was to come on the heels of the Yugoslav Fifth Party Congress, convened to debate breaking with the Soviets. On the last day of the congress I was listening to Tito's speech with my friend Stojan Pribicevic, an American journalist of

(406) Meeting entrepreneur Mike Todd at the Belgrade airport in 1954. The biggest headache was not getting authorities to agree to the Yugoslav army participating in a production Todd was trying to put together—it was finding out who had authority to allow Todd to enter Yugoslav airspace in his unscheduled chartered plane so he would not be shot down.

Yugoslav extraction, at the home of a Belgrade family. There was a telephone call. A voice instructed Stojan and me to leave the apartment at once and wait in the street below. Guessing that Tito had sent for us, I whispered to Stojan, "My camera's at the hotel. Ask if I can go get it."

"No time," the voice said, and hung up.

Tito received us at his residence and laughed when I told him I was in deep trouble. "You're the only photographer I'm going to see and you aren't satisfied?"

"It's *Life* that won't be satisfied when they hear I had no camera."

"Don't worry. You'll get your pictures," Tito promised.

Days went by. I grew increasingly anxious. My visa would soon expire. Stalin's men and their satellite henchmen were also in Belgrade trying to see Tito. Forty-eight hours before my visa was to run out, I got a message: Take tonight's Orient Express. Get off at Ljubljana. You will be met.

I saw Tito long enough to get my pictures. He looked haggard and soon hurried off. I was sure the political situation had seriously deteriorated since I had last seen him until his secretary told me that Tito had only crawled out of bed to keep his promise to me.

"I must ask you," the secretary went on to say, "not to mention that Tito is really sick. He wants this to be a diplomatic illness."

Such confidence in me made me wonder if he would trust me with his autobiography. Sounding out a few influential Yugoslavs and finding them receptive, I wrote Ed Thompson that I was reasonably confident I could talk Tito into writing his memoirs for *Life*. On getting Ed's okay, I wrote Tito, who would not commmit himself until the spring of 1951. When spring arrived, I was told to keep in touch. At length I was notified that Tito would receive me between September 28 and October 5.

Vladimir Dedijer, whom I had known since 1943, called late at night on October 4 to say he would pick me up at five A.M. We drove to Kraljevo in central Serbia to wait for Tito's blue train to pull in. On its arrival we boarded to confer with Tito.

"How can you expect the president of a socialist state to publish his memoirs in a capitalist magazine before they appear in Yugoslavia?" Tito objected. "Besides, I have no time to write."

I suggested that, as Dedijer was an historian, we could work with him as long as the text was in Tito's own words and signed by him. This met with his approval. "Tito Speaks" appeared in 1952.

"Tito Speaks" led Dedijer to write a biography of Tito and I became his literary agent. I sold the serial rights to *Le Figaro* and the *Sunday Times*, while the book went into so many foreign editions that when Dedijer asked me, "What next?" I said, "Make it into a musical and call it 'Tito Sings.'" Our American publishers asked me for book ideas. I suggested "*Marlene* by Dietrich." Everybody loved the idea except Miss Dietrich. She told me that, although she was a grandmother, she would die a virgin as far as writing was concerned.

For a time I was literary agent for Marie-José, the exiled queen of Italy, and acted as her personal messenger when the president of the Italian republic took books out of the Rome libraries for the queen to use as research material, and on that I wound up my career as a literary agent.

Mike Todd flew to Belgrade to see if I could arrange to have units of the Yugoslav army participate in a film version of *War and Peace*. (Todd never made the picture, nor did he pay me.)

At the same time I was suffering from belated reactions to the war. I got so nervous flying that I would go to ridiculous lengths to see which flight took the least time. I kept having recurrent nightmares.

The more I thought about my life on that flight to Brussels the more I realized I was drifting. For quite a while I had wanted to write a book. This would mean settling down! Why not try it?

Eighteen months later I was divorced, had the first draft of a manuscript, and was on my way to the States with a Milanese who had dancing blue eyes. As far as I was concerned, I was through with my past.

I was wrong. There was a war in my native Algeria. I went there to report it for *Life* and took my new bride along.

407

(407) Twenty-eight years after I had spent hours fidgeting at the Café du Dôme while my father and Man Ray discussed art and drank pernod, I picked up where my father had left off. By then Man Ray had given up photography and returned to painting, but he still remained an uncompromising Surrealist.

War in Algeria

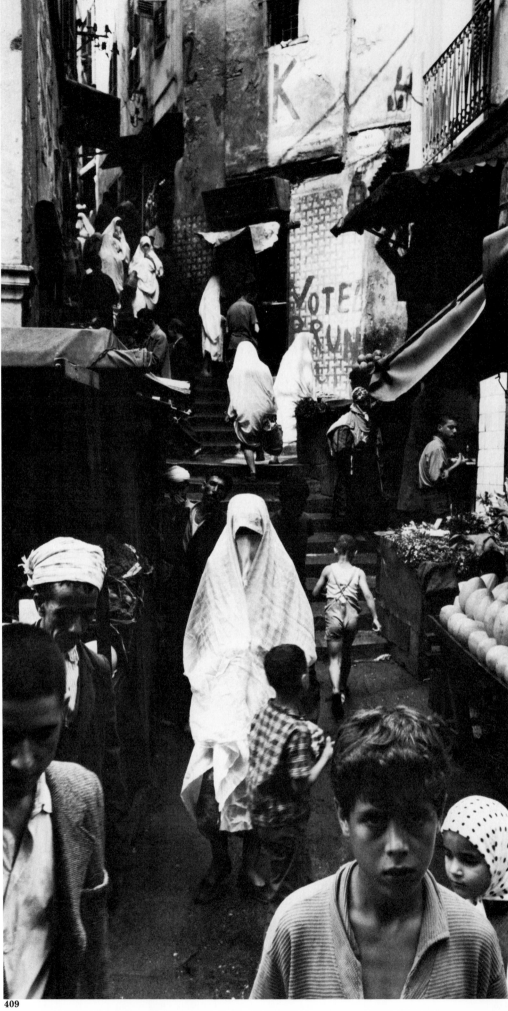

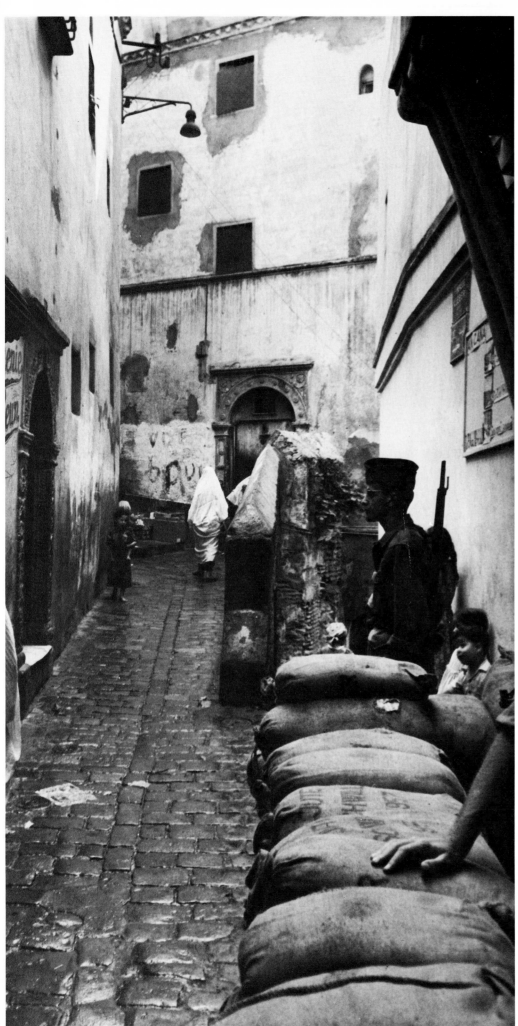

(408) General Jacques Massu, whom the French government entrusted with the mission of wiping out Arab resistance in the Casbah, did so with draconian methods. The general is seen here with his adopted Arab son and pet dog.

(409-410) Streets in Algiers Casbah.

(411) Colonel Gabriel Favreau, commander of the French Foreign Legion's Fifth Infantry Regiment, questioning an Arab in the mountains of Kabylia.

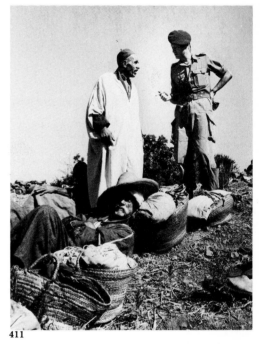

411

410

(412) *On Sunday, August 16, 1959, twenty Arabs from the city were found murdered in the hamlet of Souk el Dnine near the bay of Bougie, one of the innumerable and unexplained massacres during the Algerian war.*

I was greeted by a bad-tempered French captain who said, "I've had a potful of hearing about how we torture prisoners. Go to Souk el Dnine and see what those Arab sons of bitches have been up to."

"Coming with me?" I asked.

"Not a chance," he said. "I've had it with the *fellaghas.*"

Outside the hamlet of Souk el Dnine I came upon a squad of French marines. Usually boisterous, these leathernecks were silent. "They're in there," one volunteered with a jerk of his thumb toward a narrow opening in a tight cluster of aspen trees that grew amidst a tangle of briar. The briar looked like a barbed-wire entanglement set up by nature.

"Don't be shocked when you find some of them partly undressed," the army doctor said to me. "We examined the bodies to see if they had been tortured."

"Tortured?"

"The *fellaghas* torture their victims when they have a grudge against them."

"Were they?" I asked.

"One had his throat slit—the Kabyle smile, you know," a marine said. "Another got his eyes gouged out."

"Why did the *fellaghas* do it?" I asked.

"Hard to say," a captain answered. "They are all Moslems, of course, but we can't identify them because their papers have been taken away. Most of them are wearing city clothes, so we don't think they're from around here. Maybe they were prisoners being taken somewhere and were killed when the 'fells' heard we were conducting operations in the neighborhood. Sometimes that happens. They get rid of their prisoners and then scatter."

"Better smoke one of your American cigarettes," a marine said. "Two are beginning to bloat, and with this heat the smell's pretty bad."

"If you don't go farther than where the kid's lying, it's bearable," another marine explained. "He can't be a day over thirteen," a voice added.

I cleared the ditch and made my way along the narrow path draped with briar, which dangled down like curtains. I pushed aside the curtain and stared. Ahead the path widened into a small clearing. Some twenty bodies, a few of them children, were scattered across the clearing in a trail of death. The pale blue color of the clothing, combined with the utter stillness, made the scene frightfully unreal. With a mounting sense of horror I crossed the clearing, taking pictures as I went. Without warning the smell of death became unbearable. Blindly I dived into the dense briar and clawed my way out. Only later when I was jotting down notes did I notice that the sleeves of my jacket were torn and my hands were bleeding.

(413) French marines from Company 5 looked grim after coming upon the Arab civilians they found massacred in the underbrush. Several had their throats slit, an Arab practice called "the Kabyle smile."

257

414

(414) *Pro-French Arab commandos checking the papers of a suspect they had just gunned down in the mountains of Kabylia. The man was identified as a* fellagha *by a childish drawing of the Algerian national flag found in his wallet.*

"It takes an Arab to catch an Arab," said the captain of the special commando unit made up of *fellagha* turncoats. The formalities of acceptance into this unit followed definite rules. "The *fell* must come of his own accord and bring a gun along. The number of Frenchmen he has killed and the way he's killed them is an important factor," the captain explained. "If a *fell* machine guns a car and kills the passengers, that's war. But if he machine guns civilians trying to get out of the car, that's murder. We don't accept murderers." No sooner had a *fellagha* gone over to the commandos than he was thoroughly questioned. In that way the commandos got news about the *fells* before they suspected there was a turncoat in their midst. Information provided by a turncoat not only allowed the commandos to descend upon an arms and food cache before it could be moved, it also committed the Arab to the French cause. The commandos then sent out a party to rescue the turncoat's family from his village and resettled them in a safe place. The captain picked me up at the farm in Kabylia where I was staying in order to show me how effective these commandos were. Our jeep had a sheet of armor plate across the windshield. In the back seat, a radio operator kept in contact with various units. "In our outfit," the captain said, "there's no question of Moslem or European. We're all commandos. Morale is superb. Only once did we have a

415

traitor among us. I lined up the commandos and asked them what we should do. 'Kill him!' they all shouted. We did. It was hell. I ask my men to fight and die for France. But I have no guarantee we're going to stay in Algeria. You know what would happen to my Moslem commandos if we left. I'll never forget Indochina.'' The jeep climbed steep ridges and slithered on slopes like an eager pony. I caught the captain's tense excitement and realized I shared it. A report came over the radio: Team three had spotted a *fell*. We changed course to join the hunt, driving past an Arab *mechta* where a horse was going round and round in a circle grinding corn. Intent on their work, the Arabs did not look up when they heard the burst of gunfire. In the distance we saw commandos. Two men were searching the body of a dead Arab. "He's a *fell* all right," the CO said. "He's wearing bush boots, and that's prohibited." His pockets contained a childish drawing to prove it—the green and white FLN flag drawn with crayons on a scrap of paper. My euphoria of a few moments ago was dissolved by this pathetic sight. I felt shamed by the contagious excitement sweeping across Algeria, which was turning the country into a safari. "He didn't suffer," the captain said gently. It was then I noticed that the soles of his bush boots had been cut off. "No other *fell* can use these boots now," the captain remarked as he walked away, leaving the dead *fellagha* unburied.

(415) Frustrated French commandos gaze in disgust at a freshly uncovered cache used by fellaghas to hide weapons and food. As usual, the French got information on the cache only after the supplies had been moved to another hiding place.

416

(416) *The Djurdjura mountains of Greater Kabylia. The valley below was my birthplace.*

In 1959 I was back in Bouira, my hometown in the mountains of Kabylia, to photograph the Algerian war.

"I was born here and will never leave," my companion said, glancing across the forlorn Place de Strasbourg. Coldly he eyed a pair of Arabs crossing the square hand in hand. "Just look at them," he shrugged.

We came to l'Hôtel de la Colonie. "Frankly," a colonel was saying to the owner, "the name of your hotel is outdated. I suggest you change it."

The colonel drove me to the open-air cattle market, crowded with Moslems. "How many of these are *fellaghas?*" he mused. Then, in answer to his own question, he said, "Who knows? But let me tell you how elusive they can be. Recently I was out hunting and bagged two partridges. A few days later I bagged a live *fellagha*. What d'you think that rascal told me? He said, 'I have no animosity for the French, and I can prove it. Last Wednesday you shot two partridges. The second one was two yards from a bush where I was hiding. You never saw me. I could have killed you.'"

A few days later I went on operations with the Foreign Legion. One evening Colonel Fabreau, CO of the Fifth Regiment, and I were having a nightcap when a sergeant came in and announced, "He's talking."

In the dim light of the intelligence officer's tent it looked like the prisoner had a welt under his right eye, but he was cheerful enough. Each time he

brought his arms to his face, his handcuffs rattled. His antics reminded me of a monkey on a chain. Here was the first *fellagha* I had seen. I studied him carefully. The passive resistance of a single Arab became the passive resistance of all the Arabs I had ever known. What struck me was not so much that he cringed, but the sly way he did it. I looked around and realized that the *fellagha* and I were the only two North African natives in that tent. I wondered how much the others understood him. Could they read the meaning in his shifty eyes when at times he made himself look the buffoon? The more he smiled and degraded himself, the more he convinced me the French would get nowhere by using force.

Captain Billotet, a fat and jovial man, was the SAS officer in charge of the recently liberated village of Bezzit in Kabylia. His duties were similar to those performed by American military government officers during World War II, except that Billotet was alone and did everything himself. The jovial captain handled *la pacification* with great enthusiasm.

"My greatest problem," Billotet explained, "was settling a long-standing feud between the mayor of Bezzit and the head man of Beni Fouda. The feud went all the way back to the days of the Prophet and disrupted friendly relations between the two communities. Each village was solidly behind its chieftain. This was terrible for *la pacification*. So what did I do? I married the mayor of Bezzit's daughter to the head man of Beni Fouda. That settled it."

Colon friends of my father invited me to a large luncheon for twenty, the kind that belonged to another age.

"It's true we wanted a military dictatorship," my host George Dubois said.

"But not the one we got," my neighbor exclaimed.

George Dubois flapped his arms in imitation of de Gaulle making a speech. "He's too liberal!"

"He's popular with the Moslem population," a voice down the table said plaintively.

"And he should be, the way he discriminates against us," someone added.

"I could give you a list as long as my arm of ignorant Arabs with good jobs," another voice grumbled.

"Aren't you supposed to have Arabs fill responsible jobs?" I asked.

"Of course," my host said, "but let's not exaggerate."

"What else can you expect from an Arab lover?"

"Why are you so down on de Gaulle?" I asked. "You paved the way for his return to power. What's he done wrong?"

"It's not so much what de Gaulle's done as what he hasn't done, and what we suspect him of trying to do," George Dubois explained. "He must come out for integration once and for all," he said, adding hastily, ". . . integration of Algerian territory into France, that is."

"What about integration with the Arabs?" I asked.

"By all means," Dubois said, "there must be a spiritual integration."

"I never liked that word," my neighbor said.

"Why did you use it then?" her son asked.

"Because we had to say something . . ."

"But you did promise integration. You know that," the son insisted.

"He's been in Paris three months and now listen to him!" the mother said.

Back on the farm where I was born, I stared at the rows of eucalyptus my father had planted. The farmhouse was dilapidated. The sight would have broken his heart. I was merely angry. I had left the farm too young to remember it or have any ties to this old building which stood on top of a hill looking out on the Djurdjura mountains. I was angry because an old friend of my father's had tried to play on my sentiments, telling me the farm was now owned by an Arab: "He let it get run down. But what can you expect from an Arab?"

For weeks I had been a witness to violence. Although the French were strong enough to remain in Algeria indefinitely, no amount of force could break the subtle will of ten million Moslems or put an end to *fellagha* resistance in this frightful civil war which Fate had spared me from taking part in. Had it not been for my mother's insistence that we move from Algeria, I would most probably have been fighting alongside the *colons*.

417

418

419

(417) At age forty-five, I got my first look at the farm where I was born in Bouira, Kabylia.

(418) A French colon *on his farm in Kabylia.*

(419) The family of a Kabyle laborer working on the colon's *farm. These two last pictures go a long way to explain the Algerian tragedy.*

261

The Miracle Maker

(420) *Oil magnate Enrico Mattei read reports aboard his twin-engine de Haviland while friend Giuseppe Moschetto peered over his shoulder. The pair were flying to northern Italy on a trout-fishing trip.*

(421) *Mattei fishing in the Aurina valley near the Austrian border, where he kept a room at small inn. While Mattei preferred modest abodes, in everything else he wanted the best. Said he, spotting my camera, "Is that the best in the world?" When I agreed, he said, "I'll buy one."*

420

421

In 1946, at the age of forty, Enrico Mattei was instructed by the Allies to dismantle AGIP — Italy's Fascist petroleum monopoly. Taking advantage of the postwar confusion, Mattei started wildcatting instead, struck methane in the Po valley, and broke eight thousand municipal edicts by laying a two-thousand-mile pipeline grid that cut across the country. Mattei's methane eased Italy's uncomfortable dependence on foreign sources of energy. By 1953 Mattei had rammed a bill through Parliament authorizing the creation of a national agency for combustible fuel, called ENI. Launched with an initial sinking fund of fifty-nine million dollars, Mattei built ENI into a two-billion-dollar empire in nine years. As a civil servant whose salary was a nominal $24,000 a year, Mattei was officially accountable to the government which, in fact, he dominated.

Mattei always traveled with a bodyguard, having been sentenced to death by French terrorists for backing the Algerian rebels. He had also antagonized Standard Oil of New Jersey and of California, Socony-Mobil, Texaco, Gulf, British Petroleum, and Shell after he challenged their 50/50 deals by signing an agreement with the Shah for a 75/25 split between Iran and ENI. It was a pattern he would set up for oil concessions in Egypt, Tunisia, Morocco, and Libya, much to the irritation of those oil companies he called "the Seven Sisters."

In Italy Mattei had formidable enemies, too: the conservatives, the liberals, and the communists — all feared the man known as "a Ferrari without brakes." Mattei, I was told, could not even be considered self-taught . . . he was inarticulate, with a limited vocabulary . . . never had anything to say . . . had no social life, and lived in a modest Roman hotel with his Austrian-born wife, Greta.

I wondered what Enrico Mattei was really like while waiting for him in the lobby of the Hotel Eden in Rome to photograph him for *Life*.

"I've just gained control of the textile company Lane Rossi," Mattei said as he walked up to me. Although he made it sound like a lark, he was talking about a large company employing 13,500. Dismissing the two titans of Italian industry who had tried to get hold of the company, Mattei said, "It's not that I was clever — *they* were idiotic. The moment I found Lane Rossi's price reasonable, I started to buy through Switzerland to avoid attention. Even so, you'd think *they* would have realized something unusual was going on. Well, no." He sounded puzzled. I soon found out that, by "they," he meant private enterprise.

I was as unprepared for Mattei's appearance as for his forthrightness. The man I observed at lunch was a young fifty-five. With his ruddy face he could have been a Scotsman. Unlike most Italians, he was sparing in his gestures. This impression of frugality was emphasized by his old-fashioned wedding ring, the kind Europeans in modest circumstances once wore. Courteous and soft-spoken, he resorted to a half-embarrassed, half-inquisitive smile to hide his shyness, hardly expected from a man who could make or break cabinet ministers. But there was something ferocious in his laughter.

"I'll take you fishing with me," Mattei said. "Fishing is my profession and oil my hobby."

That afternoon I received a ticket for the evening sleeper to Bolzano. At the station, the conductor asked, "Isn't Mrs. Phillips traveling with you?"

In surprise I told him that I was making the trip with Enrico Mattei.

"He's not on my passenger list," the conductor said.

As the train was about to pull out, Mattei appeared, followed by his bodyguard. He looked amused. "My reservation was booked in your wife's name for security reasons," he explained.

Mattei's favorite trout streams were close to the Austrian border. There he kept a room at a small inn. His main fishing companion was Pietro. "He used to be a smuggler," Mattei told me, "until I gave him a gas station to run and made an honest man of him."

As he fished, Mattei told me about his life. The son of a poor *carabiniere*, he was born in the Marche region. "I was a premature baby and, as incubators were unknown there, the doctor told my mother, 'He will die like the first two.'"

Mattei grew up in Matelica, which boasted a bed factory and a tannery. Put to work at twelve, young Enrico first painted bedsteads, then ran errands for the tannery. By the age of nineteen he managed the tannery and moved to Milan before he was twenty to become a traveling salesman for a chemical company. By the outbreak of World War II, Mattei already owned two chemical plants. After the Italian capitulation he joined the Demo-Christian partisans. Captured by the Germans in Como, Mattei was sentenced to death.

"The first thirteen days while I waited to be shot were not the worst," Mattei recalled. "There was no hope. It was simply a question of dying well. But on the fourteenth day I saw a chance of escape. Then it became terrible. The only reason they postponed my execution was because they believed I could give them information about Monti, the partisan leader," he said. "I was so quiet they never suspected I was Monti."

Inevitably our conversation turned to the United States. Mattei produced a "Wash 'n Dry" bearing ENI's trademark from his pocket with a flourish and a smile that reminded me of a salesman presenting his visiting card. "You'll find them in the washrooms of my gas stations," he said. "The American influence is very noticeable in my offices. When I took over AGIP they had seven doormen doing nothing. I kept one. On each floor there were several attendants to help visitors find their way around. I put everybody's name on the doors, including my own, and fired the attendants. I closed down the motor pool, which was used mostly by the employees' wives, and told the staff, 'If you want to drive to work, buy your own cars.' But I did help them get their cars on the installment plan." Then he smiled. "Did you know we had offices at Rockefeller Center? I started an American company because I was missing out on certain benefits. Since I spend seven to eight million a year in America, the company saves me about half a million." Such deals delighted Mattei.

I made a number of fishing trips with him. We flew in all kinds of weather in his four-seat French jet.

One night Mattei said, "It's going to be bumpy." Once we had cleared the runway and shot into the clouds he removed his hat and crossed himself. We streaked into a storm over Elba. The bodyguard seated next to me was very still. I felt insignificantly small even though we were two big men crowded together in the back seats. Mattei looked around and said, "Makes you realize how frail man really is."

On one of our last outings Mattei mentioned that he had lost an only child. "He would be twenty-six now," Mattei said with a shy smile. "Children," he mused, "grow up to find out that everything they were taught is false. As a child they taught me that emigration was the only solution to Italy's unemployment. There were too many of us, it was said. That's not true. Recently I took out full-page ads in all the important foreign newspapers asking Italian specialists to come home. We need them here." After a pause he went on. "They also taught us that we were an inferior people who couldn't compete with the rest of the world. Look at us today." Mattei laughed. "When I send an Italian abroad now he is an executive, not a poor unprotected laborer. We gained our independence from Austria because it was going against the course of history. You can't do that. Take my oil concession agreements with the Third World. They're much more realistic than what the 'Sisters' offer. The 'Sisters' only give money. What's money if you don't allow a country to participate in its own development? Why can't people understand that the old methods are obsolete?" Then he said abruptly, "Do you know what I plan to do when I retire? I'm going to be president of Italy."

From anyone but Enrico Mattei this would have sounded boastful.

"I'll tell you why I plan to be president," he added. "I want poor Italians to know they too can become the president of their country." This was the first time I had ever heard of someone who seriously considered giving up real power for a rather empty political title without being compelled to.

Unfortunately, Mattei did not live to achieve this goal. In 1962 he died in a plane crash. Although he never did become president of Italy, Enrico Mattei did make the "Italian Miracle" possible.

(422) After inspecting a home for the aged, which he underwrote, Mattei noticed that the architect had not followed instructions, leaving the elderly unhappy. He wrote a reminder to himself, observing, "I'll send someone to clear this up."

(423) Dinner for oil magnates in Rome, January 30, 1962, hosted by Lorenzo Negro, seen with Mattei (left) and W. R. Stott of Standard Oil (right). At dinner, a pending suit between Mattei and Standard Oil was discussed amiably. On October 27, Mattei signed papers settling the suit before boarding his jet in Sicily. Seven kilometers from Milan the plane crashed, killing him.

422

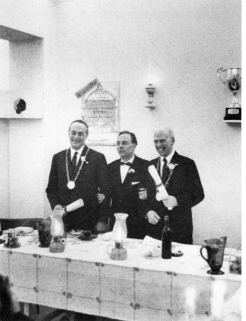

423

The Italian Miracle

425

426

By putting their country on wheels that were inexpensive, elegant, and fast, these three automotive geniuses helped rebuild postwar Italy's image around the world. The Turin factories of Gianni Agnelli (424) turned out low-cost mass-produced Fiats. Pininfarina's bold designs gave cars a sleek elegance (425). Enzo Ferrari's fiery red racers streaked victoriously around the Grand Prix track (426).

My strongest recollection of wartime Italy took place in Naples during the winter of 1944. I had gone to the U.S. army garbage dump expressly to see what I could not believe. Crowds of starving Neapolitans were waiting restlessly for the day's garbage to arrive. When the truck convoy appeared, a weary MP cracked a rawhide whip in a vain attempt to keep the crowds from getting to the garbage. As the steady stream of cans and wooden crates cascaded down the slopes, the Neapolitans dove in, up to their hips in garbage, and began to scavenge.

After getting back to the States, I was sent to Washington to meet Mr. John J. McCloy (who would become U.S. High Commissioner to Germany after the war). Although the purpose of my visit was to discuss Yugoslavia, we soon switched to Italy. I described the scenes in Naples along with the utter destruction of a country. When a pessimistic Mr. McCloy asked me how long I thought it would take to restore that country, I hazarded a guess of fifty years. Yet within fifteen years of that conversation Italy had become unrecognizable as a result of what is now known as "The Italian Miracle." It was caused by two unrelated booms—one was industrial and optimistic, the other artistic and pessimistic. One made Italy richer than ever before, the other produced an artistic renaissance that went far to restore Italy's prestige abroad.

427

With a new approach in both fashion and appliances, Italian designers and industrialists produced a distinctive new look that gave the label "Made in Italy" a guarantee of quality and taste. Innovators of this Italian look: Marchese Emilio Pucci, fashion designer (427), appliance manufacturer Giovanni Borghi (428), and leather wizard Aldo Gucci (429).

Members of every Italian class participated in the Italian Miracle. Marchese Emilio Pucci is a Pucci from Palazzo Pucci on Via dei Pucci in Florence. Emilio Pucci made his fashion debut quite by accident while at a ski resort in 1946. After voicing his dismay over the way his blond *amie* was dressed, he took up the challenge when she asked him, "Well then, what do you suggest?" by designing a blouse and ski pants. The lady was wearing his outfit on the St. Moritz slopes when she was photographed by Toni Frissell and featured in *Vogue*. Eventually the residential Palazzo Pucci was transformed into the head office of Pucci's enterprises and he became the father of the chic *prêt-à-porter* being sold for the first time on an international scale to the international set.

Like Pucci, the Guccis are from Florence. The family started out by making handbags and luggage, after which they too expanded into *prêt-à-porter* and moccasins. They have been so successful that today, if anyone says, "my Guccis," it is understood he means his shoes.

In 1943 electrician Giovanni Borghi grew weary of watching his mother pump an ancient oil stove and decided that what was good for *la Mamma* was good for Italy. Borghi's stoves were an instant success. In a few years Borghi had revolutionized the Italian kitchen by mass-producing inexpensive stoves, refrigerators, and washing machines.

428

429

430

431

Franco Zeffirelli (430) breathed new life into opera before subduing Richard Burton and Elizabeth Taylor in his film version of The Taming of the Shrew. *Roberto Rossellini (431), using outdated film stock and Roman streets for his locations, shot* Open City *and*

Vittorio DeSica was shooting a segment of *Boccaccio 70*, a film with three different sketches. DeSica's segment featured Sophia Loren in a scenario by Cesare Zavattini. The location was a small village near Ravenna. In true DeSica neo-realistic style, a local boy had been picked to play the male lead.

One evening after the day's shooting, Zavattini and I were having a drink in a Ravenna café. I asked him a question that had been on my mind since watching the scene of the handsome Emilian peasant embracing Loren. Now that the shooting was over, would he spend the rest of his life dissatisfied with his fate?

"No," Zavattini told me. "Every girl in this village believes he went to bed with Sophia and will want to go to bed with him, too. A brave Emiliano, he will do just that."

"Now suppose," I asked Zavattini, "this young man were a Roman?"

"He'd brag all over town that he went to bed with Sophia."

"And if he were a Neapolitan?" I went on.

"He'd photograph his sister naked, put Loren's head on her body, and sell the postcards."

"And as a Sicilian?"

"He would never get over it," Zavattini said.

268

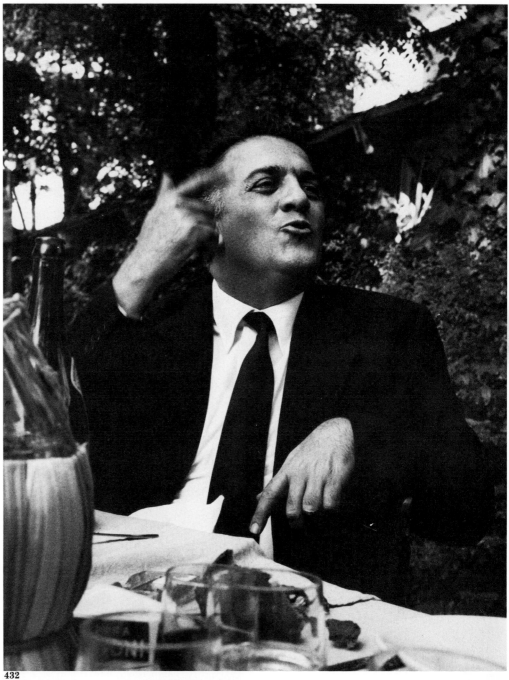

432

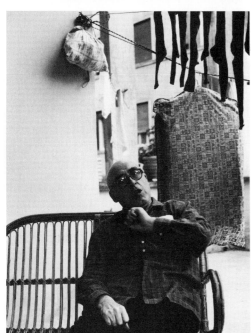

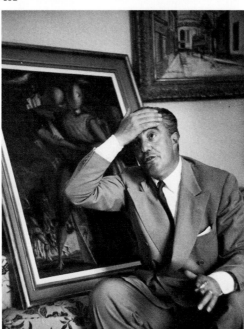

Paisan. *With* La Dolce Vita, *Federico Fellini (432) endowed the world's vocabulary with a coined word:* paparazzi. *Cesare Zavattini (433) and Vittorio DeSica (434) made* Shoe Shine, The Bicycle Thief, *and* Miracle in Milan.

433

434

The Millionaire Terrorist

In the fall of 1961 I did a story on Giangiacomo Feltrinelli, the young Milanese publisher who had created a literary sensation by bringing out *Doctor Zhivago* and *The Leopard*.

Feltrinelli was to prove far less Italian than the ringing sound of his name led me to expect. I found him pedantic and lacking in warmth. He hid behind heavy black horn-rimmed glasses and a drooping mustache. In matters of dress he preferred loose tweeds to the razor-sharp suits favored by Italians. Unlike most of his countrymen, who enjoyed American cigarettes, Feltrinelli was a pipe smoker until he met Castro and was introduced to Havanas. Richer by far than most Milanese, "Giangi," as he was nicknamed, did not share their conservative views. He was a Marxist.

"Giangi," a friend said, "sold the family bank because of political convictions. He's something of a snob about the way he makes his millions."

At our first meeting Feltrinelli declared, "I have no use for bestsellers," explaining that he was only interested in such books as *Labor Problems in the U.S.S.R.*

When I expressed surprise at his talent for not only discovering bestsellers in which he had no interest but also in his gift for getting them for a pittance, he said, "The more disconcerting I am, the better I like it."

Giangi was nine when his father died. "I missed the strong paternal influence essential for a boy that age," he said. Moreover, he resented his mother's influence. Gianalisa Feltrinelli was regarded as the most willful person in Italy. From what Giangiacomo told me, his childhood had been one long struggle to escape her maternal domination.

"Within three weeks of my birth," Feltrinelli said, "I was placed in an incubator, strapped to the back seat of the family Rolls, and, under the escort of two nurses, driven from Milan to our thirty-four-thousand-acre country estate in Austria because the air was more bracing there." In his telling of this event, which could only have been heard secondhand, I was struck by the wealth of detail and the sarcastic tone.

"Later I was sent to Switzerland every six months to be measured and weighed by the best doctors," he went on. "At thirteen I was taken to Chicago for a dental checkup because Dr. Goldschmidt had gone there to escape Hitler's Austria." Again I detected a note of irony.

"Giangi grew up alone and was educated by private tutors," a friend observed, "and I'm sure that his compulsion to get involved in everything is a reaction to that. If there's a political discussion, Giangi must get into it. If he's on his yacht, Giangi must navigate it. If he's in a restaurant, Giangi must inspect the kitchen and find out the cook's wages."

Recalling that period of his life, Giangiacomo said, "I grew up alone in a large villa. My only friends were the gardeners. There was one I especially liked and I helped him in his work. He was a Communist. By twelve I was up on my Marxism."

Feltrinelli's teens coincided with the war years. To escape from the bombardments, Gianalisa bought a large house on the then-deserted peninsula of Porto Santo Stefano. "After the Germans began using the harbor as a supply base," Feltrinelli said ruefully, "we were bombed one hundred and seventy-five times. But I took advantage of wartime conditions," he went on, "to prepare myself for the day I would run away. My dream was to join the partisans and fight the Fascists."

It was at this time that Giangi first handled explosives. "I did manage to defuse three dud Allied bombs so that townspeople could use the dynamite to blast air raid shelters," he recalled. So began Giangiacomo Feltrinelli's lifelong fascination with weapons and explosives.

"After the Allies liberated Rome in 1944, my mother made a deal with me," he said. "If I passed my baccalaureate at the July session, I could enlist in the Italian army. She never expected me to pass, but I did."

From all accounts he was a brave soldier.

Back in civilian life he again found himself at loggerheads with his mother, this time over politics. With the advent of the Italian republic in 1946, Gianalisa took it for granted that Communism would soon follow and decided to emigrate. While the family was awaiting a ship in Lisbon the twenty-year-old Giangi gave his mother the slip and returned to Italy.

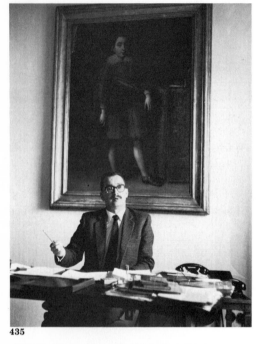

435

(435) Giangiacomo Feltrinelli in his Milan office. The painting behind him was part of a large collection of eighteenth-century masterpieces he came upon by chance "while I was going over my assets."

270

"Although my mother was terrified of Communism," Feltrinelli remarked facetiously, "she did hire a New York broker named Karl Marx as soon as she reached Canada."

With another year to go before he inherited an industrial empire, Feltrinelli took part in Communist activities. His empire encompassed a sprawling lumber company with forests in Austria; masonite, plywood, and furniture factories throughout Italy; an engineering firm with branches throughout the world; and extensive real estate holdings in Rome and Milan. The publishing house came later, and was his own idea.

A hard-driving businessman six days a week, Comrade Feltrinelli peddled the Communist newspaper *L'Unita* in the streets of Milan on Sunday mornings, much to his mother's mortification.

Feltrinelli, I discovered, led a life of costly proletarian simplicity. He refused to have a cook on his fifty-five-foot yawl, which he kept in Germany for summer cruises on the Baltic. Aside from sailing, the only other sport he indulged in was hunting. "I was going over my assets," he told me, "and discovered I owned a twenty-five-hundred-acre estate in Austria complete with gamekeeper."

Feltrinelli brought out *Doctor Zhivago* after resisting forceful Soviet intervention to prevent its publication. "In 1958 I did not renew my party membership," he explained, "because you can't operate a publishing house and be told what to do."

After I met the first and third of Feltrinelli's four wives—both extremely willful women—I realized that he kept marrying his mother. To make matters more complex, his first wife was instrumental in his getting *Doctor Zhivago* and his second, whom I never met, was responsible for his acquiring *The Leopard*. I suspect this was hard to take for a middle-aged man who, according to his former father-in-law Luigi Barzini, was impotent. Maybe this was his problem, but there was still something about Feltrinelli and all his contradictions that did not add up. He was obviously a mama's boy in revolt, but to write him off simply as the ungrateful son who became a Communist because he hated his mother did not satisfy me.

Five years went by before I met Feltrinelli again. By then he had modeled fur coats for fashion magazines and been to Cuba with the idea of commissioning Fidel Castro to write his autobiography. Although Fidel accepted an advance, he never wrote the book. Still, Giangi fell under his spell and made a number of visits to see Fidel.

By 1971 terrorism was spreading across Europe. One of its early victims was Roberto Quintanilla, the Bolivian consul in Hamburg. He was gunned down by Monika Hertl, a German terrorist, with Feltrinelli's Colt Cobra special. While a Bolivian security officer, Quintanilla had shot Ché Guevara. He had also questioned Feltrinelli when the Italian publisher was briefly detained in Bolivia. By the time of Quintanilla's death Italian police were becoming interested in Feltrinelli, who had gone "underground." On March 15, 1972, a badly mutilated body was discovered at the base of a high-tension pylon outside Milan. It was Giangiacomo Feltrinelli. His death created an uproar, which led to right-wing extremists being accused of murdering him.

My personal reaction was that he had blown himself up, as reported by the authorities. He was too much of an amateur to rig sophisticated bombs. A tape was discovered in a Red Brigade hideout. It gave an account of Feltrinelli's attempt to blow up the pylon with two associates. The trio had driven there in a Volkswagen camper. Before going into action, Feltrinelli changed from street clothes into Cuban army fatigues. While trying to set the timer, he blew himself up. So died Giangiacomo Feltrinelli, who, with his millions, had become the patron of international terrorism. During the Red Brigade trial in 1979, it was confirmed that "Comrade Osvaldo," as Feltrinelli called himself, had not been murdered but died the death of a "revolutionary soldier." In the last of the many contradictions which marked his forty-six years, Feltrinelli had assumed the pseudonym "Osvaldo"—Italian for Oswald—the name of President John F. Kennedy's assassin. Yet he had also named his son Fitzgerald in honor of the American president.

436

(436) Feltrinelli playing chess in the family villa on Lake Garda. This "mausoleum" was requisitioned by Mussolini for himself and his mistress during the last years of the war. It was not far from there that Mussolini and Clara Petacci were captured by partisans and shot, which made the villa a tourist landmark. Tourist boat guides can be heard bellowing into their megaphones, "And here, ladies and gentlemen, is Mussolini's house, which now belongs to Doctor Zhivago."

271

438

When Tito announced he would visit Russia in 1956, I was assigned to cover the trip. I had never been to the Soviet Union, and applied for my visa at the consulate in Paris. After filling in my application, I was ceremoniously moved from the crowded waiting room on the ground floor to a more exclusive one outside the consul's office. My escort pointed to a sofa, saying, "Please sit here. It's more comfortable." Soon I was ushered into the consul's office. After carefully reading my application, he offered me a cigarette and assured me I could reach him on the phone at any time, even after hours and on days he was not supposed to be in his office. I never did have any trouble getting him on the phone. The days went by. I was still waiting for my visa when Tito got back to Belgrade.

In 1975 the Italian ambassador to Russia asked my wife and me to visit him in Moscow. The formalities included sending our passports to the consulate in Washington so they could process our visas, which would take two weeks. A friend suggested a better way — going on a seven-day package deal with General Tours. For a little under six hundred dollars apiece we got our plane fares, hotel accommodations in Moscow and Leningrad, conducted tours to the Kremlin, the Hermitage and Pushkin museums, all our meals, tickets to the circus, and Russian visas by simply providing six passport pictures.

A Visa to Russia

Our flight reached Russia at dusk. Below was an immensity of snow-covered forests with small clumps of houses linked by dimly lit roads, which gave me the feeling I had stepped into nineteenth-century Russian literature. Gazing out on Razin Ullica from the Hotel Rossiya (437), I was struck by the fact that — if you overlooked the architectural monstrosities known as "Stalin's cathedrals," the red flags, and the party slogans — Moscow still had much in common with a past described by Dostoyevski.

(438) The banks of the Neva River, Leningrad.

273

Reflections at Seventy

(439) The last time I saw Tito was at his villa in Zagreb in September 1978.

(440) Life *assigned me to photograph Tito's funeral, and so came to an end a story I had been covering for thirty-six years.*

When I came across my 1948 pictures of the surrender of the Jewish quarter in Jerusalem, I wondered what had happened to the people I had photographed being uprooted from their homes. One vision in particular haunted me: the terrified little girl running down the blazing street. It nagged me that I would never find out.

Then Fate intervened. My friend Ted Rousseau, curator-in-chief of the Metropolitan Museum of Art, told me the Met ought to acquire some of my pictures. Ted Rousseau died soon after. In his memory I presented fifteen of my pictures to the museum. Thomas Hoving, who was then the director, was especially struck by two that showed the Batei Mahse district of the Jewish quarter before and after it was looted. Modernage Laboratories made the prints.

In February 1975 Ralph Baum, who ran Modernage, asked if he could show the Batei Mahse pictures to Teddy Kollek. Soon after, I met the irrepressible mayor of Jerusalem in New York. He invited me to come and see the restoration work in the Jewish quarter and arrange an exhibition of my 1948 pictures at the Israel Museum. I mentioned that if only we could find someone who had lived in the Jewish quarter before the 1948 exodus, it might be possible to locate some of the survivors I had photographed.

Teddy Kollek knew just the person. She was Rivca Weingarten, a daughter of the rabbi I had photographed at the time of the surrender. With the help of a magnifying glass she studied the contact sheets sent her and identified fifteen survivors, supplying names, addresses, and phone numbers. From this initial group my wife Anna Maria traced thirty-six more people scattered around the country. Their combined lives added up to the story of Israel. The terrified little girl turned out to be Rachel Levy, a plump and cheerful housewife whose husband was a Jerusalem taxi driver.

"A Will to Survive" opened at the Israel Museum in Jerusalem on September 21, 1976, and ran for months. As Teddy Kollek put it, "It was crowded with wall-to-wall visitors." Its great success was due to the fact that they recognized members of their families and friends in my pictures. In 1977 I brought out "A Will to Survive" in book form. This led to an invitation to a reception at the White House honoring Mrs. Menachim Begin. I was part of a group whose work was of interest to the Israeli prime minister's wife. Mrs. Carter's secretary led me to the First Lady and then went looking for Mrs. Begin. During the few minutes it took for Mrs. Begin to join us, Mrs. Carter got a rundown on my activities. Turning to Mrs. Begin, she told her about me in such detail it seemed as if she had known me for years.

Only on leaving the White House did I learn my true worth. The P.R. woman who handled my book had called the *New York Times* before I went to Washington to suggest that my visit to the White House was a possible item for the "People" section and was told that my only hope of making it would be if I was run over on the way there.

The following year I was back at the White House during Tito's state visit — this time as a photographer. Working with the White House photographers was an experience. They were all confined to a conference room. In their bush jackets with large pockets and weighted down by huge tele lenses with which they could shoot their quarry at three hundred yards, they reminded me of big game hunters. When Presidents Carter and Tito were ready for "the photographic opportunity," we were given a signal. The race was on and the speediest got the best pictures.

In 1978 I was to see Tito one last time. Before he led me to the park surrounding his Zagreb home for a stroll, we passed a large stuffed bear he had shot. "I got a lot of bears in my life," he smiled.

When I asked him to pose next to it, he gave me the same baleful look he had twenty-nine years before when I vainly tried to get a picture of him with one of his peacocks.

After we said goodbye he turned and walked away and I got one last picture of him.

Since I had been photographing Tito for thirty-seven years, *Life* assigned me to cover his funeral in 1980. A grandstand had been set up on the

grounds of his Belgrade villa, where he was to be buried. The foreign delegations at the funeral included four kings, five princes, thirty-one prime ministers, thirty-four presidents, and forty-six foreign ministers, representing most of the world's population. The magnitude of the funeral made me think back to the first time I had met Tito in his cave. The once mysterious figure was being honored as the last of the great wartime leaders. I wondered what Leonid Brezhnev, who led the Soviet delegation, had on his mind. Were it not for Tito, the Soviets would have been a Mediterranean power in a vastly different Europe from the one it was on his funeral day.

After the funeral I was startled to come upon a statue of Mosa Pijade, who had been Tito's mentor. I had known Pijade well enough to feel I was gazing at an acquaintance. I was at an age where many of those I photographed had been either forgotten, deified, turned into stone, or put on postage stamps.

Until I met George Santayana shortly after the liberation of Rome in 1944, I had never given much thought to the ravages of time. A frail eighty-one, he lived in a convent. The collar of his pajamas, which protruded above his dressing gown, had been darned so often by the nuns that it looked like an embroidered ruffle around Santayana's neck. He might have been a Velasquez painting. The philosopher mentioned Harvard and I asked him when he had last been in the States. "Nineteen thirteen," he told me. At age thirty, this was for me more than a lifetime.

I was made even more aware of time as an entity by Bernard Berenson, the eighty-four-year-old historian. It was in 1949 and I was just back from Israel. Berenson's recollections of Jerusalem were so fresh that I was puzzled how one so dependent upon comfort (his watch had to be warmed before being strapped to his wrist, while a hot water bottle was slipped beneath his napkin during meals) could have faced the rigors of present-day Jerusalem. I could not believe it when Berenson told me he had not been there since 1899, light years away for me.

At seventy, I can now look back on half a century and, thanks to the perspective time gives to events, can clearly bring into focus much that once seemed indistinct and only vaguely threatening. What is troubling the world today has its origins in the past fifty years. Owing to the nature of my work, I had occasion to observe many of the world's conflicts, a number of which are illustrated in this book.

I have entered history several times. Two thousand years after the victorious Caesars entered Rome I drove through the same triumphal arch with an American army. Another time, following in the footsteps of the Babylonians, the Romans, the Persians, and the Crusaders, I entered Jerusalem with an Arab army. I have watched the British Empire founder and was around when the Soviets started to grab the leftovers of the Hapsburg Empire in an attempt to dominate the world with their Marxist theocracy. I was present when Tito rebelled against Stalin and the first crack appeared in Communism's monolithic structure. I photographed my native Algeria as it struggled to become independent. Asked how I felt about that event by a lady from Houston, I said, "The way a Texan would if he woke up one morning to find the state run by Cherokees."

Forty-nine years after I first went to work for *Life,* I celebrated my seventieth birthday and received a gift from Teddy Kollek. He wrote that my 1948 pictures of the Old City were to be placed on permanent exhibit as part of Israel's history. That is how a twenty-one-year-old press photographer became a historian at seventy.

(441) Tito's funeral: (left to right) sons Zarko and Misa, and widow Jovanka in the Parliament Building, where the Yugoslav president lay in state, May 5, 1980.

(442) With Golda Meir, who wrote a preface to my book A Will to Survive.

441

442

444

(443) *The Iron Curtain: East German Vopo at Brandenburg Gate, Berlin.*

(444) *The Cactus Curtain: U.S. marine at Northeast Gate, Guantánamo Bay, Cuba.*

The Confrontation

Cast of Characters

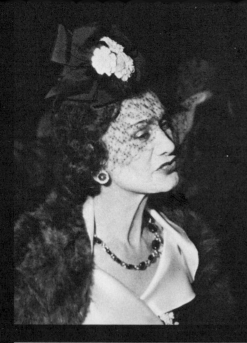
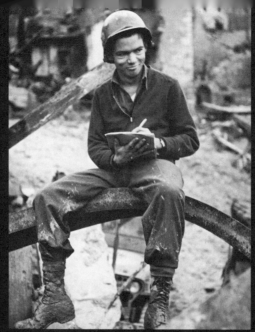

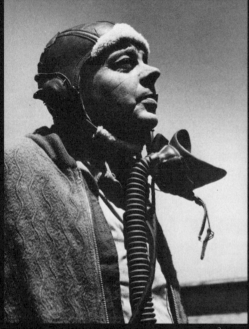
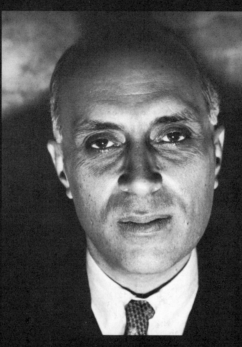
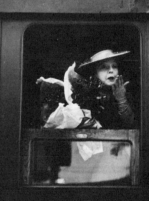

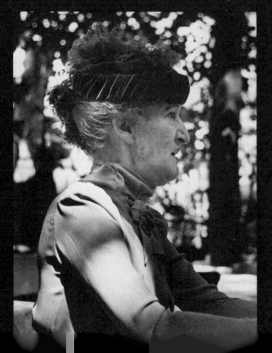

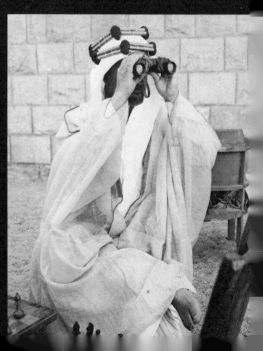